Yucatán Through Her Eyes

Yucatán
Through

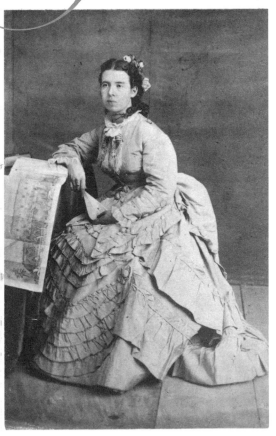

Her Eyes

Alice Dixon Le Plongeon, Writer & Expeditionary Photographer

Lawrence Gustave Desmond

Foreword by Claire L. Lyons

UNIVERSITY OF NEW MEXICO PRESS

ALBUQUERQUE

LIBRARY OF CONGRESS CATALOGING-IN-PUBLICATION DATA

Desmond, Lawrence Gustave, 1935–

Yucatán through her eyes : Alice Dixon Le Plongeon :

 writer and expeditionary photographer /

 Lawrence Gustave Desmond. — 1st ed.

 p. cm.

Includes bibliographical references and index.

ISBN 978-0-8263-4595-0 (hardcover : alk. paper)

1. Le Plongeon, Alice D. (Alice Dixon), 1851–1910.

2. Le Plongeon, Alice D. (Alice Dixon), 1851–1910—Travel—Yucatán Peninsula.

3. Archaeological expeditions—Yucatán Peninsula.

4. Yucatán Peninsula—Antiquities

5. Le Plongeon, Alice D. (Alice Dixon), 1851–1910—Diaries.

6. Photographers—Yucatán Peninsula—Biography.

7. Women photographers—Yucatán Peninsula—Biography. [1. Mayas—Yucatán
 Peninsula—Antiquities.]

I. Title.

II. Title: Alice Dixon Le Plongeon.

 F1435.D48 2009

 972´.6501092—dc22

2008049353

Book design and type composition by Melissa Tandysh

Composed in 11/14 Adobe Garamond Pro

Display type is Bernhard Modern Std and Bickham Script Pro

FRONTISPIECE: Alice Dixon Le Plongeon photographed by her father Henry Dixon at his studio at 112 Albany Street in London. On the desk is a drawing of the House of the Governor at Uxmal, Yucatán, drawn by Frederick Catherwood for John Lloyd Stephens' book *Incidents of Travel in Yucatan*. Circa 1871. Research Library, The Getty Research Institute, Los Angeles, California (2004.M.18).

Para el pueblo de Yucatán,
y mis amigos y colegas que allí habitan.

To the people of Yucatán,
and my friends and colleagues there.

Contents

CONTENTS

Illustrations

The Diary of Alice Dixon Le Plongeon, 1873–76

ILLUSTRATIONS

Foreword

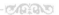

In the January 14, 1899, issue of *The Woman's Tribune*, Alice D. Le Plongeon published an essay that traces the genesis of political oppression from prehistoric clan communities to the French Revolution. Her essay, "A Thought on Government," is a pessimistic reflection on the corruptions of power, and it concludes with two questions: "Is the great American republic destined to be wiser in this matter than the many nations which have already lived, struggled, decayed, and vanished? Will the wisdom and goodness of its remarkable and noble women help to make this Republic more enduring and more perfect than all the nations that have preceded it?" Writing from New York, where she had settled after adventure enough for a lifetime, Alice would have been well pleased—though doubtless dismayed by the long lapse of time—to learn that in 2008, her questions had been on the lips of fellow citizens anxiously awaiting the outcome of a presidential primary election. She would be even more gratified to see that many of her writings survived the next century and are again reaching new audiences with Larry Desmond's biography and transcription of her Yucatán diary.

When Alice Dixon Le Plongeon (b. London, 1851; d. New York, 1910) moved from Yucatán to Brooklyn at age thirty-three, the closing years of the nineteenth century foreshadowed an era of momentous change in the opportunities women could reasonably expect. A young English bride who spent her early married life traveling in Mexico, she was among the vanguard of women who pursued unconventional careers on unfamiliar terrain. This was the heyday for Victorian ladies who set out on overseas journeys, and in the

archaeology of the Old World several women of Alice's generation were later recognized for their achievements, among them Jane Dieulafoy (1851–1916) and Gertrude Bell (1868–1926) in the Middle East, Margaret Murray (1863–1963) in Egypt, and Esther Van Deman (1862–1937) in Rome. Relatively few of her contemporaries, however, were engaged seriously in the nascent field of Mesoamerican archaeology.

Extraordinary as she was, the Alice who spoke out against political inequity was very much a woman of her time. Her history lesson shares space on page four of the *Woman's Tribune* with correspondence, narratives, and advertisements—a collage of feminist and feminine endeavors that conveys the cultural milieu in which her singular sense of self took shape. Column one leads with two sonnets by Helen Hay, "The Coming of Love" and "Age," pensive meditations on milestones in a woman's life. Writing on behalf of suffragists, Elizabeth Cady Stanton and Susan B. Anthony penned an articulate protest against retrogressive legislation aimed at installing a male oligarchy in the new state of Hawaii. Immediately following Alice's piece is a colorful travelogue describing Perth, Australia, and commenting sympathetically on the temperance of aboriginal natives—a racially progressive viewpoint that recurs in a page-one article complimenting the heroism of Negro regiments. World travel and national politics share space with advertisements for a rejuvenating new Turkish bath, as well the popular patent medicine known as Hall's Catarrh Cure. Mrs. McNaughton posts dental office hours, and copies of "The Well Dressed Woman" can be ordered for one dollar. Here too Helen Pearce offers her services as a practitioner of Divine and Mental Science ("which is efficacious when all else fails"), to bring forth "actuality, harmony, health and strength."

Contributors to the *Woman's Tribune* shared convictions and sentiments that are echoed in the pages of Alice's Yucatán diary, an account of her travels in Mexico between 1873 and 1876. Larry Desmond's biography narrates the life of a woman whose interests ranged from exploration of an exotic lost civilization to political activism and social justice. Patiently recopied from field notes and letters during a sojourn in Belize, the diary sketches the daily progress of the Le Plongeons' archaeological mission. Not quite an excavation daybook but much more than a chronicle of personal experiences, the diary offers readers a rare insider's view of nineteenth-century field investigations in the era just prior to the emergence of Mesoamerican archaeology as a professional discipline. Seasoned with affection for an eccentric older husband ("the Doctor"), her account tells of the exasperations of a lengthy wilderness expedition and their stalwart endurance of draining physical ailments. We encounter a young woman eager to leave behind a comfortable middle-class youth in London. In Mexico she found an ideal setting to fashion an alternative dramatis personae, casting as players Maya warriors in the

still-simmering Caste War, and pretty mestizas in white dresses, with herself as protagonist in a grand enterprise.

Over the course of two extended campaigns in Yucatán, Alice worked side by side with her husband Augustus to investigate Maya ruins at Chichén Itzá, Uxmal, and a number of smaller sites. They cleared and excavated overgrown monuments, made casts of ancient reliefs, and produced an important series of documentary photographs. The couple's livelihood depended on the support of local officials, patrons eager to learn of the latest discoveries, and collectors keen to fill North American galleries with Mexico's ancient art. Alice maintained a hectic schedule of lectures and popular writing for U.S. audiences, which supplemented the couple's modest income from photograph sales. Journalist, amateur ethnographer, and photographer, Alice's bibliography reveals in a glance the breadth of her curiosity. In addition to general-interest articles on locust plagues, infant-rearing practices, hammocks, and Indian dances, she published technical advice on the merits of using the collodion versus the gelatin process in field photography as well as a moving account of the fall of Chan Santa Cruz (Quintana Roo), capital of the Maya free state. Compassionate and at times high-handed in her relations with the local community, Alice's letters hint at the disappointments of breaking ground in a field destined to be dominated by a younger generation of male scholars. North American museum men and academics in the emerging discipline of anthropology had scant time for the speculative musings of the Le Plongeons, a pair of amateur adventurers who clung to outdated theories of Maya origins devised by an earlier generation of French antiquarian explorers.

Despite its shortcomings as an objective ethnographic investigation, the diary opens a window onto life in southern Mexico's Yucatán peninsula during the final quarter of the nineteenth century. It is set against the backdrop of political turmoil and class rivalries that were peculiar to Yucatán in the decades following the French intervention. This first-person description of unearthing and surveying the remains of Maya cities is one element in a larger collection of manuscripts, field notes, and photographs acquired by the Getty Research Institute in 2004. The Le Plongeon archive fills in long-missing details of Augustus's earlier career as a physician and proprietor of a photographic studio in Peru, where he developed an abiding interest in megalithic architecture. Their papers extend beyond the public realm in which Alice earned the means to support their collaboration and allow us to piece together the kind of multivocal biographical profile that Rosemary Joyce conceived for Dorothy Popenoe in Honduras.

Augmenting the widely scattered letters and photographs collated by Larry Desmond and Phyllis Messenger in their first book on the couple, the rediscovered documentation of the Le Plongeons' Yucatán expedition

has been catalogued in archival detail by a scholar of early photography in Central and Latin America, Beth Ann Guynn. Guynn's finding aid is at once inclusive and schematic.

> Title: Augustus and Alice Dixon Le Plongeon papers, 1763–1937, bulk 1860–1910.
>
> Description: 39.4 linear ft. (63 boxes)
>
> Arrangement: Organized in five series: I. Augustus Le Plongeon papers, 1846–1914; II. Alice Dixon Le Plongeon papers, 1873–1910; III. Photographs, 1851–1933; IV. Drawings, maps, and plans, 1860–1931; V. Papers of Henry Field Blackwell and Maude Alice Blackwell, 1763–1940.
>
> Biographical or Historical Notes: Augustus Le Plongeon was a medical doctor, photographer, antiquarian, and amateur archaeologist of French origins. In the early 1860s, after spending time in Chile and northern California, Le Plongeon moved to Lima, Peru, where he practiced medicine and photography, and became interested in Peruvian archaeology. On a trip to London he met Alice Dixon, daughter of the photographer Henry Dixon. The couple returned to North America where they married and devoted their lives' work to excavating, documenting, and interpreting the Maya ruins and culture of the Yucatán peninsula. They spent over a decade exploring Yucatán and Central America, excavating at Chichén Itzá and Uxmal.
>
> The collection documents the archaeological excavations, fieldwork, research, and writings of the nineteenth-century photographers, antiquarians, and amateur archaeologists Augustus and Alice Dixon Le Plongeon, the first persons to systematically excavate and photograph the Maya sites of Chichén Itzá and Uxmal (1873–1884). The couple's pioneering work in documenting Maya sites and inscriptions with photography, which in many cases recorded the appearance of sites and objects that have subsequently been damaged or lost, was overshadowed in their own lifetimes by their theories of Maya cultural diffusion, and in particular by their insistence that the Maya founded ancient Egypt. The Le Plongeons' work, and evidence of their wide-ranging interests, is found in manuscripts, diaries, correspondence, and photographs. The collection also contains papers belonging to Maude and Henry Field Blackwell, who inherited the literary estate of the Le Plongeons.

The catalogue entry summarizes the Le Plongeons' research and landmarks in the career of Augustus. For Alice, there is this succinct snapshot.

The papers of Alice Dixon Le Plongeon coincide with her married life, and consist of correspondence, her field diary, research notes and manuscripts, and published articles. Her correspondence includes 12 letters from Phoebe Hearst, one of the Le Plongeons' benefactors. Research notes, unpublished writings, published articles, and sheet music (*Maya Melodies of Yucatán*), attest to the wide range of subjects on which Alice wrote and lectured after the couple's return from Mexico, and include not only Mexican archaeological and ethnographical topics, but also subjects such as Hawaii, old London, natural history, and women's rights. Unpublished manuscripts include the typescript for a book entitled *Yucatán: its ancient palaces and modern cities*.

This eclectic mix of themes prompts researchers to consult a folder-level finding aid, where the researcher discovers that Alice published not only articles of an archaeological and ethnographic bent, but also whimsical sheet music and poetry. Her creative energies even brought forth a novel in verse titled *Queen Móo's Talisman* (1902c), a romance of political intrigue, murder, and the loss of empire at Chichén Itzá. Other manuscripts delve into the myth of Atlantis and imagine the Maya as progenitors of advanced Old World civilizations. Reading these fanciful literary efforts, it comes as little surprise that the character invented by Alice—a plucky young Englishwoman in the wilds of Yucatán—has inspired twentieth-century playwrights, a film-maker, and adherents of new-age spiritualism. Her compelling story is ripe for the big screen.

Within the Le Plongeon diary, however, perceptive readers can hear the echo of Alice's personal voice. Setting her apart from the mainstream of intrepid late Victorian tourists are her writings on the culture and customs of isolated Yucatecan villagers and landowners. She depicts a region that was still well off the beaten path for most European travelers. Although concerned with the ancient Maya and their survival in the customs of modern Indian communities, her journal is more narrowly focused on the daily progress of the couple's archaeological mission. Alice nonetheless writes with a special empathy for native women's lives, reserving caustic impatience for male workers, guides, and bureaucrats. Far from being spontaneously jotted notes, its vignettes are clearly tuned to engage a public readership. If Alice harbored any doubts about the unusual path she traveled, they are well masked, and one must read between the lines of her correspondence to get a sense of the tensions and disappointments of the life she and Augustus shared.

Not listed among better-known authors on contemporary Mexican and Latin American culture, Alice's observations can be compared to those of other European women who wrote of their impressions in the New World.

Family letters of the Scottish-born Fanny Calderón de la Barca represent a high point of this genre and paint a vivid panorama of social life and manners in Mexican cities. Calderón published her widely read letters in 1843, a skilled literary accomplishment that may have served as a model for Alice. Alice's near contemporary, Caroline Salvin, described her stint with naturalist husband Osbert Salvin at Copán in a diary, which was later circulated as *A Pocket Eden: Guatemalan Journals, 1873–1874.* Two decades later, Anne Cary Maudslay spent a honeymoon trip in Guatemala, where she and Alfred Percival Maudslay (Salvin's collaborator) investigated the ruins of Quiriguá. Characterizing her Central American sojourn as a lonely time relieved only by the antics of a pet squirrel, Anne tended to camp life and devoted free time to keeping a journal, which later served as the basis for several chapters in a popular book she coauthored with Alfred, *A Glimpse at Guatemala* (1899). Of the publications by spouse-collaborators, Alice's are by far the most intellectually ambitious.

Anne Cary Maudslay cuts a prim figure in an 1894 photograph, seated sidesaddle under a parasol as she gazes up at one of Copán's monumental stelae. By contrast, Alice—nearly ubiquitous in Augustus's views of Chichén Itzá and Uxmal—poses in breeches and boots against the sculptured façades of Maya monuments. In an unpublished manuscript, "Yucatán: Its Ancient Palaces and Modern Cities," she underscores the fact that she rode her horse Charlie astride, noting the negative effects that female attire have on women's actions and minds. The camera captures her playing guitar and busying herself in the rustic camp they set up inside the ruins. Other women active in Mesoamerican research, including Caroline Salvin, the accomplished illustrator Annie Hunter, and the artist Adela Breton, made a mark illustrating natural history, Maya architecture, and archaeological artifacts in highly accurate and evocative watercolors. Skills learned in the photographic studio of her father, Henry Dixon, equipped Alice for the challenges of managing cumbersome equipment and chemicals in primitive surroundings. Despite the obvious conclusion that in the many views of Augustus, the individual behind the camera was his wife, Alice does not figure in the scholarly literature on the pioneer generation of women photographers. It was Alice who was responsible for developing and printing in a makeshift darkroom and who authored several technical articles on photography. In addition to images of Augustus's heroic discovery of a Chacmool figure, sensitive portraits of local women, market scenes, townscapes, and nature studies may be attributed to her.

Photographs by the Le Plongeons have not won the admiration that the fine large-format views by their competitor Désiré Charnay have earned. Their approach to architectural survey, however, was innovative in its use of stereography to create a three-dimensional visual experience of relief

ornament and glyphs. The couple's joint enterprise preserves valuable evidence of ancient monuments that have been altered by exposure, excavation, restoration, and plunder. More than a studio assistant, Alice merits a place among the early female practitioners of scientific field photography. Headed by Anna Atkins's 1843 cyanotypes of British algae, the list of women engaged with photodocumentation—as opposed to portraiture and artistic photographs—is not a lengthy one. Caecilie Seler-Sachs's photodocumentation of Latin American travels and Oaxacan artifacts, made together with her botanist husband Eduard Seler during their 1887–88 and 1895 field seasons, stands out. Together with her writings, Alice's views of sites, camp life, and *couleur locale* represent the contributions of a young woman of great breadth and enthusiasm, armed with sturdy self-confidence.

Alice Le Plongeon's absence from the roster of late Victorian women of accomplishment can be explained by her steadfast support of Augustus's far-fetched notions. A partner in what Matthew Engelke has termed the "endless conversation," she has been classed with the unofficial helpmates and insignificant others married to academically prominent spouses. In a 2004 volume of *History of Anthropology* devoted to *Significant Others: Interpersonal and Professional Commitments in Anthropology* (Richard Handler, editor), Engelke's essay notes that spouse collaborations have often been central to the advance of anthropological scholarship. That Alice has not found a place in disciplinary history is partly due to the exclusion of women—a burgeoning presence in late 19th-century anthropology—from professional organizations and university positions. Deliberate in her choice to give public voice to the antiquarian speculations of her husband, Alice stood by him and so slipped outside the fringes of an increasingly scientific field. Assuring that he stood out, she chose to recede until after his death, when she published an interpretation of the ancient Maya as the original Atlanteans. Such outlandish theories isolated her from the mainstream that socially advantaged peers, such as Zelia Nuttall (1857–1933), managed to occupy. For this reason she remains an unlikely candidate for remedial histories of women in fieldwork. Her fortunes may yet witness a revival. Placing greater emphasis on the sociology of research, students of disciplinary history are now turning to early photographs in order to recover local contexts and to acknowledge the extended network of contributors—including Mexican residents, workers, and various "excluded others"—whose lives were intertwined with the archaeological enterprise. Alice's written narratives bring the Le Plongeons' rich visual archive to life and constitute a body of evidence that can be gleaned for regional and community histories.

Paradoxically, the preservation of the Le Plongeon archive was safeguarded by adherents of the very esoteric beliefs that had undermined the couple's credibility in the anthropological establishment. Maude Blackwell,

a friend of Alice's who was active in theosophical circles, deposited segments of the archive where she believed they would be taken seriously. Far from the dismissive eyes of academic elites, the papers, negatives, drawings, and an extensive photographic archive survived mostly intact in the libraries of two theosophical and philosophical research centers in Los Angeles. Much of this material was later organized and studied by Leigh McCloskey and Stanislas Klossowski, who listened to the different voices in which Alice and Augustus spoke and determined to place their work in a public repository. At the Getty Research Institute in Los Angeles, Larry Desmond has reassembled the far-flung fragments of a creative life with great care. As her biographer, his voice joins those of past friends and collaborators in a much-deserved tribute to the multifaceted Alice Dixon Le Plongeon.

<div align="right">

Claire L. Lyons
Curator of Antiquities, J. Paul Getty Museum

</div>

Preface

Before Alice Dixon Le Plongeon's papers became public in 1999, some important sides of her life came to light during my work on the archaeology and photography of her husband Augustus Le Plongeon. Augustus's photographs of Alice, taken in Yucatán in the 1870s, showed a determined woman, often in the midst of the Maya ruins with her rifle and binoculars in hand or enjoying an afternoon with Maya friends. But Alice's writings on photography soon convinced me that Augustus was only half of the photographic team because through them it became clear she had mastered the complicated nineteenth-century art.

Her angry and emotional letters about the confiscation of the Chacmool statue she and Augustus had spent weeks excavating at Chichén Itzá exposed a fiery yet determined and insightful temperament. That temperament would express itself later when she wrote for professional journals and newspapers about the exploitation of Maya women in nineteenth-century Yucatán and worked for women's rights in the United States.

Phyllis M. Messenger, coauthor of our 1988 book *A Dream of Maya: Augustus and Alice Le Plongeon in Nineteenth-Century Yucatan*, saw Alice from her own perspective. She observed, "Alice Le Plongeon arrived in Yucatan as a young woman, seeing the world for the first time. As one of the first European women to carry out research in that area, she had to make her own rules as she went along" (Desmond and Messenger 1988:130). Phyllis's insight that Alice made "her own rules as she went along" was key to understanding that Alice was determined to create a life for herself beyond her London middle-class origins.

Ten years before *A Dream of Maya* was published, I learned from Manly P. Hall, president of the Philosophical Research Society in Los Angeles, that the Le Plongeons had kept diaries during their years in Yucatán. I had pointedly asked him if there were diaries or field notes in the collection, and he replied that for about a week he actually had in his possession two handwritten volumes that he thought were diaries. But he had returned them to the owner, Maude Blackwell, at her request, and he had not seen them or her since the 1930s. The news was mixed, but I thought they might be found someday stored in the "attic of an old home in New York or London" (Desmond and Messenger 1988:129). That was when my search for the diaries actually began, but what I did not fully realize was that along with the missing volumes was an entire archive of Alice's papers.

That collection of letters, manuscripts, and more than 2,400 photographs had been inherited by Blackwell from Alice when she died in 1910. Sometime in the late 1920s Blackwell moved from New York City to Los Angeles, but with the Great Depression and the death of her husband, her financial situation became desperate. Yet, in spite of her financial problems, she flawlessly fulfilled her vow to Alice to care for her writings and photographs.

In the early 1930s Blackwell sold Hall part of the collection, and while Hall realized there were more materials, only Blackwell knew their full extent. She was an associate of the United Lodge of Theosophists in Los Angeles, and because she was no longer able to care for the remaining materials, she called upon her friends with the lodge to help her store and protect them. The boxes of photographs and archival materials were accepted and well cared for, but their whereabouts was unknown to archaeologists and historians.

By the early 1990s, after I had written and visited practically every archive, museum, or library where the volumes might be stored, it seemed to me that there was little chance of finding them. I had even written the United Lodge of Theosophists, but received no reply. The usual author's queries were placed in the *New York Times* and *Times of London*, and the Dixon family was tracked down in England. Alison B. Eades, great-grandniece of Alice, wrote the entire far-flung family urging them to search their attics for diaries or field notes. Nothing turned up.

Then, when I least expected, in 1999 the entire collection suddenly surfaced and was offered to the Getty Research Institute in Los Angeles. In preparation for acquisition, Claire L. Lyons, then collections curator for the history of archaeology and ancient art for the Institute, called me for background about the Le Plongeons. Almost before she could question me, I asked her, "Are there any field notes or a diary?" She replied that there was one handwritten volume, and the description she gave me matched what Hall had told me in 1978. And while the second volume was missing, the number

of photographs, unpublished manuscripts, letters, and other archival materials in the collection was astonishing.

Once everything was cataloged, I rushed to Los Angeles and the first thing I read was the diary. Alice had compiled it from copies of her many letters to her family and notes made in the field. I found her description of her first three years in Yucatán to be so insightful and compelling that it has been included in this book. It is not a dry anthropological description, but rather a day-to-day narrative about what she saw and felt during those first three years with all the emotions of her young life. I found the diary well worth the wait.[1]

While the Getty Research Institute holds the most extensive collection of Alice's letters, articles, and unpublished manuscripts, I have also drawn upon the archival resources of a number of other institutions in writing this account of her life. My hope is that it will not only be a good read but will also stimulate my archaeological colleagues and historians to find additional perspectives about her work and life.

Acknowledgments

Many colleagues, friends, and institutions deserve thanks for their support in the writing of this book. First, my thanks to the entire staff at the Getty Research Institute (GRI), Los Angeles, for their unceasing efforts to facilitate my work with the papers and photographs of Alice Dixon Le Plongeon in the research library and special collections reading room. They are an extraordinarily helpful and dedicated team of professionals.

The staff members I worked most closely with were Claire L. Lyons, Beth Ann Guynn, and Peter Bonfitto. At the time of this writing, Lyons was curator for the history of archaeology and ancient art and initiated the process that resulted in acquisition of the Le Plongeon archive by the GRI. I would like to extend personal thanks to Lyons for sharing with me her extensive knowledge of nineteenth-century expeditionary photography and archaeology, her suggestions on the structure of the book, and her many insightful comments on the life and work of Alice.

Beth Ann Guynn, special collections cataloger and rare photographs specialist, knew the entire collection inside and out before I ever looked at it. But she went far beyond a thorough knowledge of the collection's letters, unpublished manuscripts, and photographs and began her own study of Alice and the material. She located long-forgotten articles that resulted in a thorough bibliography of Alice's writings and uncovered numerous newspaper notices of her many public lectures.

Once I had completed the transcription of Alice's diary, Guynn volunteered to work with me on a number of occasions to make certain it was

accurate. That entailed not only comparing my transcription with the original, but also, owing to her keen interpretive skills, helping to unravel the meaning of many of Alice's scribbled words in English, Spanish, French, and Yucatec Mayan.

Peter Bonfitto, GRI research assistant, assisted in the transcription of the diary, kindly responded to my last-minute requests for additional photos, answered many administrative questions, and thoughtfully brought to my attention important GRI archival materials not part of the Le Plongeon collection that were important to the book.

Special thanks to the very talented artist-philosopher and actor Leigh J. McCloskey who knew the importance of the Le Plongeon papers and photographs and offered them to the Getty Research Institute to make certain they would be archived as a collection and made available to the public.

I would also like to thank a number of scholars whose expertise contributed in innumerable ways to this book. First is Susan Milbrath, curator of Latin American art and archaeology at the Florida Museum of Natural History, for her help with my often obscure questions about Maya archaeoastronomy, hieroglyphics, and art; Jesse Lerner, a documentary filmmaker and professor of media studies at Pitzer College, Claremont, California, helped with his knowledge of nineteenth- and early twentieth-century Yucatecan literature; Paul G. Bryan, metric survey team leader and head of the photogrammetric unit for English Heritage, York, England, worked closely with me over number of years to make known the historic importance of the Le Plongeons' 3-D stereo photos for heritage preservation; professor of art at California State University, East Bay, Phillip Hofstetter facilitated my library inquiries and shared his perceptive reflections on the Maya; and finally professor of Hispanic studies Roxanne Dávila at Brandeis University who provided many important insights about the manuscript and generously shared her own research on the history of Mayanist studies.

Mil gracias a maestra Catalina Callaghan in Yucatán who reviewed and edited my long list of people, place names, and words in Mayan and Spanish, but also helped to translate the many passages Alice wrote in Spanish in her diary.

For their continuing support and help with my questions about the archaeology and history of Yucatán, many thanks to my colleagues: James M. Callaghan, anthropologist and director of the Kaxil Kiuic Biocultural Reserve in Yucatán, and INAH (Instituto Nacional de Antropología e Historia) archaeologist Tómas Gallareta Negrón, a leading authority on the northern Maya lowlands, director of the Xocnaceh project, and codirector of the Proyecto Arqueológico Regional de Bolonchen in Yucatán.

Descendants of Alice's brothers and sisters have provided rare family photographs, genealogical information, letters, and related materials. I

would especially like to thank Alison B. Eades, great-grandniece of Alice, for taking time from her work in international development to share family impressions of Alice and to locate letters and other historical items. Others in the Dixon family that have helped with this project are Jill Eades; David Eades; Donald and Diana Dixon; Pat Young; Pat's mother, the extraordinary Roberta (Bobbie) Stacey, who knew Alice's sister Mary Elizabeth Dixon (Grandma Mully) and Alice's brother Thomas James Dixon (TJ). And a newcomer to this project from northern England is Katie Cussons, second great-grandniece of Alice, who at age thirteen e-mailed me, "I think that it is very thoughtful of you to search for all these years to bring out the best in Alice. I am sure she will be most grateful."

Very special thanks are due to photo librarian Lynne MacNab who generously provided me with her extensive research notes on Henry Dixon and the Dixon family. Those notes came from her work at the Guildhall Library in London that resulted in an exhibit on the photography of Henry Dixon. Her insights on Alice, knowledge of nineteenth-century photography, and research about Henry Dixon's important photographic work have been invaluable.

The following facilitated access to their institutions' photographs: John Fisher, librarian with the Guildhall Library's prints and maps department in London; Charles Spencer, chair of the department of anthropology at the American Museum of Natural History in New York; and digital imaging manager Lindsay Caulkins, also with the Museum.

As much as researchers rely on the Internet these days, nothing can surpass the help of librarians. My thanks go to Elizabeth W. Pope, reference librarian at the American Antiquarian Society, for her many excavations of the AAS archives, but specifically for her search of seventy years of the *Proceedings* of the AAS that verified Alice had indeed been the first woman to publish in that journal. At the Brooklyn Public Library, Elizabeth Harvey, librarian for local history, found notices of Alice and Augustus in the *Brooklyn Daily Eagle* for a ten-year period not yet computer searchable. And finally, Carol Saloman, archives librarian at the Cooper Union in New York City, brought to my attention nineteenth-century photos of the Cooper Union's Foundation Building where Alice lectured.

Friends not directly involved in Mesoamerican studies have also contributed to this project. Physician James Tetrud critiqued and provided me with many helpful comments that were incorporated into the manuscript. Software engineer Alex Rush brought Mollie Fancher (the "fasting girl" of Brooklyn) to my attention, and that put me on the trail of Alice's involvement with Spiritualism and metaphysical phenomena. My special thanks to artist and poet Robyn Martin for her sketch of the Le Plongeons' Lerdo Monument. She along with organic farmer and artist Arlo Acton, editor and journalist Bart Anderson, and teacher Paula McFarland have listened to my

ramblings about the Le Plongeons over the years and have given me many important, fresh insights.

From the very beginning three colleagues have made special contributions to my writing about Alice and Augustus and encouraged the development of this book. Many thanks to James R. McGoodwin, professor of anthropology at the University of Colorado, Boulder; Phyllis Messenger at the Institute for Advanced Study, University of Minnesota; and Luther Wilson, director of the University of New Mexico Press.

Finally, I would like to thank the publishing team at the University of New Mexico Press who have all played a vital role in the production of this book. This is a team effort, and so it seems appropriate to credit key members Lisa Pacheco, Melissa Tandysh, Andrea Lee, and Maya Allen-Gallegos.

Introduction

IN HER LIFETIME, WRITER AND EXPEDITIONARY PHOTOGRAPHER ALICE Dixon Le Plongeon was well known for her writing, lectures, photography, and work for women's rights. But during the fifty years after her death in 1910, she was all but forgotten by historians and archaeologists. In the 1960s and 1970s she received short notices by a few writers, but they had little to go on, and she remained in the shadow of her husband, archaeologist and photographer Augustus Le Plongeon, for another thirty years. After her papers were made available in 1999, an examination of her life and accomplishments on their own merits became possible.

Born into a successful, middle-class, professional London family of the mid-nineteenth century, Alice learned photography as a teenager by assisting her father in the family photography business. Henry Dixon, her father, distinguished himself as an important London photographer, and his photographs are today held in a number of major museums and photo archives.

But Alice had ideas for a life that went far beyond Victorian London. She realized her lack of aristocratic origins would make it difficult to fulfill her dream of becoming a writer and thought opportunities might lie outside of England. As fate would have it, she met Augustus Le Plongeon in 1871 when he was at the British Museum investigating its materials from Mexico, and they fell in love.

Augustus was born on the Island of Jersey in 1826 and educated in France. When he met Alice he had already spent more than twenty years living in South America and California. He had exciting new ideas about the ancient

Maya that intrigued her, and within a short time they made plans to explore the Maya ruins of Mexico's Yucatán peninsula.

After moving to New York City in 1871 and marrying, they spent the next two years preparing for their archaeological work in Yucatán. Then in the summer of 1873, they sailed for Yucatán where Alice began her writing, and she put her photographic skills to work as an expeditionary photographer. The Le Plongeons lived in Yucatán and Belize until 1884 and traveled throughout most of northern Yucatán, explored Isla Mujeres and Cozumel Island, and photographed and excavated at many Maya archaeological sites. At Chichén Itzá, Alice took charge of the excavation of the Platform of Venus.

Their photography was a radical departure from previous photographic methods in the Maya area where photographers took only a few photos of the ruins using very large glass-plate negatives. Alice and Augustus were the first to systematically photograph Maya buildings and their archaeological excavations in 3-D using hundreds of smaller glass plates. Alice prepared all the wet collodion glass-plate negatives, then developed and printed them, leaving most of the camera work to Augustus. Today more than 2,400 of their prints, negatives, and lantern slides are archived in public collections.

At the time of Alice's birth in 1851, the Caste War of Yucatán had already been raging for four years, and twenty-two years later when she landed in Yucatán she was confronted by it firsthand. At the archaeological site of Chichén Itzá, Alice and Augustus were under constant threat of attack by the Chan Santa Cruz Maya, who often patrolled many miles from the Line of the East that divided their territory from Yucatán. In the village of Tizimin, near that line, the warning bells sounded one night, and Alice threw on men's clothing, grabbed her rifle, and readily manned the barricades against a Maya attack. In time she began to see the Maya rebellion as justified because of the hundreds of years of oppression, but she was shocked by the unchecked violence on both sides.

Alice was first a writer, but she used her mastery of photography to supplement her articles and books about nineteenth-century Yucatán and the magnificent ancient Maya cities. Soon after her arrival she started to write about life in Yucatán, her travels, and ongoing archaeological work. A decade later those articles began to be published in popular and professional journals. Her lengthy article, "Notes on Yucatan," printed in the 1879 *Proceedings of the American Antiquarian Society*, was her first published article and also the first by a woman author in the society's long history.

In 1884, after eleven years in Yucatán, she and Augustus established residence in Brooklyn, New York. Within a short time Alice joined with the women of organizations such as Sorosis to work for voting and economic rights. Through her lectures and writings, she sought social justice not only on behalf of women living in North America, but also for the women of Yucatán.

Within a few years she was an established lecturer in the New York area, and consistently drew large crowds in auditoriums such as Cooper Union's Great Hall and Chickering Hall on Fifth Avenue. Her lectures were entertaining, but they were much more than a traveler's account, and she spoke on a broad range of topics, including Maya history and archaeology.

During their years of archaeological work in Yucatán in the 1870s and 1880s, Alice and Augustus had concluded that the Maya founded Egyptian civilization. That proposal was not seriously disputed before the chronologies of Egypt and the Maya were fully understood, but by the mid-1890s it was clear to archaeologists that Egyptian civilization had developed much earlier and independently of any Maya influence. Her views, and those of Augustus, slowly began to be rejected as contrary evidence mounted, and in the end their conclusions received no support from archaeologists.

Around this same period, the Le Plongeons' income became severely curtailed because of the economic collapse in the mid-1890s. In addition, Augustus developed a serious heart ailment due to the stress caused by the rejection of his book *Queen Móo and the Egyptian Sphinx* that sought to prove the Maya founded Egypt (Augustus Le Plongeon [ALP] 1896a). He then stopped publishing and died in 1908.

Yet during this time, Alice continued to write articles for journals and newspapers and divided her days between writing and caring for Augustus. Also at this time she began to write about the spiritual side of her life. In 1892 she published an epic poem called *Queen Móo's Talisman* in which she explained how unseen forces had brought Augustus to her, and how their spiritual link to the ancient Maya led to some of their archaeological conclusions.

Her determination to write never flagged, even during the difficult last ten years of her life. Although she continued to defend the notion that the Maya founded Egyptian civilization, she published articles on the history of Yucatán, the Caste War, the women of Yucatán, and an epic poem of several hundred pages titled "A Dream of Atlantis." Alice died in 1910, well known for her writing, lectures, photography, and work for women's rights.

PART ONE

London and New York

A girl of lightsome heart

Was told, "He comes! With him thou must depart."

To find her in the East, he sailed from the West,

Responsive to the power of soul's request.

Resistless forces bade her to fulfill

The part that she, by her own human will

Had planned upon a day, when swayed by love

She would her consort find, on earth, above,

Wherever might he dwell there too would she:

Attachments deep can bind like stern decree.

ALICE DIXON LE PLONGEON, *Queen Móo's Talisman*, 1902

I Never Want to Be Married!

1851–71

ALICE'S PARENTS, HENRY DIXON (1820–93) AND SOPHIA COOK (1827–1916), were married in St. Pancras Church in London on September 18, 1848, and Alice, their second child, was born in London's Regent's Park district at 83 Stanhope Street on December 21, 1851. Henry was a copper-plate printer, a skill that prepared him well for a career in photography that began in the mid-1860s. Alice, always proud of her father, wrote for the *Photographic Times* in 1890 that he "learnt very thoroughly steelplate printing . . . to learn how pictures should look when rendered in black and white" (Alice Dixon Le Plongeon [ADLP] 1890c:648). He became an accomplished photographer of museum objects and historic buildings in London. While his studio was a great success, he also sought to contribute to the development of photographic technology and "was an informed and early adopter of new photographic developments" (MacNab, personal communication 2008).

Lynne MacNab, formerly photo librarian for the Guildhall Library in London, carried out extensive research on the photographic work of Henry Dixon, and based on his letters and articles she has suggested that he appeared to be a "no nonsense, affectionate and egalitarian sort of person, who quite likely have encouraged Alice's natural curiosity and talents" (MacNab, personal communication 2008).

Sophia's father, James Cook, had been roasting cook for the Duke of York, and later was proprietor of an inn and butcher business in Byfleet, Surrey, southwest of London. Sophia helped out in the family business. Both Sophia and Henry came from large families, and they in turn had nine children.

Alice's uncles and aunts were always in and out of the house for social gatherings and the holidays. Her uncle Dr. Jacob Dixon (1806–89), an attending physician at the Homeopathic Hospital on Great Ormond Street in London, was her favorite and a strong advocate of Spiritualism. Alice remained close to him throughout her life. In 1875 while she was living in the remote town of Valladolid in Yucatán, she wrote him to express her respect and affection:

> Our best friend in Valladolid is Doctor Manzano, in fact we are living in one of his houses. This man is a <u>number one</u> physician, and a <u>number one</u> in conduct and character. Intelligent, affectionate, virtuous. I have a double reason for regarding him with friendship since he is a <u>facsimile</u> of my uncle Jacob. In general appearance, manners, mode of speech, everything. Privately I call him <u>my uncle Jacob in Yucatan</u>. In one point he differs with you, not having studied spiritualism, he is not a spiritualist [ADLP 1875a; underlines by Alice].

Uncle Jacob saw to Alice's education in Spiritualism, and she wrote that he "seemed to think it a necessary part of my education to initiate me into the phenomena that he was investigating with ardent enthusiasm" (ADLP 1908). She and her uncle were not the only members of the family involved in Spiritualism. In a letter from Roberta K. Stacey to her younger cousin Alison B. Eades in 1990, "Bobbie" wrote that her grandfather Robert Walter Igglesden and Alice's sister Mary Elizabeth Dixon (Grandma Mully) were "originally Unitarians, but later turned to the Spiritualist Church, which they did far too much to support, and practically impoverished the business." Alice's other sisters and brothers were members of the Unitarian and Free Christian Church but readily accepted her enthusiasm for Spiritualism.

Spiritualism began in the United States in the 1840s and quickly spread to England by the 1850s. As a Spiritualist, Alice's uncle Jacob believed that special people, called mediums, have the ability to communicate with spirits, and that spirits can even evolve to higher levels of perfection. Alice grew up as the Spiritualist movement flowered and was greatly influenced by the mediums who her uncle invited to his home for what were called "family circles." The Dixon family's religious convictions were clearly outside the mainstream Church of England.

Alice's older sister, Lucy (1850–1931), was also born in the Regent's Park district of London, and Alice would remain very close to her throughout her life. Bobbie knew her great-aunt Lucy, and found her "a very sweet person, gentle, almost always smiling, always looking a little fragile" (Stacey 1990, letter to Alison Eades). After Alice and Lucy, Sophia gave birth to seven more children: Jessie (1854–1906), Thomas James or "TJ" (1857–1943), Ellen—called

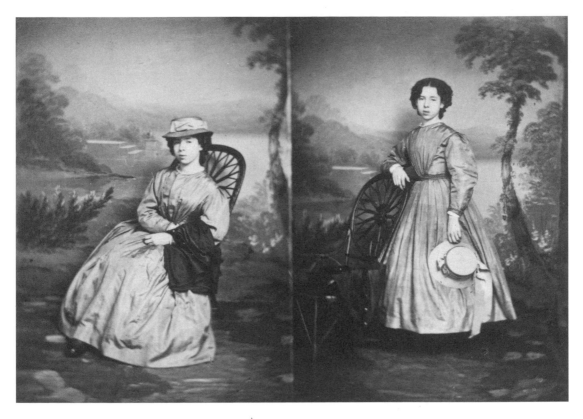

"Nellie" (1859–1903), Harry (1861–1941), Sophia (1863–1924), Mary Elizabeth (1865–1935), and Agnes Clara (1866–1901).

Bobbie was also in frequent contact with her great-uncle Thomas James who enjoyed hearing young Bobbie recite "The Hunter," a poem written by the British poet Walter Turner about Yucatán (see appendix 2 for "The Hunter"). Bobbie recalled, "Then there was the photographer, Uncle Tom, tall, bearded, and very distinguished" (Stacey 1990, letter to Alison Eades). Jessie died young, but word of her fame as a professional singer was passed down to Bobbie by Mary Elizabeth ("Mully") who had accompanied her on piano: "One sister . . . was a concert singer, and Mully in her youth used to be her accompanist" (Stacey 1990, letter to Alison Eades).

Alice was well educated in music, mathematics, history, the classics, literature, and writing. As a young teenager she had hoped to become a singer, and her love of music remained with her through out her life. But as she matured she began to dream of a career as a writer. Her teachers prepared her well and she had a natural talent, so once she got settled in Yucatán she began her writing. Photography for Alice had always been part of her life and she took it for granted, but the invaluable training she received from her father later became an important complement to her writing.

I NEVER
WANT TO BE
MARRIED!

9

Alice's brothers were equally successful. Thomas James worked with his father as a photographer, and after Henry's death he took over the business. Harry, a noted London artist, was in Paris in the 1880s at the Académie Julian in the ateliers of Bourguereau and de Lefèbvre. The *Benezit Dictionary of Artists* states:

> He became a member of the Royal Society of British Sculptors in 1904. In 1892 he sculpted the two lions that stand at the entrance to the Imperial Institute. He also produced engravings and watercolours on animal themes. He exhibited regularly in London at the Royal Academy from 1881 and at the Suffolk Street Gallery [2006:971].

Harry Dixon's large watercolor titled *Lions* is at the Tate Gallery in London.

Henry Dixon's photographic business used cutting-edge technology and employed his wife as well as a number of his children, including Alice. In 1871 the London census listed the three oldest sisters, Lucy, Alice, and Jessie, as photographer assistants that lived at the family home and studio at 112 Albany Street near Regent's Park (London Public Records Office 1871), but it is not clear exactly what work they performed.[1] Within a few months of the census, Alice left London for New York with her husband to be, Augustus Le Plongeon (1826–1908). Ten years later in 1881, Alice's mother, Sophia, was listed by the census as a photographer assistant along with Lucy, Jessie, TJ, Ellen, Mary Elizabeth, and Agnes Clara. Harry was noted as a "student for painting" and his sister Sophia a "milliner" (London Public Records Office 1881).

During her years assisting in the photographic business, Alice became familiar with her father's photographs of the Holborn Viaduct project made in the late 1860s. In the 1870s, while photographing in Yucatán, the Le Plongeons placed Maya assistants in their photos in positions reminiscent of how workers and supervisors were arranged by her father in the Holborn project photos. The placements provided scale and enhanced perspective in the Le Plongeons' 3-D stereo photos of Maya buildings.[2]

Alice's brother TJ was too young to work on the Holborn project, but even before he was twenty he saw a future in photography and began working with his father. In 1875, "Henry and Thomas James traveled to Portsmouth to photograph the ships, crew and equipment of the vessels *Alert* and *Discovery* prior to their departure for the Artic. Some of these photographs (of the crews) were submitted to the Photographic Society Exhibition" (MacNab 1997). The photographs of the ships' crews and equipment were wildly praised, and "The *British Journal of Photography* lists Henry as amongst the great photographers of the period" (MacNab 1998).

Much of Henry Dixon's business involved photographing objects in museums, and Alice later used the considerable experience she had gained to

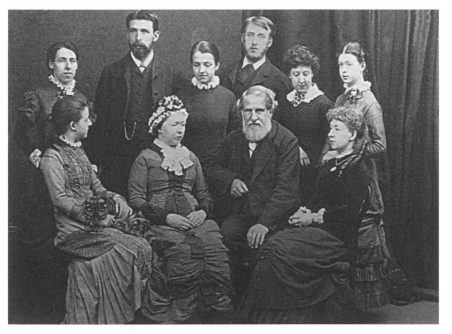

Alice's mother, father, and brothers and sisters in a formal sitting that was probably taken at the time of the double wedding of her sisters Agnes Clara and Sophia in May 1891. Alice is not in the photo because she was delayed in coming to London until the summer. Seated, left to right: Mary Elizabeth, Sophia, Henry, and Jesse. Back, left to right: Ellen, Thomas James, Lucy, Harry, Sophia, and Agnes Clara. Courtesy of Alison B. Eades.

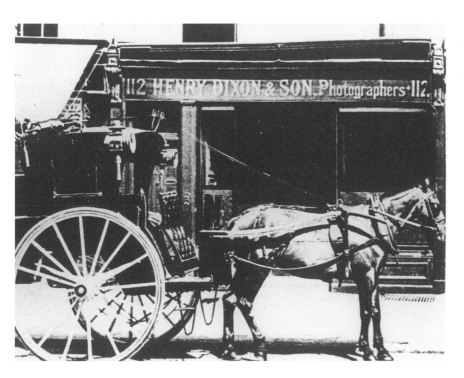

The photographic establishment of Henry Dixon and his son Thomas James, 112 Albany Street, London. Circa 1910. Photograph probably by Thomas J. Dixon. By courtesy of the Guildhall Library, Corporation of London.

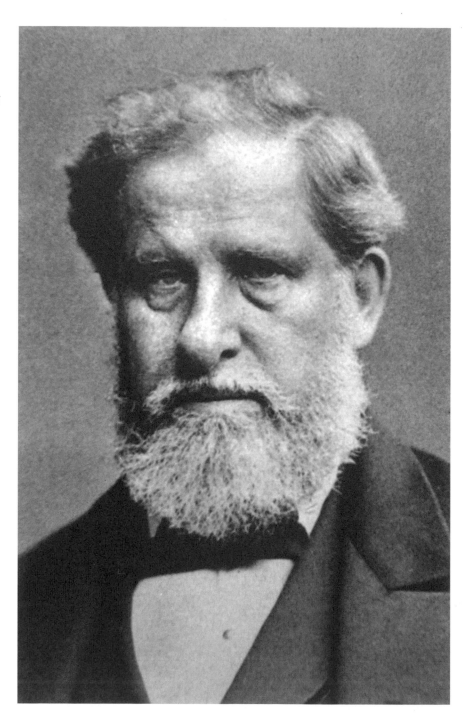

Henry Dixon.
Circa 1885.
Courtesy of
Alison B. Eades.

photograph Maya artifacts when she was in Yucatán. Her father and brother also taught her the complexities of animal photography. Animals with their quick and unpredictable movements were always a challenge in the early days of photography when it was almost impossible to take exposures fast enough to stop motion. Between "1875 and 1885—Thomas and Henry Dixon engaged in photographing animals at London Zoo. Over 100 were taken in all, many of the big cats, particularly lions and tigers" (MacNab 1997).

A photograph of a jaguar in Augustus's book, *Queen Móo and the Egyptian Sphinx*, may have been taken by TJ in the London Zoo (ALP 1896a:Plate LXXII). What is intriguing about this photo is that the zoo jaguar has been neatly superimposed onto the photograph of a jungle setting probably taken at Chichén Itzá. Alice and Augustus did photograph numerous animals, birds, insects, and reptiles in Yucatán, and more than fifty of those photos are archived in museums in the United States and England.

In 1879 Dixon received a commission from the Society for Photographing Relics of Old London to photograph "endangered and architecturally significant London relics [buildings]" (Foote 1987:134). The society believed that photographic recordation was the best way to mitigate "The twin threats of abandonment and change" (Foote 1987:139). Similarly, the Maya ruins faced the "twin threats," and after Alice and Augustus learned of the deterioration of Maya buildings in Yucatán, they carried out detailed and systematic photographic recording.

Dixon's carbon prints of London have provided an irreplaceable record of the city before the changes of the twentieth century and are archived at a number of repositories, including the London Museum, the George Eastman House in Rochester, New York, and the Gernsheim Collection at the University of Texas. The largest collection of Dixon photographic material is in London's Guildhall Library Print Room "including over 200 original glass-plate negatives dating from 1862 until the early twentieth century" (MacNab 1998).[3]

At the time of Alice's birth, Augustus Le Plongeon was twenty-five years old, had traveled the world, learned photography from the pioneering English photographer William Henry Fox Talbot, and operated photographic studios in San Francisco, California, and Lima, Peru. He was born on the Island of Jersey on May 4, 1826, and schooled in France in the classics, math, languages, and topographic surveying.

In his early twenties he sailed with a friend from France to Chile, taught mathematics at a school in Valparaiso, and then in 1849 shipped out for San Francisco to seek his fortune in the Gold Rush.

In 1851, having contracted severe fever in the course of his official duties [in California], Dr. Le Plongeon visited Europe and England. At the Sydenham Palace exhibition [The Great Exhibition at Hyde

Park, London] the paper photographs made by Fox Talbot were admired by the Doctor and he lost no time in inducing that gentleman to teach him his method [ADLP 1909:277].

He then returned to San Francisco and soon opened a photographic studio on Clay Street near the waterfront.

From the beginning, Augustus was dedicated to photography and wrote rhapsodically for the *Photographic Times*, "Photography since I learned its first rudiments from Mr. José Talbot, in 1852, has fascinated me, and has been to my mind a kind of enchanted ground" (ALP 1879b:79). He was apparently on very personal terms with Talbot and used a nickname "José" rather than his given names. Talbot also had a serious interest in Middle Eastern archaeology and worked to translate Syrian and Chaldean cuneiform writing. While Augustus had visited Talbot primarily to learn his photographic methods, hearing firsthand about his work in Middle Eastern archaeology may have struck a chord in Augustus that developed more fully during his years in Peru.

Augustus's photographic studio in San Francisco in the 1850s provided a good income, but around this time he also began studies in medicine by "riding with the doctor." In the nineteenth century, there were two routes for the student of medicine. One was to attend medical school, and the other, as chosen by Augustus, was to apprentice oneself to a doctor. The level of medical expertise gained by this method was considerable, and he became well respected as a physician in the 1860s in Peru and during his travels throughout Yucatán with Alice in the 1870s and 1880s.

In 1862 "Le Plongeon left San Francisco and moved to Lima, Peru where he [opened a photographic studio and] began using the wet collodion glass-plate negative process for studio portraits, and to record the ancient ruins" (Desmond 2001:117). In Peru he photographed Inca and other ruins and quickly became intrigued with the ancient civilizations of the New World. To satisfy his curiosity, he studied the historical writings of the French scholar Charles-Étienne, Abbé Brasseur de Bourbourg. Brasseur's ideas led to Augustus's decision to search for a single source for world civilizations. It was an undertaking that occupied many scholars in the nineteenth century.

Brasseur had proposed that Old World civilizations had their origin in the New World. And specifically, he thought that the ancient Maya of Yucatán *might* (Brasseur thought more study was required) have founded Egyptian civilization. The field of inquiry was wide open, the profession of archaeology was not fully formed, and the chronologies of the Maya and Egyptian civilizations had not been worked out. So, by the end of the 1860s, Augustus had decided to leave Peru and prepare for a life studying the Maya.

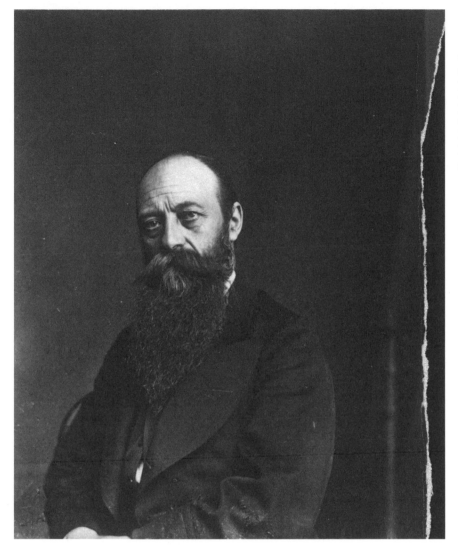

Augustus Le Plongeon
at age forty-five. 1871.
Photo by Alice Dixon
Le Plongeon. Research
Library, The Getty
Research Institute,
Los Angeles, California
(2004.M.18).

He traveled to London to take a firsthand look at Mexican manuscripts and Maya artifacts at the British Museum.

His first stop was San Francisco in the summer of 1870. At the California Academy of Sciences he gave eight lectures to fellow members of the academy on earthquake phenomena and the ancient civilizations of Peru. His lectures were illustrated with "lantern slides" made from his photographs. The *Proceedings of California Academy of Sciences* (1868–72) have a short note about one of his lectures: "September 5, 1870: Dr. Le Plongeon read part of a long article on the aboriginal ruins of Peru . . . exhibited a collection of remarkable skulls, and specimens of art from the ruins, with photographs of architecture" (California Academy of Sciences 1873:133).

I NEVER
WANT TO BE
MARRIED!

Augustus Le Plongeon (bearded) below his second-floor studio, Galaría Fotográfica Norte Americana, located at Plateros de San Agustín in Lima, Peru. 1860s. Research Library, The Getty Research Institute, Los Angeles, California (2004.M.18).

After making his report to the academy, Augustus left for New York, and in March 1871 he sailed for London. He told Alice, shortly before his death in 1908, that he had had a premonition he would meet her on that trip, and Alice later stated that the "meeting was prophecied to him" (ADLP 1908).

Alice was nineteen years old when Augustus began his journey to London, and her uncle Jacob hoped to learn something about his young niece's future. He invited a medium named Hearn to his home to hold a séance—Alice would not forget *that* séance. Writing almost forty years later, she gave the details of her encounter with a "speaker [who] called himself John King, once Sir Henry Morgan of piratical fame" (ADLP 1908).

Alice began—

> I took part in a family circle in Dr. Dixon's house, there were pres-
> ent only himself, wife and sister-in-law, besides the medium, named
> Hearn. On the table was a small card-board tube, funnel-shaped. As
> soon as the lights were extinguished, the paper trumpet was whisked
> up to the ceiling. I was holding one, and Dr. Dixon the other hand
> of the medium [ADLP 1908].

Apparently an old hand at séances, Alice was not surprised by the disembodied voice that greeted her, but what did shock her was the spirit's assertion that she would soon marry.

The usual loud voice was then heard greeting those present. It came to my right ear opposite to where the medium sat, and roared out in thunderous tones, "Gusher, (the name he had given to me), Do you want to be married?" I answered, "No! I never want to be married—I will be a great singer." The reply was a roar of laughter, and when that was ended the voice added, "Long before you are twenty you will be married and very far from your own country" [ADLP 1908].

The spirit continued with an even more detailed prediction:

Some time later in the same room the same voice repeated the above assertion to me, and added, "He was started now, and is on his way here, you will have to go with him" [ADLP 1908].

As Hearn had predicted, Alice and Augustus met shortly after he arrived in London.

The following facts are strange indeed. On a certain day, my father wished to send a man who was in his employ to a certain business house. I hastened to him and begged to be allowed to go in his place. Why? I cannot tell to this day, but while absent from home on that errand I met, in the most unexpected manner, a great gentleman who had come to London for the express purpose of studying certain manuscripts and ancient sculptures in the British Museum [ADLP 1908].

While the actual details about their initial meeting are sketchy, she does say how her mother reacted.

Upon my return to the house of my parents, who brought us up very strictly, I went direct to my mother and made the following strange statement, "Mother, while I was out today I met him who I know that I shall have to marry by and bye." The dear mother gave me a very serious look, and reminded me that I was too young to give a thought to any such matters, and that it was foolish to take a fancy to any one at first sight. Then I replied that I had taken no fancy, only that I had a feeling that it would have to be as I told her. The stranger thus met was Dr. Le Plongeon [ADLP 1908].

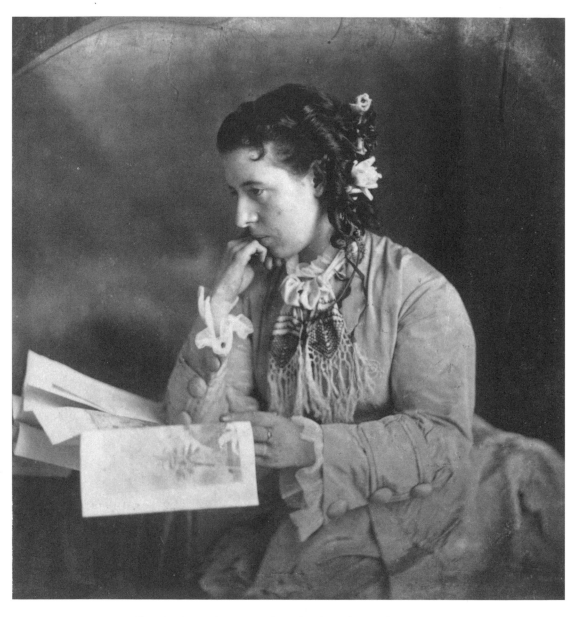

Alice Dixon Le Plongeon with Frederick Catherwood's panorama drawing of the east façade of the House of the Governor at Uxmal, which was published in *Incidents of Travel in Yucatan* by John L. Stephens. Circa 1871. Photo by Henry Dixon. Research Library, The Getty Research Institute, Los Angeles, California (2004.M.18).

HENRY DIXON
PHOTOGRAPHER

112 Albany Street Regents Park

LONDON

Nº ...

ALL NEGATIVES PRESERVED AND PORTRAITS
OF ANY KIND PRODUCED FROM THEN.

Marion, Imp. Paris.

[2004.M.18 – 410.13]

The imprint used by Henry Dixon on the reverse of photos made at his studio on Albany Street in London. Circa 1871. Research Library, The Getty Research Institute, Los Angeles, California (2004.M.18).

Both Henry and Sophia must have been shocked when they were introduced to "the stranger" twenty-five years older than their daughter. But in spite of their shock, they were "impressed with him as a tough man of the world, yet of a gentlemanly French background. His descriptions of far-flung places and mysterious lost civilizations captured Alice's imagination and intellect, and his kind-hearted, understanding manner captured her heart" (Desmond and Messenger 1988:11). Alice's "poise and confidence" and her "questioning spirit must have caught Augustus's fancy, for the seasoned explorer, twenty-five years her senior, began courting her" (Desmond and Messenger 1988:11).

Little about Alice's courtship was passed down through the family, but Bobbie Stacey had heard a few things about Alice and Augustus from Grandma Mully, and possibly even from TJ. She had an interest in Alice and read her book, *Here and There in Yucatan*, which was a gift from Alice in the 1890s to a family member. Bobbie wrote Alison Eades, "Alice . . . married an American/Frenchman by the name of Le Plongeon, with whom she went exploring in Central America, sending back articles to various American journals, some of which were gathered in a book called, 'Here and there in Yucatan,' of which I have a copy" (Stacey 1990, letter to Alison Eades).

Augustus's courtship of Alice lasted into the summer, yet she remained firm in refusing marriage. Her brothers and sisters, at first reserved, began to developed a distinct liking for Augustus because of his honesty and forthrightness. He was clearly in love with Alice, and they had little doubt that he had the financial means to properly care for their sister. His plans for research in the jungles of Yucatán had the family a bit worried, but Alice presented it as an exciting challenge and soon had everyone convinced that she was up for the adventure.

Alice quickly learned the basics about ancient Maya civilization from Augustus, and then began her own studies. She purchased a copy of John L. Stephens's book, *Incidents of Travel in Yucatan*, and read the two volumes cover to cover. Published in the 1840s, after thirty years it was still the best account available about the ancient Maya and life in Yucatán during the early nineteenth century. The portraits of Alice with the panorama drawing of the House of the Governor at Uxmal from Stephens's book were probably made to emphasize her serious interest in the Maya.

In addition to her readings and discussions with Augustus about the civilizations of the Maya and Egypt, she also had long talks with her father about photographic techniques that would be useful for recording the Maya ruins. Soon she felt she was ready to begin her adventure—the time to depart London had come. New York would be their first stop so that they could purchase expedition equipment and inform the Mexican authorities of their plans.

But for Alice the most difficult part was to convince her family, and the man she loved, that they should sail for New York unmarried. The family knew there was no reasoning with strong-minded Alice, but they had faith that Augustus would maintain a gentlemanly distance. That meant they would have separate cabins on the ship, and when they arrived they would have to live apart—those were the customary standards. So to the relief of all, Henry and Sophia finally gave their blessings, and with mixed emotions they saw their young daughter aboard the steamer for New York.

I NEVER
WANT TO BE
MARRIED!

Beyond the blue, the purple seas,
Beyond the thin horizon's line,
Beyond Antilla, Hebrides,
Jamaica, Cuba, Caribbees,
There lies the land of Yucatan.

WALTER JAMES TURNER, "The Hunter," 1920

Preparations for Yucatán

1871–73

ALICE AND AUGUSTUS LANDED IN NEW YORK CITY DURING MIDSUMMER 1871 and immediately got settled. Augustus had previously lived in New York, and his friends had been alerted that he and Alice would soon be arriving. They made this first step in Augustus and Alice's journey to Yucatán easier by meeting them at the docks and arranging for housing.

It turned out to be a great summer for Augustus because Alice finally agreed to marry him. The marriage took place on October 16 before a Brooklyn justice of the peace named Vorrhies and was witnessed by friends. Alice and Augustus appear to be responsible for some minor omissions and discrepancies on the marriage certificate that can be attributed to the pressures of social respectability in the late nineteenth century. While Alice gave her address as 403 Marcy Avenue, Brooklyn, Augustus gave no street address and simply wrote, "Brooklyn." Alice was nineteen years old when she married, but her age is given as twenty, and Augustus at forty-five dropped a year and was noted as forty-four years old (New York City Archives 1871).

Alice continued to study everything she could find about the ancient Maya, and while Stephens's book, *Incidents of Travel in Yucatan* (1843), gave her a good idea of what she would find in Yucatán, it was the writings of the French scholar Brasseur de Bourbourg that deepened her ideas about the Maya. Soon after they met, Augustus had brought to her attention Brasseur's books on the diffusion of cultures, and once they arrived in New York he quickly put Alice in touch with the full range of materials by Brasseur in university and public libraries.

What convinced Augustus that the New World was the place of origin of world civilization were his visits to the spectacular cities of ancient Peru and the writings of Brasseur. Specifically, Brasseur proposed that the Maya, with their complex civilization, had brought the indigenous peoples of the Nile Valley writing, religion, and architecture. It is unclear if Brasseur thought the Maya actually colonized Egypt for any length of time, but he identified what he thought were remnants of Maya writing, language, religion, and architecture in Egypt.

In the early 1860s while working in the archives of Spain, Brasseur had unearthed a description of the Maya of Yucatán written by Bishop Diego de Landa, a Franciscan, who came to Yucatán in the 1540s. He translated Landa's book, *Relacíon de las cosas de Yucatán* (1864), into French and published an explanatory volume with the title, *S'il Existe de sources de L'Histoire du Mexique dan les monuments Egyptiens et de L'Histoire primitive de L'Ancien Monde dans ales monuments Américains?* (Brasseur 1864) (Translated: *If there are sources of the primitive history of Mexico in the Egyptian monuments and the primitive history of the Old World in the American monuments?*). In his lengthy introduction, Brasseur noted the many cultural commonalities he thought the Maya shared with the ancient Egyptians, and that introduction was read closely by the Le Plongeons.

In fairness, it should be pointed out that Brasseur's proposal was only tentative and that he recommended archaeological research be carried out to determine the proposal's validity. The age of Egyptian civilization was still unknown in the early nineteenth century, and few scholars thought that the complicated and advanced architecture they saw was the end result of a long period of cultural development. Had Brasseur been aware of the archaeological evidence buried beneath the surface of Egypt, he might have realized that civilization had not arisen suddenly in Egypt. But he saw only the spectacular temples and pyramids, religious beliefs painted on the walls of tombs, and fully developed hieroglyphic writing.

Like Brasseur, Alice and Augustus had no knowledge of what lay buried beneath the surface of Egypt. What encouraged them further was Brasseur's admonishment to carry out archaeological excavations: "America, up to the present day, has not been the object of any serious archaeology; the few individual works cannot be compared with the multitude of those which have taken place for Egypt" (Brasseur 1864:23). For Brasseur, the richest of all places for archaeological evidence was Yucatán where there are "kept the most relics that are the most complete and the easiest to find in its monuments" (Brasseur 1864:7). That was where the Le Plongeons were headed.

At the time the Le Plongeons never imagined that Brasseur's theories would some day be considered outside mainstream archaeology because the proposals in *S'il Existe de sources de L'Histoire du Mexique* had yet to be seriously opposed. His earlier writings on Mesoamerica were accepted, and his

discovery of Landa's *Relación* and the *Popul Vuh* Maya manuscript made him an important and respected scholar. But in fewer than ten years, his conclusion about the diffusion of civilization from the New World was seriously questioned by scholars, and the eminent historian Hubert H. Bancroft fulminated against Brasseur's later work, *Quatre Lettres sur Le Mexique*, as "a chaotic jumble of facts and wild speculations that would appall the most enthusiastic antiquarian" (Bancroft 1882:128).

Two years before the reproach by Bancroft, Augustus had fully aligned himself with Brasseur and wrote: "Brasseur de Bourbourg . . . [is] the man who has done most to raise the veil that covers the history of nations on the American Continent, that have risen higher in the scale of civilizations, and that—many—many hundreds of years before the oldest nations, even, of which we have written history" (ALP 1880a:337). Augustus saw it as his mission to "raise the veil" even further and wrote in the *Proceedings of the American Antiquarian Society*:

> I began my work in Yucatan, I will not say without preconceived ideas, but with the fixed intention of finding either the proof or the denial of an opinion formed during my ramblings among the ruins of Tiahuanuco [Peru], that the cradle of the world's civilization is this continent on which we live [ALP 1879a:69].

While Augustus had conceived the idea of explorations in Yucatán prior to meeting Alice, his statement does not acknowledge that he and Alice worked closely as a team. In public she was always careful to keep Augustus in the limelight, but her family and close friends knew the large part she played in their work. In a letter to her family written in Pisté, Yucatán, in 1875, Alice noted that she had also studied the Maya, and that "Our object in visiting Yucatan, was to study its famous ruins, to which our attention had been called by the works of John L. Stephens, Waldeck, Brasseur de Bourbourg and others" (ADLP 1875c).

It was 1873, and aside from the potentially thorny question about the origin of Egyptian civilization, Alice and Augustus saw awaiting them an exciting future of discovery, writing, and photography. The role of photography suddenly became larger when they learned from travelers that many of the ancient Maya buildings in Yucatán were not only slowly deteriorating, but also were being seriously damaged by looters and stripped of stone for modern buildings.

Alice was shocked when she first viewed the ruins and wrote to the *New York World*, "The Peninsula of Yucatan is strewn with fragments of departed grandeur; silent, deserted, fallen cities. Some are not approachable without danger, lying as they do within the territories of hostile tribes.

Others—and these are the worst treated—are in the power of the whites" (ADLP 1881b:2).

They were fortunate to have been alerted before leaving for Yucatán and had decided to make a record of as many buildings as possible. But such a plan would require hundreds of additional photos, and to take such a great number was a major hurdle in the days when negatives were exposed on glass plates and significant quantities of photographic chemicals would have to be carried with them into the jungles of Yucatán.

The photographers who preceded them, such as the French explorer and antiquarian Claude-Joseph Désiré Charnay, took only a few photos at each site. Photographers like Charnay were limited by the large size (30 × 41 cm or 12 × 16 inches) of the fragile glass plates, and they were burdened even further by the large cameras, many lenses, tripods, and darkroom equipment. Alice and Augustus solved the problem by working "out a method for detailed and systematic documentation using large numbers of smaller stereo glass-plate negatives" (Desmond and Bryan 2003:109). While stereo 3-D photography had become popular, thanks to David Brewster's book *The Stereoscope: Its History, Theory, and Construction*, it had not been used in a systematic way to record Maya archaeological sites (1856).[1]

The use of the smaller format stereo 3-D image (10 × 20 cm, or 4 × 8 inches) facilitated the process of making a wet collodion glass negative because it was easier to manipulate and required fewer hard-to-find processing chemicals. For each large glass plate used by earlier photographers, six photos could be taken using the smaller plates, thus making thorough documentation of archaeological sites feasible.

Many years later in a letter to Charles P. Bowditch, professor of archaeology at Harvard University's Peabody Museum, Augustus glowed about their decision to use stereo 3-D photos, "I took stereopticon pictures of Yucatan in preference to single ones because they are more realistic when looked at with the proper instrument and they enable me to study the monuments as well, and sometimes better, than if I stood before them" (ALP 1902c).

While the quality of a stereo 3-D photo could be superb, much depended on the skill of the photographer. Alice and Augustus went to Yucatán as well-seasoned photographers and were able to make very high-quality negatives, but they still had to contend with the complicated and often idiosyncratic wet collodion glass-plate negative process.

Each glass plate was first thoroughly cleaned and inspected to be certain it did not have scratches. An application of clear collodion was then spread over the glass and sensitized with silver nitrate. The plate had to be quickly placed in the camera before it dried, the photo taken, and then the plate was returned to the portable darkroom and immediately developed. To make matters even more frustrating, contamination of the processing chemicals was

always a possibility, and in the stressful jungle environment mistakes in mixing the various solutions could easily occur. Alice and Augustus often complained of insects or dust stuck to a wet collodion negative, which required the photograph to be retaken.[2]

No substitute for the complex collodion process existed until the development of the commercially manufactured dry glass plate. Alice knew of the Eastman company's dry plates and hoped they would be available before the couple departed for Yucatán. But it would be a number of years before the plates would be useful in the tropics, and so the Le Plongeons used the wet collodion negatives during their entire time in Yucatán. A short time before they returned to New York, Alice experimented with dry plates, and a few years later wrote about the results in an article for the *Photographic Times*:

> The introduction of gelatine dry plates has been a godsend to all who roam far from home . . . [but] . . . high temperatures of the air and water made it almost impossible to develop the negatives. . . . Ice could be obtained in the capitol [Mérida] at twelve cents a pound, but in the forests of the interior, such a substance was unknown, even unheard of [ADLP 1888e:581].

Once the Le Plongeons had decided on the use of stereo 3-D images, the remainder of their photographic equipment was purchased to conform to the smaller format. Their camera equipment consisted of two Scovill Manufacturing Company view cameras, for taking stereo images on 4 × 8 inch plates or single images on 5 × 8 inch plates, and a variety of lenses. In a short article for the *Photographic Times*, Augustus gave details about the lenses they planned to use:

> The expedition about to visit Yucatan has at its disposal Harrison's globe lenses—the same used during my explorations of the ruins of Peru and Bolivia; a pair of stereoscopic Harrison portrait lenses; Ross lenses (combination for portraits and views); Dallmeyer wide angle; Hermagis view lens; etc. [ALP 1873b:133].

Augustus, known for his meticulous photographic requirements, made an examination of the lenses for the Scovill Company and reported, "I have compared carefully the relative qualities of them all with the Morrison and have found the Morrison superior, with no ghost, perfectly achromatic, lines mathematically true, and a perfect focus in every angle in which the camera may be placed" (ALP 1873b:133). Augustus then added the "11 × 4 Morrison wide-angle lens to the stock of the expedition" (ALP 1873b:134). In recording architecture, it is important for the image to be free of curvilinear lens

distortion, and so the Morrison wide-angle lens, with its "lines mathematically true," was an excellent choice.

To carry their considerable amount of photographic equipment on the rough roads of Yucatán, Alice wrote that Augustus devised a box in which darkroom equipment and all their camera gear could be easily stored.

> Before going to explore the ruins in Yucatan, Dr Le Plongeon invented a box in which everything could be packed in small compartments, and which could afterward be set up to serve as a darkroom, a sink and dark curtain also found a place in the box; and the apparatus could be put into working order by two people in less than five minutes. [ADLP 1884a:302].

During July 1873 Alice and Augustus made their final preparations for departure. Augustus had finished his book *Manual de Fotografia* for the Latin American market (ALP 1873a). It covered all aspects of photography, and in a promotion, the editor of the *Photographic Times* reviewed it as "the best handbook of photography in the Spanish language" (ALP 1878a:232). Sales of the manual helped in part to support their years of work in Yucatán.

Alice and Augustus had booked a stateroom on the steamship *Cuba*, which was scheduled to depart from New York on July 29. Prone to seasickness, Alice hoped for a smooth voyage. The *Cuba* carried the United States mail and a few passengers to various ports along the coast of Mexico. It stopped first at Havana, and then went on to the port of Progreso on the north coast of Yucatán where the Le Plongeons planned to land. Once in Progreso, they weren't far from Mérida, the capital of Yucatán.

In the special photographic box, they carefully packed hundreds of glass plates, their chemicals, cameras, lenses, and a piece of technology called an actinometer (used to calculate the time required to make a photographic print). Then there were Alice's writing materials (pens, ink, plenty of paper, bound notebooks, and envelopes), Augustus's emergency medical equipment packed in his doctor's bag, clothes for all occasions—including Alice's "pantaloons" for work in the ruins. She decided it would be practical to wear pants in order to climb about more easily, but had also devised a work skirt that could be let down over the pants should the social situation require it.

Alice and Augustus informed the New York newspapers and popular magazines about their plans, with the hope the papers would publish Alice's stories about their travels and discoveries. The prestigious American Antiquarian Society in Worcester, Massachusetts, told Alice that while they could make no guarantees, any papers she might write about Yucatán would be reviewed for publication. Augustus received a commitment from the society's president Stephen Salisbury Jr. to publish Augustus's reports about their discoveries.

While Alice wrote a number of articles in 1877 and 1878 about Isla Mujeres, Cozumel Island, and their explorations along the east coast of Yucatán, they were published after her 1879 article, "Notes on Yucatan," for the *Proceedings of the American Antiquarian Society*. Much of her time was spent editing Augustus's archaeological reports prior to publication by the American Antiquarian Society because English was not his first language. Alice likely spent considerable time polishing his writings.

Augustus focused his writing on their archaeological work; however, he never failed to speak out against injustice when he saw it. In many ways he remained unchanged from his California Gold Rush years in the 1840s and 1850s when he was revolted by the atrocities carried out against California Native Americans. In a fiery note he wrote, "The California tribes were inoffensive, and were shockingly ill-treated by the white savages, who thought nothing of shooting them down like rabbits" (ALP ca. 1907–8).

Once their preparations were completed and after the farewell parties, the day of departure finally arrived. Alice had heard that letters from Yucatán to England could take as long as two months, so before departing she posted a final letter to her family. Her mother and father, her uncle Jacob, and all her brothers and sisters hoped that the voyage would be smooth and that the next letter they would receive from their adventuresome Alice would tell them of the wonders of her life in far off Yucatán. Her family would not be disappointed.

Alice and Augustus departed New York on Saturday, July 28, 1873, as planned, on board the *Cuba*. But all was not smooth sailing because the ship "was at that time in a very dirty condition. So much so that we were forced to quit our birth, and sleep on the floor of the stateroom leaving the bed to the disagreeable little insects that infested it" (ADLP 1873–76:1).

After she recovered from the insect bites and seasickness, she wrote that she "had a most pleasant voyage" (ADLP 1873–76:1). On arrival in Havana they planned to "take a stroll in the city," but the "officers who came on board [told them they would] not be allowed to do so—. . . as yellow fever was rife" (ADLP 1873–76:1).

On August 7 they arrived at the port of Progreso, Yucatán, but the shallow water required the ship to anchor several miles offshore. Alice and Augustus, and their considerable amount of equipment, had to be brought to the wharf in a smaller boat. But at long last they had reached Yucatán.

Reached Progreso, and glad of it—for the Cuba was intolerable after the spaniards came on board—although Captain Boettig did his best to make things pleasant. We came ashore in a lighter. It took us three hours, for the *Cuba* cast anchor six miles out. I was sick [ADLP 1873–76:45].

Map of Mexico and Yucatán showing land and sea routes. No date, but probably nineteenth century. No publisher. Research Library, The Getty Research Institute, Los Angeles, California (P840001).

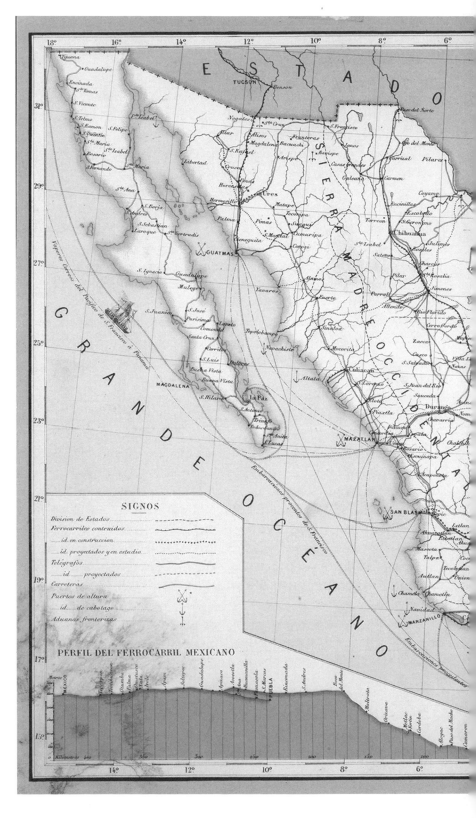

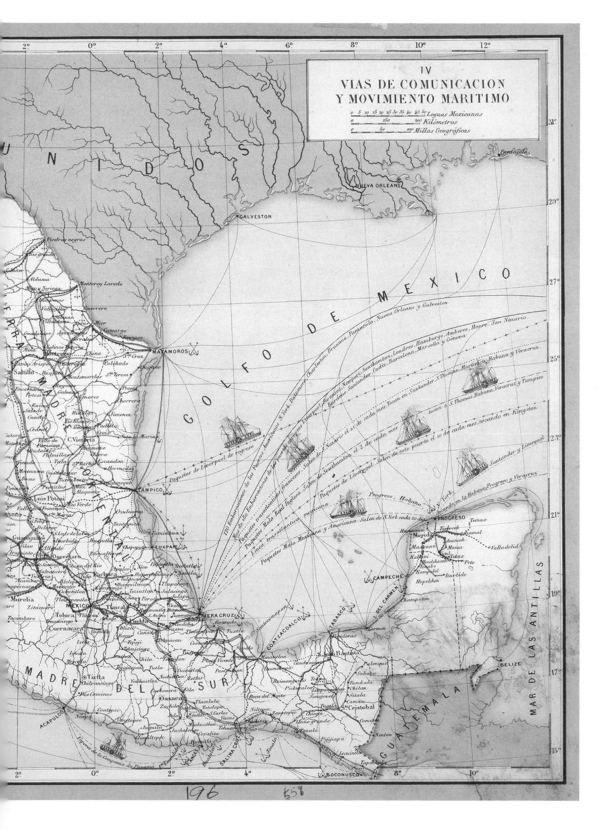

IV
VIAS DE COMUNICACION
Y MOVIMIENTO MARITIMO

Leguas Mexicanas
Kilómetros
Millas Geográficas

As they drew closer to shore in the lighter, Alice and Augustus could hear the ominous bugle warning that Mérida was experiencing an epidemic of yellow fever. But they were not deterred, and next day they hired a wagon for the short distance to Mérida. Soon Alice contracted the disease. She survived, thanks to the care given her by Augustus.

Alice wrote her family about the difficult start in Yucatán, and that Augustus was jailed for more than two weeks for brandishing a revolver in a Mérida courtroom. He had been insulted during a legal proceeding and tried to settle the matter in the style he had learned during the California Gold Rush. Seemingly spurred on by the difficult start, Alice maintained her determination to see Yucatán and to learn what she could about the ancient Maya.

After about six months living in Mérida and visiting nearby villages, Alice and Augustus finalized the arrangements for their journey and were on the road. They traveled throughout northern Yucatán in a *volan coche* (a wagon with two large wheels pulled by a mule) where they photographed the people, the landscape, and Maya ruins, and carried out archaeological investigations. Alice sensed the historic importance of their travels and work and recorded almost every aspect of their adventure in her own notes and in letters to her family.

She later compiled her letters and notes for the years 1873 to 1876 into what we now call her diary. It is an impassioned account of travel, people, customs, life in country villages, photography, and their investigations at the ancient Maya cities of Aké, Chichén Itzá, and Uxmal.

In the jungle, she and Augustus faced near starvation, deadly snakes, swarms of insects, intense tropical heat, and illness. There were days when Alice was "heartsick" and homesick, but also days with her close friends and exciting archaeological discoveries, and she was often in wonder at the myriad of beautiful flowers and animals she saw firsthand in the wilds of the tropical forest. But it is best to let Alice speak for herself in Part Two about those first three years in Yucatán through her diary.

PART TWO

Yucatán.

We shall ask you to accompany us in our travels among the ancient cities of Yucatan; and when we speak of the people who inhabit the country to-day, we shall tell you the truth about their customs, their civilization, their physical and mental attainments. We hope that if there are any Yucatecos present, when we criticize what we believe should be criticized, they will not regard it as speaking ill of their country or of their people; nor when we tell of their merits and virtues, look upon it as adulation. As travellers, we must speak of things as they are.

ALICE DIXON LE PLONGEON, "Notes on Yucatan," 1879

The Diary of
Alice Dixon Le Plongeon
1873–76

Arrival and Travels in Yucatán

July 1873–October 1874 DIARY PAGES 45–52

After an eleven-day voyage from New York on board the Cuba, *the Le Plongeons arrived at the port of Progreso, Yucatán, Mexico. The first serious obstacle they encountered was yellow fever, and Alice came close to dying from it. Second, a low intensity guerrilla war, called the Caste War, was underway. The battles between the Maya, called the Chan Santa Cruz, and the army of Yucatán took place on both sides of what was known as the Line of the East. It marked the territory firmly held by the Chan Santa Cruz Maya east of the city of Valladolid, but the line was fluid. When the Le Plongeons were working at the ancient Maya city of Chichén Itzá, only fifteen miles west of the line, they faced the constant threat of attack.*

During the Le Plongeons' years in Yucatán, villages and haciendas were often under siege, and Yucatán government forces made numerous unsuccessful attempts to control Chan Santa Cruz territory. After the Le Plongeons' final departure from Yucatán in the mid-1880s, it would take until 1901 before Yucatán came under full control of the central government in Mexico City.

Because of the warfare, Alice and Augustus realized they needed the protection of the army to carry out their investigations at Chichén Itzá. They were unknown in Yucatán, but soon managed to arrange the necessary political and military connections to successfully carry out their plan.

Map of the State of Yucatán. No date. Martin y Bañó, Barcelona. Research Library, The Getty Research Institute, Los Angeles, California (P840001).

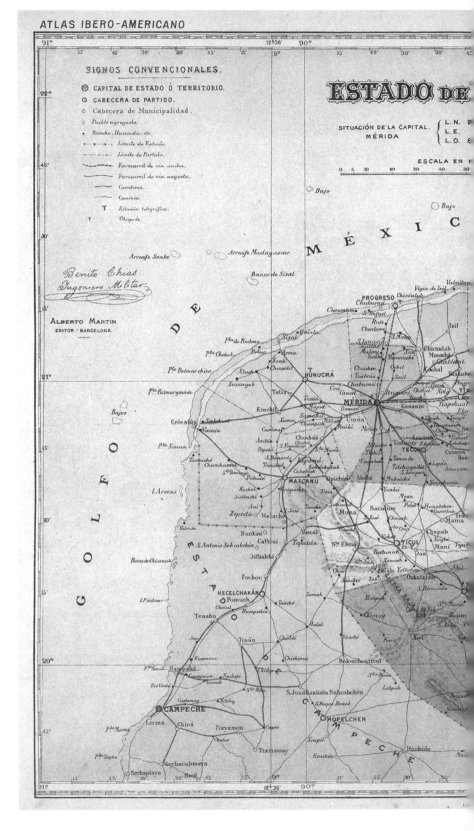

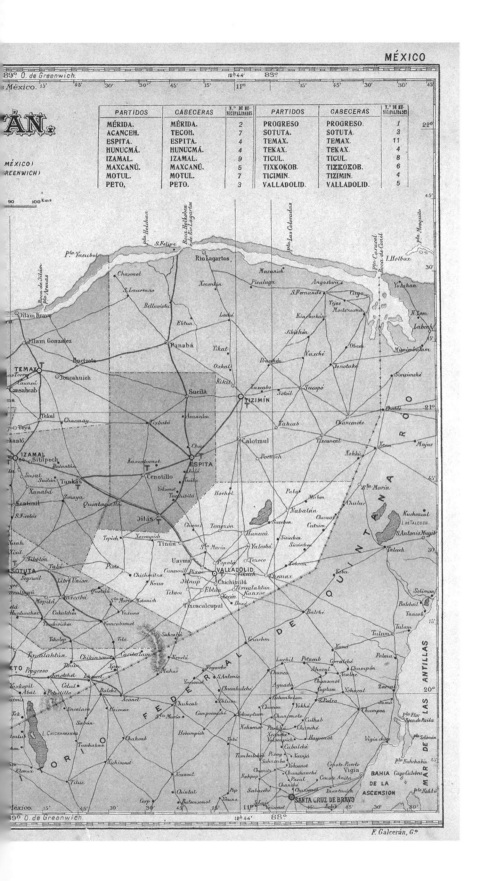

PARTIDOS	CABECERAS	N.º DE MUNICIPALIDADES	PARTIDOS	CABECERAS	N.º DE MUNICIPALIDADES
MÉRIDA.	MÉRIDA.	2	PROGRESO	PROGRESO.	1
ACANCEH.	TECOH.	7	SOTUTA.	SOTUTA.	3
ESPITA.	ESPITA.	4	TEMAX.	TEMAX.	11
HUNUCMÁ.	HUNUCMÁ.	4	TEKAX.	TEKAX.	4
IZAMAL.	IZAMAL.	9	TICUL.	TICUL.	8
MAXCANÚ.	MAXCANÚ.	5	TIXKOKOB.	TIXKOKOB.	6
MOTUL.	MOTUL.	7	TIZIMIN.	TIZIMIN.	4
PETO,	PETO.	3	VALLADOLID.	VALLADOLID.	5

F. Galcerán, G.º

THE DIARY OF
ALICE DIXON
LE PLONGEON

37

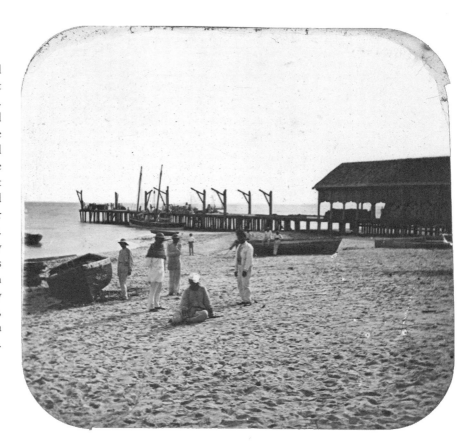

The wharf and a storage shed at Progresso, Yucatán. The wharf extended only a short distance from the beach, and so landings had to be made in a small boat while the ship remained at anchor in deeper water far from shore. Circa 1873. Photo by Alice and Augustus Le Plongeon. Research Library, The Getty Research Institute, Los Angeles, California (2004.M.18).

From the port of Progreso they took the short wagon ride (twenty miles) to the capital city of Yucatán—Mérida. Almost immediately Alice contracted yellow fever. She managed to recover with the help of Augustus, but soon legal issues resulting from their efforts to rent a house landed Augustus in jail. While their beginning was hard, Alice remained undeterred.

1873

July 28

Left New York on board the "Cuba." It was infested with bugs—otherwise we had a fine passage.

August 3

Came into the Havana harbour. Did not go ashore. Took some more passengers on board. Some traveling actors and dirty spaniards.

7th

Reached Progreso, and glad of it—for the Cuba was intolerable after the spaniards came on board—although Captain Boettig did his best to make things pleasant. We came ashore in a lighter. It took us three hours, for the Cuba cast anchor six miles out. I was sick. The moment

we stepped off the wharf, we sank ankle deep into the hot sand through which we plodded our way to the Hotel Mendezona. Here we breakfasted, in company with some others who had come ashore. We had a letter of introduction* [Refers to note in margin, which reads "From the Mex. Consul in N.Y."] for Mr. Aspe, administrator of the customs house. He received us very kindly. We also made the acquaintance of Don Jose Rosado—As for the Amer. Consul, Martin Hatch, he had come on board the "Cuba," and when introduced to us advised us not to land because the yellow fever was wreaking havoc among the strangers who arrived. He had just lost his father.

We passed the day in the customs house in the rooms of Mr. Aspe's family. In the morning we took seats in the mail coach and arrived at Merida about 8 o'clock. Went to the only hotel, kept by Fancisco* Lopez, took supper, went to a room to sleep but were prevented by mosquitoes and most uncomfortable catres [sleeping cots].

August 7th, 8th, 9th ⟶ Mérida

Looking for a house—none to be had. Went in the evening to the Plaza de Jesus to hear the retreat [military concert]. On our way home, stopped at the drug store of Don Jose Font. He gave me a glass of soda water. When I returned the glass to him Dr [Augustus] looked at me and told me I had yellow fever. We had some medicines at once prepared, and then we returned to the hotel Meridano.

11th to 20

In bed. Dr my only nurse did not sleep many hours till he saw me out of danger. I remained very weak, having taken no food, and plenty of purging.

We have secured a small house and will move to it as soon as I can go out.

Our landlady is very old, wears a wig, and is lately married to a very young man.

The etiquette here is for us to send cards to all those whom we wish to visit us. Dr has been delivering some of his letters of introduction. Among the number, one to Ramon Aznar. Another to Mr. Guzman, a Cuban living here in exile with his wife and daughter, and two or three

* Alice was preparing her diary for publication, and had not yet corrected the misspelled name Francisco. This transcription has retained her writing errors, notes, and corrections (crossed out words) in order to preserve as well as possible the document in its original form. But it also provides a few corrective notes, translations, and comments to help the reader follow her travels through Yucatán.

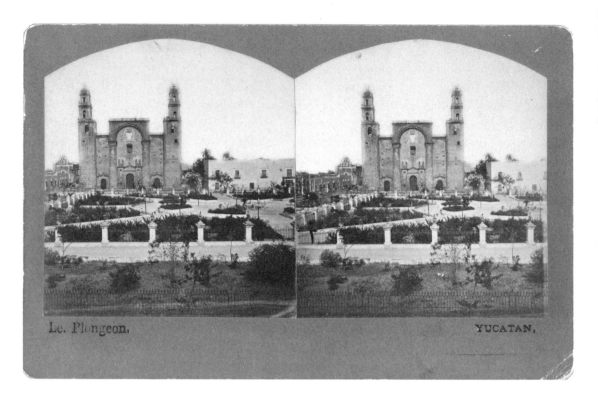

Lc. Plongeon. YUCATAN.

Cathedral of San Ildefonso and gardens in Mérida, Yucatán. Construction of the cathedral began in 1521, and it was completed in 1598. Circa 1873. Photo by Alice and Augustus Le Plongeon. Research Library, The Getty Research Institute, Los Angeles, California (2004.M.18).

faithful black servants that have followed them here to serve them. [The following is written in margin.] (is very anxious to do <u>something</u> for us)

20 to 30 [through September]

Arranging a studio at the back of the house. Ramon Aznar has been to see us, and our landlady Doña Concha [blank space] promised to repair the house, and with that understanding we agreed to pay her 16 $ a month rent. Now we find that the house leaks all over, and she does not wish to keep her word. Moreover she wants her rent in advance.

This we refused. So Dr Le Plongeon was summoned to pay one years rent in advance. He attended the summons. The lawyer, one Escalante, was very saucy in his speech. Dr requested the judge to cause him to be more respectful. The judge complied in a half and half manner, and the lawyer took no notice of him but went to say that Dr <u>Le Plongeon was a stranger and no one knew who he was, or he could pay for the house.</u> Again the Doctor asked the protection of the judge. But matters continued the same. The Dr asked for permission to go home for money to pay for paper that would be required. He came home and got his revolver—returned to court. The lawyer did not become more respectful so Dr said "Mr judge, since you cannot cause me to be respected, I can do so myself"—He slapped the lawyer's face on both sides; where upon

Escalante drew a sword cane. Dr drew his revolver from the pocket, and placed it against his leg, muzzle down—and said "You may put that needle away—those things were my toys when a child." The other one, when he saw the revolver ran away on all fours and the court cleared in a moment. Then the Dr said "I have slapped his face, I give myself in charge, but Escalante must also be arrested because he has drawn a weapon against me." Well the Dr was sent prisoner to the Castillo [Castillo de San Benito], incommunicado for cogato de homii deo. But the lawyer remained free to roam.

I passed a miserable day wondering why Dr did not come. The breakfast remained untouched. In the afternoon Montero, brother of Garcia Montero, came with a slip of paper. "I am in the Castle. See Herrera, Correas, and Ramon Aznar—Augustus Le Plongeon."

I dressed, locked up the house, and in ten minutes was in the house of Herrera who lived exactly opposite to us. I had visited his family once before. They received me very kindly. After accepting a seat I asked for Don Jose Herrera. He was out. I told them the case. I next went to the house of Correas, three doors off, he also was out. And I learned from him that Ramon Aznar was in the street, so it was no use for me to go to his house. I returned to the house of Herrera. He soon arrived, and when I told him what was the matter he went out to see what he could do. In the evening Mrs Herrera was kind enough to assist me in sending to the Castle a hammock, and some supper. Otherwise the Dr would have remained in a dirty cell without food or bed. I passed the night alone in my house. Did not lie down.

Next day I went to see Dr in prison—met there General Palomino, Teodosio Canton and I think, Meneces. After the third day Dr was removed to the hospital in the Meforada where he had a room, and could walk about the premises. The case was put into the hands of Judge Buendia. X [Refers to note in margin, which reads "Buendia died suddenly apoples [apoplexy] in 1881."] Herrera could do nothing because at the time he was Chief Justice. I passed the days at home and the nights in the hospital. Every evening I took the Dr his food. At this time I was very short of cash, but it did not matter for I would not eat even the tidbits that were sent to me by Mrs Herrera. One or two raw eggs was all I took each day.

October.

After being detained fifteen days, Dr Le Plongeon was dismissed, and returned home to my great joy. During the imprisonment Don Ramon Aznar came to see me, and had the impudence to say that "Dr Le Plongeon must have been intoxicated." The family of Herrera during those fifteen days showed me every possible kindness, which I never forgot.

We visited Judge Buendia, who behaved very kindly to the Doctor.

The lawyer Escalante, sent word to beg Dr Le Plongeon not to touch him.

We have made the friendship of Da Bruna Galera Casares, and her daughter Raquel, who plays very nicely the piano. Another young lady who plays very nice is Leonor Tappan.

We visit Dr Tappan from time to time. He is a Bostonian, and a clever surgeon.

One day we went to look over the Castle of San Benito. It was built by the Franciscan friars, upon an artificial mound X. [Refers to note in margin, which reads "in the eastern part of the city."] Today it is in ruins. It is enclosed by a high wall with turrets. In 1820 the 300 monks who dwelt within these walls were driven out at the point of the bayonet. The convent and the two large churches serve now as barracks and prison. In one of the lower cloisters going out from the north, and under the principal dormitory, are two parallel corridors—the outer one faces the principal patio, and is of indian architecture[.]

1874

February

Carnival in Merida is a gay time—the principal entertainments are balls and paseos in which people dress to their fancy though very few masks are used, and no rotten eggs are thrown around—nor even egg shells filled with other substances.

March

General Palomino, commander of the federal troops here, and inspector of the military lines, was kind enough to provide us with a servant—Guadalupe from the Zapadores. He was a good boy, and understood carpentering, but loved too well the rosy cup no matter in what shape it presented itself.

Alice and Augustus had made the acquaintance of General Guillermo Palomino, an important military and political figure, who backed their explorations at Chichén Itzá and in 1882 became governor of Yucatán.

After the carnival in Mérida, Alice and Augustus traveled to Progreso and made a number of photos of the buildings and recorded the activities at the port. However, they could not print negatives on the spot because Progreso's water caused the photographic paper to stain.

April ⟶ Progreso

We made a visit to Progreso just to catch once more a little sea breeze and take some photographs of the place—and people if they wished—

We found some difficulty in getting a house—Don Braulio Canton was kind enough to give us a room in his warehouse or storerooms.

There are no bathing booths at Progreso—Rosado Vega is very kind and obliging. We were invited to attend a ball, and did so, but did not remain long, not caring to dance, which was the order of the evening. The water of Progreso is quite useless for photography. We made some negatives of different people, but could not print them until reaching Merida, because the water turns the water as yellow as saffron.

On the beach of Progreso, there is a great quantity of sponge of all qualities, besides plenty of seaweed, shells—coral, etc.

Anxious to see the countryside and acquaint themselves with both the people and the ancient ruins of Yucatán, the Le Plongeons departed for the city of Izamal. Having quickly learned to adapt to the tropical heat and humidity, they brought their hammocks. In Yucatán, the hammock is used in cities as well as in the countryside because it provides a cool sleep above the ground, and with netting it can give almost complete protection from mosquitoes.

In Izamal, during the sixteenth century, the Spanish built a convent over much of the pre-Columbian ruins in Izamal, but what remained of the pyramids was still impressive in 1873. Today the pyramid of Kinich Kak Moo, the largest in Yucatán, is an important tourist and archaeological attraction, and the underside can be accessed by tunnels. Augustus squeezed through some of the narrow tunnels, and his observations were recorded by Alice.

They rode with their equipment in a two-wheeled carriage, called a volan coche, *drawn by a mule. It was a rough ride, but a common means of transport in Yucatán during the nineteenth century. With its large wheels, the cart could negotiate the potholes and deep ruts of Yucatán roads without getting stuck. In spite of their misadventures on arrival, the Le Plongeons quickly adapted to life in Yucatán and received a fine welcome most everywhere they traveled.*

May ⨝ Izamal

We left Merida to go to Izamal. Our conveyance was a <u>bolan</u> <u>coché</u> [*volan coche*]—not very comfortable, but strong.

There was plenty to attract the attention on the road—but the butterflies were remarkable for their numbers—we passed through clouds of them. A house had been hired for us in Izamal. We went to it. It had rained hard during the last hour, and the house was well supplied with small pools of water on the floor of each room, nowhere to hang a hammock. Dr sent by Guadalupe, a letter of introduction that he had for D. Joaquin Reyes, and within an hour this gentleman was kind enough to send his carriage to our door with an invitation to go and dine with him.

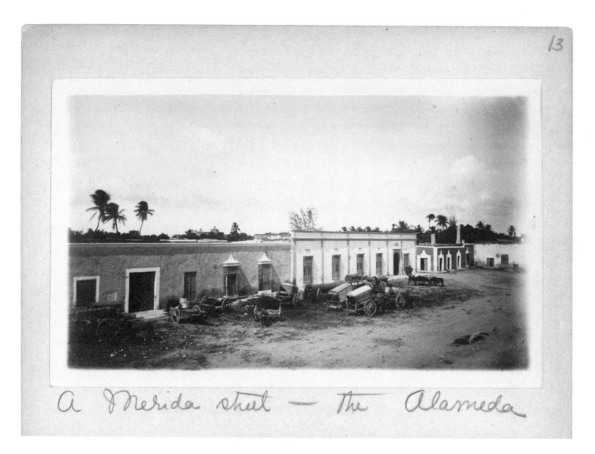

13

a Merida street — the Alameda

"A Merida Street—
The Alameda,"
with *volan coches.*
Circa 1874. Photo by
Alice and Augustus
Le Plongeon.
Research Library,
The Getty Research
Institute, Los
Angeles, California
(2004.M.18).

May

He rescued us from our leaky house and furnished one of his own for us; at the same time insisting that we should use the family table. Don Joaquin suffers from dyspepsia, and is in consequence of an irritable temper after meals—but is a very good man and most staunch Catholic. He is the principal merchant in Izamal, and makes money. His wife Belen, his daughter Aurelia, two growing sons, besides some little ones, all do everything in their power to make us feel at home—

Dr Le Plongeon went under the serro [*cerro*, hill] of Izamal (i.e.) the largest one, and thereby obtained a reputation of wizard.

For a full description of Augustus's exploration of the pyramid of Kinich Kak Moo and how he became known as a wizard, to at least a few of the local people, see appendix 1.

June

Guadalupe got very much intoxicated and one day got into a brawl

and fought; Dr threatened to have him whipped—whereupon he decided to desert, but we discovered his plan—took away his weapon, and put him under arrest. After two or three days we took him out, and sent him to Merida.

July

We returned to Merida—could not find a house of any kind—Mejor Benites, residing here with his wife and family was kind enough to let us have a room in his house.

There we prepared for our trip to the East.

September

October

Epidemic of small pox in Merida. Don Liborio Irigoyen the governor.

On hearing that the Le Plongeons would be departing for eastern Yucatán, the governor asked them to vaccinate as many people as possible against smallpox— but no funds were available. To make matters worse, it was not always easy to convince the poor farmers that the vaccination would prevent smallpox. Vaccine was often in short supply, and the Le Plongeons had to replenish their supply of "vaccine matter" directly from a previously vaccinated arm. They left Mérida on November 14 and traveled first to Tixkokob and then on to Hoctun.

Newly arrived in Yucatán from big city life in London and New York, Alice was quick to condemn meals that she thought were poorly prepared as well as the unsanitary conditions in country houses where animals and people live in close proximity. Apparently, she was not acquainted with the life of poor farmers in rural England. But in terms of social customs, she found quite acceptable the family arrangement of the Catholic priest in the village of Hoctun. He had fathered daughters with each of three sisters, and Alice happily reported that the daughters of those unmarried unions "are received in good society."

After a few days in Hoctun, Alice found a school for young women and quickly became friends with the teacher. She pointed out that the school had "two good pianos" and a teacher with great talent. Alice was interested in the education of girls and considered academic subjects such as geography and arithmetic of great importance. To her delight, she was asked to teach a music lesson.

During their exploration of a nearby cave, Alice shocked one of the men who accompanied them when she refused his "gallant" offer to help her climb over a wall. She removed her skirt—and, in pants, simply climbed over the wall.

As they traveled from town to town, they set up their photographic studio in a tent and took portraits of the town's people to make a little extra money.

On December 8, they left Hoctun for the city of Izamal to attend the annual fair. At the large outdoor market they set up their photographic studio. They attended a bullfight—but were "not much amused."

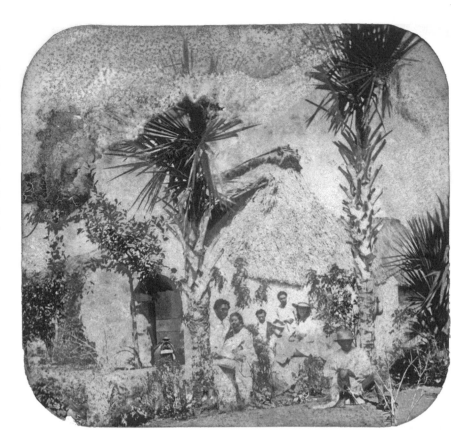

On the Road to Chichén Itzá

November 1874–September 1875 DIARY PAGES 53–109

November ⤳ *Merida*

In the beginning of the month we thought of starting for Chichen
Itza, stopping a short time at each of the places through which we passed
so that we might know Yucatan modern as well as ancient.

Dr Don Liborio Irigoyen gave us a letter recommending us to the
attention of the magistrates, etc., etc. of the places which we expected to
traverse, with order that they should aid us by all the means in their power.
At the same time as the epidemic of small pox was on the increase he asked
us as a particular favor to vaccinate the people wherever we went, as he
could not afford to pay a doctor to do it. So our starting was somewhat
delayed owing to the great difficulty we had in finding vaccine matter.

14 ⤳ *Hoctun*

At last on the 14th November 1874 we started east. The convolvulus,
of every color, were then in full bloom, and made the hedges, or rather

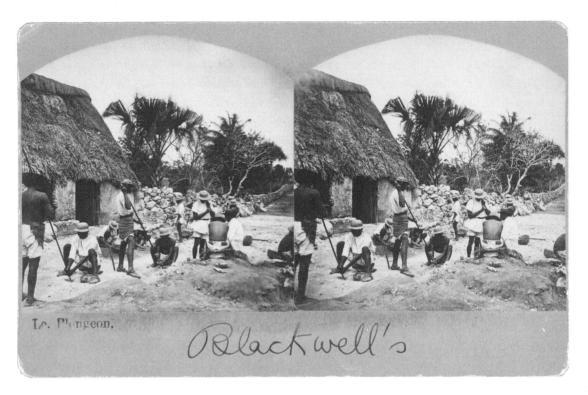

Le. Plongeon.

Blackwell's

Maya men repairing
a road in Yucatán.
Circa 1874. Photo by
Alice and Augustus
Le Plongeon. Research
Library, The Getty
Research Institute,
Los Angeles, California
(2004.M.18).

the woods, on each side of the road, lovely. The first place we stopped at was Tixcocob. The <u>jefe politico</u> was Señor Gorozica—The governor had telegraphed to him to prepare breakfast for us; and get the people together to be vaccinated. All this was done with good will—Dr Le Plongeon went to the school where all the children were together, and did good work there.

At 5 PM we came into Hoctun. The entrance was pretty. The children, of which there seemed to be a good supply, were goodlooking and generally blue-eyed, something unusual here. We carried letters of recommendation for the Cura, and for the family of Gamboa. Without such letters we should run a poor chance of shelter in these villages. The first group of men we saw we inquired for Mr Gamboa, and received the disagreeable intelligence that he had departed for Merida. We then asked for Father Escalante, and found him in his rooms adjoining the church, swinging in a hammock. We presented him the letter, and also that for Gamboa, it being open. He read them, invited us to take a seat, and seemed to think that there the matter ended. We told him that our <u>bolan</u> was at the door with our luggage; because we did not know where to take it. We desired a room in which to hang our hammocks; and something to eat. After revolving the matter over and over in his mind, he decided

to conduct us to the residence of a shoemaker. We found that the shoemaker had also gone to Merida, and his wife did not wish to take people into her house without first consulting him. A pretty position, truly! The stars beginning to appear; our baggage in the middle of the square, no shelter to be found, and the stomach very empty. At the sight of strange faces, a good number of boys of inquisitive age (between 5 and 15) had congregated round the door. The priest caught one by the shoulder, and sent him to ask his mother if she could provide supper for a lady and gentleman. The boy, returning, informed us that at 9 o'clock we could go to his mother's house and eat eggs and chicken. But, where to pass the night? The woman who sold us our supper for 10r [10 reals]—, politely, but positively refused to accommodate us—Happy thought! The priest remembered that a house, newly painted, was as yet unoccupied. He sent to inquire if the owner wished to let it for eight days—We received answer that for 50 cents a day we could have it. There being no choice we accepted, although we knew that it was more than the just price. The house had two rooms—only one was for us; as the other contained furniture in storage. Our room was large, clean, and pleasant. It was furnished with a very small table, one chair, and a candlestick.

We landed our trunks and hammocks under the strict vigilance of the curious boys that had faithfully followed our bolan. After entering our things our next business was to go and look for our 8 o'clock dinner. Although the people are really very honest, we preferred locking the door—the key had entered the door lock—but to withdraw it, c'ctait une autre affair. The priest tried, we tried, all the curious boys tried. In vain! It was decided that one should remain on guard, the rest chatter with him and we go to dinner.

Accompanied by the priest we arrived at a house, and were introduced into a large room. At one end stood a table, on it the favorite saints of the family, under a glass case. Under the nose of the saints were some dirty cups and saucers being washed by a little girl of about 5 years— she was obliged to keep herself on tiptoe to reach the table. Many other things were crowded around the saints. Something, more useful than ornamental stood on the ground close by; and various small boxes were stowed up in the corners of the room. Four hammocks were hanging. One was occupied by a screaming baby, and a dirty child—its nurse. A woman, fat, fair & forty, about, dressed in uipil [*huipil*] came to receive us, and seated herself in another of the hammocks. We were invited to "cofer [*coger*] hamaca" [take a hammock] but took chairs instead, not being great lovers of fleas. A little girl, and a dirty old man seemed to be cooking the supper, for they left the room every few minutes, returning quickly to continue their scrutiny of the strangers. The kitchens here are

built out in the yard, and we understood at once this room which we now occupied constituted the whole house. We saw no table preparations, and our patience was exhausted two or three times over, before we were invited to eat. The table was small, the plates were turned down, and no knifes or forks were visible. When we lifted the plates we found one knife, fork, and spoon to be divided between three people—for we had told the coachman, quite a decent fellow, to eat with us lest he should go without.

There was a broiled hen undercooked, two fried eggs floating in fat, four raw eggs put into a basin of hot water, a small piece of Dutch cheese, with the imprint of somebody's teeth upon it—and some very dirty tortillas. With the aid of our fingers we tore the hen to pieces and ate it, we sucked the raw eggs, and those that were fried we ate with the knife and fork. Afterwards a cup of chocolate, the worst we had ever taken, with two or three biscuits concluded the repast. We asked the fair fat lady, mistress of the house, how much we owed her. "Ten reals," she said. ($1.25). As this was more than twice as much as they would have charged one of the country, we resolved not to eat there again.

We found, on reaching our house, that our sentinel had succeeded in withdrawing the key, so we retired to sleep in our new and clean house. Dr was prevented from sleeping by a bad cough.

November 15

At 6 o'clock in the morning we made our toilet as best we could, using for wash basin, a photographic dish. After taking a general survey of our premises, for there was a yard at the back of the house, we sallied forth in search of the magistrate. We found his wife at home—dressed in uipil. She was thin, dark, and plain, but quite cordial in her reception. We took a seat, and she sent for her husband. His daughters are received in good society. Meanwhile we asked her where we get board. That, she said, would be very difficult, for in the village everything was scarce, but in the afternoon she would let us know if she could accommodate us. The gentleman arrived, summoned two or three others and after some talking, it was arranged that we should vaccinate the poor gratis and those who had the means were to pay 25 c. each. From that moment all the people became poor. We carried to Mrs Gamboa the letter which we had for her husband. Mrs Gamboa was quite a pretty Japanese type, even the almond eyes, and dark olive skin were there; and she a perfect lady in manners and appearance.

She had six or seven children round her and plenty of servants. She looked about 25 years of age. The letters which we gave her she carried to the desk, saying that she would read them presently. Later on we knew that she had never learned to read or write. This ignorance is common

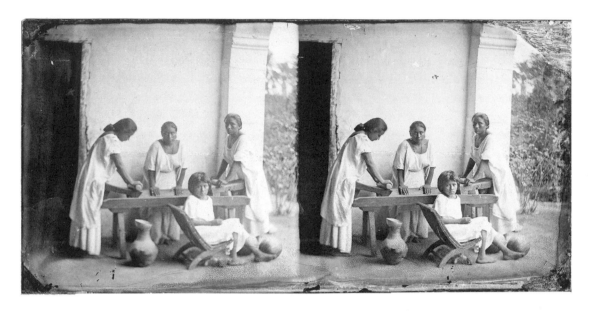

Maya women using *manos* and *metates* to grind corn for tortillas. Because Alice was a woman she was welcomed by the women in villages to learn about their life and to photograph them. Augustus, on the other hand, was mainly restricted to the men's sphere of work. Circa 1875. Research Library, The Getty Research Institute, Los Angeles, California (2004.M.18).

here. The house we had taken belonged to her brother, and she very kindly offered us her services. Now was the moment to secure food—we were happy enough to succeed. It was arranged that we should eat at her house, and pay her ~~36~~ 75 cents a day for both. At 9–30 we breakfasted. Everything was well prepared, and Da Elena was over anxious to please us. During breakfast we were informed that in the house between that of Da Elena, and the one which we occupied, lived a lady and gentleman, Cubans, and that they kept a school for young ladies. We expressed our desire to visit it, and the lady, Da Eufemia sent word that she would be happy to receive us. We found a goodsized room, well filled by about eighty <u>butacas</u>, a small wooden seat, now only used in this country, formerly in Assyria and Babylonia. These were occupied by girls ranging from 6 to 18 years of age. Lovable-looking girls clothed with the greatest simplicity. They were employed in fancy needle work.

At the further end of the room, ~~seated~~ in a large armchair, near a small round table, sat the mistress, who on our entrance arose to receive us. She offered us seats and showed us the work of the girls, which was very fine. We wished to purchase some beautifully embroidered handkerchiefs but they were to be kept for the examinations. The lady however begged us to accept one that had not been made for a specimen. The elder girls were working floss silk upon white satin. All appeared very contented. Mr Fernandez, the husband of Da Eufemia is a gentleman of good figure, and handsome face. At his invitation we entered the class room, and found the scholars were advanced in grammar, geography, arithmetic, and writing. We have seen no establishment in Merida equal

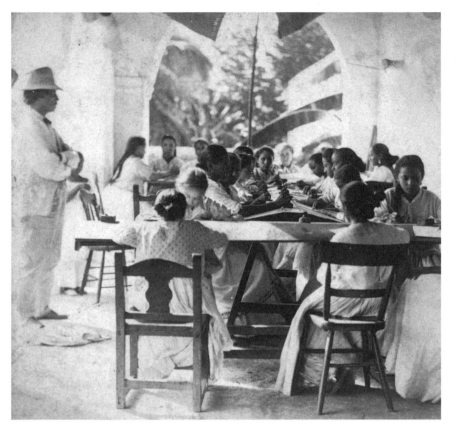

A school room in Hoctun, Yucatán. The girls were taught writing, arithmetic, and grammar in addition to skills such as embroidery. 1874. Photo by Alice Dixon Le Plongeon. Research Library, The Getty Research Institute, Los Angeles, California (2004.M.18).

to this, for in that city they leave school very young—while here were girls of 18 studying hard.

Our next thought was the building of a studio. We contrived it with four poles, and such pieces of white cloth as we had with us, but a whole week passed before we were satisfied with our light, and we resolved to avoid this trouble in future by making a linen tent, on our arrival in Izamal.

Hoctun is in advance of some of the larger cities of Yucatan for it can boast of two good pianos, and a professor who plays several instruments: he is also the director of a very tolerable band. El maestro, as he is called, is a young man of 25 years of age, romantió [*romántico*, romantic], persevering, and talented. Three months before our arrival in Hoctun, he had seen and touched a piano for the first time. When we arrived he had already composed some pieces, and could play the instrument neatly. He took the trouble of composing a song and dedicating it to me.

Father Escalante invited us to visit his <u>family</u>—quite extensive, though he is not married[.]

His daughters are received in good society and no one dreams of holding them responsible for being illegitimate daughters, nor do they

much criticize the Father although he lives with three sisters, and has a family with each. But this is common among the priesthood of Yucatan.

December ∽ Hoctun, Izamal, Tunkas, Senotillo Tixbach

About thirty people sat for photoes during the 2nd and 3rd week. Don Vicente Fernandez was apparently the father of the place for he brought the people to the house, and paid for the greater part of them, afterwards collecting the money for himself. The people are ignorant and simple, and they yield at once to anyone whom they believe to be their superior. They had not yet begun to study music in the school, or liceo as they call it. I explained the tonic solfa method to Dn Domingo Maria Ricaldi, the <u>Maestro</u>, and told it would be an excellent way of teaching them—They wanted me to give them the first lessons.

Tonic sol-fa is a method for teaching sight singing. The method was codified in the 1840s by the English Congregational minister Rev. John Curwen (1816–80). In the 1850s, Curwen published songbooks using the method, and it is likely that Alice had learned the method at school and used it during her singing lessons.

The evening before we intended to leave a ball was given in our honor. The orchestra played. The young men could not be persuaded to enter the room, as they were dressed in meztizo costume, having had no notice beforehand of the ball—The meztizo costume consists of wide white drawers, and the shirt left hanging over them. Cheap and comfortable. So the girls danced with each other—and at 10 PM. bade us a very affectionate farewell.

We were prevented from starting next day, but in the evening went to visit a cave said to exist about one mile from Hoctun. Not knowing the road we invited some friends to accompany us. They did not make up their minds to it until near the <u>oracion</u>. We took a pound of candles in order to see our way in the cave. They cost 50 cents. Don Vicente, X [Refers to note in margin, which reads "Da Eufemia and."] his servant, Father Escalante, accompanied us, also a number of small boys, who came as they said, to shew us the way. We had to traverse a <u>milpa</u> (field). Dr leapt over the wall that enclosed it. Don Vicente placed his hand for me to step upon and jump over. To that gentleman's surprise, I removed my skirt, threw it over his arm, ~~with~~ apologized for so doing, and sprang over the wall. Da Eufemia refused to proceed, so I remained with her while the gentlemen went. It was quite dark when they came out of the <u>milpa</u>. They had not found the cave, but they had lost the candles, and succeeded in falling two or three times over large stones, for it was already dark.

December (continued) ∽ Izamal

We left Hoctun for Izamal. That city was celebrating its annual

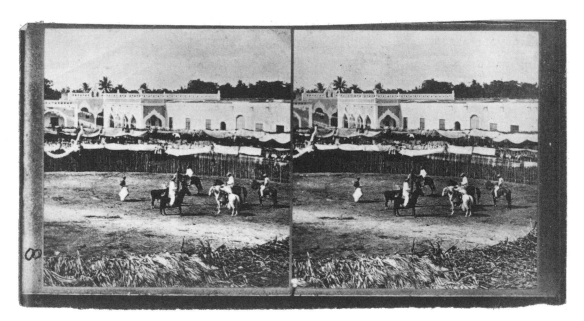

A bullfight during the fiesta at Izamal. The matador can be seen to the left with the bull facing away from him. 1874. Photo by Alice and Augustus Le Plongeon. Research Library, The Getty Research Institute, Los Angeles, California (2004.M.18).

fair—The merchants come from all the surrounding cities to buy and sell—quite a business affair, mixed with some diversions, bullfight, ball, etc. The feast of Our Lady of Izamal is celebrated at the same time; and she has many devotees.

We decided to plant a photographic establishment and work at the same time we saw the fair. By good fortune we obtained a small house on the square, together with a goodsized yard. We placed our tent, and hung a large sign across the street, from house to house. A few people sat for portraits—some paid, others did not. Meanwhile we obtained two or three views—one of the ring, another of the horse fair, and one of the square, with its many stalls where every thing attainable was sold for a medio. We passed among them two or three times, and were amused to see the number of trinkets, which mean nothing, and cost little more. German toys, pieces of colored glass, were on sale for fifteen times their value. During the two last days the prices came down—those selling prefered money to glass.

Señor Don Fermin Irabien, with his daughter Conchita, and his sisterinlaw, Leonor Rosado, invited us to accompany them to the bullfight— We did, but were not much amused. Four men armed with <u>rejones</u>, a kind of spear, took up position in the ring—another part was occupied by horsemen with lasos in hand. Two others, each with a piece of matting about two feet square waited to receive the bull. The orchestra played; and the bull was brought in dragged by a rope passed through the nostrils[.] They tied him tightly to a pole in the middle of the ring, in such a manner

that by touching one end of the rope he would be free. Those on foot retired. Those on horseback approached. A boy came and tied around the bulls body, a bunch of fire crackers, and walked off. The horsemen pulled the cord and escaped in a hurry. The enraged bull rushed forward like a mad thing. The two men came to meet him, and parried his attack with the piece of matting. When the bull no longer wished to play with them—a bugle was sounded, the men retired, and those armed with spears came down upon him; inviting him to attack them by whistling, shouting, and putting themselves in his path. Every time he ran at them they thrust their weapon deep into the back of his neck, and the blood ran in torrents over his body[.]

When he was too far gone to make any advance towards the men, the horsemen caught him with their ropes and dragged him away. Six bulls were thus sacrificed. We may rather call this a bull hunt—We saw three bullfights, in none of them was any man hurt. The <u>palcos</u>, built of poles and palm leaves, were well filled with ladies gaily dressed, gentlemen, children, and servants, for everyone must see the <u>torros</u>, and these ladies cannot take the children without the servants to attend them, for every child a servant, when their means allow. After the fight, they returned to their homes to eat fruit and rest awhile. At 3 o'clock they dined and then began to prepare for the ball which was to commence at 8 PM. The young ladies were occupied about 3 hours in dressing their hair. We attended one of the balls, given in the corridor of the city hall[.] The ladies were elegant, and some richly dressed in satin—but in company with the satin dress, we recognized the necklaces that we had seen in the small stalls on the <u>plaza</u>. Nearly all the girls carried on the top of the head about one foot of false hair, and a great number of artificial flowers. The dresses were absurdly long, and the ladies wore on the flesh a coating of white powder. The balls always concluded at midnight. The daughters of Yucatan show how much indian blood runs in their veins by their mode of adornment. They wear two or three necklaces at once, of different sizes, shapes, and colors, the whole thing not being worth a dollar. The bigger the ear-ring the more beautiful they consider it—and no number of rings on the fingers can satisfy them. Plenty of gambling was carried on during the fair. In the square a number of small tables were placed, and there, dainty lady, and poor indian stood side by side, and ran equal chance of impoverishing or bettering their purse.

The fair concluded, the visitors left Izamal and we among them for Espita.

The Le Plongeons departed Izamal for Espita via Tunkas, Cenotillo, Hacienda Tixback, and arrived at Espita on December 19. The farther east they traveled

the closer they were to the Line of the East that divided Maya territory from that governed by the government of Yucatán. The chances of attack became ever more possible, and soon after they arrived in Espita they received warnings that the Chan Santa Cruz Maya were marching on the village.

We found the roads worse than ever. Hills and valleys of stone. The mules were strong, the bolan new and wellbuilt, happily, for we were heavily loaded. In all the road we saw no game.

We stopped to vaccinate at Tunkas, a small village, and met there a priest from Izamal, Avila a merry fellow, one or two other gentlemen were also there in the house of Señor Don [blank space] where we put up (He was afterwards killed by revolutionists)[.] His wife was a sweet little woman, and very kindly prepared us a good breakfast—After which Don [blank space] accompanied Dr to the schoolhouse that he might vaccinate all the scholars. Then we departed, amid warm invitations to return.

At dusk we arrived at Senotillo [Cenotillo], another village. We carried a letter of introduction to the curate Don Jorge Burgos: found him living in great poverty with his mother, an old lady of 82 years. They received us very kindly, and by sending all round the large square, on one side of which they lived, they finally procured for us a basin of broth and some tortillas. Afterwards the kind old lady made some chocolate for us. We sent out to call all the children and vaccinated all who came, not a few. None of the officers of the place made their appearance.

We went to see the church and found it falling to pieces, it had no longer a roof, except over the altar. The cura was kind enough to offer us as shelter for the night, the only room in the convent which remained habitable—and we slept there. Before daylight our hospitable host sent a table furnished with a good desayuno [breakfast]—afterwards he accompanied us to see a <u>senote</u> [cenote, a water-filled limestone sinkhole] which was underground in the yard of one of the indian huts. Before 6 am we were again on the road. At 10 am Tixbach [Tixbacab], a large hacienda, was reached. Here we breakfasted on deer meat, which was by no means dear, and eggs. Then we vaccinated the people, and passed on, after giving one or two private consultations, gratis.

19th ❧ Espita

We found Espita, which we reached 5 o'clock in the evening preparing for Christmas. We directed the driver to the house for which we had a letter of introduction—moreover Mrs. Quirino Peniche had, in Izamal, given me a personal invitation[.] Dr alighted and gave the letter to the lady herself. She put it away without reading. Her husband was in the country, she said, and did not know where we could find a room. She did not invite me to alight and rest, nor offer any apology for not doing so. This was the

first and last person we found uncourteous, and inhospitable, in the whole of Yucatan. So we went to the convent which adjoins the church. We had no letter for the ~~convent~~ cura, but when we told him who we were, and that we had come to vaccinate the people, he welcomed us very kindly; put a room at our disposal, and busied himself in looking for a house. As it was rather past dinner hour—we could only obtain beans and eggs with tortillas. We opened our trunk and found that a bottle of cyanide, which had found no room in the photographic box had smashed—and its contents spoiled two of my dress, a Mexican sarape, and a pair of fine doe-skin pantaloons. Worse than all our actinometre [a nineteenth-century instrument used to determine the length of time needed to print a photo] was broken and not another to be had in all Yucatan! The trunk itself was very much broken. Everything had been packed with care, but the roads were terrible. We had a letter of introduction for Sr D. Cipriano Rivas. We gave it to one of the many curious boys gathered round the doorway, and told him to take it to the gentleman. Dr had to go out to the shops to hunt for a bottle in which to put the scattered cyanide. Meanwhile Don Cipriano Rivas came to acknowledge the receipt of the letter, and put himself at our service. Querino Peniche, just returned from the country accompanied him. Don Querino did not apologize for the conduct of his wife, but said he was going back to his plantation the next day and would rely upon Don C. R. to do <u>his</u> part for him. Rivas complied with his own most faithfully, and has been a good and constant friend. We passed the night in the convent—and the next day they furnished us with a room in the city hall in consideration of what we had come to do.

20th

We planted our canvas studio in the back yard, and hung our sign in the front balcony.

One of the first things we did in Espita was to visit the girls lyceum. It was very inferior to that of Hoctun, and the teacher, wife of Herrosa, was loud in her complaints of the inconstancy of the pupils. Rafaela, wife of Rivas, was in the school at the time we went and she took us to her house. There we met for the first time Señor Don Virgilio Perez de Alcalá. The people of Espita are very fond of music. Don Virgilio brought us a serenade that night at 12 o'clock, and was surprised because we got up and opened the door to them, the custom being to ignore their presence, so they said.

We were anxious to vaccinate at once—but the authorities were unable to induce the people to submit to it, because the festival was coming off in a few days—and they feared it would interfere with their pleasure if they and their babies had sore arms.

We did persuade a few, but they failed to come to us at the right

time, so we gathered no fresh vaccine from them, and we had not enough to go on with. The people were so careless; and the authorities so indifferent that finally we were reduced to what we might gather from the arm of one fat boy—and we had to watch it, and caution every few hours. We were rewarded by good and plenteous vaccine matter. But had patiently to wait for the people until the <u>fiesta</u> would conclude.

23rd

The fiesta commenced with a <u>vaqueria</u>, a dance of the indians and meztizos—The music and the step are both monotonous. A large square harbour was built in the principal street and there the <u>ball</u> was held.

We were invited to be there at 8 o'clock in the evening. The meztizas wore their usual dress, pic & uipil, of the best kind they could obtain. Their feet were incased in fine white satin slippers, and on the head they carried a small hat tied under the chin. From the hats hung ribbons of all sort of colors, and as long as the purse of each would allow.

Each one tried to vie with the others in their number of rosaries and rings. They dance singly. At midnight the company disbursed—but at 9 am next morning [December 24] dancing commenced again. We were not present. Bullfights were carried on with great animation. Gambling also.

25

Midnight Mass in the church. Earlier in the evening gentlemen of the city had prepared for a ball—and hired the orchestra—but it proved a failure, because the ladies had not sufficient notice to prepare themselves for it. All, however, attended Mass. There was a grand procession of the infant Jesus in wax, or wood, I don't know which. And just as it concluded an alarm spread of—Indians!

Preparations were made for defense—but the alarm proved false, and those who got frightened suffered for nothing.

After the festival we vaccinated, and two X [Refers to note in margin, which reads "Old Mariano Chablé gave us a clue to the Akabsib inscription. According to a <u>Maya</u> MS. that a very old man, Manuel Alayon had, in Valladolid, that only he could read, it is a prophesy of a rope that would be stretched between Saci & Tihó (Merida & Valladolid) by people, not natives of Yucatan."] or three times nearly lost the whole thing owing to the utter carelessness of the people.

[December 30]

Espita had only one physician when we were there Dr Don Fabian Vallado, a pleasant and intelligent gentleman. He had made money with his plantation, and cared very little about practicing his profession. He put all his medicines at our disposal and begged Dr Le Plongeon to attend to the people during his absence—We did so—and cured several cases— two or three of <u>Alferesia</u> [*alferecía*, epilepsy in children].

After spending most of December and January in Espita, the Le Plongeons departed for Tizimin. It took all of the first day to reach the halfway point at Calotmul, only eight miles from Espita. After spending the night, they set out for Tizimin where Alice saw firsthand the reality of the Caste War. Chan Santa Cruz Maya guerillas, determined to retain their territory, were reported to be heading for Tizimin.

By the time the Le Plongeons reached Tizimin they had developed a better understanding of Yucatecan customs. Alice was learning fast and was so intrigued by Yucatecan society that she kept notes on how formal visits are made to important families, and the way greetings are made between young women.

Carnival in Tizimin slowly got underway, and after a few days students began their lively celebrations with music and dance. Alice was particularly taken by the young women dressed in their traditional Yucatecan huipils. *She exclaimed, "The girls of Tizimin are always pretty."*

∽ [1875]
January 24th ∽ Calotmul

When we left Espita, the people of Tizimin had been sending us messages to "make hast" for some days past.

The city most liberally (?) provided us a Bolan coché to go in. The road beyond Espita was worse, if possible, than that which we had traversed before. Four leagues of torture, and we reached Calotmul. The authorities of the town came in body to greet us—opened the hall of sessions for us, and in less than half an hour assembled all the people that we might stick our lancet into them. Business over, we went to ramble about the place, and see a very pretty <u>senote</u>. While admiring it a gentleman came to invite us to dine at his house—<u>Jefe politico</u>.

We were nothing loath, for we had expected to fast. At the table we met the priest of the village and found him to be by no means fanatical. His father a very brave old man, was also there, and bore many unpleasant marks of the service he had rendered in the war of races [the Caste War].

We passed the night in the same apartment where we had vaccinated—and before sleeping examined our surroundings. There were about eighteen old flint guns all useless; [for] the defense of the town; a guitar without strings; a writing desk; a closed bureau; and two wooden benches.

At dawn we prepared for departure; we took no <u>desayuno</u>, not knowing where to obtain it.

January 25th ∽ Tizimin

When in the bolan, and on the point of starting, the Jefe politico (Magistrate) came to bid us goodbye. At the same time he offered us, in

the name of the town, a small paper parcel. Judging from the size, and supposing it was silver, it contained two or three dollars. At the same time he apologized for the small quantity, which he said, was due to the extreme poverty existing in the place. We thanked him and requested him to give it to one of the many poor who might be ill.

The entrance to Tizimin is very pretty. The square looks clean bright & cheerful. The place has a general air of prosperity that is wanting in most of the other villages & cities.

Arriving in Tizimin at the breakfast hour, 10 o'clock, we found no one waiting in the city hall to receive us, although we had sent them word of our coming. We waited in the square, seated in our carriage until our patience was giving out. Hotels are unknown here—we knew not where to go. Finally a man appeared—when he heard our name, we were invited to alight and enter the city hall, where two rooms had been vacated for us. They only contained two chairs. We hung our hammocks, and commenced to unpack. Before we had been installed half an hour, a very thin gentleman, who introduced himself as Florentino Montes, came to invite us in the name of Santiago Perez to go at once to the house of that gentleman, and accept no other shelter. No excuse would be taken. Don Santiago received us with open arms, and gave us an excellent breakfast, the very best that could be procured in that city. He would not hear of our return to the city hall—but had his writing table removed from his parlour to another room, and put the parlour at our disposal as a sleeping and sitting room. One room is enough in this country—The hammock serves as bed at night and as sofa by day. If a sheet is used at night, it is put out of sight in the morning.

So our luggage was brought from the city hall in the big square, to the house of Don Santiago, in the small square which is just back of it.

Don Santiago is poor because he gambled away a small fortune. He says that he did so because his wife did not behave herself. A funny kind of vengeance which has fallen only upon himself—for she is living with her relatives who are well off. And a poor, and good woman, his mistress and servant, by whom he has one child, toils day and night. All he cares for is this ugly little baby, the memory of his first wife, and abanero [*habanero, capsicum chinense*, a chile], which he thinks is an infallible cure for all ills. He is eccentric, for he says he takes a pleasure and pride in getting up each morning, knowing that there is not a cent in the house, and that he can procure it within an hour. Vox populi, Vox Dei. The Vox populi says that he has done his wife great injustice.

Tizimin is certainly the prettiest place we have yet seen in Yucatan. The people amiable and handsome, more robust looking than elsewhere. They are indolent par excellance, passing their life very much occupied

in doing nothing. Nature has made them musicians. They pass the day swinging in the hammock, and playing the guitar; and in the evening sit at the street doors to fulfill the same occupation, and jest with one another after their soft indolent fashion.

There are two physicians here—one is Don Alcala, brother of Alcala, the present magistrate of Tizimin. The other is [blank space]

Cura Perez occupies a very ancient, but wellpreserved and fortified convent.

Fruit is abundant. Oranges 25 for 6 cents. They are said to produce intermittent fever. In fact after eating a great number, I myself had that disease. They seem to produce a general relaxation. Coronel Trinidad Oliva a musician by birth, and a valiant soldier, had some large orchards of orange trees, and used to send to me by the peck till Dr requested him to send no more, lest I should kill myself with them.

Our first sunday in Tizimin we went to hear the retreta played—and discovered that when Luna refuses her light, that city remains in darkness by night; even the Plaza Mayor. The band was playing under the portico of the city hall—The musicians formed the entire audience, so we also beat a retreat.

We were advised to send our card to the principal families—they were not many. We did so, and received visits in return. Yucatan is the reverse of the all other countries in the world. A stranger arrives. He may visit whom he pleases and be sure of a kind reception. But one who does not know the customs of these good people, and remains in his house, expecting the residents to make him a call, will remain isolated. He may send his card if he cannot make the visit in person. The vaccinating was carried on with animation, even the little indians presenting themselves. Meanwhile we heard terrible accounts of the small pox in Merida. Twenty-six deaths per day is a large number for a city of 40,000 inhabitants. Large assemblies were forbidden, and the bell was not allowed to be tolled for any death. The burning of the dead which would have been effectual in bringing to an end the epidemic was not practiced, owing to the religious ideas and fancies of the people.

February 6th

First day of Carnaval—was not celebrated in any way whatever. No one shewed the least animation—and the festival appeared likely to pass unnoticed.

8th

At an early hour Los Estudiantes made their appearance, about 20 or 30 of them—each one dressed to his own fancy, with a knife and fork stuck in the hat, ready for breakfast. Some carried guitars, others bottles of beer, and glasses. They entered the house, sang pretty Estudiantina

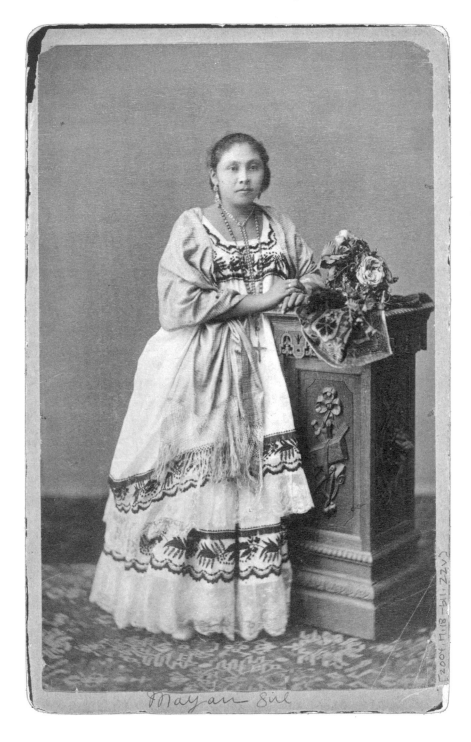

Mayan Siu

Portrait of a woman
in a traditional
Yucatecan *huipil.*
Circa 1875. Photo
by Alice Dixon
Le Plongeon.
Research Library,
The Getty Research
Institute, Los
Angeles, California
(2004.M.18).

composed the previous night by one of them, Don Felipe Perez, cousin of Santiago, and invited us to drink with them. They also gave us an invitation for a ball that night. Then Dr took their photo and they left.

Later in the day another group arrived, masked as negros. These contented themselves with dancing and trying to say funny things. Dr shewed them that he could speak their negro spanish and dance as well as they, which seemed to give them great satisfaction.

A third group came to visit us, of young ladies, dressed as Meztizas. On their entrance they appeared to us, as a shower of beautiful flowers. A charming group for any fairy scene. What an exquisite novelty it would be for a ballet. The girls of Tizimin are always pretty. Today unusually so. The dress became them and shewed off their fine forms to advantage. The abundance of jewels and many colored ribbons, were very effective. Nor had they forgotten their snow white powder (made in Yucatan from egg shells) and a little carmine for the cheeks and lips. A jaunty hat completed this costume, proper to Yucatan, and seen nowhere else.

The maidens were in good spirits. We had to receive from each an embrace and a kiss. (It is etiquette, in Yucatan, for all ladies, be they strangers or friends, to embrace upon meeting each other. The embrace is graceful, and peculiar. One raises the right arm, the other the left. Some clasp each other round the waist; others put the hands on the shoulder; according to the intimacy between them. Touching the shoulder is the greater etiquette)[.] One or two of the young ladies were smoking, but the sigarette was very small, and handled with as much delicacy that it added to their charming appearance. Some gentlemen who accompanied them played the guitar, while the frolicsome girls went through a country dance[.] Their bewitching little feet were encased in delicate white boots with high heels, and large buckles. We promised to meet them at the ball, that night and they bade us <u>adios</u>.

The ball was somewhat stiff. The young ladies had retained their hats, powder, and carmine, but a fancy ball dress took the place of the graceful <u>uipil</u>, and dancers were tired. The musicians were not sober, and produced occasional discords. The hall was nevertheless animated until 1 am when all retired.

[February 19]

Colonel Francisco Canton was expected in Tizimin[.] Don Santiago had a grand breakfast prepared for him, and to the orchestra out to meet him on the road. The infatuation which the people of the east of Yucatan have for this man is remarkable, for he is uneducated and vain—a brave soldier, no more—a mere revolutionist.

Dr attended the breakfast. I breakfasted in my own room—when the lady whom we paid to send us our meals, sent it at the usual hour[.]

In eating some fish I got a fine bone stuck in the throat. Dr could not see it, but I felt it. Suffered all day & night. Gargled with laudanum to keep the inflammation down.

20th

Dr went in the morning to the post office alone, I stood before my looking glass, and held my tongue down with one instrument while I examined my throat; I saw far down, on one side, a bright speck[.] After many failures, I at last succeeded in catching it with the pinchers, and drew it out of its flesh—I was fully an inch long—Dr thought I had nothing in my throat, but the bone before him undeceived him.

March 3

Notice was received that the indians were coming to attack Tizimin. Dr wrote to General Palomino in Merida asking him to send some troops to defend the City. 50 Mexicans were sent under the command of Captain Boza. Happily the notice proved false. But as the moon was nearly full we thought it possible that the indians might come, and slept always with three things on hand—Cash, firearms, and male attire—After a week seeing that nothing occurred we no longer took this precaution.

15th

I was ill all day and much depressed—Dr very busy.

A warning came during the night that an attack by the Chan Santa Cruz Maya was imminent—Alice and Augustus prepared for the battle.

At 8–30 we retired to rest and sleep.

Don Santiago is a lover of music, and when the silence of night reigns over the city, he likes to go to the house of his friends, wake them, and take them out into the streets to give serenades. This on moonlight nights. He is always a wellbehaved gentleman; but sometimes enthusiastic. On the night of the 15th we were awakened from a profound sleep by the voice of that gentleman. He was speaking with great animation in his room. A moment afterwards he went to knock at the doors of his near neighbors, shouting to them to get up. We heard it plainly. "Is Santiago drunk or crazy?" said the Dr. "The moon is bright, probably he wants to serenade." But even while we spoke—the bugle was heard calling the people together, and the next instant the bells of the church began tolling a general alarm. (This is the custom to call the people together, when their is danger)[.] We sprang from the hammocks. It was the work of five minutes to dress (I in male attire) hide the lenses under a pile of stones in the yard—grasp our money—and our weapons—and go forth.

Everyone was up and stirring. If we had found the enemy before our door, as we half expected, we had decided to fight our way with the

bayonet of our remingtons, to the old convent which stands on the opposite side of the square. From there we could fire advantageously—We found the families gathered at their house doors. We told them to come with us to the convent. They refused, saying that there was plenty of time yet. They were delighted to see us armed in their defense. A pale, exquisite light shone over the city, and it made the women and children look ghastly—I could not help thinking ~~of what~~ how much more ghastly they might look when morning dawned—They were sitting on the door steps of their houses waiting—for what? For the alarm. Then they escape if possible; and if not, they would be cut to pieces by the terrible <u>machete</u>.

The convent was the strongest, and highest building in the city, we again advised them to go there—But they shewed no fear, and said they would wait. When half way across the plaza we met our friend, Osorio, accompanied by fifteen men going to the outskirts of the city to form a barricade. We bad him godspeed and passed on to the city hall, which adjoins the barracks. We were among the first arrivals. Within half an hour 30 or 40 gentlemen assembled. One or two had good weapons, several had small hunting guns, and the balance only machetes. Captain Bosa greeted us with a pleased smile; his men were ready within barracks, out of sight. My dress was a disguise[.] No one recognized me until I spoke. We entered the hall of Sessions to read the notice which had been received. Two pacific indians had arrived in Calotmul stating that the enemy had burned a farm. These two had escaped after seeing the indians divide into two parties, one marching on Tizimin, the other on Valladolid. We might then expect them within an hour or two. It was now midnight. The National guard, of which Santiag Perez has lately been named colonel, did not hasten to appear. The few who came brought only machetes. We were assured that these men all had one, or more, weapons hidden in their houses. We were led to believe that 2 or 3000 men were marching against us—we were about 100 to meet them, only 50 of us well armed—and the indians have good rifles. Even ammunition was scarce, and men were immediately set to make some, half of the which was stolen during the night, by the national guard: they were not detected. Dr proposed barricading with faggots, which the bullets would not penetrate, and which could, on the near approach of the enemy, be set fire to after having turpentine poured on them. The indians would not pass over the fire & would have to wait, or look for other entrances than the roads. Meanwhile we should gain time. Owing to the ignorance, little energy, and absence of a good commander, the idea was not carried out. Dr also proposed to make a large collection of corks, run nails through them and strew them over the roads, this would disable the enemy. But the project was not realized.

Dr took me to a friends house, close by, that of Alcadio Aranda, then he went home to get his truss of surgical instruments, my thick shawl, and the field glasses, with which, at dawn, we could see a long distance. He returned within 15 min. The night was cold and I wrapped my shawl round me with pleasure. At 1 am an old soldier, Father of the priest of Calotmul, arrived from that place with news that that village would be invaded within ~~half~~ an hour or two. He said "You know me, and I say you may cut off my ears, if they are not there before 5 o'clock." He had come to as assistance—But Tizimin herself was in need and could afford none[.] So the poor old man retraced the four weary leagues in a state of mind easier to imagine than describe. He might find his home in flames on his return; and his family cut to pieces. The moon would be down in an hour. If the indians did not arrive within that time, we might consider ourselves safe until dawn[.]

There was great confusion among the men of the national guard. They are undisciplined—Don Santiago knows nothing of military affairs, and is too proud to take advice. The citizens, merchants, organized themselves into bands, and occupied the entrances of the square. On the part of the federal troops nothing was heard, save the "Quien Vive?" of the sentinels.

Everyone who intended to fight wore round his hat a strip of white calico, a countersign. The moon went down, and darkness reigned, but for the faint glimmer of stars, and the cigars of those who stood here and there in the streets. Doña Emilia Aranda and myself passed the rest of the night swinging in a hammock and singing. At 4 am day dawned. The first faint glimmer could only be seen by those who were watching for life and death. An hour later Dr Le Plongeon went to the top of the convent and with his field glasses surveyed the country round. He saw nothing, not even smoke. The tizimineneans assured us that the enemy entered always under cover of the bush, and follow no road, so it was impossible to see them. Captain Bosa was advised by the Dr to place a trustworthy man on the top of the church, field glass in hand, to keep a constant look out. This was done.

[March 16]

We had noticed during the night, the nonappearance of one of our friends, Don Felipe Perez, a correspondent of one of the Merida papers. He was the petit mâetre of Tizimin, adored by many, and particularly by himself—goodlooking, with some talent, especially for music and flirting, paying court to all, and, as far as we could see, caring for none. He visited us frequently, and professed a sincere friendship. His absence surprised us on this occasion. At 6 am he made his appearance, with a monster cartridge box at his back, and a countersign in his hat. He told

us with the greatest <u>nonchalance</u> that he had heard neither bells nor bugle. (It was not his custom to be so deaf to bells—besides his house faced the church and barracks)[.] He said people had knocked at his door four times, but he did not answer, lest they might wish to take him out serenading, for which he did not feel inclined, as he had retired with headache. A strange explanation truly.

We expected each moment to receive some fresh notice—every man was at his post, and resolved to fight to the death if necessary. At 9 o'clock we went home to breakfast, beginning to believe with all our heart in the falsity of the alarm. At midday we took a walk of a mile or two, rifle in hand, in direction of Calotmul. Colonel Oliver [Oliva], and a few men, who had, under his command, built a barricade, at a short distance from the town, accompanied us. Every thing was tranquil. The people remained on the alert all day. After our 4 o'clock dinner we went to sleep for two hours. At 8 o'clock we again dressed and went out, prepared to pass another bad night. At the door of the next house we found the Magistrate Alcalá; and learned that the alarm had been false—No indian in sight.

A man in one farm had been told by Mr <u>Somebody</u> that the indians were coming in large numbers. He sent word on to the next farm, and then went to work to prepare his weapons. Cleaning them he let them off. The man in the second farm heard the report of the rifles and ran to Calotmul with the tidings that farm number one was already taken. From Calotmul came an official dispatch to Tizimin: hence the panic. We did not cut off the ears of the old man who lost his bet.

We returned to our hammock and slept in peace without dreaming of indians.

27th [or March 17 or 22] ❧ Tizimin, Teco

We had the pleasure of examining the convent which we had intended to use as a fortress. It is a very strong building where five hundred families could take shelter, pure air, and good water, in case of a siege—for there is a large courtyard in the center with wells.

A few days before our departure from Tizimin the city presented us 16$ for the service we had rendered in vaccinating the people (This city suffered less than the others, owing to the timely application of vaccine. I one morning performed the operation on 40 girls).

We accepted the offering with thanks and that same day, accompanied by three or four ladies of the City, and the curate, went to distribute it among the old women who were sick and poor. I could not go alone, not knowing where to find them. One of the young ladies distributed the money at her own discretion, upon condition that none should be given where any man lived, for they would spend it for liquor. She gave

1 to some, 2 to others, and 3 dollars to two old women, whom she said were quite helpless. Let us hope that someone felt a moments gladness—at least I did.

They all said a great deal upon the reception of the money—but as they spoke in Maya I do not know what, except the <u>Dios Botec</u> [*botik*] (thank you).

The outskirts of Tizimin are very pretty, a little paradise, disfigured by poverty and sickness. The Doctors do not think it their duty to visit those who live far off and have no fee to put into their hand, so the poor sicken, die, and bury each other the best they can.

During the next three days our door was besieged by beggars, complaining, and asking in most beseeching tones "why I had forgotten them." They seemed to think that we possessed an in exhaustless mine of gold. To all I had to answer <u>Mixan</u>. So it is. If I made a few friends by giving, I made more enemies by refusing, doubtless they thought me very cruel but this was the only way to rid myself of them.

Tizimin boasts of a reading room, and feels great pride in it. We are told that formerly it had its choral Society, but for want of enthusiasm and constancy, it came to the ground. Probably the reading room will share the same fate, for I am told that more gossiping than reading is done there. We have done more photography here than elsewhere.

The volan coche, *drawn by mules, was about the only wheeled vehicle that could carry the Le Plongeons and all their photographic equipment over the rocky road from Tizimin to Teco. It was a very rough ride, but Alice managed to keep her ironic sense of humor.*

There are many disagreeable things in life—many inconveniences; one of the most inconvenient in our estimation is the <u>bolan</u> <u>coche</u> of Yucatan. At 3 o'clock in the afternoon, yesterday, the mules were harnessed; so taking leave of our hospitable host, we prepared to occupy the bolan.* [Alice's footnote reads, "This bolan was kindly sent to us by Don Cipriano Revas, to take us to his hacienda of Teco, where he wanted us to visit his family."] We were advised that one of the mules was very lively. Lively was not the word for it—she was wild. I put my foot on the step to get up, Doctor stood on the other side of the carriage, holding the reins, and the coachman stood in front of the mules. All this did not prevent them from starting forward. Stupidly I was dressed in petticoats, and could not jump back when they rushed ahead. The only thing, with my skirts caught, was to run with them—this I did, Dr soon bringing them up against the wall. Don Santiago ran to our assistance. Dr told him to cover the eyes of the mules. For once in his life Don Santiago followed an

advice and we succeeded in getting up. Uncovering their eyes, Santiago sprang back and off we went at a dashing rate. We had scrambled in as best we could, not having time to accommodate ourselves, and once the bolan in motion, as the roads are composed of small hills and vales of stone, we were pitched about every which way. So there we were, seated on a thin soft mattress that in less than five minutes would be any where but under us, most likely it would be huddled up between us, forming a nice safe bed for our two rifles which occupied the center of the carriage; and we should remain sitting on the iron headrest, camera stand, etc etc which which occupied the sides. But happily the road, like life, has its smooth places, as well as rough, and when we came to them, we did the best we could for ourselves in order to sustain the next shaking. We were squatting turkish fashion, and more unstable than a ship in a stormy sea. To converse we had to shout so as to be heard above the noise of the wheels rattling over the stony road, and we ran some risk of biting off our tongues in the attempt. Moreover, we were under the pleasant conviction that at any moment either of the wheels might come off. In this way we passed three leagues.

One of the mules was injured, and Alice seems to take satisfaction in describing in bloody detail Augustus's work to sew up the gash.

We turned to the right down a road cut through the forest. We were but one mile distant from the farm of Teco, and the road was good now. When the house of Don Cipriano was almost in sight, the coachman alighted, gave the reins to the Doctor, and informed us that we had to go down a very bad hill. And in fact it was bad. We came down safely, and were congratulating ourselves, when the coachman, pale as the young ladies of Merida, after they use <u>polvillo</u>, called our attention to one of the mules. In coming down he had put his haunches under the bolan and from a hook there had received a gash across them about 18 inches in length, and between one and two inches deep. The blood was flowing very freely. In the first moment we were startled, not knowing how serious the wound might be. Trusting the mule would keep up we told the boy to drive on to the farm, where we could sew up the wound. The short distance we had to go appeared as a mile. Arriving we found our good friend Mrs Rivas awaiting us with a very pale face. We alighted, saluted her, told her of the disaster. On her part, she had just received a fright—for the clock had fallen from a high shelf to the ground, and she supposed it spoiled—happily it escaped damage. We asked for a big needle, and henequen with which to make threads to sew up the gash.

A crowd of men, women, and children, half naked sallied from the

many small huts, that surrounded the <u>Casa Principal</u>. Mrs Rivas shouted out her orders in the ancient tongue of the Mayas, and we in that moment examined our surroundings. The house was composed of one long room, the walls of small poles planted in the ground, and the spaces filled in with mortar. The roof was strongly constructed of poles and palm leaves, closely interlaced with long thin sticks.

Each servant wanted to apply his own remedy to the wounded mule, but we insisted upon sewing it up. After a deal of rushing, screaming, and many disagreements, we succeeded in obtaining needle and thread.

We then had the mule thrown down on the ground tied the legs together, and two indians held him down. Dr held the flesh together as he wished it, while a servant sewed it up. At the first few pricks the beast jumped like a mad thing; and the skin was so hard they had first to bore holes with an awl and then pass the needle through.

When the work was half concluded Mr Rivas arrived on horseback from Espita. He shewed great concern at what had happened to his favorite mule. We assured him that in fifteen days the mule would be as good as ever, if the inflammation was kept down with cold water. Well sewn up, and his feet set free, the mule sprang to his feet. We gave to eat and drink, and let him loose until the next day. We then took supper, conversed awhile, and retired to rest.

23

We arose late, late for Yucatan 6 a.m. and found the morning rather cold than warm—In fact I had not felt so cold since leaving New York. We took chocolate, then went to examine a cave at the back of the house. It was very picturesque with a pool of water at the bottom, and traces of an artificial wide stone staircase leading down to it. A good nook for the families to take shelter in if the indians should attack the farm—for in the interior of the cave, quite out of sight, we found one or two good sized, natural apartments.

24

At 6 a.m. we went to wander in the uncultivated part of the farm. Heard a great noise of many birds but they were not in sight—returned to the house—had the mule washed, and saw that it was doing well. Went with Mr & Mrs Rivas to visit their orchards. An abundance of pineapples, plantains, mangos, and other fruits. Next visited the bee-hives. Under a thatched roof was a slanting framework, and resting upon it 1 or 200 pieces of tree trunk—these were the hives. Through the center of each was a small hole, through which the bee could pass, at each of these entrances, a bee sentinel constantly stands. The instant any danger menaces them he give notice, and they barricade the entrance from within. When we arrived the servants were about to open the hive, and extract

the honey, if there was any. Both ends of the block of wood were covered with mud, less the small hole mentioned. With machete they knocked off the mud, and then removed the square piece of wood which closed up the hive. The block was hollow and there the bees made their nests and stored the honey. Of course on opening it the busy little people swarmed out. They did not attempt to sting anyone. I have gathered them in my hands and found them as harmless as the sweets they produce. The servants cleaned the hives, and assured us that each would return to his own particular one; and that if they were not cleaned from time to time the bees would no longer deposit honey in them. After cleaning them the indians passed them through and through with an aromatic branch chaka [*chaká*, a type of wood], rubbed the interior with a little honey closed up the ends, covered them with mud—and then with charcoal ashes, imprinted by a mould, the name of the owner of the hives on the mud.

After breakfast Mrs R. was fully occupied. Being time of fiesta, she had to dispatch her many servants on a leave of absence. Some came to ask money; others, the greater number, aguardiente (rum).

Everything given out was noted in a book, and they would have to pay for it by their labour.

A lad of about 16 came. He was falling with intoxication; but he wanted a little more. By mistake he was served with some that had a very small quantity of water with it. His indignation knew no bounds—He rolled out his Maya with fervent disgust—Sat down on the ground, and thumped the hard floor with his hands. Even tried to cry in order to better express his great grief. He was given a glass of pure liquor and told to go away. Instead of obeying this order he lay down, and gnashed his teeth together. A small, half starved dog, with a very sad face, came and stood by him. The boy immediately began to caress it with great affection and at this moment another indian arrived to him away—He immediately sat up with great dignity, and told him to "keep at a distance, for he was quite sober." And he managed to walk away, cursing and swearing, with his little dog.

In the afternoon the son of Mr Rivas caught an Iguana, and brought it to us. We broke the spine near the head, but it died very slowly. We dissected it, and it was quite a difficult operation. There were 50 eggs inside of it. Slippers are made here from the skin of the Iguana.

25th

We could not go hunting for our gunpowder and shot had not yet arrived from Espita. Nevertheless, we went, revolver in pocket, to see what we could find. The first thing we discovered was a large nest of red ants. These little animals, half an inch long, are really formidable. They form roads which for their size are magnificent Broadways—about 6 inches wide

and perfectly equal throughout, of some hundreds of yards in length—(I presume, for I have more than once tired in following them). These industrious beings form societies of millions—We have noticed that some are much smaller than others, and these appear to do the work and bear the burdens, while the bigger ones go unloaded. It is to be supposed that they serve the others, their positions being that of slaves. On the occasion of which we speak a perfect regiment of them was carrying home from a long distance, pieces of green leaves, about six times bigger than themselves. We saw one ant larger than the rest and killed it to see what effect it might produce. One or two came to examine it, and went at great speed to their nest, we suppose to carry the news of the death of some chief. The balance of the ants paid no attention whatever to the corpse on the road. We next wounded one. For a long time he could not move, when he did we perceived that he beat all the smaller ones who came in his way, and hobbled home little by little. Externally, their house was a heap of clay, with a hole in the top—too small for us to enter so we know nothing of the interior— But there was a constant going and coming through the entrance, and the greater part of them carried in a green leaf. Later in the morning we found a good sized hole in the earth; and were told that it contained a boar (Javali) as they call it. We went to the house to fetch a dog, there were about 50 on the farm—the greater number of them small and their flesh so scanty one might have sworn they had eaten nothing since their birth. The dog we took with us tried to enter the hole, and drag out the animal that he appeared to smell inside; but the opening was too small. An indian boy gathered some dry sticks, set fire to them, and cast them into the opening, then built up a good fire in the entrance. Thus the animal must come forth or burn to death underground. After a while we put out the fire and found the opening filled up with ashes. We had put too much into the hole, and had nothing with which to empty it. With patience, and machete, the indian boy removed the ashes, but nothing came forth, so we supposed it had escaped by some other passage underground.

26th

Went to hunt, but caught nothing. In the evening went to one of the fine apple orchards. Found the walls (composed of loose stones piled one over the other) had been knocked down in several places, and the pigs had entered doing all sorts of mischief. The lady called some men and told them to see to it.

Alice learned how the Maya are kept in a state of servitude on the haciendas.

Slavery does not exist here. Things are arranged in the following manner. The servants ask money from the masters because they need it for one

thing or another. It is given to them and noted down in an account book. They are always in debt to the master, thus work with a very ill will. An indian wants to change master. He must find someone willing to pay what he owes—and he enters his service owing to the second what he owned to the first. The debt invariably increases. The people assure us that this is the only way to keep a good servant. And with all, if the master is not there to tell them at every moment "do that" "do this" everything is left to go to destruction. On the other hand some of the masters abuse greatly of the more indians, putting down to their account more than they owe.

March 27

We repeated the hunting excursion, and succeeded in finding nothing. When near the house we saw a very bird. (called <u>Toh</u>, because it seems to cry toh! toh! and also because it has a stiff, <u>straight</u>, tail, consisting of two feathers, and <u>toh</u> in Maya means straight)[.] We shot at the <u>Toh</u>. It fell wounded. At the same instant a loud outcry was raised. We ran forward to see what had occurred, and found the indians grouped around a child who had the blood running down his face. We had shot him. We hoped that the eyes had not been hurt. Happily they had not. After using cold water we found that the forehead was only slightly wounded with small shot. His mother was very much distressed, and thought that her child would certainly die. We sounded the wound to the bone, but found no shot, so put some black sticking plaster over it, and assured them that all would be right.

The mule wants constant attention for the flies deposit their worms in the sore; and the poor beast persists in finding some way or other to scratch his wound.

Slash-and-burn or swidden agriculture has been used in Mesoamerica for thousands of years. Even during the nineteenth and twentieth centuries it was used in northern Yucatán. The soil is very thin, and so the forest is burned to provide important nutrients for the growing of maize and other crops. Maize can be grown for two or three years on a piece land prepared by burning, then it is abandoned again, and the crop is planted in the next burned field. The cycle of burning and planting thus moves over the landscape and eventually returns to the area first burned. Alice wrote a rare firsthand description of the burning and planting of a maize field.

28

The soil is so poor in this part of Yucatan, which the white yet hold, that in order to enrich it they cut the trees down, and when very dry burn them. The ashes are left until a heavy rainfall; then the seed is put into the ground—just dropped into small holes made by an iron poind, one

or two feet apart and barely covered with a few inches of earth. We were glad to have an opportunity to see a milpa burned. Several indians, nearly naked, went to the side of the field from which the wind blew—each provided with a long pole, split through and through, and tied together about half way down to prevent it from spreading open too much. The end of this pole was set on fire, and burned steadily and slowly—a fine torch. The men placed themselves a short distance one from another, and each with his torch kindled the wood at his feet. When well alight the file of men all moved forward a few yards, shouting lest one should remain behind, and again thrust their torches into the dried branches. The wind was high and the flames spread very rapidly, while the smoke blackened the atmosphere around us, and created such a heat, that when once we saw the whole field a sheet of flame, we returned to the farmhouse.

We had the pleasure of eating beef steak today—the first time in three months. A farm house is generally a hall of plenty—but the farm houses of Yucatan have to live on eggs and chickens. Watching all night in the forest, they may from time to time enjoy a deer, for any other food they have to send several miles off. We had sent for meat on this occasion and being able to cook it ourselves had enjoyed what we have been unable to obtain in the cities. There they cook the meat out of all shape.

29

Took a walk through the burned milpa, hoping to find some dead game, but the servants had evidently preceded us. We found naught. We saw a snake that some of the boys had killed—six feet long, with a beautiful skin, like an exquisite oilcloth. The indians said they had never seen one like it.

31

Went on horseback to a small farm, one league distant from Teco. Saw a very beautiful cave. They tell us it is inhabited by an animal, called <u>Culu</u> [*culú*, a wild dog–like animal] that sometimes walks on all fours, and at other times upright. That at dusk a great noise is heard within the cave, as of many animals fighting. That after dark the <u>Culus</u> come forth, climb the trees, and steal the fruits; or hunt in the fields after deer. They are much feared—said to be in appearance, something between monkey & wolf.

We offered a reward to anyone who would bring us one of them . . . This cavern was altogether above ground, and very extensive . . . We went into one of the small thatched huts, and found the family sharing the room with turkeys, hens, dogs, and all the other animals belonging to them. The furniture consisted of three hammocks—the rest of the room was filled up with wooden and clay utensils. The only seats were tiny wooden stools, scarce large enough to squat on. A woman was cooking. The fire place consisted of three stones forming a triangle.

April 1

Went with candles to examine the cave at the back of Mr Rivas farmhouse. Found within, and half under it another small cave whose entrance was neatly covered with an immense stone. It must have taken fifteen men to place it there and was so neatly adjusted, that a casual observer would never have noticed it. We moved it by means of levers, and entered. Found only bones of small animals, and a coconut shell.

2

Rained heavily—just what the burned milpa wanted.

April 3

Went into the bush and lost our way.

4th

Went to visit a farm where the sugar cane is cultivated. Saw another pretty cave—a senote in the bottom of it. Some very beautiful columns have formed by the water dripping from the roof. The farm is in a very abandoned state, but if cultivated would be pretty. There are an abundance of coconut trees, and we took milk from some of them—very cold, and tasted like a good ice cream. Saw a very fine tree something like the poplar of Europe, called here <u>alamo</u>. The Maya name for it is <u>Copó</u>. The branches sprout downwards and when near the ground form roots at their extremities, and plant themselves. This particular tree we saw was forming five new roots.

A lady conveyed in a litera, overtook us on our way to the farm—and we exchanged a few words of conversation. The litera is a sort of small van, but instead of going on wheels, it is carried by two mules, one in front, the other behind. The weather is quite cool. . . . The butterflies are again becoming numerous and beautiful[.]

5th

Went to ramble in the forest, and found a pile of stones upon a high terrace. We presumed it to be an house of the indians at the time of the conquest. We continued our way, and found 12 or 13 of the same sort, and further on came to a very large, deep, dry, senote. The Dr made his way down into it, and found it full of plants, but not any water in the bottom.

Even large Mamay trees were there laden with fruit. Coming to this spot I had marked our road carefully—Instead of returning by my marks Dr chose another way, and we lost ourselves. In the thick forest we could hardly see the sun. We could not even find the senote again. We returned two or three times to one spot. Dr climbed a tree to look for the senote, which we knew to be a few yards distant, but the bush was too thick for him to see it. More than an hour we were pushing our way through thorny bushes, and piles of stones. When we returned to the house Mrs Rivas had sent a boy to look for us.

Mrs Rivas gave us a story of Tizimin.

A Mr Sierra, who made himself very busy in politics to the detriment of the country, was commander of the National troops, and also magistrate. He was unprincipled and cruel in the extreme. It is well known that he caused a young man to be harnessed to a <u>bolan</u> <u>coché</u>, and caused him to drag it through the streets with two men at his side whipping him all the way along. This just for petty personal illfeeling, in which the young man was not to blame (O! Grand Republic! O Liberty!!)[.] At the same time there lived in Tizimin a widow, Mrs Iman, with her two daughters, beautiful girls, and one son, the support of the family. Mr Sierra had had him shot, and the oldest sister swore to avenge his death. It is said that she, Inez, accompanied by two gentlemen brothers of Santiago Perez, put themselves in communication with the indians of Chan Santa Cruz, and gave them their word of honor, to deliver Tizimin over to them, and afterwards lead them on to Merida. The indians accepted the offer upon condition that Inez should become the wife of their leader, a white man, living among them.

Four hundred men entered Tizimin with a few gentlemen at their head—these, having thus far succeeded got frightened at their own work, and determined to turn things round the best they could. They told the indians amuse themselves for awhile, because the preparations for marching to Merida were not yet completed.

These two or three—first traitors to the white, and afterwards to the indians—then went to the city authorities, told them what they pleased and asked for advice. They arranged the matter in the following manner; to their eternal shame!

The national guard was ordered to make friends with the enemy, and quietly take from them all ammunition, and each man was to hold his tongue concerning the business. This done the leaders united their 400 men, formed them in the square at 10 o'clock in the morning, under pretense of taking them to Merida, and at a sign given by their leader the national guard fired upon them and took to the bayonets. Very few escaped, and ran away—Nearly all of the poor indians remained dead in the <u>Plaza</u>. If this had not been done Yucatan might now belong to the indians, for they had planned to kill all the men, and make the best ladies of the place their wives. Each indian had already chosen his wife, saying among themselves, "I will have Mrs So and So and you will have her sister, who is also pretty[.]" Inez Iman afterwards married and was very happy for eighteen months, at the end of that time Manuel Sierra, who had killed her brother, killed also her husband. She had one daughter, they live today in Merida, very poor. The mother sews, the daughter is a very beautiful singer, but makes nothing by her voice. Manuel Sierra was killed

in a revolution, being chopped into fine mincemeat, by a large number of people whom he had wronged.

9th

Saw a slender snake, 6 ft long, color yellow and black—We fired at it with our revolver, but did not hit it. By climbing the trees, and slipping from bough to bough it escaped us.

10th

Went to gather fine apples—found that the pigs had entered again, and eaten all the ripe ones.

12th ⤶ *Espita*

Left Teco—bearing with us many pleasant remembrances—for Espita. Mr & Mrs Rivas most kindly told us to go to their house and occupy it until they came, and as long after as we liked.

We left the mule almost cured. A man had to keep it free from flies all the time while it healed.

Reached Espita at dusk. Recieved visitors immediately.

13

Cooked beefsteak, eggs, rice—~~all in a single~~ our only utensil being a small clay pot—We breakfasted with the knife and fork used by the monkeys, our noble ancestors.

14

Wanted to buy some black thread—was told that Don Tulano might have some, as he kept many curiosities in his store.

15

Ate a few oranges[.]

16

Had a slight attack of fever. "Can it be the oranges?["]

21

We hear that the smallpox has reached Tizimin[.]

Two indian boys arrived from Teco to get agua ardiente. It is astonishing the amount these men can take. I have seen one alone drink three pints of rum without water, and remain sober, or so slightly affected that it could not be noticed. Mr Rivas assures us that any indian can drink 6 pints a day, and he says he keeps them healthy—the indian who does not drink is lazy and ill.

The indians hate to speak spanish—only do it when obliged.

It is not known why the columnist "Aristofanes" launched a written attack against Augustus in the Revista de Mérida. *Augustus might have offended someone in the towns of Teco or Espita, and rather than confronting him directly they passed on their complaints to Aristofanes. After all the furor, the article had little impact on their relationship with other Yucatecans.*

We are told that in the "Revista de Mérida," the paper for which Don Felipe Perez writes, signing himself <u>Aristofanes</u>, our name was mentioned. Obtaining the paper we read the following, which had been written in Tizimin.

<u>Mr Le Plongeon again</u>.

This presumptuous Doctor, learned archeologist, has left this city. We believe with foundation that he has no right to complain. For this reason a disagreeable surprise has been experienced upon hearing that he speaks of it in no very flattering terms and especially of the citizen Perez Virgilio, who not with standing his precarious pecuniary position, generously lodged him in his house, and did for him all he could. By what we see the habit of the Doctor is to run down the places through which he passes. A fine traveler. Our neighbor Espita, who treated him as well as possible, according to the information we have received, has also suffered his calumnies. It is well that the other cities through which he passes, should know it.

But this does not prevent us from giving our particular thanks to the Doctor. Impoliteness detracts nothing from the bravery. At the alarm of indians he was among those who presented themselves at the barracks, together with his lady, dressed as a gentleman, with their rifles which can let off 20 shots per minute, as the Dr said with his foreign accent. He illustrated the matter with magnificent, and original theories of defense. For the general good and particularly for the benefit of military men and students of strategy, we will quote two which we remember. The first consisted in collecting pieces of cork, sticking into them sharp tintax, and strewing over the path of the indians. These would without doubt tear the feet, and at least detain their march, if not cause them a shameful flight[.] Here is the other one, no less important. Faggots, as the Dr called them should be made, the part toward the enemy of green sticks, and the interior part of dry sticks. These moveable faggots would be a strong parapet for our soldiers. And in case of retreat, they could be bathed with turpentine or any other inflammable liquid, and set fire to. This would impede a regiment of invaders. The utility and wit of these theories can be very easily seen. It is evident why the Dr propagates conceptions prejudicial to the reputation of a village who welfare he so much desires. Tizimin April 13 /75 Aristofanes.

That is to say the day before we left <u>Teco</u> the gentleman was concocting this interresting article. Happily at the time of our reading it he was not on hand, for he would have found us there.

The first part of the article was quite false. The second only put himself in ridicule[.]

Dr wrote to him, and promised to horsewhip him when he <u>met</u> him, as he did not think it worth while to go to Tizimin. Don Felipe answered him, saying that he knew he was a coward (because Dr charged him with hiding all night, when the panic took place) but it was the fault of Nature, not his own. The Doctor again answered him and wrote one also to D. Santiago Perez Virgilio, challenging him. That gentleman answered him that he did not like <u>camoras</u> [*camorras*, quarrels] with friends.

May 1

Sunday. Went to see the market of Espita. For a wonder there was plenty of beef, for two animals had been killed during the night. Mutton is not seen here. It is said that sheep cannot be reared here.

Sitting on the curbstone of the sidewalk, down one side of the <u>Plaza mayor</u>, were a number of indian and Meztiza woman—all spotlessly clean in their costumes of white linen. Each had a small basket and spread on the ground in front of her, plantain leaves, or a small cloth. Upon this the good were spread. We passed them one after another, and found nothing worth buying: not a fruit—not a chicken—and only 6 eggs among the whole crowd of sellers. One had a few miniature onions, another some calbash about the size of our fist, for which she asked 6 cents each[.] There was also a little piece of parsley. The balance of the stock consisted of sweet tortillas, dulce made with burnt sugar—a few sweet potatoes, cooked and cut up into small pieces. The general appearance of the market was a row of women each with a heap of sweet tortillas in front of her. The coin that appeared to be most current was lead (a farthing)[.] Half farthings were also in circulation in the shape of 6 coconibs. Three coconibs = a quarter farthing, or 1/8 of a cent.

I sent out for 6 pence worth of eggs. They were found after a long hunt, and brought to me 24 in number. A large hen costs 25 cents. A chicken 6 c[.] Some potatoes have reached Espita; after be sent from the States to Merida. We bought some at 12c a pound; rice costs the same.

3rd

Dr has undertaken to make a bolan coche for our particular use. It gives him very hard work but progresses favorably; and more rapidly than it would in the hands of the workmen here.

We have sent a letter to Dr Manzano of Valladolid with a letter of introduction that we had for him. We ask him to rent a house for us in that city.

This morning a gentleman came to see us from Tizimin. No illusion was made between us, to the dirty article of Don Felipe Perez Alcalá. Today Merida is in fiesta celebrating the victory that Mexico gained over the french [blank space] years ago.

May 5

A poor man whom the Dr cured when we were before in Espita, came today bringing 12 pounds of sugar, cultivated on his own little piece of ground. Having no money, and being grateful he gave what he had. We accepted against our wish, because we saw that he would feel offended. We sent the sugar to Mrs Rivas in Teco.

After almost two years in Yucatán, Alice should have known that in the market everyone bargains for the final price of a product. Not to bargain is a breach of etiquette, and at worst it can be considered an insult. The market is not only a place to buy and sell, but also where one learns the latest news, meets old friends, and renews social connections.

I bought a dead deer for 4 reals—50 c. indeed it was dear, for I learned afterwards that it was worth 2 r. The people here have a bad habit of asking just double what they expect to receive.

Dr was called to see a child, far gone with Alferesia, Dr Fabian Vallado was absent; so he went, and succeeded in saving it.

10

The mother of the child whom Dr cured, came today to thank us and ask how much she was in our debt. We charged her a trifle only. She appeared grateful and promised to bring it next day. She never returned.

19 ☙ Santa Maria, Popola

Left Espita with some regret—not for the place, but for our good friends there. For the first time we had the satisfaction of traveling in our own bolan coché. True it was only half completed, owing to the indolence of the Espita mechanics. Each journey we make in Yucatan the road appears to us worse than any we have before traversed. That to Valladolid was no exception to the rule. It was atrocious enough to kill mules & passengers; break bolan and luggage. We had done away with the uncomfortable mattress and sat on a bench with cushions at our back, an improvement which we realized and appreciated to its fullest extent. The journey was of ten leagues. We had barely concluded two, when a small nut which a boy had placed badly, came out as we passed over a very stony hill. Dr & the coachman mended the disaster with ropes, meanwhile I sought carefully for the missing nut, but failed to find it. At 9 a.m. we reached the hacienda of Dn Roberto cousin of Cipriano Rivas whose house we had just left[.]

We found a building two stories high, containing 14 rooms in a state of ruin, surrounded by grounds which had at one period, been highly cultivated if we may judge by the many conveniences which we encountered for the purpose of irrigating, & the pretty accomadation of flowerbeds & vases. The only person who put in an appearance was an old indian woman. We asked for something, but could not even obtain tortillas. The place was so picturesque that we loitered half an hour to examine it. Many small huts formed a village. These were occupied by the servants of the farm, who, in this case, pass the greater part of the time doing nothing. This state of ruin is party owing to the indolence of the people & partly to the indian war. When they invade, they burn, destroy, rob what they can carry, & clear out leaving desolation behind them. The people make no attempt to put things right again, their plea being that the same thing will happen again. Seeing that nothing could be obtained in the way of food we took our departure, and an hour later reached another farm. This was in good order and prettily arranged; but the house was small and paltry compared to the other[.] Our coachman sought the mayordomo [steward], who kindly opened the door of the casa principal. Don Eligio Rosado, the owner was at his residence in Valladolid. We asked for eggs and a boy was dispatched to search for some among the cots of the servants. Each has a small thatched cottage of one room, and generally they possess a pig and some hens, while the dogs and children are always numerous. At the back of the principal house was a large yard containing some mules and fifty or sixty horned cattle. We took some milk just from the cow, and went to see the trapiche by means of which the sugar is expressed from the cane. We did not see the operation[.] On our return to the house the boy brought us 10 eggs for which we paid a medio. These with a few tortillas made our breakfast.

The Le Plongeons continued their slow progress, staying the first night at Santa Maria, then the next day passing through the ruined village of Popola, and went on to the city of Valladolid, where they spent more than three months before continuing on to Chichén Itzá. They made portraits of the town's people and in the process also made many new friends. Because of the possibility of attack by the Chan Santa Cruz Maya at Chichén Itzá, they organized a military escort before departing in September.

At 1 am we started again, and at 4 o'clock stopped at Santa Maria hacienda de Don Fermin Irabien. A smart shower had already making the road very unpleasant—the wheels clogged dreadfully—so we decided to pass the night there. The mayor domo was very kind, and afforded us every accommodation. He had an abundance of good carpenter tools,

which he put at our disposal, together with his servants. The bolan had twisted on the axle; so under direction of the Dr it was put right again. After dinner there was a general vaccination all around—Not one on the farm remained unvaccinated. 30 or 40 big swarthy indians who were if not naked, very scantily clothed also submitted quietly. After dark the frogs began to sing, and the concert was kept up with animation until daylight. El mayor domo, Don Ramon Alpuch insisted upon our remaining to breakfast and as it was very muddy we thought it well to let the sun dry them somewhat. At 10 a.m. we set out for Valladolid[.] We had to go four leagues. Just after starting, while yet on the farm premises, (henequen, sugar, beans, corn, are the principal growth in Santa Maria. It is a pretty place, and plenty of roses grow in the garden) we saw stretched across the road in the full glare of the sun, a sleeping man. If we continued the bolan would have passed over him and he would have found himself in the next world without knowing which door he had entered[.] The coachman gave us the reins, alighted, and with the same care that a mother would lift her babe, took him in his arms and put him on one side, under the shade of a tree, placing his hand upon his hat to protect it from the stones. The wheels became clogged with mud, and we made slow progress. At 3 P.M Popola was reached, a village altogether invisible to the passing traveler, the ruined church being the only building in sight: nevertheless we are assured that this village hidden among the bushes, contains 1500 inhabitants, all indians. We were suffering with thirst so the coachman entered the bush to see a dwelling place, where he might obtain water. After 20 m. patient waiting he appeared with an indian, who carried water on his head in the dried shell of a calbash. He was as naked as decency would permit; and had perfect Egyptian features. In payment we gave him agua-ardiente to drink, and he remained very satisfied. The reason these people have for thus hiding is fear of the revolutionists, and of the Santa Cruz people who once entered Popola and destroyed all they could. A little after 4 o'clock we entered Valladolid. The first thing that called our attention were the wide, wellleveled streets—and the church in the plaza mayor—the prettiest church we had yet seen in Yucatan. We went, for the moment to the house of D. Fermin Irabein—and were received very kindly by his family. Dr Manzano had taken a lodging for us in the plaza. Hither we soon went. We did long remain there. Dr Manzano had a small [room] next door to the one he occupied, and he put it at our disposal. We lived there very quietly making portraits during the months of June, July, August.

June, July, August ↝ Valladolid

Coronel Felipe Diaz was at that time Commander of the troops in the East. I during this time, had a false P y.

For some reason, Alice's confidence in Spiritualism was shaken during this time, but apparently her doubts lasted for only a short time. She expressed her complaints in a letter to her uncle Jacob, written while she lived in Valladolid:

August 15, 1875

[Spiritualism has] been my most beautiful illusion, but like many others, it is shattered, destroyed. I have been infatuated, I am no longer, that is all. I long ardently for the sweet presence which had become of my existence, but I do not perceive it. From time to time the spirits foretell us something. When the thing foretold is pleasant it does not come to pass; when unpleasant they take good care to bring it about. Can I love such friends? [ADLP 1875a]

[September]

Ituralde was the magistrate. Cura Ituralde was his brother. A very good man who had a great horror of thunder and lightning.

15

The Anniversary of the proclamation of Independence in Mexico[.] In the morning the National troops, about 50, marched round the City. From 8 P.M. till 10 P.M. the square was lit up according to the idea of the people—small bonfires here & there and rows of small oil lamps. The moon was bright, and the artificial lights made so much smoke that the city remained darker with them, than if the moon had been the only light[.]

16

A ball in the evening in the city hall. During the day speeches delivered, under the portals of the city hall and the band played a few measures from time to time—A ball in Valladolid is like a ball in any other part of Yucatan. The young ladies dressed in muslin with plenty of satin ribbons, and very common white lace, pretty boots, and very high head-dresses. The people of Yucatan are like a lot of babies. When they want to celebrate a festival; they call band of the city, and have it to play a tune at every opportunity. The few gentlemen promenade the streets and feel very patriotic.

The Maya city of Coba, with its lakes and many pyramids, would have been a spectacular archaeological site for the Le Plongeons to visit. The architectural style of the Maya buildings is different from other regions in Yucatán, and the higher rainfall has created a lush forest environment.

There are ruins at a place called Cobah [Coba], about 8 leagues from Chemax and fourteen from Valladolid, going southwest. We wanted to

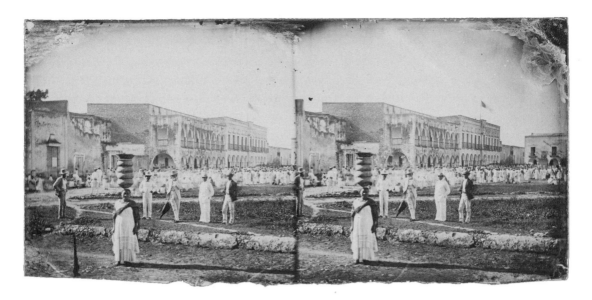

Woman in the market at Valladolid, Yucatán. Circa 1875. Photo by Alice Dixon Le Plongeon. Research Library, The Getty Research Institute, Los Angeles, California (2004.M.18).

go there, but the people of Chemax pretended that if we open a road to the place the indians might attack Chemax.

At 10 a.m. we left Valladolid for Chichen Itza, 12 leagues off.

But I think that before losing sight of Valladolid I must say a few words about it. It is the last large city going eastward—forty leagues from Merida—the journey in bolan takes between two and four days. We have come thus far, and always met with the warm hospitable friendship, so common to the people here. We have gathered friends like beautiful pearls by the wayside, and treasure them in memory.

Valladolid is a quiet city in the last stage of decay[.] It has been pretty. Once the streets were wide and well kept. They are yet wide, but overgrown with grass. Even the principal square is so choked with weeds that every now and then the indians are made to clear it. The roads have a small path in the middle, made and kept clean by the pedestrians, for the only carriages which pass at times are the carts that bring or take away goods—or a bolan coche arriving from or starting on a journey. Only one Caleza [calesa, a two wheeled caleche, shay, or covered carriage] exists there and it is never used. Entire streets are in ruins and no one dreams of rebuilding. They say the indians have destroyed them and they will do so again. They do not even clean and repaint the houses in the plaza mayor—such apathy, distrust, and fear of the indians. There are five churches—only two are in use and they are never filled. The church of Sisal with a ruined convent, is where the young ladies go to promenade, an easy kind of pilgrimage, for they do not retire without kneeling before

the altars. The church in the square is in good condition, and in our estimation is prettier than the Cathedral of Merida[.]

The only apothecary stock is that which belongs to Dr Manzano, who has in his house the necessary for making the medicine that he desires to administer. There are various shops and in each all things can be bought that is to say, all that the city has. Even the bakeries sell muslin dresses, tallow candles, etc. etc. The butcher shop is not known in Yucatan, even in the capital. Meat is sold on stands, in the square, from 5 to 10 o'clock in the morning. At night the city is in darkness because "La Casa Municipal no tiene plata[.]" The city has no funds. The young ladies are neither very pretty or very ugly, and they are seldom seen in the street.

Chichén Itzá

September 1875–December 1875 — DIARY PAGES 110–83

General Palomino had sent word to Colonel Felipe Diaz to send soldiers with us, 100 in number to protect us in Chichen. Dn Felipe had made up his mind to go also with his wife to see the ruins. Colonel Coronado another friend, would also be of the party.

With a military escort, Alice and Augustus began the last leg of their journey to Chichén Itzá via the burned-out village of Piscoy, then through Uayma and Tinum. Once they reached the village of Dzitas they stopped for the night. The next day they traveled only a short distance from Dzitas to visit friends at the Hacienda San Juan, and stayed an extra day because the road to Pisté had to be cleared by Colonel Coronado.

The important Maya city of Chichén Itzá covered an area of at least two square miles. It came to power around AD 850, and within one hundred years controlled a vast commercial network throughout Mesoamerica until its downfall around AD 1100. The wealth derived from its sphere of influence allowed the construction of its hundreds of public and religious buildings such as the Castillo Pyramid, Great Ball Court, Monjas, La Iglesia, Akabdzib, Temple of the Warriors, and an astronomical observatory, to name just a few. Its downfall "could well have been caused by a combination of over-population, environmental degradation, droughts, leadership failures, and warfare" (Sharer and Traxler 2006:592).

The Le Plongeons departed on September 25 for the village of Pisté, which is less than a mile from Chichén Itzá. After viewing the Castillo Pyramid (also called the Pyramid of Kukulkan) from the roof of the church in Pisté, they continued on to the ruins where they worked for more than three months.

When we started every one stood at their street door to see us pass. We carried as little luggage as possible leaving the rest in care of Dr Manzano. Our photographic apparatus was all enclosed in Drs patent dark box. This was put behind the bolan, and we had to put heavy stones in front to balance it. We had offered a seat to Colonel Coronado, but that gentleman had not sent us word so we started without him. At midday we reached Piscoy[.] At Piscoy only one house remains, and it is in ruins for since the indians burnt the place the inhabitants live under the bush. Half a league further on we saw just ahead of us the bolan of Colonel Diaz, containing two of his children and three mestiza servants. We did not overtake them because we stopped to take water on the road. Soon we were overtaken by the calecin of the Colonel who occupied it with his wife and little daughter. They passed us their load being very light. About 2 1/2 leagues from Valladolid is Uayma. Here we found the troops and our whole party taking breakfast of dry tortillas and cold water. We did likewise. Everyone was good humoured, and Coronado who had preceded us on horseback was again invited into our bolan. (the one made by Dr with red velvet cushion seats) He declined[.]

From this point we started in grand procession—Calecin of Diaz & wife led the way—no! I am mistaken the officers on horseback went in front—after the Calecin went the bolan with the girls, next ourselves and the soldiers brought up the rear. These appeared more like banditti [bandits], owing to their varied costumes, and irregular march. They began a race to see if they could keep up with us and did so pretty well. Our road was bound on either side by thick forest, and the whole thing was picturesque in the extreme. Our mules were not lively and we did not get over more than a league an hour. (Yucatan league which may be considered as five miles, because they are very crooked) We saw that one youth lagged dreadfully. He was not indian, and very little meztizo[.] He appeared ready to fall, the veins in his neck were swollen almost to bursting. We told him to come and sit beside the coachman, but he only yielded when he could no longer stand. Two others were told to get up also, because he felt ashamed to be the only one riding.

A good friend Colonel Traconis had been kind enough to send with us two horses that we might mount from Tzitas [Dzitas] to Chichen where no bolan could pass. That the men might have more room in the bolan, Dr mounted one of these horses; and a little later Coronado who had become tired took the vacant seat. He wanted to pass the bolan that was ahead of us, but as we were three times more heavily loaded than they, all his shouting was in vain. The mules would not perhaps could not. The calecin had passed far ahead of us. The two bolans kept up the chase with animation

and fun until 2 PM. when we reached Tinum. We entered at full speed and had only time to see that the place contained an old church with a high tower built upon it, wherein to keep a lookout for the enemy. We drew up at the school house containing three rooms. We had barely time to enter when the rain began to pour down. The race had saved us a severe wetting. All the things remained in the bolan, and seemed likely to get well washed. As all the weight was at the back of our bolan it was tipped back and the rain entered at its pleasure. Dr went to aid the boys prop it up with a stick, and returned wet to the skin—and no change of clothes to be had then. Meanwhile we were driven, by little and little into the only corner of the house which remained dry, for the thatched roof looked like an old barrel. The storm did not pass until 4 o'clock, and after taking some dinner in the house of Mr Letina, it was decided that for the sake of the children, we should not make a fresh start till next day. The moon would not rise till 2 a.m. and we had a very bad road to run. The stick which propped up our bolan snapped, and we tumbled for contents of our box, when the toldo [awning] fell back very heavily[.] No one rested well that night. At 2 a.m. we took chocolate, prepared by the wife of Diaz. At 3 o'clock we started. The moon should have been bright, but the clouds were heavy and we could hardly see our way. The road mostly clay was very heavy, and the mules did not approve. Zitas [Dzitas] is four leagues beyond Tinum, and the most we did was two miles an hour. When half through the journey our bolan came to a complete standstill: the mules positively refused to move. They turned their noses to the bushes and began to eat. Some of the men tried to push the wheels while others pulled the beasts forward; and the coachman aided by another whipped the animals. These only turned their heads, looked at their tormentors, and again went to chewing. Diaz who was much ahead of us sent an officer on horseback to tell the men to take the box from the bolan; and to keep guard over it while others went to Zitas for indians to carry it. This was done, but the mules did not intend to move, and when a mule don't wish— - - ! We grew tired of this fun and alighted with the determination of walking. After a muddy promenade of one mile, we came to the Calicin of Diaz which had drawn up to await us. He begged me to take his seat within, but I was unwilling to disturb him. We were considering the propriety of saddling the horses, when our carriage appeared in the distance, and shortly we again took our seats[.]

At 10 P.M. we reached Zitas. The uncle of Mrs Diaz, Don Pablo Loria had had the goodness to prepare a house for us to rest in, his being too small to contain more than his relatives. We had hung our hammocks and were beginning to feel at home, when Mr Mendez cura of the place came to make us a visit. We had already met him in Izamal. He was then in health—now very ill but he came to offer his services and put

his house at our disposal. Dn P Loria invited us to breakfast[.] During breakfast I bit on a nerve of a hollow tooth, and it ached afterwards for a whole week. When we learned that the road to Piste was not open— Coronel Coronado offered to go ahead with some men and clear the way, and afterwards clear the ruins. He would be in Chichen to receive us. This was agreed upon and they started. Around the roof of the church of Zitas, Mr Mendez has built quite a hasty barricade behind which the city can be defended, for more than once it has been badly treated by indians, and revolutionists[.] Very few houses remain in good condition; and it is the pueblo which has least pleased me yet—sad in aspect and gloomy.

We had dispatched six indians, or <u>hidalgos</u>, as they are called while serving the place in which they live, to get the box left on the road. They arrived in about an hour grumbling at the weight. It weighs 200 lb. We remained in Zitas with the amiable family of Loria until 11 a.m. 23 inst.

23 ⌇ *San Juan Piste*

We breakfasted with Cura Mendez at his earnest request. Then we started in bolan to visit the county seat of the father of Mrs Diaz, [blank space] Loria. It was only a journey of half an hour—We were very kindly received in the hacienda. The Casa principal was yet unfurnished, so we found the family living in a thatched house. Four years before the church had been built by order of Mr Loria. It is quite pretty, with a vestry, and dwelling place for the priest at the back of it. Everything clean and neat. The priest is yet wanting and the vestry serves as a storeroom during his absence. A <u>padre</u> is invited from one of the neighboring pueblos, when they need Mass celebrated. There is a large enclosure around the building; and when we arrived numerous rosebushes were in full bloom. Not having a large house where to receive us Mr Loria prepared for us the room at the back of the church. Here we took a delightful bath for the servants were abundant, and our hostesses kind. We passed a very pleasant two days visit in this hacienda, called <u>San Juan</u>—except for the dreadful toothach, which prevented me from taking notes concerning the place. I passed the night walking up and down the room in agony.

25 ⌇ *Chichen Itza*

When we left they begged us to visit them again on our return from Chichen[.] All the soldiers but fifteen had gone forward with Coronado to clear the road & monuments—and prepare the Casa Principal for our reception. The work was well done. Of course we had to put up with hills and dales—mud, sticks, and stones[.] When about one third of our way, a heavy rain fell, and we stopped at a place which had once been a city, but which now cannot be distinguished from the balance of the bush except by a heap of stones, remains of a wall. We were on horseback[.] Mrs Diaz was carried a <u>coché</u>—a tiny palanquin made of sticks—Her servant

Maria came on foot. The children had been left in the farm. We took what shelter the bush afforded. The indians put the <u>coché</u> on the ground & I crept in under its roof. We got pretty wet though the rain did not last long. We reached Piste at 4 P.M. Piste today is uninhabited except for the few troops placed there as an advance sentinel. The only habitable building is the church, now barracks. All the other houses are ruined. 30 Some years ago, one election day, the indians massacred the people and destroyed the place[.] We entered the room at the back of the church that had once been Recamura [*recámara*, sleeping room] de la Virgen, and found it turned into an officers' mess room. We sat on the stone steps which led up to this room, and made a good dinner of cold boiled eggs and deer meat, killed the day before by the soldiers. We went on the roof of the church and and saw in the distance the Castle at Chichen, towering above a vast sea of verdure, as a lighthouse in mid ocean. As night was approaching we pushed on to our destination[.] We followed the road opened by Coronado, and entering Chichen passed between the gymnasium [Great Ball Court], and building opposite to it which we take for an amphetheater. Next we passed by the foot of the grand old castle [Castillo Pyramid], and then again entered the bush following the

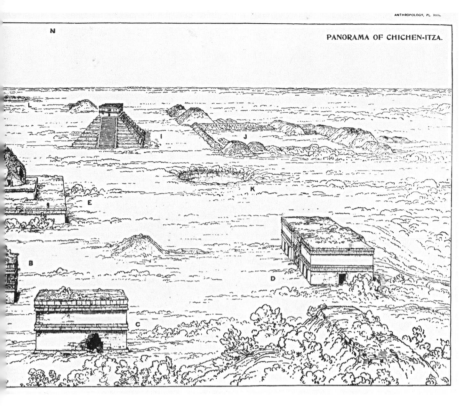

PANORAMA OF CHICHEN-ITZA.

Panorama of
Chichén Itzá.
(A) Monjas,
(B) La Iglesia,
(C) Southeast Annex,
(D) Akabdzib,
(E) Observatory,
(F) Red House,
(G) House of the Deer,
(H) Great Ball Court,
(I) Castillo Pyramid,
(J) The Market,
(K) Xtoloc Cenote,
(L) Cenote of Sacrifice.
Drawn by William H.
Holmes. 1895.
*Archaeological Studies
among the Ancient
Cities of Mexico.* Part I.
Monuments of Yucatan.
Field Columbian
Museum, Chicago.

same road. In front of the Castle is a large clear space. Ten minutes later
we reached the Casa principal where the troops, 100 men, had stationed
themselves. This house had been built forty years ago with the idea with
the idea of forming a large farm among the ruins—while yet unfinished
the indians killed all the people, and destroyed what they could. In the
church are a lot of skulls. Our men recognized some of them as belong-
ing to people they had known, or they pretended to. Back and front of
the house are large corridors, and at each end of them a room. There are
three other rooms. There is a well at one end of the house.

[Below are the names of the areas of the house]

r	corridor	r
r	room	r
r	corridor	r

noria

Blackwell's

Chichen forest
Le P.

Ruins of Chichen Itza

This photo, taken from the top of the second story of the Monjas building, may be the earliest overall photographic view of Chichén Itzá. Alice wrote on the back of the photo: "Yucatan—Chichen Itza—Ruins. Birds eye view of the forest and monuments from the head of the stairs heading to the third story of the palace and Museum." On the right, closest, is the Observatory overgrown with vegetation, behind is the Castillo Pyramid, center is the Upper Temple of the Jaguars, and on the left is the Casa Colorado. The thick vegetation had to be cleared before more photographs could be taken. 1875. Photo by Alice and Augustus Le Plongeon. Research Library, The Getty Research Institute, Los Angeles, California (2007.R.8).

When we arrived all was light and animation. Coronado received us with open arms and at once asked Dr if he was satisfied with the road he had opened. There were only two small rooms which had not leaky roofs—doors had never been put up, nor floors put down, so we had a dust carpet. One of the dry rooms was assigned to us for a sleeping room, with Mr & Mrs Diaz. The other served to keep stores and ammunition. We were all very tired so we hung our hammocks. So tired was I that I

slept all night forgetting that I had on my Wellington boots. We had to sleep dressed for various reasons. 1st We were not the only occupants of the room. 2nd there were no doors and the soldiers were sleeping on the floor of the next room. 3rd We were on enemies premises. [A pencil line drawn on the margin starts on page 116 and continues, on-and-off, to page 252. A note in the margin by Alice on page 175 states, "not copied."]

The Monjas is a three-storied structure with a broad, steep stairway leading to the first level. This stairway faces northward, not east, as stated by Alice. Two stairways lead up to two smaller structures on the second and third levels. The east wing (called the Annex) has several rooms at ground level with doors facing north and an east façade with very finely executed stone motifs.

The building that Alice and Augustus used as a darkroom is now called La Iglesia, but was named the "Museum" by Alice. It was photographed by the Le Plongeons in 3-D stereo shortly before the upper right corner of the roof comb collapsed. Because the Le Plongeons took photos of buildings in 3-D, they can be used to generate scaled architectural drawings so that changes over the past one hundred years can be measured by archaeologists and conservators.

The Akabdzib is a single story building to the east of the Monjas. Room one has a stone lintel with a hieroglyphic inscription facing the entry, and on the lintel underside is a bas-relief of a seated figure and hieroglyphic writing. The Le Plongeons ingeniously highlighted the hieroglyphic inscription on the lintel, and then photographed it using a very long exposure. Alice made a drawing of the underside because the camera could not be positioned to get a photograph. Epigraphers in recent years have concluded that the hieroglyphic text and carved relief under the lintel commemorate the sacrifice of a warrior or ballplayer by a ruler named Great Jawbone Fan in the year AD 891.

Rooms of the Akabdzib are arranged on three sides around what is called the "core." It is an enormous cubical foundation of rubble, faced in cut stone, that was constructed to support a second story that was never built.

26

Early in the morning we went to visit the <u>Monjas</u>. Henceforth we shall take the liberty of calling [sic] Palace—for it has never served as nunery. Coronado had done all that the time would allow to open roads from one building to another, and clear the bush from the buildings. But the Dr not being there to explain just what he wanted the work had been don rather at random. Too much had been done in some parts and not enough in others. The first building we entered, and which seems to be part of the Palace, consists of two rooms, small but very lofty. The roofs form triangular arches, inside: outside the roofs are flat. The outer walls are beautifully adorned with sculptured stones, the principal feature being

Le. Plongeon. YUCATAN.

The Great Ball Court at Chichén Itzá. The thick vegetation had been cut to allow a full photographic view of the ball court. Photo by Alice and Augustus Le Plongeon. 1875. Research Library, The Getty Research Institute, Los Angeles, California (2004.M.18).

an immense face. This building habitable—only the floors are worn out, one part of a wall, and the doorway somewhat broken. Traces of ~~stucco~~ cement yet remain in the walls. The next building we entered was one single room, here we proposed to place our dark box. [La Iglesia] All round the wall were traces of stucco inscriptions otherwise the interior was the same as the other, with the addition of small holes made here and there in the walls, probably for ventilation, for they were a little too high to serve as windows for looking out[.] The ornaments on the front of this house seemed more ancient than the other. There are some small headless figures sitting crosslegged on either side of the monster face, and strange to say they have by them a thing exactly like the sign which in Egyptian means <u>offering</u>. Large trees grow on the roof of this building[.]

The principal building almost adjoins the one just mentioned. It stands North and South, has its entrance between the two smaller buildings. The rooms on the ground floor number eight; all small, long and narrow, and the roofs triangular arches without exception. The middle part of this building is a solid mass of masonry that has on the east side a staircase of 40 steps, very steep. This leads to a terrace and here is another building—15 more steps lead up to the roof of this building, and on it were two small rooms now in ruins. At the top of the 15 steps is a small nich, like sentry box. Under this staircase is a passage way, there

are 6 niches, big enough for a man to stand in. On the soffit of each are hieroglyphics. At each end of this galery are three rooms, and on the side of the building opposite the gallery is one long room were may be seen abundant tracings of mural paintings, but time and willful hands have destroyed so much that nothing connected can be made out of it. All the exterior of this building is beautifully carved and ornamented, presenting generally gigantic full faces. Between the eyes are small faces, seemingly portraits as no two are alike.

[The following paragraph that starts at the bottom of diary page 117 has been crossed out. A note in the margin states, "Did not go to Castle."]

We went to the Castle. Staircase of 100 steps, slippery; chocked with weeds, and tiresome to ascend. The mound is quadrangular—has a stairway on every side, and is built in andines [*andenes*, platforms]—A gradated pyramid. The Castle on the top is beautifully built. The four entrances, which correspond with the four stairs, are richly adorned with sculptured figures, lifesized. A corridor occupies three sides of this building. In the fourth is a room. Here is the principal entrance. At the foot of the steps are large stone snakes, the feathered serpent <u>Kukulcan</u>[.] At the entrance to the room are round stone pillars covered with the feathers of the serpent—There are square columns with <u>bearded</u> men carved thereon. In the room are beautiful Sapote [*zapote*] beams very finely carved, <u>bearded men</u> being among the figures. [The crossed out paragraph ends here. Written diagonally through this paragraph is, "Did not go to the Castle that day at all"]

X [Refers to note in margin, which reads "The men have strongly barricaded the house of the hacienda. Yet they are afraid & ask—'When will you finish?'"] Our dark box did not arrive from Zitas as soon as we would have wished so we lost a few days, but meanwhile rambled about and examined things[.]

Dr made a plan of the Palace, aided by lieutenant Carillo—Also of the Akabzib, an important, and interresting building. The building takes its name from a ~~lintel~~ stone that forms the lintel of one of the doorways, for there is an inscription on it that no one has yet deciphered. It is a mysterious writing as <u>Akabzib</u> implies (Akab, dark. Zib, writing) But if what Mariano Chablé told us be true X [Refers to note in margin, which reads "see page 83."] then the name of the place might be Alcabzib (rapid writing[.] Meaning the telegraph, or telephone. There is a figure & writing on the under part of same stone. There is no other carved stone in the whole house. There are 18 rooms and it is build on a slight natural elevation, there is a deep hollow close by, which may have been made to get stones for a massive wall that today shuts in the principal entrance of the building. Two of the rooms contain imprints of red hands[.] As we found in making the plan that the whole center is closed we we decided to try and open it.

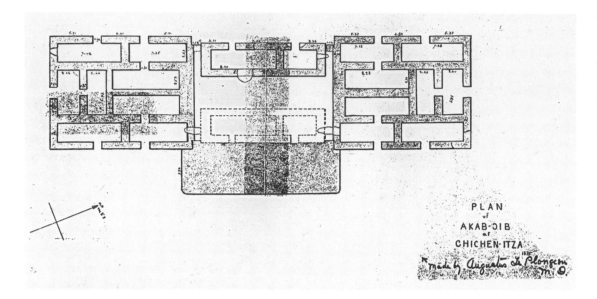

PLAN
of
AKAB-OIB
of
CHICHEN-ITZA

Made by Augustus Le Plongeon
1875

Plan of the Akabdzib building at Chichén Itzá. Room 1 is in the center far left. Notations give dimensions and indicate where the Le Plongeons excavated through the walls of the building. Dashed lines indicate possible rubble-filled rooms within the great core foundation. 1875. Drawn by Augustus Le Plongeon. By courtesy of the Latin American Library, Tulane University, New Orleans, Louisiana.

Alice mentioned that the great core or foundation for the Akabdzib second floor had no access. But a wide stairway had been built by the ancient Maya on the east side of the building to access the upper story. Sometime between 1840 and 1873 the stones were removed and used for construction of a nearby building.

Typical of nineteenth century explorers, the Le Plongeons decided to dig through the walls to discover what might lay within the core. By today's archaeological standards their short excavation tunnels are very rough and uncontrolled. Fortunately, the walls were not decorated, and their excavations into the core did only minor damage. They quickly found that the core was built using pieces of large, uncut limestone placed in courses and packed with dirt. Near the walls, they found the rubble fixed in place with three or four feet of mortar.

They then moved on to what is now called the Great Ball Court—the largest in Mesoamerica. In the nineteenth century it was called the "gymnasium" or more oddly, the "tennis court." It is approximately 450 feet long and 100 feet wide with tall, vertical stone walls on each side and a temple at each end.

The Upper Temple of the Jaguars was built on top of the east wall near its south end. That temple was of great importance to Alice and Augustus because it contained a historic Maya mural in full color and considerable sculpture and meaningful bas-reliefs. The murals and bas-reliefs on the outside of the temple were interpreted by Alice and Augustus and used as the basis for many of the conclusions in Augustus's book Queen Móo and the Egyptian Sphinx. The Le Plongeons made tracings of a good portion of the murals and photographed virtually all the bas-reliefs and sculptures in the temple.

Alice then described a small room at ground level that is adjacent to the east side of the Great Ball Court called the Lower Temple of the Jaguars. The stone

walls of the room are covered with finely carved bas-reliefs of human figures. Unfortunately, most of the carvings are at ground level and have been worn by the touch of tens of thousands of visitors. Today the room cannot be entered, but the interesting bas-reliefs can be seen from the entrance. The Le Plongeons made a very accurate record of the room with 5 x 8 inch 2-D photos and overlapping stereo 3-D photos.

Saturday 29

We went to the Tennis Court. Its walls are parallel 40 ft high & [blank space] long. On the South end of the East wall is the most interresting building of all the monuments. There we passed the greater part of the day. This building had originally two rooms. Now only one is complete. The walls of it are covered with paintings—some well preserved. No trace of stairs remains, we clambered up the place where it may ever have existed, over stones and fallen trees. Within the room well hewn stones are strewn in abundance, some with traces of paint yet on them. The square pillars which form the door way, have on each side well preserved figures nearly lifesized, and represented in full uniform of some kind. Each face is different from the rest, and on some part of the stone there is generally an animal—above the head, or on the breast, some where, as totem of the person that the sculptor intended to represent. The room thus preserved was was the inner chamber. The outer has fallen—its remnants serve as obstacles to the approach to the other. The lower part of the round pillars which formed the entrance yet remain. They represent Kukulcan[.] The base of the pillar is Kukulcan's head, with the tongue hanging out.

[The following paragraph and a margin note have been crossed out.] This head was completely buried by dust and debris but we disinterred it. The tongue was apart from the head, but we replaced it. X [Refers to note in margin, which reads "One of the men who assisted nearly fell down the 40 wall."] It took three men to raise it. On the outer side of the round pillars are square ones, covered with sculptured figures apparently warriors. The floor is well made of square cut stones. The cornice of the outer part of this building is finely carved in this manner. [Small sketches of shields and scribbles of tigers by Alice show their linear placement.] Two tigers and a spotted shield alternating with each other[.]

At the same end of the same wall where this building is, which we call the Tiger Building, at the foot of it nearly on a line with the ground, and forming, as it were, a part of the same edifice, there is the inner wall of a room that once existed. The stones of it are comparatively small but they have been first placed and afterwards carved in such a manner as to form one picture which represents a woman sitting on a throne, surrounded by Kukulcan, and processions of people in different dresses &

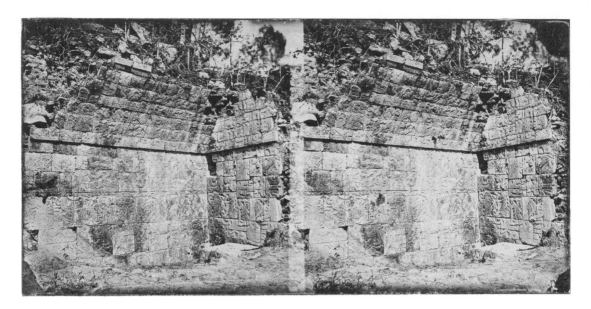

Overall view of the Lower Temple of the Jaguars and bas-reliefs on the rear wall. The full wall of bas-reliefs was also photographed by the Le Plongeons section by section, close up, and in 3-D stereo. 1875. Photo by Alice and Augustus Le Plongeon. Research Library, The Getty Research Institute, Los Angeles, California (2004.M.18).

of various types, <u>bearded</u> men not excepted, who come to bend, the knee, and present offerings to the queen protected by Kukulcan[.]

All have on elaborate headdresses, or crowns, of various forms, and very long feathers from the top fall over the back of the head. They have large ornaments in the ears and nose. In the right hand they carry battle axe—in the left a bunch of arrows, nearly as long as the men are tall—Some have short skirts with fringe reaching the knees the upper part a tightfitting short coat with a wide belt round the waist from which hang various things behind, apparently ornaments—They have finely embroidered garters. Sandels that are brought up so as to cover the heel, leaving only the toes and instep exposed. The sandels are highly decorated. Some have serpents for garters[.] In all this procession not two faces are alike[.] All may be portraits. Some are much worn—others are perfect. The face of the queen has been purposely destroyed. There are very handsome faces among them. Debris was piled up against this wall[.] We decided to have it cleared.

On our return to the hacienda we found one or two of the men with chills & fever. So sent a letter to Dr Manzano, for quinine. In the evening Colonel Diaz received an official dispatch from General Cabañes stating that the Indians were supposed to be marching on Tunkas. Diaz and his secretary Herrera were employed nearly all night sending dispatches to various points, and taking necessary precautions. We thought for a moment that our expedition might have a disastrous end.

30th

Early the following day, another dispatch came, telling that two spies had been taken half a league south of Tixcacal. They had tried to entice

a man away with them, but he refused stating that companions awaited him. Don Felipe has given counter sounds and signs to be used in case of danger. It seems to me much ado about nothing. The house is well barricaded back and front. Colonel Coronado sent word that in case of indians he would be with us immediately. He has had to leave us to attend business in Valladolid. We received quinine from Dr. Manzano. Mrs Diaz sick and I unwell. Had a pig killed[.] Found it full of trichina [*Trichinella spiralis*, parasitic nematode worm]. The men ate it with pleasure. I hope no one has felt bad results at any time. Every evening the hacienda is very animated. The boys make larg bonfires in the front yard of the house. The church, on a slight elevation to the right of the house, also has its guard & bonfires. There the altar still stands with its naked wood crosses. In the vestry is another small altar, covered with skulls and bones of the people who were killed by indians. Whoever they were they have yet teeth that I would be glad to have in place of mine. All the skulls were very round.

October

We put up our dark box in the one roomed house of the Palace.

Took three views of the Palace. One Captain Coronado seemed to delight in moving. He spoiled two or three plates, and laughed at his work to hide his discomfort before his men; and for his better defense he said the Dr was a chamban [*chambón*, clumsy]. Major Leal killed two pigeons, and Coronado a wild turkey[.]

Food was scarce. No eggs had been brought from the neighbouring farms, and the men who went to hunt deer, failed. In the after part of the day we examined two small buildings. One, which seems to have been a private residence has three doors all leading to the same room. On the inner wall are some perfectly unimpeached hyeroglyphics—there are other apartments beyond. This building is on a terrace[.] The other, at a short distance, is much ruined.

I must give an idea of the life of the soldiers, and our men hidalgos as they are called. At 5 a.m. each recieves a jicara of pinole, corn toasted, ground, and prepared as coffee, mixed with plenty of sugar. At 10 a.m. the breakfast of thick tortillas (pimpimuah) & meat, when there is any, with frigoles, black beans. The dinner at 3 P.M. is the same as the breakfast. Before taking pinole in the morning, they take agua ardiente. To those who suffered from ague and fever I administered quinine, 4 gr. to each. They did not like it, but it cut the fever immediately.

3rd

Passed the day in the Akabzib, trying to open with crowbars a way to the middle of the building which appears to be a solid mass. Our patience was rewarded by meeting with more and more stones. Eight men were at work, and they sweated so much that they used their machetes to scrape

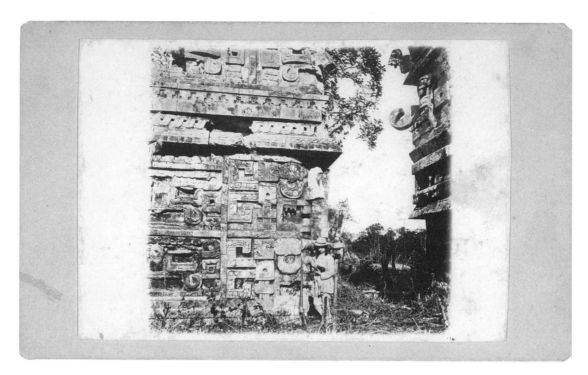

Alice with her binoculars and Remington rifle at the northeast corner of the East Annex of the Monjas building, Chichén Itzá. 1875. Photo by Augustus Le Plongeon. Research Library, The Getty Research Institute, Los Angeles, California (96.R.137).

the sweat from their bodies. On the floor of the room where they work were scattered ~~skeletons~~ bones of deers & skeletons of snakes. I gathered the skin of a serpent which time had bleached. We made openings in three different parts of this block of masonry[.] When about to leave the building Mrs Diaz came to see us and proposed opening another place we left it for the following day.

4th

Took four views of the Palace, but as our bath was new it did not work very well. . . . Lent our hunting gun to one of the men. He killed 35 pheasants. It made a good dish for the men, lasted three days[.]

5th

Opened the wall proposed by Mrs Diaz, but met with no better success. Also tried to enter by the front—nothing[.] A letter from Valladolid tells Coronel Diaz that the families of that city feared greatly that the people working at the wall might remain there turned into statues.

Nine pheasants were killed in the afternoon.

Dr wanted to examine the roof of the Akabzib, and on the tree by which he climbed up there was a very beautiful spider. The back was beetle shaped, and like polished steel, having bright red spots. The legs of brilliant bronze color. The web it weaves is golden silk abundant and strong. The spider is spiteful and poisonous.

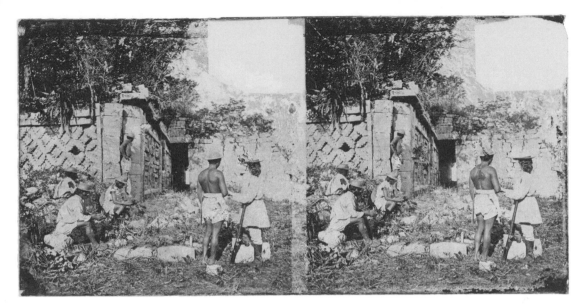

Some of the men caught two large bats and amused themselves by torturing them, then killed them. The child & the savage delight in torturing those more helpless than themselves.

6th

We penetrated a wall three yards thick. On the other side of it the stucco was clean & well preserved but still we only saw stones before us.

Took three views of the Palace. Went home to breakfast at 10 a.m. Found Mrs Diaz almost insensible with a rush of blood to the head. Attended her until restored. then breakfasted & returned to the ruins. To our intense disgust someone had entered our dark box with a desire to see the negatives, and not knowing how to handle them, had spoiled our mornings work which had cost the Doctor many tiresome ascents up the Palace stairway of forty steps. We failed to find out the culprit, he being much of a coward to acknowledge what he had done. On the second floor of the Palace on the wall of a room to the left of the second staircase there are tracings of mural painting[.]

We had the indians to make a ladder of poles tied up with vines, and mounted it to wash the traces of paint. Found it water color, having washed it, and made out a figure playing a long trumpet.* [Refers to note in margin, which reads "'Relacion de las cosas de Yucatan.' By Landa. Translated by Brasseur de Bourbourg. Page 124 art. XXII. These instruments are mentioned."] There were other figures fulfilling the same occupation, but very indistinct[.] Later we went to the Akabzib. At 3 P.M. heavy rain. Dr who never rests while able to stand, took this opportunity to see what could be done with the hieroglyphics on the lintel of the

Alice leans on the arm of a Maya assistant as she points out a feature of the second level of the Monjas building, Chichén Itzá. From here the Le Plongeons took their overview photo of Chichén Itzá. 1875. Photo by Augustus Le Plongeon. Research Library, The Getty Research Institute, Los Angeles, California (2004.M.18).

THE DIARY OF
ALICE DIXON
LE PLONGEON

doorway. The stone was much discolored, but otherwise unharmed. To make the lines appear <u>intaglio</u>, Dr first cleaned the stone then covered all the surface parts with black crayon. Meanwhile I looked on, and by what I could make out thought that the story of old Chablé had some truth in it. Certainly a line runs from one end of the slab to the other.

When we went to the house we would have been glad to have a private corner where to bathe and change clothes for we were very uncomfortable[.]

More than a week since we had been unable to undress, and a microscopic red insect, the smallest of garapatas [*garrapatas*, ticks], did its best to augment our torture.

7th

Went early to the Akabzib and ~~took~~ made a drawing of the long nosed man under the lintel, it being impossible to photograph it owing to the position of the stone. We had a framework of poles made in order to stand the camera on a level with the hieroglyphics we had worked upon the day before, and after some difficulty obtained a photograph with 10 min. exposure of the plate.

Were more than ever convinced that the stone contained a prophecy of a telegraph, or telephone. Took a general view of the building, and carried home the negatives remembering the fate of the last we left in the dark room.

8th

Went at 6 a.m. to the ~~Akabzib~~ Museum to remake the views that had been spoiled. We introduced some of the workmen in the pictures. One in particular for his extraordinary size & beauty of form. He was more than half naked, and stood as still as a statue. Cauich, as he was called could not exchange a word with us for he knew not spanish—and of Maya, we only knew how to say <u>Ma pec</u> (don't move). We have seen him lift stones weighing 70 lb, and throw them from him as if they weighed but an ounce. A modern Hercules yet a very gentle man.

The excavation was continued in the Akabzib. I sat in a draught to see the men working, & caught a severe cold. Only a few days before I had got rid of the toothache.

Sunday 9

Took a view of Museum, and of a fallen room in the Akabzib to show the form of the roof. We climed to the top of the building called the Caracol, and took our stand upon its highest point. There was just room. Three people could not have stood there.

This building is upon two very extensive terraces. It is circular. There are passages, and a spiral staircase in the center that leads to the roof. It could only have served as <u>astronomical observatory</u>. The <u>red hand</u> is on

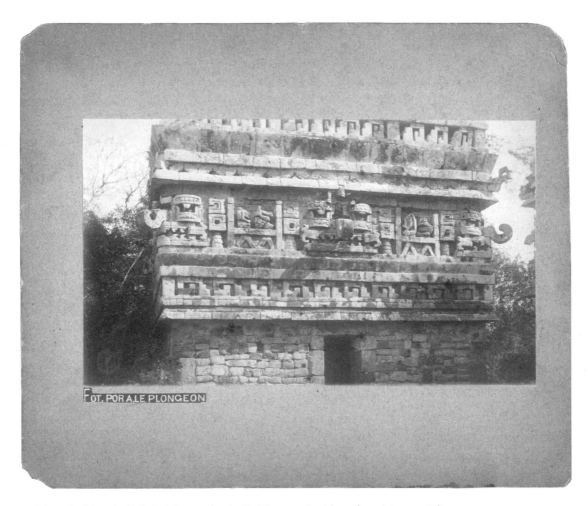

La Iglesia building (called the Museum by the Le Plongeons) with roof comb intact. A few years after the photograph was taken the upper right corner collapsed. The Le Plongeons also took a 3-D stereo photo of the façade that was used recently by archaeologists to make a scaled drawing of the missing corner for restoration purposes. Research Library, The Getty Research Institute, Los Angeles, California (2004.M.18).

the outer wall. We continued work in the Akabzib. At midday rain fell and continued till night.

10

Everyone got up with a desire to put on a blanket; cold. Before breakfast Dr went to take a plan of the <u>Casa Colorada</u> called by him <u>A royal residence</u>. The rain of yesterday made my boots so wet I could not get them on, and the ground was too wet for slippers, especially with influenza[.] We received from Valladolid 6 cans of lobster, they came well, for food was scarce. Everyone was desiring to return to Valladolid, but our

work was scarce begun. We had only 18 negatives and expected to carry away 50 at least. The officers, with one or two exceptions, were disgusted with life at Chichen Itza, and showed it plainly, taking interest in nothing. They were anxious to be in Valladolid before Christmas drew too near. Their heart was in the fiesta already, although they had plenty of time before them.

11

Took two views of the <u>Observatory</u> and one of the <u>Royal Residence</u>. In passing from the museum to this building we discovered a fallen mound and two large serpent heads. At the entrance of nearly all the building in Chichen, these heads are seen. In the afternoon Dr mounted on a slight wooden framework platform to take the façade of the building in which was our dark box. Just after finishing this plate we saw millions of ants, large & black [Page 127, 1875, Chichen, October 11] marching in columns down upon our quarters. We abandoned the premises. They attacked & ate alive a scorpion, and a lizard; in fact everything they could find, then beat retreat[.] We did the same shortly after, and on reaching home, found we had lost our ivory rule[.]

Da Tranquilina has started in coché, with an escort of soldiers, for San Juan. I remain the only woman here.

12

We took a general view of the ruins from the top of the Museum, and a plate of several stray heads, that we had picked up here and there sculptured in the round. The smallest of these measures—Forehead to chin 22 centimetres[.] With head dress °35. Width of face °25[.]

We were happy enough to find <u>the rule</u> in the Observatory & forthwith took measurements of that building to make a plan. It is much ruined. We had finished our work and were about to return home when the Colonel sent word that he would like to speak with us. Having finished our work in that part of the ruins, we had thought of packing the box and sending it to the farm, where would take one or two views and then move to the Castle. We hurried home leaving everything, and were given the following to read.

The letter sent by Colonel José M. Rodriguez, the officer in charge of defending the Line of East from Chan Santa Cruz Maya incursions, warned the Le Plongeons and their detachment of soldiers at Chichén Itzá to be ready because the Maya might cross into Yucatecan territory.

Comandancia de esta Raza

En esto momento que son las once de la noche he recibido un poste del destacamento de Tixcacal en que se me dice que los indios

se encuentran en el ranchito Celtun y que es probable que querran invadir la linea, lo que participo a ud para que este despuesto.

> I. y L. Valladolid Octubre 11 de 1875
> Jose M. Rodriguez
> *C. Coronel, Jefe de la linea de Oriente*

Diaz said he thought it his duty to go at once to Valladolid. And Dr told him to go by all means. We were tired of seeing the black looks of some of the officers[.] For our part we would remain with our workmen, armed, and go to sleep each night at Pisté[.]

We had everything brought from the ruins. I needed Dr's scizzors, but found them missing from the truss. I sought in the bag—soap, candels, matches, bullets, everything except scizzors. Of course no one knew anything about them (?)[.]

13 ⮞ *Piste*

At day break everyone was rushing about preparing for the march. Our packing was tedious but we were ready as soon as any of them. Dr and I had no horse. We had made up our mind to walk. Colonel Diaz however assured us that if we went on foot no one would ride[.] So we had to accept two horses, and two officers went on foot. Our apparatus was carried up into the [temple atop the Castillo Pyramid] where we should have to use it, and we returned to Piste in grand procession. There everyone scrambled for some breakfast the best he could. A 11 a.m. Diaz started with his men for <u>Kaua</u>. Lieutenant Carillo remained in charge of the Canton of Piste, with sergeant Aguilar, a good natured mulatto. When Colonel Diaz left we gave him at his request 20 Remmington shots. Diaz left his steed for the Dr and I was to use that of Carillo. Up to the time of the troops starting for Kaua no fresh notice had been recieved.

14

At daylight we went to a well of thermal water, which is in the plaza of what was once Pisté. The well is not far from the church, and we took a fine bath, the first in a fortnight. We almost rejoiced at being obliged to leave Chichen, so great a satisfaction did the water give us. This well, or noria, is in fact a senote very deep. The opening is small, and there is no possible means of getting down into it. They have placed planks across it for the men to stand on and pull up water in bark buckets[.]

Early in the morning, and we have not been there at any other hour, a hot steam rises in abundance from the water[.] Piste has been pretty once, but the indian has driven away the white man, and only scattered walls of the stone houses remain to tell the sad story of that election morning. In no place have I seen such abundance and beauty of wild flowers. We sent three men out hunting. One shot at a deer, another at a

wild turkey, but both failed to bring down the game. Still they brought two Chachalacas (wild hen). I am unwell with bilious attack.

In the building of this church some sculptured stones have been placed miscellaneously. One of these the Dr employed himself in making a drawing of. It represents a priest dressed in long robes, with a scroll in hand.

The Le Plongeons next investigated the Castillo Pyramid with its four wide stairways and temple on the top. The pyramid measures more than two hundred feet on each side and is about eighty-feet high at the top of the four broad stairways; the whole structure is oriented a few degrees east of north. Unknown to the Le Plongeons, the pyramid was built over an earlier pyramid that can now be seen by entering at ground level through a doorway on the north side.

They immediately saw the importance of the figures and iconography carved on the columns and walls of the temple atop the pyramid, and photographed each one in 3-D stereo. The darkroom was placed within the temple, but to bring the processing water from the Xtoloc Cenote (about one-hundred yards away) up the steep pyramid stairway required the continual help of their assistants. Between photographic sessions they measured the temple and pyramid in order to draw a scaled plan.

At 1 P.M. we went to the castle accompanied by 4 armed men. The staircase is not as difficult to ascend as that of the Palace & Museum. The steps are well preserved, and the only thing that makes it dangerous is the height. We put our box in working order. I laid down on the stones and slept heavily. We scraped some of the dust from the floor. The dust was 6 inches deep and the floor beneath it well preserved, made of fine mixture like the floors of the modern houses in this country. We washed part of it and found it covered with a bright red paint. Perhaps this was done that the blood of the wounded might be less apparent.

16th

Working in the castle. Our food for the day was a can of lobster & two thick tortillas. At midday I felt quite sick with sleep, but the swarms of flies prevented me from taking a nap.

The lintels in the doorways of this building are of sapote. They have been carved, but now few traces of the design remain. We made an intensely interesting and important discovery. On one of the carved pillars of the principal entrance, we found a long bearded figure dressed in elaborate costume. If I were a disciple of Allen Kardec, I might swear that it was Dr in his last incarnation, so much do the features resemble his. [Allan Kardec was born in France as Hypolyte Léon Denizard Rivail (1804–69) and was the founder of Spiritism.] Having found one bearded man we looked for more, and found 12 in different parts of the room in the Castle. As far as we made out, some are suffering torture, others in

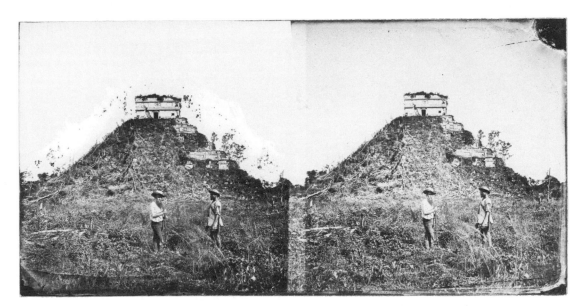

Augustus Le Plongeon and an assistant near the west façade of the Castillo Pyramid. 1875. Photo by Alice Dixon Le Plongeon. Research Library, The Getty Research Institute, Los Angeles, California (2004.M.18).

the act of worship. We had to wash these figures before taking plates of them. This took some time as we had to send the men to the senote for water, and they, glad of an opportunity, probably remained to take a bath, for they tarried long. We, meanwhile, took a plan of the edifice. The pyramid is a nine graded zigaraq [ziggurat]—100 ft high. On each side is a staircase of 94 steps[.] The building on the top has an entrance which corresponds to each stairway. Three sides of the building are occupied by a corridor on the fourth side is a room. This is the north side. On the sides of all the doorways are sculptured figures. The generally measure 1 meter 48 centimeters, the same size as our workmen[.] Carved on the left hand side of the principal entrance is a skeleton in grand uniform. This figure is °95 high—with cap 1.°15. Did this figure give the warriors to understand that death awaited them at the entrance of the castle? The two square pillars within the room support massive sapote beams, and have on each side large sculptured figures unhappily much destroyed but not beyond restoration. Above these large figures are small ones apparently being chastised. The beams, also destroyed <u>hacked by macheté</u> yet bear tracings of very fine carving representing figures dressed in elaborate attire[.]

The two outer pillars are round, and carved to represent the body of the winged serpent the heads are at the foot of the grand staircase. On the capital of the pillars are bearded men worshiping a tree. Some of the figures were very difficult to take owing to various causes.

The stones were discolored. To remedy this we took some of the fine mortar, and covered the superior parts of the figure with it, leaving the lines black. (The reverse of what we had done with the Akabzib

A bas-relief that "resembles" Augustus Le Plongeon in the north doorway of the temple of the Castillo Pyramid. 1875. Photo by Alice and Augustus Le Plongeon. Research Library, The Getty Research Institute, Los Angeles, California (2004.M.18).

hieroglyphic) We also had to make a frame work to raise the camera on a level with the stone.

We left work when the sun refused his light, with the conviction that a week would barely suffice to conclude all the work we had to do there.

17th

Our interest was much aroused, and at 7 a.m. we were among the silent but eloquent stones of the castle. We were busy on one side of the building—our men were on the other. I had occasion to speak with with them and found them building a fire in the place where it could be seen at Piste. Immediately we caused them to extinguish it, for in case of danger, we had agreed to give this signal to Carillo. The men were ignorant of this, and wanted simply to warm tortillas. We sent two men to explore the bush and look for a large senote, said to exist near the Castle; they returned without discovering it. At 12 n. a heavy storm gathered in the horizon. From the height we occupied, all around being level, we saw it to advantage[.]* It rained in every direction, all round, yet not in Chichen[.]

* Tragically in 1978, Dennis E. Puleston, a young and very accomplished professor of anthropology and archaeology at the University of Minnesota, was struck by lightning and killed while observing a storm from the top of the Castillo Pyramid, much as the Le Plongeons had done.

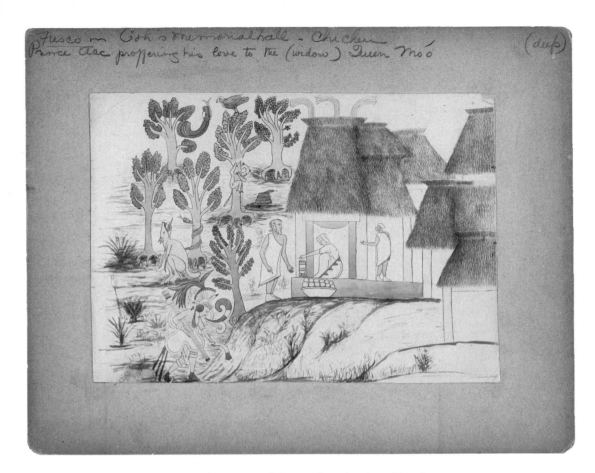

Photographic copy of Alice's tracing of a segment of the murals in the Upper Temple of the Jaguars. Written on margin: "Fresco on Coh's Memorial Hall—Chichen. Prince Aac proffering his love to the (widow) Queen Móo." 1875. Tracing by Alice Dixon Le Plongeon. Photo of tracing by Alice and Augustus Le Plongeon. Research Library, The Getty Research Institute, Los Angeles, California (2007.R.8).

The light however could no longer serve for photography[.] The stones which face North and East are much more destroyed than the others. We measured the arrows carried in the left hand of the life sized figures. They are 1m 25° long. Only °23 less than the height of the person.

Sunday 18

We reached Chichen before our men and went to the hacienda. Where a few days before all had been life and animation, if not content, we found silence and desolation—not a trace of those who had so lately left the spot. I dismounted and entered the house with a faint hope of finding the lost scizzors, but only discovered a pair of old slippers left by Mrs Diaz. They may remain there a long time as vestiges of our visit to that house.

We worked all day at the painted wall in the <u>Casa del Tigre</u>.* [Refers to note in margin, which reads "For colors see page 183." Page 183 is the December 26, 1875, diary entry.] With great care we washed it first, then took one or two tracings. Our interest increased as the work proceeded, and the sun was setting before we thought of returning to Piste. We had no tracing paper, but made a good substitute by soaking common paper in kerosene oil. We passed the evening preparing this paper, for we saw plenty of work to do in the painted room.

As the <u>recamara</u> [*recámara,* sleeping room] <u>de la Virgen</u> had no door and our men slept just outside; as also, the indians might come upon us at any moment, we always slept dressed. The soldiers slept on the roof. Carrillo would have had to do the same, but as he is quite a little gentleman we had told him to swing his hammock in our room—so he slept where we were. We took supper of a little <u>tasajo</u> (dried beef) & stale tortillas. Then we slept soundly.

A 11 a.m. the men came to ask Carillo for a little corn to entice back the <u>only</u> pig, who had run away into the bush. This was disagreeable news for we had promised ourselves the pleasure of eating him a few days later[.] Such a disappointment might have a bad effect on our stomach. At daybreak, all the men, enraged with the pig that had balked them, set out in persuit with ropes to lasso him, and weapons to fire at him if he refused to be lassoed. The pig loved liberty; and having obtained it determined to keep it if he could. Natural. They found him near the house, and set up a shouting and whistling enough to frighten twenty devils. But they could not catch the pig, so they fired and wounded him, then brought him home and finished the business with a knife. Dr and I were both unwell so we resolved to remain in Piste and eat fresh meat once again.

20

Very early we drank <u>Pinole</u>, prepared by the soldiers, and started for Chichen. On the road we heard a tiger growl, but did not see it. Carrillos horse that I ride was a little coward everything frightened him. The one that Dr used, old Charlie, as we called him, stood fire well. But he had only come manageable after having his nose knocked with a stick, for he had had tricks, and tried to throw everyone who mounted him[.]

He grew very docile with the Dr, because he was afraid of him. My grey is of a different character. If there was not another horse behind him, he would keep up a funeral march, and that was not always desireable— moreover no amount of food could satisfy his appetite, and when on the road, he saw a mouthful that took his fancy, he <u>would</u> and <u>did</u> eat it. Seeing it unavoidable, I took a switch to prevent him from sleeping too soundly on the road. It did not please him and when he knew that I had one in hand he went well. At the time of mounting him he was careful

to see whether I had, or not, a stick[.] When I had not my only remedy was to go in front of Dr big horse, that always wanted to go like a steam engine[.] When even that was not sufficient, Dr would poke him in the back with anything he had in hand. Sometimes he would break a twig in passing, and give him with that. So well did the little beast learn this that when he heard the breaking of a twig he started off without more ado. One morning I mounted, & turned his head toward the road[.] Dr had not yet taken to his horse, nor was it ready[.] My grey put all his strength against me, turned quietly but determinedly round, and took his stand behind Charlie, probably saying to himself, "If I go behind, I can do as I please[.]"

We reached Chichen at 6–30, and found to our disgust that some of the men had destroyed a stand that we had raised to take a plate of a particular stone. At this hour the light was just right for it, and we had to wait till another frame was made.

Alice and Augustus named the next building they recorded the Casa del Tigre (House of the Tiger), and then changed it to the Chaacmol Monument. Today it is called the Upper Temple of the Jaguars. In addition to the great number of bas-relief carvings on the columns in the temple, there were also sculptures called Atlantes and large scenes of historical events painted on the walls of the inner temple.

Once they had removed all the heavy vegetation from the Great Ball Court, the Le Plongeons noticed immediately the acoustical effects. Even a soft voice will produce an echo, and it is reported that a conversation can be heard from one end to the other. The Le Plongeons may be the first to have noted the sound effect, because previous explorers had not had the time to cut the heavy jungle growth. In the 1930s, conductor Leopold Stokowski went to Chichén Itzá to lead the Philadelphia Orchestra for a concert in the Great Ball Court.

October 20
This was the last days work in the Castle.

We caused the men to build a shed at the foot of the <u>Casa del Tigre</u>, and after packing all with care, the men lowered our dark box down the 94 steps. Between four of them it was yet difficult job, owing to the stumps of trees which stuck up all over the steps. At 12 o'clock we felt like taking breakfast, so mounted our horses, and left Chichen till the next day. A few minutes after setting out we met a man bringing us breakfast, but we continued our road & told the man to turn back[.] Carillo greeted us with the good news that a wild turkey had been killed[.]

21

We set the men to clear the bas-relief wall at the foot of the Chaacmol Monument, and discovered very soon that they were all suffering from a

severe attack of laziness. We sent them to clear away the brush from the from of the Castle; that we might take a general view of it, but they would not work unless Doctor stood over them. They discovered some trees of guava, and fell to eating ravenously. Dr ate one or two and brought me some. Everyday afterwards, the men would reach Chichen before us, and eat the fruits even while green so when we went to look for some ripe ones we were disappointed. We took a walk down the Tennis Court, and found that speaking on one side, the echo came from the other wall clearer and stronger than our own voice. The indians who accompanied us were afraid, but when they saw us amusing ourselves with it, he gained confidence and half smiled. Each of these walls had a large ring on the upper part of the middle. One has fallen. Two rattlesnakes entwined are carved on it. The diameter of the ring is m1 $^\circ$22. That of the hole in the middle $^\circ$47. The thickness of the ring is $^\circ$29. Near this fallen ring we found a stone, through which grew a good sized tree.

Green boughs formed the roof of our shed that covered the dark box, we had also to wall it round with the same for the light penetrated the box, so brilliant was the sunlight there. Dr received a letter from Diaz, of no importance[.]

The Le Plongeons located the North Temple of the Great Ball Court and photographed it after clearing the thick vegetation. Alice photographed the bas-relief carvings in the Lower Temple of the Jaguars and the carved columns in the Upper Temple of the Jaguars.

22

Answered Diaz letter. When we reached Chichen the view we wanted to take was not yet well lighted so we went in search of a certain <u>Xlapak</u> [Yucatec Mayan meaning "old wall"] which we knew to exist at the other end of the gymnasium walls[.] It was hidden in the bush, but knowing the direction in which it stood we took an indian and cut a path to it. We found a building very much defaced. It seems to have been a grand box where some magnates sat to see the games played. The back and side walls are sculptured all over; and parts of two large pillars remain two round, two square[.] The round ones are within, the square without, as at the Castle entrance. They also have been elaborately carved. On the wall only a few faces can be well distinguished. The best preserved is a bearded man[.] This apartment with in is m6xm2 $^\circ$45. Thickness of wall m1 $^\circ$60. Thickness of square ~~columns~~ pillars $^\circ$47. Diameter of round ~~pillars~~ columns $^\circ$74.

In the Casa del Tigre the square pillars which remain standing, have well preserved figures carved on them. These were half buried under

debris & dust[.] We had the men to clear them and endeavoured to take portraits of the silent gentlemen, but found it difficult. Owing to the position in which they were we could not get the right light on them, and had to do away with the camera stand, and lie on the ground to focus. When about to leave work, Carillo arrived with a Corporal who had been sent to Piste with 15 men to help us in our work, as a letter from Diaz informed us, and that we might be in Chichen with more security[.] Up to then we had heard nothing more of indians[.]

Dr Manzano had sent Dr a pair of boots at our earnest request, for those he had brought were used up. We already had been put to the necessity of making one good pair out of two bad—using a bayonet for needle & string for sewing thread. Carillo, to his great delight, received a bottle of Abanero, and a bundle of sigars[.] In Yucatan three kinds of sigars are used. The tobacco enclosed in a small piece of white paper is called <u>papelilla</u> (little paper)[.] Tobacco enclosed in the dry shuck of maize is called <u>joloch</u>. That commonly called by us cigar, they call <u>tobaco</u>. Tobaco, or large Havana cigars were what now rejoiced the sight of our friend[.] He immediately smoked half a dozen.

23

Passed the day taking various plates of the bas relief wall, and also got two of the portraits from the upper room. Although we had ten men with us they were very idle—pretending to do a great deal, and in fact doing nothing. We had them to continue clearing the rubbish from the pedestals, and discovered four more fine stone portraits. All the faces were so different from each other that we could not doubt them being portraits. Without exception they wore massive necklaces, and bracelets. Nearly all had rings in the ears and nose. We were not a little curious to know of what these ornaments had been composed. All the figures presented full body, and side face, and above the head, or on the breast, an animal of some kind, bird, cat, tiger, fish[,] squril, which probably means that so they were named—One has a cup above his head—Mr Cup[.]

At 12 o'clock, after doing a good amount of work we were hungry and glad to receive breakfast. The men who brought it brought also excuses from Carillo for sending it so late, but those who had brought the tortillas from the rancho where it was always made, had come very late to Piste.

In the afternoon when we wanted to go home Carillo sent us word not to wait for the horses, for they had been sent to fetch corn; so we went on foot. Hundreds of Chachalacas were round us; we could hear them, but not see any. Reaching Piste we found Carillo very much out of humour. Having dispatched his horse for corn, he had gone at 8 o'clock in the morning, on foot to a small ranch where the bread was always

made for the troops, to see if they had any kind of food to sell him. It was 2 1/2 leagues distant. He found all the inhabitants, 5 or 6 indian men all hopelessly drunk: No one dreaming of making tortillas. He, with difficulty obliged them to begin the work, and awaited his steed that he had ordered them to send him from Piste after it had brought corn from the other hacienda. Tired of waiting he returned on foot, and in a bad humour. Night set in and the horses did not appear. We were also disgusted, for one had a saddle belonging to Dr Manzano.

Oct 24

Went on foot, and feared we had lost the horses for ever[.] At middle day they appeared. We took four plates of the bas-relief wall. Went in search of a building said to exist at the back of the Castle. Took no men with us and had to force our way through the thick bush. We found the building completely ruined, made an examination nevertheless, and came to the conclusion that it had been the principal temple of worship. It was a pyramid of three terraces, and though nothing remained worth photographing, Dr made a sketch of the building as he supposed it to have been. The large serpent heads were not wanting[.] On leaving work Doctor expressed himself tired of the photographic part. It was not strange, for to get one good plate he often made ten, and for each one walk a long distance and generally make some tiresome ascent and descent. To have a plate procured with such labor, spoiled by one spot of dust just in the middle, was very provoking[.] Yet each day he had to endure it over and over again[.] On the way home we saw standing in the road, about two blocks ahead of us, a large turkey. Dr dismounted, gave me the reins of the hores, and fired, but missed his aim. This was a matter of regret for we lost a good supper. All our provisions were nearly used up. We went home, and out again with men, to try and hunt something, but failed—Others who had started earlier had better luck. They brought us a turkey weighing 10 pounds. The plumage was nearly as fine as that of the peacock.

25

We had worked hard and unceasingly for many days and were feeling very tired, so as the weather was not bright we remained in Pisté. Our men were well satisfied at the arrangement. While taking our breakfast of frijol and Pimpimuah we received letters from Col. Diaz, by, of course, a special messenger. One was concerning the provisions of the Canton, and a notice of indians[.] The other was an official dispatch, and read as follows.

Con fecha de ayer me dice el C. Jefe Politico de este partido lo que sigue:

El C. Presidente de la junta Municipal de Tunkas me dice con fecha 21 de actual lo que a la letra copio = Pongo en conocimiento

de Ud., que ayer a las cinco de la tarde fue aprendido en este, Celestino Ku, procedente de Santa Cruz, que cuando fue la encursion que llevo Aureto quedo en aquel lugar, y declara de haber estato en Cenotillo cuando los sublevados lo envadi cron asi como en Zitas. Que vino con un compañero llamado Pedro Chan que se escapó, teniendo este una señal de herida de Cala en una oreja, y el pie hinchado y como no es deficil que asome en esos lugares se lo comunico para ver si se consigue su captura = Y lo traslado a ud. para su conocimiento y de mas fines advertundole que por mi parte he recomendado a las autoridades de los pueblos de este partido para que pongan los medios de ver si se consigue la captura de la menciona lo Pedro Chan.

Lo que trascribo a ud. para que haga extensia la noticia para conseguir de algun medio la captura del referido Chan que logró escaparse.

Indepa y Lib. Valladolid
Octubre 23 de 1875
Felipe Diaz.

Colonel Felipe Diaz (formerly in command of the troops at Chichén Itzá and the Line of the East) was told by the president of the village of Tunkas that Celestino Ku, a Chan Santa Cruz Maya, had been captured. His companion Pedro Chan had been wounded in the ear and had a swollen foot, but escaped. The army was trying to find him and requested that notice of the wanted man should be posted wherever possible.

The other letter stated

"La finca Xuxul fue invadida, por los barbaros encabezados por Bernadino Cen, y Xuxul queda circa del puerto Puntachen, en que se les hizo tres prisioneros a los indios, y se dice muerto Cen. Los rancherias del partido de Peto fueron invadidos; y en Tunkas se cogió uno de los emesarios que fue anunciado en Tixcacal, lo que dirá u. al Doctor, el Sr. Le Plon

In a dispatch to the Le Plongeons at Chichén Itzá, Colonel Felipe Díaz warned them to be very vigilant because Bernardino (Bernabé) Cen and his Chan Santa Cruz Maya guerrillas had attacked the Xuxul farm, others had been operating at few miles to the north in Tunkas, and near Peto in the south. He reported he had heard that Cen had been killed.

In the afternoon we went hunting with Carillo. We walked in the direction of the ruins; and when near the entrance of Chichen turned

back. On reaching the church we found a man who had brought a letter from Kaua, the nearest Canton to Pisté. He told us that in the small uninhabited rancho, three leagues from Piste, he had seen smouldering embers that five men, not belonging to this part of the country, had used to bake some fresh corn, the husks of which were strewn upon the ground. He followed the five distinct tracks one league from the spot toward Piste and there lost sight of them, to his satisfaction—probably; for I am sure he did not like the idea of falling into an ambuscade at any moment[.]

26

We went accompanied by five hidalgos, and five soldiers[.] At a short distance from the church, but out of sight of it, we saw three turkeys ahead, right in the road. Dr alighted and fired; the birds remained firm. A second, third, fourth and fifth shot were fired, still the birds stood their ground bravely, more than I would have done, stand for a target, but they were ignorant of their danger, and the noise did not appear to disturb them. The remington raised so much [noise] each time we could not catch them. The shots produced a powerful effect however not in the right direction. Our men coming behind believed we had fallen into an ambuscade, and came running. I on horseback was holding the reins of Charlie. When they passed me I told them "pasos." They came up with the Dr—one fired at the still standing birds, and wounded one, when the others all retired to the bush. They caught the wounded bird, which proved a very young one the others escaped. Carillo hearing the repeated shots was coming to our assistance with more men, when he met one whom we had sent to get bullets to replace those wasted, who told him the truth of the matter. The bird was carried to Piste and prepared for breakfast. As all our photographic apparatus was in Chichen we felt some fear lest the enemies might have passed that way and smashed everything. Upon alighting from our horses the first thing that met our view was a beautifully carved stone, a kind of <u>coat of arms</u>. It was certainly not in that spot when we left there on Saturday. It surprised us to find it carefully propped up with stones[.] All our men denied knowledge of it. Perhaps five men who baked the corn had something to do with it. We took our last plates of the wall and a general view of the same. At 12 o'clock two men brought breakfast, and by what we could understand of their <u>maya spanish</u> we think that they placed the stone where we found it.

We were preparing to take another view, when the rain very suddenly began to fall in torrents. We had no time to ascend to the painted room. We sent our men and gathered all our traps, and ourselves into the dark box. There one had barely room to turn round, when two were inside both run the risk of being squeezed out. When the curtain began to leak, we made a bold dart for the room up on the wall. Dr took two tracings

from the wall. At 5 P.M. the horses arrived, we went to Piste carrying our lenses. On the road it rained very little, but we had scarcely arrived, when it again came down heavily.

[Alice wrote in the margin] Have described painted wall

27

At dawn it was yet raining. When we had taken our pinole it was fair and beautiful weather. The sergeant came to give us the alarming intelligence that one of the men was covered from head to foot with smallpox. He had complained of fever two days before, and we wanted to purge him, but had no medicine. The only thing we could do was to send him to Valladolid in a coché—on the road he must have got very wet for it rained hard[.] We never heard what became of him. This disease must have been brought to Piste in the clothing, we thought; so had the men to wash all their clothes. We passed the day in Piste drawing and taking notes[.]

28

Went early to work at the painted wall. Made three tracings, and at 12 o'clock went home to breakfast. In the afternoon received from Dr Manzano a letter, a bottle of ether, which we needed badly.

The men rejoiced for some aguardiente was sent for them, but no food of any kind arrived. All the meat was used up, but the soldiers were too lazy to hunt. We received two papers "Razon del Pueblo" that generally gives reason of nothing, but this time was quite animated with doings of the indians[.] A runaway servant of Xuxul had enticed the enemy to the hacienda of his master [blank space] Stevens, an american, who had treated his servants very cruelly. He died at their hands, insulted by said runaway. The mayordomo also fell victim. One who could play violin was forced to play all night while the indians danced and drunk aguardiente. In the morning assistence arrived, and Cen the chief, Bernardino Cen was killed. In another part of the state some indian spies had been taken prisoners and had said that 1000 men had left Santa Cruz with the idea of attacking Peto.

29

A day of disagreeable events. When we reached C. we sent back Carillos horse that he might come, as he wished to pass the day with us at the ruins. We decided to continue the work of digging out the walls of the Akabzib. As soon as Carillo arrived we started for that building. The leutinant in front, on Dr's horse[.] I followed, on the grey. My saddle was not well fastened & I had no reins. Dr came behind on foot with the men[.] The lazy little horse for once in his life took a fancy for galloping, and as branches hung low over our path, the first thing I knew I lost my hat. I picked it up and soon over took Carillo. Entering the gateway of the hacienda, through which we had to pass to reach the other building,

my horse saw a _pila_ containing water in the distance. He went for it like a mad thing and I had no rein to check him. When he stopped I alighted forgetting that my saddle was not girted, and came down seated on the ground rather roughly. I congratulated myself highly upon the fact that no one had seen me, nor Carillo in front, nor those who were behind. We went to the Akabzib, by back aching from the fall[.] Dr went into the tunnel to direct the excavating. The stones had to be propped up with sticks as we penetrated by little and little. The men did not understand spanish, consequently gave him much more trouble. Suddenly I felt a severe influenza on me and went to the other side of the building, where men were making another hole, to get water from one of their calbashes. I used the water, and was about to return, when I thought the Dr might be thirsty. I carried the water with me. When near the room I heard a falling of stones which lasted a full half minute. I waited breathless to hear the voice of the Dr knowing that he was among the stones, and heard it asking the men to take away the stones. They stood still like fools and only moved when I went forward. Before anyone entered the hole Dr had worked his way out. Blood on the forehead, one kneecap broken, face white as death and covered with earth, but no limb broken. He came out swearing and, scolding the men, who had foolishly brought down the stones upon him, by striking one with a careta, and afterwards left him to be buried alive, without venturing to assist him, some of them were even laughing. The water served to wash off some of the dirt, and faintness caused by the pressure of monster stones on the head, and the severe contusion that one knee had received. Half an hour later we went home—When Dr got on Charlie he told him to stand very still because he could not jump. The horse remained like a statue, until told to go. On the road my horse again threw me. My back was so lame I had very little firmness in my seat. This time he stooped to eat, and I slipped over his head without hurting myself. Carillo then told me that in the morning he had fallen in the same way.

30

No one went to Chichen. both could perhaps have gone with effort, but each persuaded the other not to; for my every mouthful of food I took that day returned from the stomach. Dr's leg was very much swollen[.]

31

Dr went to Chichen. My back was too uncomfortable for me to keep upright one hour. Carillo accompanied the Dr and they returned at 5 in the afternoon, contented because they had discovered some statues at the back of the Castle.

Sunday Nov. 1

Dr would not remain at home although the leg was very painful.

I remained because he wished it, for I felt able to go. Our previsions were entirely exhausted. The last corn was given out to make the bread of the next day. The frijoles shared the same fate. The sugar had given some days previous, so we could not even take sugar and water. It was more than a week since we had tasted meat: the men were sent to hunt each day, but it seemed that fate was against us, for nothing could be caught although game was plentiful. From time to time we had been able heretofore to obtain a chicken, and Carillo had often gone far to look for one for us. Now not even eggs were to be had. In fact the only thing left was a little coffee and agua ardiente. Even the lard was used up, so we could not even take broth made of hot water and fat[.] The men in the rancho grumbled at making the bread and the soldiers sometimes had only 1 1/2 tortillas. We sent a letter to Muchucux, rancho of Coronel Traconis, believing that gentleman was there, but he was not. Carillo was in great distress because he had not one cent of money, and knew not what to do. Already we had given him the little we had with us, to buy food for the men. There only remained to us, some old spanish coin that I was keeping to make a collection. As a curiosity we kept them safely enclosed in the truss of surgical instruments. It did not amount to much, but we gave it to a boy & sent him with it to a rancho to buy beans for the soldiers and a few eggs and calbash for us; he promised to return at 8 a.m. next morning.

X [Refers to note in margin, which reads "Told Desiderio, Camal to cut right through to a certain place."]

The dense vegetation at Chichén Itzá must have prevented the Le Plongeons from seeing the Platform of the Eagles and Jaguars located near the Great Ball Court or even the Cenote of Sacrifice from the top of the Castillo Pyramid. Finally, by chance, Augustus stumbled on the Platform of the Eagles and Jaguars, and the Le Plongeons, thinking it might be a burial chamber, decided to excavate it. It was a difficult excavation that took them about a month, but they found a sculpture they named in Yucatec Mayan Chaacmol, or Powerful Warrior. For some unknown reason, the name Chaacmol was later changed by the editors of the Proceedings of the American Antiquarian Society *to* Chacmool, *which is an archaic Yucatec Mayan word for puma.*

Dr discovered a mound with sculptured slabs, and a statue of a reclining tiger without head half buried in the ground. The slabs represented tigers, and Macaws eating human heart. This mound is not far from the tiger monument. We took it to be a mausoleum . . . * [Refers to note in margin, which reads "For measurements see page 183." Page 183 is the diary entry for December 26, 1875.] Went to bed without supper[.]

2

Early in the morning Dr took men to open the mound he had discovered. On top was a stone slab. The reclining tiger, with three holes in the back, sculptured in the round; was a little way off from the mound, but we think it was once on the top. At each corner of the mound were two tiger slabs, and two Macaw slabs, making eight of each. I remained in Piste. Dr wrote to General Palomino. I wrote to Mother and father. At midday we dispatched these letters with one from Carillo to Diaz. Carillo went to a ranchito where All Saints Day was being celebrated and I told him to bring back something good to eat. At 2 P.M. the boy who had promised to arrive at 8 a.m. put in an appearance with frijol, calbash, and 8 eggs. The men had breakfasted on bread alone, but showed no discontent. We wished they were less contented, so that they might have more desire to hunt. Happily later in the day corn arrived from the farm of Traconis. Dr returned with a rattlesnake 6 ft long, and 11 years old, if each rattle means one year. The men had killed it Dr chopped off the head. I held it while Dr skinned it. When my hand got tired I asked a corporal to hold it for me but being afraid, he refused. We hung the skin on the trunk of a tree to dry. During the night the man who had refused to help me to hold the snake, deserted and carried with him my serpent skin. I was sorry for it, as I wanted to make a belt of it. One of the Corporals brought from the rancho that was celebrating All saints, a hanal pixan (tamal). Carillo ate well there but could get hold of nothing to bring to us. The tamal was presented to us by the man who brought it[.] When he arrived it was near 8 o'clock in the morning but Dr & I got up and ate all the meat from inside of it. It seemed to us better than any ham we had ever tasted, though it was in fact a pig's foot, not quite free from hair, and trimmed with a little red pepper.

All attempts to make photographs on November 3 failed because the collodion, an important component in making their negatives, was spoiled.

3

Went to work for the first time after my fall from my horse. We worked all day in vain. The colodion was bad. At 2 P.M. a heavy rain fell, and were prisoners in the painted room until 5 P.M. We busied ourselves in restoring some of the figures. We started for Piste the rain yet falling. Half an hour later we were all under shelter, and the rain fell again very abundantly, and continued until midnight. One of the men lately from Valladolid told us that Daniel Traconis had not answered our letter owing to the severe sickness of his brother[.]

4

At daybreak the rain passed off and we went to bathe at the Noria. We

took some coffee on our return, having occasion to look at our plans and tracings already concluded, we found to our disgust that the mice were nibbling, and making beds of our tedious and laborious work. Happily the mischief was not far advanced, and the principal part was untouched[.]

We emptied the boxes and found that a happy family had made their home among some wadding that we had brought to prop up glasses. They had laid in large stores of Calbash seeds, filling every available article, and were meanwhile living on paper covered with drawings. There was clean white paper within their reach, but probably the flavor did not suit them—it had no kerosene. We killed two of these little people relentlessly; the other escaped.

At 8 o'clock went to work taking only hidalgos, and naming one sergeant, another corporal, not wishing to have any soldiers with us, they only serving to put disorder among the workmen. One of the indians, a giant in size and strength, but goodhumoured, and lazy <u>par excellence</u>, had disgusted us the previous day by his excessive indolence, so we sent him to open a road with only one other man. He tried to escape the job by pretending not to understand, but between us who understood a few words of Maya, and one of the men who understood a few words of Spanish, he was obliged to comprehend, and go to work. The rest of the men were put to work at the tiger mound. We made a photograph of the cornice of the tiger monument. On our return to Piste we found that a body of men had been sent to relieve the troops. But only eight had arrived with the sergeant, seven having deserted on the road. They brought no provisions and we were again reduced to corn—and no money in the pocket.

5th

We were early in Chichen. The first thing Dr did was to ensure the safety of the men who were opening the mound. We had commenced at the top, and found it composed of large loose stones. So after working down into it 2 or 3 feet, the men stood between four dangerous walls. Having no plank, Dr ordered the men to cut down small trees, and so propped back the stones with these poles. It was a long & tedious work, but inevitable. It occupied more time than the moving of the stones. The men, to make matters worse, could not understand what Doctor wanted to do. He stood all day under the glaring sun, and many super human efforts to speak maya, every time a stick had to be cut, or placed, or pushed lower down[.]

To Alice and Augustus's irritation, the photographic chemicals had again gone bad and a part of their camera broke, so another day of photography was lost. In the meantime, Augustus located another platform about fifty yards to the

east of the Platform of the Eagles and Jaguars with a carving of fish on it. He named it the Mausoleum of the High Priest Cay (fish). Today it is called the Platform of Venus because there are also a number of iconographic representations of the planet Venus carved on its sides. They hoped that once the excavation of the Platform of the Eagles and Jaguars was complete they could begin work on the Platform of Venus, but that excavation would have to wait until their second season of fieldwork at Chichén Itzá in 1883.

6

I was very unwell. Dr went to Chichen without me. On his return told us he had passed a very bad day. The bath fogged, the acetic acid gave out, and the dark slide broke. But he discovered another mound, larger than the one we are working at. Round it there were slabs with fishes carved on them. At midnight Sergeant Sanchez came to tell Carillo that 9 men who had been left on guard below, had deserted. They were from Cenotillo and Temax. One carried a cartridge box, and another his ammunition. Carillo at once sent all the soldiers up on the roof and kept the workmen on guard below[.]

7th

I again remained in Piste, and at 2 P.M. we received a glad surprise in the visit of our friend D. Daniel Traconis, and four men, who came bringing a few very welcome provisions. Dr Manzano, always kind, had had the goodness to send me some dried <u>Leza</u>, a magnificent fish, and some <u>wheat</u> bread. Traconis brought pavo de monte, venado (cooked in <u>pibil</u> [a traditional Yucatecan marinade]), eggs, coffee, sugar, limons, and plenty of corn for the men[.]

We sent an indian to tell the Dr that Traconis had arrived. The indian who took the message did not know how to express himself to the Drs understanding. The Dr got a confused idea of the indians having fallen upon us—or else that Carillo was left with four men only in Piste. As nine men had deserted the previous night, he thought that the others, whose time was completed, might have raised in mutiny. So he came home flying with his men behind him on the trot, and was agreeably astonished to find a good friend awaiting him[.]

8

D. Daniel accompanied Dr to Chichen. I remained much against my wish for I had thought to pass a very pleasant day with them. One of the servants brought by Traconis shot a turkey early in the morning. <u>Being no longer in need, food became abundant</u>.

The digging of the mound was continued in Chichen; they found among the stones some buttons, apparently made of limestone. They had been painted yellow and were bored with holes as if for threading. Also

a piece of bone, that seems to have been cut to fit an eye. The came to a large round stone jar,* [Refers to note in margin, which reads "This jar or urn measured 26 inch diameter, 25 deep{.} Thickness of stone 4 in."] with circular stone covering it as a lid[.] Doctor told the men to take away the stones from around it, as he believed it to be a column. Meanwhile he went to wander with Traconis, and show him the ruins[.] During the absence of the gentlemen the men discovered that the top was a lid, and went to advise the Dr of it who then returned. The men had taken the lid away. Inside was a small earthenware lid, a large round bead of jade, and some dust (which we think were brains). He became very angry, and demanded of the men what they had done with the pot belonging to the earthenware lid. The men swore that no such pot existed, they had given up all that they had found[.] But Dr was enraged and told them that the enchanted man to whom the things belonged would punish them. All was of no avail. He frightened the men but could not have from them what they had not got. Close to the large urn they discovered a fine head sculptured in the round of a calearious stone. They thought it a bust, but failed to move it, so put a few stones over it to conceal it. During the day five men deserted the canton. They had more than fulfiled their time, and had only been detained in consequence of the desertion of those who were being brought to replace them. An officer, Padilla, a fat white man marked with smallpox arrived on horseback as prisoner, to remain in Piste, until further orders from the headquarters at Valladolid. In the evening Carrillo went to get some corn from the corner of the room, and nearly picked up a coral snake, very deadly. It was killed and thrown out. A few minutes later, he nearly stepped on one in another part of the room; and when a third was brought to light he got so startled that he swore he could not pass the night in the room. Although we laughed at him for it, he went to sleep on the roof.

9

Four more men deserted during the night, the assistant of Carillo among them. The Canton of Piste remained with four soldiers to protect all the arms and ammunitions. These four had just arrived, so we did not fear their desertion. All the deserters had more than completed their time of service, which was two months. They pay was two reals a day; one real being taken from them to pay for their food. Traconis assured us that the rations, according to the regulations, were the following: At 5 a.m. two ounces of aguardiente. At 7 o'clock, coffee with sugar. At 10 breakfast of corn bread, beans, and meat. At 3 P.M. a good dinner. The deserters had received only tortillas & beans, in small quantity, twice a day. Having deserted they received not even the miserable 7 1/2 dollars for their two months service. But they were not punished otherwise[.]

Alice described a psychic method she and Augustus employed to determine if any objects had been stolen from the urn they had uncovered in the Platform of the Eagles and Jaguars. Apparently the results were mixed, which caused Alice to again question the value of such methods.

The immense Cenote of Sacrifice was located at last, but it was not much of a discovery because the Maya already knew of the cenote's location—it had been their pilgrimage destination for centuries.

D. Daniel retired to his rancho. I sent by him a letter to Luisa his wife, and Dr gave him one for Manzano, inside of which was one for mother. After his departure we placed a box upon a campstool, and sitting to it were told that nothing had been robbed from the urn—that the head discovered was part of an entire body, about 4 ft long in a sitting posture. (This was true)—that below the statue we should find the corpse embalmed in an earthenware coffin, that we should find pearls. That there were two statues under the mound (All this was false)[.]

I remained at Piste. Dr went with four hildalgos only, leaving the rest to aid in protecting the Canton. At 4 P.M. some men came from Valladolid, bringing a pig, some sugar, rice, and a pound of coffee. Corn was given out to the men to prepare pinole for the next morning. They had been without for a long time having no sugar. When Dr returned he told me he had been with Padilla, and one of the hidalgos, who had discovered it, to see the big senote, so long sought for by us. Dr declared the senote to be an awful chasm from which no one, falling in, could possibly escape. The hidalgo [blank space] had caused him great uneasiness by standing on the extreme brink, and afterwards climbing a tree and going along a branch of it which overhung the water. The three had walked all round the senote, and agreed that the circumference to be nearly half a mile; eight or nine blocks. Padilla called the attention of Dr to a small berry, as something with which he could write. Dr brought some home.

10

We found the berry to contain a beautiful blue gum. Mixed with a quantity of water it made a very fine ink. The berry is white, about the size of a large pea, & grows on a shrub. We think this blue served for the painted wall. We sent for what could be found in the neighbourhood, and preserved the seeds (Gave them afterwards to Mr Barlee, Lieutenant Governor of Belize)[.]

On the lid found within the urn, in the mound, was some ochre, which mixed with the blue gave the exact green of the wall in the Tigerhouse[.]

In order to get the stones more quickly from the mound, Dr invented a machine for raising them out of the hole, and put it to use at once[.] The

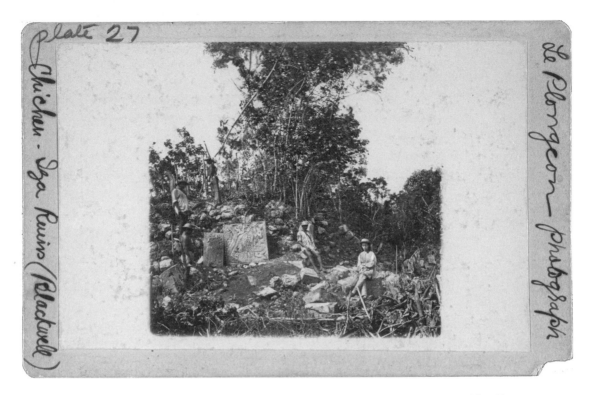

men liked the idea, for it lightened their labour very much. They called it <u>Maquinaché</u>. A <u>wooden machine</u>, which in fact it was—Merely a pole planted on the top of the mound at the side of the hole we had made. The pole was forked at the top, and balanced in this fork was another pole. A man stood at one end of it, and raised and lowered a basket attached to the other end.

We had been awakened in the morning by the voice of the pig that, Dr said, was <u>saying his last prayers</u>. Padilla, our prisoner had turned pig killer, and did the business as if he had done nothing else all his life: he cut it up in a masterly manner, and the men made a big fire out in the front of the church, and put into a large caldron, all the fat to make crackles. To leave the lard clean they strained it in the following manner: They twisted together large vines, and made a ring of them. This they placed over the mouth of an <u>olla</u>. They then placed sticks across it, and upon them laid loose henequen, which formed the sieve.

II

I went to Chichen to see the head of the buried statue. [Two lines crossed out and not readable] The day was sad in the extreme, rain fell every half hour, just enough to oblige us to seek shelter, and then it would stop. The wind was chilly, but we kept at work all day. Two men below

Alice Dixon Le Plongeon and workers sitting near the Platform of the Eagles and Jaguars during its excavation. 1875. Photo by Augustus Le Plongeon. Research Library, The Getty Research Institute, Los Angeles, California (2004.M.18).

to load the basket with stones. Two to haul it up and empty it. At 3 P.M. Dr descended & removed the covering which he had put over the head. Looking down upon from the brink of the opening, it appeared to me one of the most beautiful heads I had ever seen. I experienced an intense pleasure looking at it, knowing how long it had been hidden. Dr tried in vain to move it, it was as firm as a rock. He remained a short time below & cleared as much as he could, the loose earth away with his hands, following the direction of the body, which he found in a strange reclining, sitting posture. After seeing in which direction the body was, he found that he would have it enlarge the opening, for the statue was not in the center and the knees were yet under the mound.

When we reached the church we found that men had been sent to relieve our hidalgos[.]

Nov 12

Went to work with fresh hands. The corporal was intelligent and well behaved, and had served formerly to the cura of Valladolid, as sacristan. Better than all, he understood spanish, though could not speak it. All the men were intelligent & willing. We uncovered the head to show the corporal what we were working for, and so feel more interrest. They said that the liked the Maquinaché. To our surpise we found that a stick was moved from where Dr had placed it the previous day, and a batton was placed in a very conspicuous place. Our former men had been so stupid that Dr found himself very happy at being so easily understood by the new comers[.] At 10–30 our breakfast arrived—all ate with appetite[.]

We set the men to make the hole one yard wider, on the west side— and we then went to work at the painted wall. We washed some figures, and found depicted, very large people, narrow & badly formed, of a dark yellowish color and african type.

The figures on that wall generally measure 9 inches[.] The large people, mostly naked measure 12 inches, one third taller than the others— So if the first were the same size as the indians of today, the others were between 7 and 8 feet high. In which case, each inch and a half (1 1/2 inch) would correspond to one foot (1 ft) in nature. These big people do not appear to be slaves, for they wear ornaments and head-dresses. On another part of the wall we find very small people, naked, ugly, and of a pale yellow color. They seem to be carrying banners[.] When tired we went to see the big senote. It left a lasting impression on my mind.

The Cenote of Sacrifice at Chichén Itzá is roughly circular (two hundred feet in diameter) with sixty feet of vertical walls exposed from the water line to the top edge.

Nov 12

It is surrounded by a white lime stone, perpendicular, natural wall. We had no means of measuring. We let fall a stone from the brink, and of four seconds elapsed before it touched the surface of the water, which, far below looks like stagnant ink. On the very edge of this fearful precipice is an oven with a hole in the top.

The victims who are said formerly to have thrown themselves into the silent water beneath, probably stood on the top of this oven; and when surrounded by smoke, produced by incense burnt within the oven, cast themselves forward[.]

Alice noted their discovery of the causeway (sacbe) between the Great Plaza and the Cenote of Sacrifice. It had been used by the ancient Maya for religious processions.

The floor of the oven is covered 18 inches deep with fine ash. I took away a small portion of it. This oven is at the end of a magnificent causeway which goes in the direction of what was once the Castle. It is now a heap of ruins, but was originally well built, and raised a yard to two above the surface of the ground. On the whole it is a most romantic spot. The tomb of thousands, no tomb could be more silent—No ocean in the wildest tempest could look so solemnly awful, as this dark still water that had swallowed and closed over, so much treasure, so many secrets. If but for one moment we could see reflected on its surface some of the scenes long ago enacted on the terrible brink! Crowds of fanatical people gathered together; some in wild rejoicing, others in deep mourning. The decievers of the people, the priests, arrayed in all pomp. The unhappy victims! Some loving life, yet fearing to beg for it, throw up their arms, and with a wild shout of despair, disappear for ever. Others, stolid and proud, though horrified, go silently on their long journey. And yet others, thinking to perform an heroic sacrifice to the gods, destroys what god had given him, with a song of joy & hope—for surely! he is to live again on the third day.

13

At midday I was overcome by the heat, and went to take a nap on the floor of the painted room. This floor was covered with stones and dust. But I found one stone to fit my head and another my shoulders & enjoyed a good sleep, from which I was aroused by the sudden entrance & just as sudden departure of the Dr. I slept again, he not having spoken to me. Two hours later I learned the cause of his hurry. They had heard voices in the bush. Dr had ordered all the men to arms, & come up to fetch his own weapon. All were ready to fire upon the indians, when two of the soldiers of Piste sallied from the bush, and declared themselves to be the

speakers. They were advised never to come in that creeping way again, for they might receive a bullet, and we find out who they were too late.

The opening of the mound was continued amid many difficulties. Large stones constantly fell in spite of the large poles. We were very anxious to see the entire body of the statue, and O! how slowly the work advanced! We had not yet decided upon the means of taking it out. Means! we had none; except <u>brain</u>, and in this case <u>brains</u> had not only to find the <u>way</u> to do it, but to invent the means, almost without elements.

Dr Le Plongeon left off sleeping, and laid awake thinking, night after night, during that time[.]

We continued every day the restoring of the painted wall, and the story it told became by little and little clear to our understanding.

When we wanted to go home, my horse wanted to play tricks. Dr mounted, I made him turn round & round until tired, after which he behaved better.

14

On the way to Chichen, (the Dr went in front) a small boy suddenly started up from behind a cross that was on a pile of stones, on the road side. My horse took fright, stood upon his hind legs, began to leap, & nearly threw me. . . . We restored two groups on the painted wall—one being in Stephens book, incorrect. Tracing from that wall was very painful work for Dr Le Plongeon, for all the upper part had to be done standing on a ladder improvised out of round sticks. The position was anything but pleasant, and the feet complained of the rope like steps . . . When we went down to breakfast we found one man lying on a stone shaking with ague[.] He did not complain, nor ask to go home, but when we proposed Piste, he went gladly. The corporal ordered ordered one of those who brought the breakfast to stay in his place, but the man refused to obey him. Dr punished him by making him keep guard four hours instead of two, during the night, and made him work in Chichen always afterwards. Strange to say he became one of our best men.

15

We went to the house of the hacienda with six men to bring from there, strong square poles (<u>rollisos</u>) [*rollizo*, a round log] to help us in our getting out the statue. We did not enter the house fearing to get covered with fleas. While the men where in the house selecting the poles, part of the barricade, put round the corridor a month a month before, fell down, as if pushed by a great strength. If there had been a plank floor, I should have supposed that the movement of the men did it.

The cause was not apparent, no one had approached it. We thought it well to take the opportunity while the men were with us, to go and put in safety some loose heads, that we had picked up in different parts

of the ruins, and placed on the walls of the palace. Our shortest road was through the house. We came out of the other side of it, our clothing richly ornamented with fleas. We brushed them onto the ground, they being too numerous to kill. We found that the soldiers, who had caused us an alarm a few days before, had taken care to throw down three of the heads, breaking them a little more yet. The roads we had left well open a month before, were already closeing up, so rapid is the growth. We put the heads in the room where our dark box used to stand. When we got back to the hacienda our horses had a good feast in the coral [corral] upon the fine guniec [guinea] grass, grown 2 ft high, since we had left it. In the morning, when we were at work at the mound, I got quite sick with sleep. Wass obliged to go & sleep in the painted room. I was awakened by a boy who made a long speech in Maya. At the left hand side of the statue they had found another urn, larger than the first, and Dr had sent for me to go and see it. The men were very excited, and anxious to lift off the lid. Three of them managed it—and then recoiled with, at seeing inside red paint, that they took for blood. There was in fact plenty of dry blood with the paint, but it was of course no longer red, and the men did not recognize it as blood. We did not attempt to take away their fear, it was convenient that they should have it. They begged the Dr to go down the ladder into the hole. He did, & took from among the blood and paint, some tiny pieces of mother of pearl, and put them in his mouth[.]

This, he told the indians, disenchanted the whole thing, and they could gather the contents of the urn without fear. Some will think this very stupid, others very wrong. But we had to manage, one way or another, the men we had with us. They were full of superstition[.] To try and shake it was useless. They were afraid, yet we needed they help. Our only remedy was to pretend to have power to prevent anything from harming them.

We gathered what we took for blood, in a rag. There was some very fine red paint among it; we separated it also some tiny pieces of mother of pearl, which dissolved in the mouth. There was also an oblong green jade bead, highly polished (The same I had later, set in gold, in Mexico, and use it as a brooch). We preserved everything, setting aside the greater part of the blood, to be burned later in the day. Near the urn they found part of a flint lance head. On the right hand side of the base of the statue were 31, finely cut arrow heads. 28 white ones—and 3 dark green.

The first urn had contained a little ochre, a round bead, and some ash—brain (?)

The second had red paint, an oblong bead, and some dried up matter—blood (?)

When we burnt the blood the men were so horrified that they took

to their legs, and weapons, and hurried away, not stopping within five blocks distance of the place where we were. Then stopped to await us. We asked they why they had left. "O,["] they said "there was a dreadful smell of sulphur.["] Nicholas Kus, their corporal, had been the first to run. Now, he wanted to make out that he had gone to fetch the men back. In the day, when he had emptied the urn, he had seen his hands covered with red paint, and believing it blood was so horrified, that he took his weapon, and under pretense of being very tired, asked leave to go & hunt pheasants. He did not catch one[.]

After supper in Piste when the men were lying on the ground out in the open air, Dr went to them and made along speech to take away their fear lest they be too timid to work the next day.

He told them in language that they could comprehend that the ancients believed in reincarnation, and put their belongings in their graves so as to have them again at the time of their resurrection. Then the men turned round & told us that they believed just the same thing. They said: "We know that we have to come and live here again after death[.]"

Dr told them that they need not be startled at the blood, because the first urn contained the brain, the second the heart.

Stories about events during the excavation of the Chacmool eventually grew to mythological proportions as they were passed on from generation to generation of archaeologists. Beginning about fifty years after Augustus's death, permutations of those stories would find their way into books and articles.

Most of the artifacts found by Alice and Augustus that were associated with the statue are now stored at the American Museum of Natural History in New York City, and the Peabody Museum at Harvard University.

16

We cleared the figure entirely from the stones, and saw then what a strange posture it was in. On the other side of its base we found another 31 arrow heads. Several of them were green . . . We continued the restoring of the wall and made three tracings. We began to understand that the life of the spotted tiger, leopard, (Chaacmol), was depicted in that room.

17

I remained in Piste till after breakfast. Dr went early with the men. When they arrived they heard two shots in rapid succession. The Dr sent a sentinel up to the Castle, and gave orders to have the arms in readiness. He measured the statue; & then returned to Piste. He wrote to Traconis asking him to send us planks, to make a box for our <u>Chaacmol Statue</u>. After breakfast, Dr returned to Chichen. He found it would be

absolutely necessary in the absence of all machineary, to open the mound on the East side, in order to get the statue out.

They commenced an opening 2 yards wide, and during that day, penetrated one yard. Dr meanwhile made four tracings from the wall . . . For supper we ate the last of the fish that Dr Manzano had been kind enough to send us[.]

In the afternoon the men asked for a holiday to wash their clothes. Dr also remained in Piste copying tracings. At 6 a.m. Dr & I took a walk in search of turkey. We failed to find it, but enjoyed the beauty of the flowers, which in Piste are really exquisite. Within the space of a few yards we gathered a daudy [handwriting uncertain] bouquet. We were again reduced to corn and frijol—so in the afternoon the men went to a hunt called Puh [*P'uh*, hunting] But returned very soon empty handed.

Happily we received plenty of corn from Muchucux[.]

18

The day was passed in the painted room by us. The men worked at the mound. Every day we discovered something new on the painted wall, and little by little the story it revealed became clear to us.

19

Dr was directing the work at the mound. I was up in the room, trying to make out some more of the faded figures. I discovered Kukulcan (winged serpent) in several parts of the wall, we have already copied—As it played an important part we had to retrace[.]

20

The men worked at the mound—We at the wall. At 8 a.m. we went down, & found the men all lying on their backs. We reproved their indolence, and remained to see that they worked. They finished taking away the stones, and we had them to make an inclined plane from the statue up to the surface of the earth—& we intended to get out the statue the day following God helping, and Divil willing . . . Received from Valladolid sugar, coffee, and aguardiente; but no meat, and that was what we most desired.

21

*[Refers to note in margin, which reads "I must not omit to say that there were three well made floors in this mound. The lowest came to the shoulders of the statue, the second on a level with the ground{,} the third about 2 yards above. All painted yellow."] Passed the day trying to get out the statue, but ten men could not move it. We tried in vain. When leaving Chichen we sent the men ahead. They awaited us at the entrance of the road, and when asked what was the matter told us that the enemy was behind. Dr asked them how many shots they had. Only two each. This was bad, Dr had told them always to carry a certain number[.] We

told them to go on to Piste, and we followed on horseback Dr bringing up the rear, on my grey, and I mounted on Charlie, who bore me along very carefully.

When we arrived, the men explained themselves in Maya to Carillo. One of them returning from a senote where we sent them every evening to fetch water for the next day, had seen a figure squatting in the bush.

This senote was also very interesting. We got water there, as access was easy—and a staircase leading down to the bottom, existed yet, though its builders were forgotten and ignored.

Dr wanted to go back to Chichen with men, at once but Carillo said that darkness would overtake them. It was therefore arranged that at 5 o'clock next morning a party should go in quest of the supposed enimy[.]

22

Sergeant Sanchez (white—capenter) was to have started with him at 5 o'clock. When we got up at 6 and found him in Piste, we asked why. "O,["] he said, ["]the men did not want to go." Dr then called for volunteers. All the hidalgos came forward at once. Ten soldiers were called out against their wish. Dr headed the hidalgos—Sanchez the soldiers. Reaching Chichen the party divided, Sanchez went one way with his men—Dr another. Agreed that they should search certain places and then meet at the Palace. If either met with the enemy 2 shots were to be fired in succession, as a signal, for the others to join them. No matter how much game might come across their path, no one was to shoot. The march was made noiselessly, every blade of grass examined, and the result was—nothing. They came upon turkeys, and a herd of deer—food enough for a week or two, but lost it all, being prohibited from shooting. Sanchez returned to Pisté at 9 o'clock with the information that nothing need be feared. Dr remained with his men to work and sent me the black tent for me to line[.]

When he came home he told me he had found the indians knew how to hunt their kind. The ten men together had made less noise than the sighing of the wind, and they examined shrub. They passed the day trying in vain to move the statue[.]

For afternoon ration the men had a little boiled rice. All the corn and beans being again used up.

23

Sent a man to Muchucux to get a thick rope, a pulley[,] corn, and frijol. Seeds of Calbash were given out for the mens breakfast. We sent our hidalgos to the wood to hunt deer, and make rope of vines. At 4 a.m. the moon yet bright Dr & I went out to hunt rabbits; but fortune frowned upon us. We went out two or three times during the same day, but met with no better fate. The Muccena hung everywhere in abundance, enough to supply all the drugstores in creation—but that would not make a good

soup. So all we gathered were a few seeds of convolvulous [a twining plant with funnel-shaped flowers] to be planted in more hospitable ground than this lovely spot that only offered flowers to hungry stomachs. The men returned at 2 P.M. without rope, pulley, or game. Carrilio sent to a ranchito for some calbash, and we made a good meal on them. Chichen remained in its solitude, Dr being busy in Piste, it was useless to send the men to work alone. During the day we received a visit from a very peculiar lizard[.] The people here call it a viper, because its bite is very poisonous, some say <u>deadly</u>. We attacked it and saw verified what many had told us—that it had the property of letting fall the tail, which has a poisonous dart, upon its pursuer. When with its tail this lizard is from 7 to 8 inches long—of a yellowish green color. The tail is about two inches long, and tapers very suddenly. When thrown off it remains wriggling on the ground for some time and the lizard makes its escape. We have not had the opportunity of watching the growth of a new tail, but are assured that it grows again and again, and very rapidly.

We have certainly seen the <u>Chocan</u> with tails of various sizes, and they look quite funny[.]

Nov. 24

Took 16 men to Chichen. Raised the statue upon <u>rollisos</u> and put in position to be pulled out with little trouble[.] Dr had improvised a capston, with a stone ring, and tree trunks. We had a good strong roap made of the bark of <u>habin</u>. In a bad moment that we turned our back the men went into the hole and maliciously, or with an idea to better the matter, spoilt the work of the previous day and put the statue into such position that it was difficult to get it out again, entire. It was tipped up on one corner and its only support a few poles. To put it straight again appeared almost impossible. It was in such a ticklish posture, so heavy, and we without machinary. Falling on its side on the stones beneath it would inevitably be broken. No better fate awaited it if were allowed to touch the walls of the hole, for the loose stones would then come rattling upon it. The space around it was not two yards square, and for a moment we saw a most interresting object foolishly, if not willfully destroyed. Dr was so enraged with Nicholas Kus, that he seemed inclined to stick his knife in him. He ordered all from the spot except two men, and told me to ~~defend~~ hold the rifles from all, if they wanted to touch them. So, revolver in hand, I kept watch over the arms—and the men sat down and sulked. Meanwhile Dr calculated upon the best means of saving <u>Chaacmol</u>. It was a work of great skill. With only two men to help him who understood him badly, within an hour we had the object of our anxiety again in good position. Dr was exhausted and disgusted. He promised Nicolas Xul [alternate spelling; also "Kus"] a whipping[.]

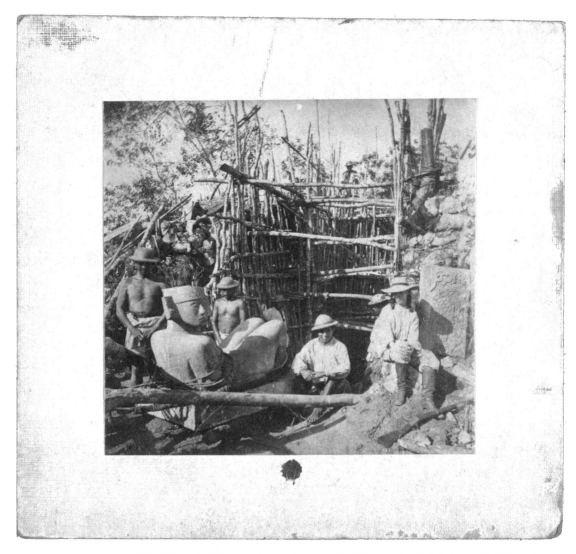

Alice Dixon Le Plongeon is posed next to the Chacmool as it is being pulled from the excavation of the Platform of the Eagles and Jaguars. Photo by Augustus Le Plongeon. 1875. Research Library, The Getty Research Institute, Los Angeles, California (2007.R.8).

We sent the men home, and went to breakfast in Piste on beans and frijoles. During the day Letters were received from Valladolid stating that Palomino might perhaps visit Piste. Dr advised the officer in charge to have the quarters well cleaned—but Carillo always indolent, found a thousand excuses & difficulties[.]

25

Not satisfied with the mischief of the day before, some of the men began to cut the vines that held the poles round the excavation. Happily

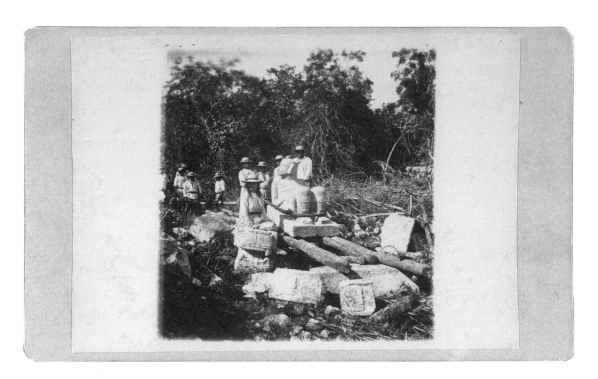

we saw it in time to prevent any serious mischief, and ordered them to rebind strongly. We put the <u>habin</u> roaps round Chaacmol and had the men to work the Capston. The statue did not move—but the rope stretched and broke. We knotted it, and told them to haul it up. They laughed and said that the "Maquina ché could not pull out the enchanted man." But it began to move steadily & slowly and in less than 10 minutes was above ground. Then the men looked stupid with admiration.* [Refers to note in margin, which reads "The base of the statue is five feet long. It is 3 ft. 7 in wide{.} 3 ft 9 in high from the base to the top of head{.} From foot to knee 31 in."] The ribbon round the neck was painted red, it held a badge on the breast. The bracelets were yellow, so the garters. The ribbon that fastened the sandals on were red. The half of the body, the right half was painted natural color—a very plane yellowish brown (a weak solution of aguacate pip gives the exact color) . . . Finding that the large loose stones continued below where the statue had stood we ordered the men to renew the frame work support and continue excavating. They had believed the job was finished, and seeing that it was not, worked most unwillingly. We went away to prepare to make some photographs, and on our return found them all sitting down. Dr told them if they did not work he would not have them paid, at which they at once went to work, but they did every thing the reverse of which they were told. After much patience and repeating to

Alice Dixon Le Plongeon and Maya excavators with Chaacmol that is ready for transportation to Pisté. Note rope around base that was used to pull the statue from the excavation. 1875. Photo by Augustus Le Plongeon. Research Library, The Getty Research Institute, Los Angeles, California (96.R.137).

THE DIARY OF
ALICE DIXON
LE PLONGEON

them the same thing over several times Dr took his knife and destroyed their work which they had persisted in doing badly. It had some effect; they worked well for the next hour or two. At 2 P.M. some hildalgos came from Piste. We did not understand what they said to Nicolas Kus—but he told us that they had come to relieve him and four of his companions, and with out asking our permission delivered their weapons to the new comers and started for Pisté. We set the new men to work and in the course of the day penetrated one yard deeper into the hole, without result[.]

26

Early, men were sent to the Akabzib to fetch mortar for cleaning the room the occupied.

A pig arrived from Valladolid and his death caused a general rejoicing.

Nicolas Kus, and the others who had left us the previous day without permission, had deceived us, their time was not completed. To punish thier bad behavior. Dr sent them to the hacienda of Chichen to fetch a large square urn, beautifully sculptured, that we had seen there. The carried it from the farm to the entrance of Chichen and declared themselves unable to carry it any further. They absolutely refused to obey the sergeant who accompanied, and the urn was left on the road. We took two photos of the castle. Neither could serve. That building seemed to be bewitched. We have taken so many photos of it & none good. We took two photos of the statue, and the men went a yard deeper into the hill. During the night two of the hidalgos, persuaded by Kus, deserted, & went to Valladolid[.]

Nov. 27

The men were again sent to bring the <u>pila</u>, or urn. We went later taking 6 new workmen. In the road we met the men carrying the urn to Pisté. They stopped & set it on the ground for us to pass. My little horse was afraid, & would not go by it. I got down, Dr mounted it[.] After whipping the horse & obliging it to put its nose again and again into the object of its terror, we continued our road. None of our new men understood a word of spanish. By force of signs, working with them, we had something done. The men who brought our breakfast, brought me letters from home dated August 30. Three months to reach us, and we read sitting on stones, in a wild forest. At midday it rained & we had to go early to Piste. The urn had been brought to Piste, but they broken it in two. We were both sorry & angry. At 11 P.M. sergeant Sanchez came to tell Carillo that Nicolas Kus had deserted with five others.

Sunday 28

Dr wrote a long letter to Diaz giving an accurate account of the conduct and desertion of the hildalgos[.] We remained in Piste and had the men to cut down two large trees, from the trunks of which they made

four wheels, to serve for a small cart which would have to be made to bring the statue to Piste.

Shortly after breakfast an aide-de-camp, Valadez arrived to inquire into the cause of the desertion of the soldiers. Valadez arrived hungry, and asked for breakfast. He was given tortilla and a piece of pork which remained—but was intensely disgusted when told that there was no frijol, no aguardinente[.] Dr needed a machete, and taking one from among those of the deserters, he drew it from its scabbard, and two small buttons dropped at his feet, those taken from the mound[.] Upon inquiry we found it to be a machete used by Kus.

29

Valadez took declarations concerning the desertions of the men, and left. In Chichen we passed a very unsatisfactory day. The men did not understand us, and were besides very lazy. We made some tracings from the painted wall[.]

All of the meat was again used up. The rations for the day was bread and a little boiled calbash, that Carillo had been able to procure from the rancho where the bread was cooked.

30

We had 6 men, they worked badly & unwillingly. While we were absent making tracings, one of them amused himself by playing on the statue with his machete. We arrived in good time to prevent serious mischief. Dr immediately ordered a framework of sticks to be built over it. Moving the figure on one side, with only one other man, he strained his hip badly.

For two or three days Dr had complained of a dreadful itching in the head & beard. Cutting his hair I found the cause of it, and passed nearly the whole day patiently killing about 200 enimies which had probably been thrown upon him by some (?) friendly indian. Carrillo had the room half cleaned. Instead of putting on whitewash they had, to save labor, scraped the dirtiest parts of the walls[.]

December 1

We had not expected to enter upon that month in Piste[.] Six men worked at the hole all day and did not go 2 ft down. We used our last sheet of paper on the painted wall, though a few things we had wished to copy remained untouched. Rained heavily at 12 o'clock.

December 1

Received from Valladolid for the Canton—25 lbs of tasajo (dried beef the greater part of which was bone)[.]

2

Being tired of constant misunderstanding, we took a soldier to interpret for us. We made a plan of the Tiger Monument, and had the men to continue digging the hole. Rained hard at 1 o'clock. We all took shelter

in the painted room. Had to remain till 5 when the sun had nearly set—then went home under the rain which continued till 7 P.M.

3

In order to get anything done had to remain by the men all day. At 2 P.M. sent them to hunt deer, or any thing else they could find. We measured the walls of the tennis court. It was tiresome work.

The Colony received from Valladolid Sugar 25 lbs. Coffee 6 lbs. Rice 6 lbs.

4

Continued the work at the mound. In the afternoon the men looked tired & bored, so we took them to all the ruined edifices, that they might once see the work of their ancestors.* [Refers to note in margin, which reads "One of the bearded men in the Castle they believed to be the Dr."] I returned home very unwell[.]

There was a pig awaiting death in Tinun. He was to be executed at Piste, so 6 men were sent to fetch it in <u>coché</u>. Upon his arrival he was condemned to die at 4 o'clock the next morning, sunday.

In archaeological excavations it is standard procedure to dig through all cultural levels until "sterile" earth (free of any cultural material and usually below the layers with evidence of human contact) is reached.

5

The sentence was carried out—and it was feast day for the men for they had fresh meat. I was too unwell to go to Chichen. Dr took 6 men to work at the mound—We did not want to give up while the loose stones continued. Black earth was reached[.]

We went to sleep early—At 9–30 were awakened by a grand tempest which lasted until 11 o'clock[.]

Dec 5

Before the rain commenced to fall we stood outside to enjoy the magnificent display electricity. Thunder & lightning were both continuous, the streaks of lightning darting in every direction[.] It was one of the most beautiful storms we had ever seen. Only have seen one better, that was in New York in the year /71[.] Dr. advised Carillo to have all the powder and shot taken from the roof & brought into the room with us, to avoid an explosion. This was done—meanwhile the rain began to fall in torrents.

I have never in my life seen such a rain. It continued for some time. I did not sleep one moment all night in consequence of a severe toothache. How I regretted to have no forcep on hand.

6

Passed a horrible toothache day[.]

Took eight men to Chichen. Dug one yard down into the solid earth, to the great disgust of the men. We were now at a depth of 10 meters from the top of the mound; and satisfied that nothing remained to be found—we decided to let the stones fall in from the four sides. In that way we could see anything that might be among them. The men put themselves on the beams which supported the framework & began by letting down the north side little by little. The stones which had been so difficult to keep up, were now hard to bring down, owing to the strong manner in which they were propped. The men consider the job good fun (love of destruction)[.] They hopped about on the beams like birds on a perch, to escape the falling stones. While engaged in this business an indian unknown to our party sallied from the bush[.] Our Corporal shouted out "Who are you?" "Where do you come from?" "How many are you?" One by one eight came from the bush. They said they were servants from a rancho belonging to Dn Fermin Irabien (?)[.] The rancho they named was uninhabited. Four were lads dressed in <u>pampanilla</u> [shorts or loin cloths]. They had loads strapped upon their heads. There were three young men, unloaded except one who carried a gun. The other was a very old man, perhaps a hundred years old, for this eyes had turned blue, and his flesh hung loosely over the bones[.] It was always interesting to us to speak with these very old indians. On this occasion I was almost crazy with a tumor growing at the root of my tooth. Not in a mood to speak to anyone, or even to look at them I sat on a stone & nursed my misery. Dr, as he told me afterwards did not even see the old man who hung back, so busy was he directing the tumbling of the mound. The seven younger visitors approached the statue, and gazed at it very earnestly through the framework which surrounded it, but the old man remained far off looking at it with a strange expression of awe. Heaven knows what were his thoughts. They listened with open mouths to the Corporal while he told them that it was a man enchanted since 10,000 years, and that we had found his blood in <u>that</u> urn. The old man from time to time said "coox" [*kó'ox*, let's go!]. When the men touched the stones on the western part of the hill, they fell with a great crash from allsides, causing even the framework of poles to move in a mass. The man inside sprang to the top like a monkey & saved himself[.] They are great gymnasts. They set up a great shouting when the mound tumbled down. The old man advanced a few steps, but remained silent[.] We saw that before leaving chichen the party ascended to the castle. After their departure we began to drag the statue, by means of <u>habin</u> ropes, and levers, over the stones up which we place rollisos. We thought we were starting it for Philadelphia!!

The ground was scattered with sculptured stones of every description, a terrible impediment to the departure of their old buried companion. With much labor we moved it halfway round the mound.

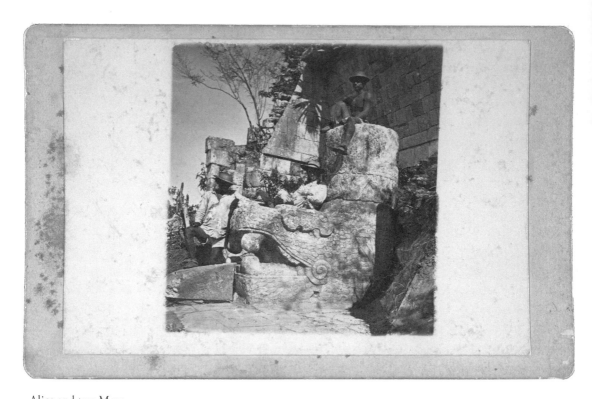

Alice and two Maya assistants resting at the base of a serpent column at the entrance to the Upper Temple of the Jaguars. The feathered serpent, called Quetzalcoatl or Kukulkan, was sacred to the ancient peoples of Mesoamerican. 1875. Photo by Augustus Le Plongeon. Research Library, The Getty Research Institute, Los Angeles, California (96.R.137).

8

There being no road through which to take the statue, it was left alone & the men put to open a road. We made two photos of the statue. Two men were set to clear one of the heads of Kukulcan at the entrance of the painted room—for they were both buried in the dirt of ages. In the afternoon we moved the statue a half a block further on, the men foolishly, getting it half tipped over twice, giving Dr. much trouble to straighten it again[.]

9

We set eight men to finish clearing the head of Kukulcan[.] The Cabo of the hidalgos, a good natured docile fellow, while moving a big stone with one of his men, had the misfortune to let it fall upon his big toe. Happily the foot was not crushed, but it just caught the nail and wrenched it out all except on little spot where it hung. He turned faint with pain, but the next moment asked with great <u>sang froid</u> for the Dr's penknife, and with his own hand finished taking off the nail. We made him sit down and keep quiet. I dipped my handkerchief in cold water and wrapped it round his toe; we had no other remedy on hand. We did our best to console him; but he was very sad, and sat quite still saying from time to time "Mala suerte!" "Un herido!" (Bad luck—One wounded

man). Another man nearly fell down the 40 ft wall. Only his quick gymnastic movements, saved him from a sudden, & cruel death. Dr wanted the Cabo to go back on his horse, but not knowing how to mount, he prefered to walk. He must have suffered a great deal in doing so.

10

Having had the man to keep cold water on it all night in the morning Dr dressed the wounded toe. He made a shield for it with paper and gum, and told the man to keep still. Charlie, the horse was lame for some reason or other, so we all went on foot to Chichen I prefering to walk. Under Dr's direction a small truck was made, and the statue raised on a level with it. That small cart was made without a nail; the only tool employed was the machete (The wheels are in the museum of Merida). We made a photo of the Kukulcan head which the day before had cost a toe nail. The great stone tongue was away from the head but three men replaced it where it should be.

On our return to Piste Captain Fernandez came to put himself at our orders. He had come to releeve Carillo, who had immediately started for Valladolid[.]

11

The day was passed in getting the statue on the cart and moving it a short distance. 6 men were quite insufficient for the work[.]

Sunday 12

Weather decidedly cold. We miss Carillo. He has been very obliging and kind, doing his utmost to obtain any little mouthful of food for us. Early in the morning one of the boys entered the room to get sugar. The boy left his business to listen to Dr & I who were speaking english When Dr spoke to me the boy said from time to time. "Si Señor" "Bueno" & so on. So little did he understand spanish that he could not distinguish it from English, but believing himself spoken to, thought he must say something.

In Chichen we had our men, eight, to fetch from the other mound, a slab of a fish, and took a picture of it. Also took a portrait of Mr Turtle, which we found in the outer part of the tiger monument.

13

Very cold. In seven hours, moved the statue between 3 and 4 blocks ahead. We had to open and level a path for it, as we went. The men pulled the cart by means of ropes they had made. At 3 P.M. we went to Piste, when I discovered a serious loss, my <u>comb</u>.

14

When we wanted to go to Chichen we were told that the Captain's horse had run away. Since the departure of Carillo Dr had used this horse, & I the big Charlie. Doctor under pretense of going to hunt followed

the tracks of the horse & found it tied up in the bush. We saw through the whole thing. Captain Fernandez, anything but pleasant, had a new saddle, & was unwilling for Dr to use it so he had the horse taken away. Dr rode the horse bare back to Chichen . . . Moved the statue two blocks on[.] Finished the photography & had all the things carried to Piste[.]

15

Having received paper from Valladolid, we made it transparent with lard, and concluded our work on the painted [wall]. Eight men moved the statue three blocks forward.

After taking our breakfast we went with the boy who had brought it in direction of the <u>Caracol</u> in the hope of finding deer. Dr led the way, I followed, the boy came behind. I stopped to examine, & called the Dr's attention to an extraordinarily large mushroom. I said "How I wish it was a mushroom." The boy who stood a few steps behind me shouted "Señora, Señora!." Believing that what I touched was poisonous, I took one step back. They boy showed great alarm. "Xen" he said, "mas, mas[.]" I thought I might be standing over an ant nest; and went one or two steps towards the Dr. On his side, the boy retreated, exhibiting great alarm. "Bax" [Ba'ax—"What . . . ?" meaning the beginning of a question] we questioned him. Dr at last saw the object of his alarm— an immense rattlesnake coiled up, looking like one of the many small piles of earth we had already passed—It ~~He~~ was sunning ~~him~~ itself at the door of ~~his~~ its house—a hole in the earth—& preparing to spring at me.

Dr had passed by without seeing him. My stoppage irritated the otherwise <u>quiet</u> <u>sleepy</u> beast. I went quietly towards the Dr—He took my revolver that I carried at my waist—went close to the rattlesnake—tried to shoot down its throat—but, alas! the shot was damp, did not go off. He cocked the revolver again—This time it had effect, but not as he had wished. The movements of the snake prevented it. The bullet entered the side of the neck, and did not produce immediate death. The snake turned & thrust its head into the door of its house. "Kill it" I said for I wanted to make a supper of it—seeing it about 6 ft long. We were in the bush with gigantic trees around, dried leaves upon the ground, but—not a solitary small stick to be had. Before Dr could unscrew his ramrod, rattles and all had disappeared[.]

Where I first stood the huge snake had been coiled up close behind me—When the boy shouted I had gone even nearer to him little dreaming of danger. If ever I saw a dark skin turn white, I saw it then.

On our return to Piste we knew that the Captain had received notice of indians from Valladolid. They, had got new weapons and were likely to attack Cantonil[.]

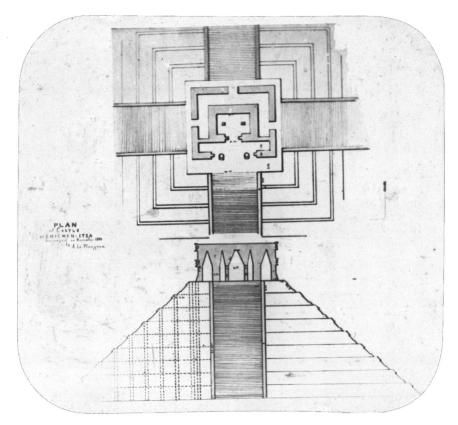

Plan and section of
the Castillo Pyramid
drawn and signed by
Augustus Le Plongeon.
Dated December 1884.
Research Library,
The Getty Research
Institute, Los Angeles,
California (2004.M.18).

16

We went to Chichen with one boy. Made a plan of Tennis court[.]
Also of the pyramid on which the Castle stands. This concluded our
work at Chichen Itza. We bade farewel, not without regret, to that most
interesting spot.

In opening a new road, the men discovered an old one that formerly
run between Chichen & Piste. As it was more level, & more direct than
the one in use, Dr had it re-opened. With nine men we carried the statue
three blocks—on the new-old road.

17

Dispatched nine men to continue opening the road. Dr went after
breakfast to oversee the work. I remained in Piste to fulfill the intensely
interresting occupation of making one pair of good socks out of two old
pairs.

18

Dr went <u>all alone</u> to Chichen to take a measure he required[.] The
men continued to open the old road. Portions of wall yet stood on either
side of it showing that it had once been very wide[.]

Sunday 19

Some meat arrived from Valladolid. Five hidalgos were relieved—The new workers were so willing & energetic that they carried the statue 6 blocks ahead. Dr sent a letter to Palomino asking for an order to reopen the road to Zitaz—One to Font, asking a box from Merida in which to pack the statue[.]

20

The 12th day since we began to move the statue[.] We got it to the entrance of Piste, where the old road ended[.] In Following this road we came to the cemetery formerly used (by the people of Piste, and for some years past buried under the bush. We should have liked to enter this <u>holy ground</u> (campo santo) but . . . when we had gone a few steps forward, the mucuna tormented us to such a degree that we quickly retreated, leaving the dead undisturbed . . . Already our small cart wanted repairing, so the statue was taken off and placed upon poles . . . We had to send one man home from work quite sick[.]

21

The shortest day in our year. I was born on that day, in the year 1851 A.D. So now I am 24 years old[.] Dr. wanted to take our small cart to Chichen to bring from there a tiger & eagle slab which he wanted to send to Philadelphia with the statue. When he called his men together three declared themselves very ill. He examined them, and found them well. Taking them on their own ground he gave them all a dose of qunine & prohibited <u>all food</u>! He caused to be taken from them their <u>sabucanes</u> [a woven bag for carrying things], that their families had furnished with corn food, differently prepared. These poor fellow had (according to their own account) their fameles sick with smallpox. They feigned sick to be sent back to them. The presence of a <u>real</u> physician spoilt their plan.

The truck had been carefully repaired, & Dr went with 6 men to Chichen, in search of the slabs. Their strength was not sufficient to carry the stones, so Dr was obliged to abandon the idea. We left the statue in the woods to await the box, we had asked from Font. Lest any of the men might try to smash it we impressed upon them the idea that it was an enchanted man.

Dec 22

The sick men declared themselves well. Dr declared them sick, & said they could not eat. In the evening the begged for food, & it was given to them.

The people in the rancho refused to make the bread any longer—So it would have to be fetched from Tinun in the future . . . Nine men were set to work to commence opening a road to Zitaz.

We received a wedding card from General Palomino. Captain Fernandez received an official dispatch from Diaz[.]

This told that <u>the public</u> was speaking of revolution, and that if anyone in the Colony <u>moved</u>, the officers in charge would be held responsible. Dr wrote a letter to Diaz, being begged to do so by Fernandez, telling him that the officer in Kaua reclaimed a pig which rightly belonged to Piste. "What did we care for politics being, as we were so hungry?["]

23

We found the road to Zitaz so bad that the statue could not be taken over it. Therefore Dr directed the opening of a new road, through the forest.

O! how happy we felt; when we saw the statue in good preservation; and on its way to compensate some of our labors & sufferings!

Captain Fernandez sat his men to open all the road for a short distance round the church, that he might see the approach of any intruder—by day—but he left the lower part of the church quite abandoned during the night. He, & everyone, except Dr & myself—slept on the roof of the church. Any number of men could have entered the three or four doorways during the night: got up onto the roof without impediment—or killed the soldiers <u>one by one</u>, when they came down at daylight. It never occured to Captain Fernandez that he ought to put a sentinel below because a lady was there[.]

We only have light from 6 a.m. to 6 p.m.

24

Men continued opening the road toward Zitaz.

25

Christmas day!!! The road continued. By nine o'clock every man was on the roof. We went up to <u>look at the stars</u>—There was one exquisitily beautiful in the east. At eight o'clock we took to our hammocks[.] Dr slept at once. I, from wher I lay, suddenly saw a great light in the church. I saw it through the nich where formerly an idol of the virgin stood. This nich was back of the <u>altar mayor</u>. I approached Dr & spoke to him. He did not wake. I jumped into the nich that over-looked the church. One third of the building was well illuminated, but I could distinguish no figure. I returned to the Dr & told him what I saw. He got up. The light had disappeared. He went up and reported to the Captain—That gent remained above, and after some delay sent down four soldiers[.]

They made as much noise as possible, with their rifles on the flagstones outside of our door; then then dawdled about for a full 10 minutes to look for torches. Finally they entered the church and found <u>no-one</u>. We slept with our weapons on hand, but nothing occured. Dr said the

light must have been <u>fuego fatuo</u> [in Latin *ignis fatuus* or will-o'-the-wisp], from the dead bodies[.]

26

The men worked on the road. The men grumbled at the want of meat. Dr gave his Reamington to one said to be a good hunter. But he caught nothing.

Dec 26

Measurements from Tiger Mausoleum

Slab of man lying as if dead—4 ft 4 in. × 1 ft 10 in × 8 inches.
Slab of tiger, eating heart 8 ft 4 in × 3 ft 4 in × 1 foot
Slab of Eagle, or Macaw 1 ft. 8 in. × 2 ft. 11 in × 8 1/2 inches
Statue in the round, wounded tiger 3 ft 4 in × 2 ft 2 in. × 1 ft 6 inches
Eight Tigers. Eight Macaws.
Colors used on the painted wall of tiger monument.
Prussian blue—Dragons blood—Ochre—
Dark yellowish green—produced by a mixture of indigo with a very
 little yellow[.]
Burnt seina, with a little Bistre gives the flesh color.
For the lines, outlines, of the figures, a mixture of <u>laque violette</u> <u>raw
 seina</u> and a very small portion of Carmine.
On the shield of two of the soldiers found painted on the wall we read
 the following. They are at one end of a large canoa[.]

Alice took care to copy the graffiti as it appeared on the wall. The names were written vertically and within a circle and are of a doctor Cabot who accompanied John L. Stephen and his illustrator Frederick Catherwood during their expedition to Yucatán.

S. Cabot Jr. of Boston U.S.A. Anno Domini 1842
S. Cabot Jr. F Catherwood 24th March 1842
We have not found in ~~in~~ part of the ruins the name of Stephens[.]

Mérida, Aké, and Villages to the East

December 1875–April 1876 DIARY PAGES 184–213

December 26

Monday. In the evening men came from Piste with corn. We were very tired of Piste: had heard nothing yet from Font about the box. Decided to go to Muchucux. Dr went on one of the horses that had brought corn—I

on Charlie. Dr. of course had to go on sacks, there was no saddle. The road was abominable. We arrived in the evening and were very affectionately received. It was the time of Cosecha [harvest][.]

Homesick for London and her family, Alice wrote to her parents:

Piste, Yucatan, Mexico. Sunday Dec 26th 1875
My very dear father & mother
 Yesterday was Christmas day, and perhaps before I am able to send this we shall have entered the year—76. I am sure that today you are shivering with cold; while we bask in the sun. Every place and every people with their joys and sorrow. How intensely I should now enjoy a visit to a theater, a little music; apiece of roast mutton; a cup of tea, etc., etc. Don't laugh—I am very much in earnest. If you were here you would feel the same thing, but you would know the pleasure of life in the wilds. No one to please except yourself and companion, nothing to do except your work [ADLP 1875b; see appendix 4 for the complete letter].

27

 We saw the sugar making—Traconis was very poor. His wife very clever. She made nice meals out of a few vegetables and eggs. The <u>coronel</u> was very just with his servants. He caused them each to have a book of their own, & made them compare it with his, so that they might know, no injustice was done them.

28

 They whitened the sugar with earth . . . The trapiche was moved by horses. The boiling, crystallizing & filtering were very interesting to me; but too well known, to need writing down here. There were plenty of oranges in Muchucux.

Thursday 29

 We started to visit Kaua. But the sun was setting before we got half way there so we turned back.

30

 Went to Kaua. Plenty of garapatas. Two large senotes. Dr went down into one, with Traconis and by means of leaves, discovered a strong current. It was a very pretty senote, but the garapatas were intolerable. Kaua is a ruined town.

[1876]

January 1

 Left Muchucux with the family of Traconis and seven servants.

About half way to Piste we found a branch of leaves in the road. Dr & Traconis went into the bush to see who might be found—for a branch, among the indians, means that the road is closed—. They found no track. We continued the march. The country through which we passed was beautiful, but the journey was tiresome because the horses went slowly.

We found that Captain Hernandez had been removed (at Dr's request) and a certain Vargus had come in his place. [The following two sentences are crossed out] He had caused the men to hunt, and when we arrived of venado was ready for eating.

When we had left Piste Dr had lent his rifle to the men, & told them to hunt. They had hunted a deer, and preserved a fine leg for us. When we arrived it was half putrid—the men accepted it from us and ate it joyfully. During the night Dr & I both had a severe attack of ague and fever.

Sunday January 2

Went to Chichen with our visitors. Felt ill all day long, had fever, and could hardly walk about.

3

Made a photograph of Chaacmol; after bringing it close to the church, with the aid of Traconis men. Traconis & wife left, a gave to their son Juan, my escopeta [shotgun][.] He wanted one very badly, and his father could not afford to buy him one.

4

Continued the road to Zitaz. Dr received a letter from Diaz telling him that within a few days the hidalgos might be taken away. Received a melado (Calbash boiled in syrup)[.] The weapons from Muchucux would at least be taken, owing to a revolution[.]

5

Took the tiger on the road to Zitaz, three blocks from the coco tree. Took it in the bush—covered it with oilcloth & built a roof over it. Then covered it with branches, so that no passerby might see it. Packed our boxes.

6

Left Piste. Abandoned our statue, well protected, untill we could return with a cart to carry it away[.] In Zitaz we went to see the Cura who had our bolan in charge. Passed a few hours in the house of Dn Pablo Lorea—Dr had a bad attack of fever.

7

Arrived at Valladolid at 1 a.m. Found Dr Manzano up. Conversed with him for awhile[.] Colonel Diaz visited us during the day. Told us he was very sorry to have had to take away the men and weapons, but Canto (Tiodasio) had raised a revolution[.]

8

Dr had a very severe attack of fever. Carrillo visited us[.]

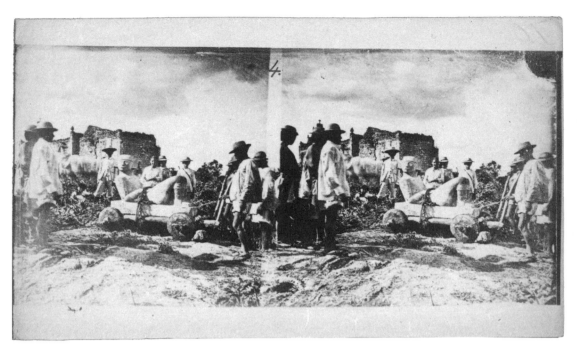

The Chacmool on
the wooden cart
handmade by Augustus
Le Plongeon. It took
twelve days to clear a
road so that it could
be transported from
Chichén Itzá to Pisté.
Alice in hat stands
in background. 1876.
Photo by Augustus
Le Plongeon. Research
Library, The Getty
Research Institute,
Los Angeles, California
(2004.M.18).

9

Decided to start for Merida. All the mules were in cosecha, and we could find none for our bolan[.] Our bolan had to be left Valladolid[.]

11

I had made a copy of all our negatives and at 10 o'clock at night was mounting them. Packed afterwards[.]

12

Took chocolate with Dr Manzano at 5 AM. By the by, on the 10th we were showing to Manzano the earthenware lid & he accidentally let it fall[.] It broke in pieces—he mourned over it a great deal. The coachman was disinclined to carry the luggage. He had an empty Bolan to take to Merida besides the one in which we were going. He put the luggage in that. We reached Zitaz at 11 a.m. Were very kindly received by the family of Lorea. Dr had an attack of fever & ague. Dn Pablo gave us a house, belonging to him on the other side of the road, to rest in. We took a good nap. At 10 p.m. by moonlight we left Zitaz. The road was atrocious—I was very sea—or rather bolan sick[.]

13

Reached Izamal at 8 a.m. Were very warmly received by Dn Joaquin Reyes. At 10 p.m. went to sleep in the room he had formerly put at our disposal.

14

At 2 a.m. left Izamal. A better road. About 4 o'clock in the morning,

Dr was taking a nap—we came to a group of men stationed by the way side, all armed with rifles. I put my hand in my pocket for my revolver, and with the other touched Dr, & whispered to him—"men on the road, armed." They were about 20 in number. We passed. They said nothing, nor did we. We went very slowly to see that they did not harm the boy coming behind with the other bolan and our luggage. The men made no movement. We left them standing in the moonlight just as we had found them (afterwards we were told they were waiting for certain politicians). At an early hour we took chocolate at Tixcokob [Tixkokob]. Reached the house of D. Juan Jose Herrera in Merida at 12 o'clock where we received a hearty welcome, and breakfasted.

15 ⇝ *Merida*

Visited Da Rudacinda Rosado de Irabien—Dn Dario Galero invited Dr & I to dine with him next day[.]

16

We dined with Dario, his sister, and his daughter the ex-belle of Merida. His house is a palace. It was prepared for Carlota, who lived there during her stay in Merida. Dario gave a fine dinner[.] Afterwards several gentle-men arrived, and all went to gamble in a room set apart for that purpose[.] Dario was not glad because Dr. refused to play. The old sister of Dario sang and played the piano quite nicely. Dominga was very amiable to me[.]

27 ⇝ *Motul*

Left Merida for Motul, a villa 10 leagues distant[.] The road was the best we had yet passed over, in Yucatan. We stopped half way at a village called <u>Conkal</u> to take some Chocolate. The <u>pueblos</u> presented a clean and prosperous appearance very different from those of the East. At the entrance of Mutul we had to pass over a very stony piece of ground. In doing so one of the screws broke and our bolan came half way down on one side. I alighted, and accepted the invitation of a young shoe maker to enter his house close by. The city was in <u>fiesta</u>. At this moment the indians and their numerous babies, were returning from bullfight, to their <u>ranchitos</u>. As is the custom, all had to stop and see what was tak-ing place. The bolan was tied up with ropes, and we started to conclud our journey. Never had we seen so many of these indians together. The <u>Plaza mayor</u> was so crowded, we could scarcely pass through it, and every here and there we found a dark skinned gentleman stretched across the stretched across the pathway in a happy state of unconsciousness, enjoy-ing the festival <u>a lo indio</u>. In all the crowd we saw no dispute, though the majority of the people were intoxicated. We had a letter of introduction from Dn Liborio Iregoyen, already sent to Judge Francisco Guitierrez. To his house we went at once. His wife, and widowed daughter were at the window. They were expecting us and gave us a warm welcome.

Since a week, when they had received Dn Liborios letter they had taken a house for us. The house adjoined their own and was newly cleaned & arranged. We asked where we could obtain board. Mrs Gutierrez kindly undertook to provide it. So during our stay we ate with the family[.]

Sunday—last of the fiesta. I was unwell so did not go out to see what took place. The people were inthusiastic in their praise of a traveling gymnast troop.

In the evening two old indian women, accompanied by two young ones came to complain to D. Francisco. One had bought a turkey which had been stolen <u>from</u> the other.

The purchaser had paid for the bird 7 reals, not knowing that it was stolen property. One wanted back her turkey, the other her money. They both jabbered away in good maya that we did not understand. The judge told them to come again in the morning. They went away enraged with each other.

We sent our cards to the principal families, as etiquette demands in Yucatan.

February 1

A lady & gentleman, Mr & Mrs Losa of Merida, who had been enjoying the fiesta, visited us. We had known his brother Miguel Losa in Valladolid. Mrs Losa was pretty and charming. When she saw the photos of Chaacmol she assured us that the indans today when conversing take that same position as one of rest. After breakfast we arranged a studio for taking portraits. While thus occupied Mr Casiano Lauri, for whom we had brought letters of introduction, came to scc us. He put his house at our disposal[.] When he left he sent us some good fruit to which we did ample justice. In the afternoon notice was received that in Cansaca [Cansahcab], about 5 leagues from Motul a party of revolutionists had made a move & ransacked some houses[.]

Motul is a pretty place, but the church is one of the ugliest in the state. This I found out because Da Demetria, Mrs <u>Gutierrez</u>, asked me to go to mass with her. During mass there were four dogs in various parts of the building. One with priest at the foot of the Altar, another a few yards to my right. The one at the altar was not a christian, for he passed the whole time rolling on his back, scratching out his fleas, and staring imprudently at the devote congregation. The second was an heretic, for he neither crossed himself, nor beat is breast, but amused himself playing with a very small dog. I could have pardoned that, but later he had a fit of convulsions, and came quite close to me. The fright he gave me was unpardonable. If I fear anything it is the bite of a dog,

THE DIARY OF
ALICE DIXON
LE PLONGEON

& hydrophobia is common in Yucatan . . . I sent letters home with a few views. In the evening there was some confusion in the neighbourhood, caused by the death of a lady. The grief of the husband was so loud as to be heard nearly a block distant. A rush was made for some gunpowder. Of course we asked "What for"[.] And learned that it is customary throughout the Peninsula to burn gunpowder round the hammock or bed which the body occupies, the moment life is extinct. No one could tell me why.

In less than half an hour the was filled with the friends of the departed. They dressed the corpse, and folded the hands across the bosom as is customary for married ladies. Maidens have the hands clasped as if in prayer and a wreath of white flowers on the head and on the breast[.]

3

Before breakfast, 12 hours after death, the gentlemen of the neighborhood carried the lady to her last resting place. According to custom, the lady friends would keep a candle burning day & night, for one week in the room where she had died, and every night they would upon the same spot pray for the repose of her soul.

In some of the villages, on the 7th day a great feast is made in which more is spent than at a wedding[.] The time is passed, eating, drinking, gambling, & praying.

We have been assured that poor people will sell even their small hut to fulfil this last duty to the departed—and a girl who has nothing else will sell herself to honor her father, mother, or husband. All the inhabitants of the place have to be invited to this feast[.]

This information I received from Da Demetria G. We went to visit Mr. Lauri. While there 300 Mex. soldiers entered the city to pass on to hunt down the revolutionists.

4

Motul is not without a senote. Its waters are said to work miraculous cures. A lady assured me that friends of hers who had been unable to nurse their offspring, obtained abundant milk by bathing there[.] Intermittent fevers are cured as if by magic etc. etc[.] We went to see it. It is in the outskirts of the villa and belongs to a poor man who has built a small house near the entrance. Little by little he is making a fairylike grotto of the senote, where in the warmest months of the year, the people pay him a medio (6 1/2 cents) & go to bathe.

In return for this medio he provides them with lights, and curtains off a part of the cave where they can dress and undress. He also sells refreshments, for which he asks his own price.

The mouth of the cave is small, and was formerly very bad, but now has a good stone stairway cut in the rock. We entered into a well [not

readable] spacious hall, which in the first moment appeared to us black as night, coming as we did from the sunlight. Here balls are sometimes held. About 25 yds beyond we saw under a very low archway water sparkling like a thousand diamonds, from the reflection of a small light that entered from above[.]

The bather enters, and finds himself in a deep pool of perfectly transparent water which a space as large as the hall. We did not enter the water, but stooped, to look into this great natural bath. The water was very soft to the touch, almost as if mixed with soda[.] It is probably lime water, as is generally the case here[.] The transparency is such that stones can be counted in the bottom though at a great distance. At first one does not see the water. It would be easy to walk into it unawares. . . . We received notice that on the previous day the Mexican troops had fought the revolutionists in Temax, three leagues from Motul & in Cansacah [Cansacab]. The people of Motul were alarmed[.] Many packed their belongings, ready to start away if Canto's party should arrive.

Feb 4

On this account, the upset, we received very few visits in answer to our cards.

5

Notice of another conflict in Temax. 16 Mexicans occupied the church. 8 of them went out with the officer to defend the Plaza. The others remained to guard the ammunition. Those in the Plaza had to stand against 200 or 300 for 6 or 7 hours, when national troops arrived from Merida and killed a great number of the revolutionists, who afterwards dispersed. Four of the Mexicans were wounded, & brought into Motul. Cosme Crespo, one of the revolutionary leaders was shot. The property of Teodosio Canto was confiscated.

This is the story as it reached us.

6

Received a visit from the Cura. Took a photo of Mr & Mrs Gutierrez[.]

7

Received a visit from a Cuban gentleman, ~~who~~ practicing medicine in Motul. The people spoke very highly of him; but he spoke very badly of the people. He called them gamblers, scandal mongers, quarrelsome, ungrateful.

10

For want of better occupation pass our time reading novels[.] Read "La hija del Judio." It is well written—By Dr Justo Sierra. Gives some of the history of the Peninsula[.]

Read La Reine Margot—by Dumas.

Mrs Lauri and four young ladies came to see us all pretty and amiable[.]

11

Mr Lauri brought his carriage to our door. We went with him to a small village one league distant. Arrived there we alighted and went to see the serros [*cerros*]. On the right hand side of the road were two, one with a platform half way up like that of the large serro at Izamal. On the left hand side of the road three mounds very much destroyed. The indians of the place told us that rooms existed at the base of the mound[.] The men who were serving in the <u>casa Municipal</u> accompanied us with their machetes, to open a path that we might examine said rooms. We were disappointed for the rooms were of spanish construction, as we could easily see by traces of circular arched doorways. Returning from the <u>pueblecito</u> we went to visit the <u>quinta</u> of the curate of Motul. He had not yet a house built on it—but yes, a very pretty garden and some excellent oranges, which we helped ourselves to & found very sweet—being stolen. Men were working the henequen, with a machine & small steam engine which had cost, when it reached Motul 1200$. The machine wasted a very large part of the filament.

12

In the evening we visited the young ladies who had been to see us. Found them, as in Tizimin, pretty[.] Rumours from the capital informed us that the good people were discussing Chaacmol—their right to it— and our <u>non-right</u> to take it away. There was also news that a revolution was feared in Merida. Dr visited the mounds of Motul. Found them much destroyed—but in one discovered traces of the phallic worship. Broken fragments of the male & female organs remained, & he tried to carry some away, but being made of mixture, not carved in stone, only succeeded in obtaining one piece.

13

Dr wrote to Mr Bernado Peon asking permission to visit his hacienda of Ake, where he was told there were ruins.

14

Went in bolan coche with part of the family of Mr Gutierrez to visit a small country seat beloning to him. When one league from Motul we stopped at a small place beloning to his daughter who accompanied us. There we found two men working henequen by hand with the <u>Tonkos</u> [similar to a machete, but shorter]. The work is slow, though some men can prepare 25 lbs a day. The work is cleaner, & less wasteful than with machine. One of the men thus employed, failed to come & greet the lady to whom the place belonged. Mr Gutierrez called him, & boxed his ears. The had to put down his head, and hold his tongue. Poor Indian! For the

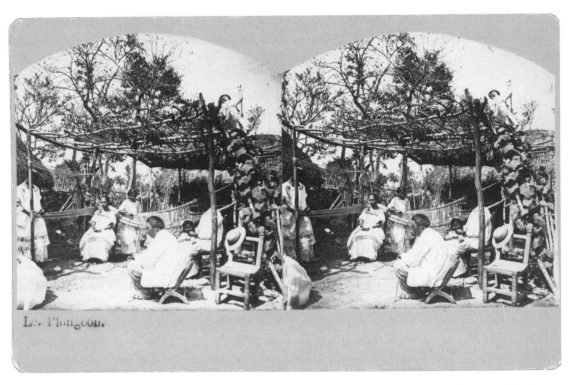

Le. Plongeon.

first time in Yucatan we saw here a few sheep. They were worth 4$ each[.] We ate some fresh oranges, and passed on to San Antonio[.]

The commerce of Motul is henequen, and henequen bags; with fruits & vegetables that are sent to the Merida Market. 6000 bags are sent every Monday to Merida.

San Antonio is quite a pretty place, and has a nice little cottage. We ate raw tamarinds, then as the cows were being milked drank some of that. Afterwards took coconuts & oranges—Strange to say the stomache complained of this liberal treatment.

Dr made three photographic views with much trouble for the wind was very high & dust flew in every direction[.]

After their side trip to the lovely village of San Antonio, they returned to Motul by the same road, and then traveled south to Tixkokob where they spent six pleasant days, thanks to the hospitality of Pablo Ancona, the Catholic priest. The distance from Tixkokob to Aké is about eight miles, but to their surprise, the road was almost impassable.

15 ⟶ *Tixcokob*

Left Motul. Reached Tixcokob at 10 A.M. Went to the convent, whither we had been invited to arrive by the Cura, Pablo Ancona, to

Yucatecan family in their garden at Tixkokob, Yucatán. The women are in traditional *huipils* and are weaving hammocks. 1876. Photo by Alice and Augustus Le Plongeon. Research Library, The Getty Research Institute, Los Angeles, California (2004.M.18).

whom we had been introduced by Judge Gutierrez in Motul. He received us with open arms, and all the hospitality for which he is renowned. In the afternoon he had his carraige made ready, and took us to a small finca where he had planted an orchard of almost everything. The cabbages would have graced a garden in any part of the world. While standing there several ladies came for the same purpose, and the Cura introduced us to all of them. As Cura Ancona had made a very good road from the <u>villa</u> to his quinta, and is always improving it, it serves commonly as a <u>paseo</u> for the ladies. I sent a large bunch of bananas to my friend Mercedes Irigoyen. The bunch contained 64.

17th

 Sent cards to the people in Tixcokob.

18th

 In the room adjoining the vestry we found a man making a hammock of of red, blue, yellow, & white enequen. Upon enquiry we found that the colors were produced from. <u>Red</u> from the wood <u>Chacté</u>[,] <u>Yellow</u> from wood called <u>Mora</u>. <u>Blue</u> a mixture of <u>Palo tinte</u> and <u>Cardenillo</u>.

 Mrs Gorozica came to see us—& took us to visit other people . . . Saw a man making henequen twine of two threads which he had previously prepared[.] In one hand he held the ends of the two threads, with the other he rolled them, separately in one direction over his naked thigh: then rapidly back the two together in one direction. We timed the work by our watch— without saying anything to him—& found that he twisted a yard in each minute. Working thus all day long! the operator can earn a—medio!! A very old man, Mayor domo of Ake, arrived from Merida, & brought—by word of mouth—permission for us to us the house of Don Bernado in Ake. He told us that Mecedes I. de Herrera now had a little daughter. Later in the evening a telegraphic dispatch was received in Tixcokob from Mr Peon asking if we had yet started for Ake. Our answer, whatever it might be, had been paid in Merida. Of course we answered a simple negative[.]

19

 Received a letter from Dn Alvaro Peon Rigel—in answer to the one we had written to Don Bernado—putting Ake at our disposal[.]

20

 Dr answered Don Alvaro. I wrote to Mercedes.

 We arranged to start for Ake—three leagues from Tixkokob—on the following morning[.]

21 ✇ *Aké*

 We had received from some very favorable accounts of the ruins of Aké—From others the reverse. L. Stephens says little of them, but he had so misled us concerning Chichen Itza; we thought it best to see Ake for ourselves[.]

To our surprise we found the road, leading to one of the haciendas, of one of the richest men in Yucatan, almost impassable. At least for the saving of his own carts & mules, he might have looked to it.

We arrived at the gate which was closed, & I saw no one. After a while old Don Filipe Burgos (the Mayor domo) one of the skiniest beings I ever looked at, appeared, and led us to the Casa principal, which he then unlocked[.] A good sized room. Containing half a dozen rickety chairs a bare wooden table, a small heap of corn in one corner on the floor, two empty bottles on a shelf formed in the wall; constituted the contents of the room. One room adjoined it, smaller & entirely empty. There we hung our hammocks. Cura Ancona had provided us with breakfast. Otherwise we should have gone without. The hacienda of Ake* [Refers to note in margin, which reads "In maya language we do not find the ethemology of Ake. But Ake was the third person of the triad at Gsneh. See Sir Gardner Wilkinson."] has once been very pretty, but now it is a dreary place. The two rooms I have mentioned are the only habitable ones. The corridor without, has a thatched roof. On the whole premises there is but one good fruit tree. A Mamay. There are plenty of trees loaded with sour oranges[.]* [Refers to note in margin, which reads "Want of Attention! All the oranges here turn sour unless engrafted with sour oranges. So Cura Ancona says."] The only vegatables growing on these large premises are a few onions, and some radishes grown old & woolly. Everything dirty & out of order—Nothing worth looking at save eight pigs. In the cattle yard are 100 horses, and 200 oxen. Such was Aké in the hands of Dn Bernado Peon.

At his request, his nephew Don Alvaro had written to put everything at our disposal, but with difficulty we were able to purchase a few eggs for our dinner. After breakfast; Dr took a look round. I went to the hut of the Mayor domo. Found a pretty girl grinding corn. Here is the dialogue that passed between us. "Good morning Señorita, [not readable] you have a hammock to sit in." I accepted the seat. "Tell me, hija, what do you eat here."

"Bread."

"Is there anything else to be had here?"

"Nothing"[.]

"Can you make bread for me?"

"Oh! Yes."

"Have you any eggs?—for sale I mean."

"For sale, yes."

"I had expected to find everything for sale here, so brought nothing, so hope you will be kind enough to sell me what the place affords."

The girl looked at me amazed.

"Ah! When La Señora (Mrs Peon) comes here, she brings servants, furniture, and provisions."

Dr returned from his stroll somewhat disappointed. The ruins were of an architecture very rough. And the mounds, less two, so much fallen that it was difficult to decide how they had been.

Our slumber was disturbed during the night by the presence of various Chocans (the viper that throws off the tail). In the morning we had men to hunt them from the ceiling. Three fell & one cast off the tail when dying. These animals make a noise like the cackling of hens[.]

The archaeological site of Aké is smaller than Chichén Itzá and Uxmal, but it was linked in ancient times to the important Maya city of Izamal by a causeway (sacbe) almost twenty miles in length. The site had a long occupation that began around AD 250, and continued into the sixteenth century.

The Le Plongeons began their exploration of Aké by inspecting a long, low structure with a broad stairway called the Palace. What intrigued them were the many columns in the Palace that were made by stacking large stones. They concluded the stone columns not only were an architectural feature, but also were a method the ancient Maya used to count the years. That assertion has never found any support from archaeologists.

22

Went out at daylight to examine the ruin called <u>Palacio</u>. Old Dn Filipe had been told to put the 10 servants at our disposal, so we set them to cut down the bushes which prevented us from seeing will the objects of our interest. [One line of text is crossed out—not readable.]

The Palace is an oblong pyramid, of very rough construction certainly not built by the Itzaes. Aké was inhabited at the time of the S. Conquest 300 years ago. They were a very warlike people who lived there.* [Refers to note in margin, which reads "Cogolludo or Landa, says this. I do not remember which."] El Palacio is a mound of three terraces. A wide and very irregular staircase faces the South.* [Refers to diagram in margin, which is labeled width, length, depth.] The width of each step varies between 1.30° and 1.50°. The depth is 0.50° centimenters. Each stone is between 1.90° and 2 meters long.

To place these stones must have employed the strength of many men of our size, or perhaps the builders were giants for we are told that the skulls of gigantic people have been found here. Indeed only giants could ascend & descend this staircase without getting tired. Here and there we find stones that indicate that these steps were originally 36 in number, though today 18. Yet I do not see who could take the trouble of moving away every other step. These stones may possibly have assisted in building

Ruins of the Palace at Aké. 1875. Photo by Alice and Augustus Le Plongeon. Research Library, The Getty Research Institute, Los Angeles, California (2004.M.18).

the hacienda of Aké. On the upper terrace are 36 columns—three rows, twelve in each row. The distance between each column N. and S. is 1.15°. Distance between them from E. to W. 4.45°. They are 4.10° high. Each pillar is formed of eight square stones, placed one over the other. On the top of the seventh are four small ones, one at each corner. The eighth rests upon these. No attempt has been made at hewing. They are very roughly squared, and in order to level them, the spaces are filled up with small stones & a very coarse mixture. A great part of this filling up has fallen away, and today between the large stones the iguanas find a good home. The thickness of the column is 1.7° × 1.30°. They are surely the columns of which Cogolludo speaks. The monument bears no traces of roof. We made a plan of the building. A hen was given us for breakfast. I asked the price of it, and was told "nothing." A nephew of Cura Ancona, came with another gentleman to make us a visit.

23

I was useless the whole day long with a severe attack of intermittent fever.

What the hacienda contained was afforded to us. The cows were milked for our special benefit, and we drank fresh milk, but when we wanted to keep it to make cottage cheese, we found it not practicable[.] The milk is very poor, owing to the writched pasture. Dr took three or four views. Only one served[.]

24

A tiresome day for us. We had thought to make a certain amount of photography, and it seemed that everything had combined to prevent.

The sun was very incontant, and when it did deign to shine at the right minute, the wind swayed the trees back and forth & made hideous blur on the plate. When wind and sun favored us, the indians, placed to beautify the picture would move. In the dark box the dust gave us much trouble, and had difficulty in keeping the curtains down owing to the wind. We obtained only three plates, after making a great number, then gave up, for the colodion began to rib[.]

We had no other with us, so in the ~~evening~~ afternoon at 3 P.M. Dr mounted a horse not much bigger than himself, and started with a servant for Tixcokob. At 8 P.M. he returned, then we took our dinner. A small chicken with some broth and torillas—luxurient for the place. Dn Filipe did his best for us, and the pretty girl with whom I had conversed on the day of our arrival, cooked to the best of her ability[.]

24

Before breakfast we took three views, but the bath fogged and our labor was in vain. In the afternoon I was down with fever. Dr took a plan of <u>Sucuna</u> (Brothers house)[.]

25

Soon after 6 a.m. A party of indians, 5 men, as many women, and 6 or 7, arrived. They had come in pilgrimage from a neighbouring hacienda to adore the Virgin of Aké, a wooden doll about 1 ft high, and ugly enough to frighten away the devil. One man carried a violin, two guitars, another a drum, and the fifth aguardiente. The women carried babies, and provisions for the day. This virgin is said to have performed many miracles. The women commenced the business of the day by putting on clean <u>uipils</u>. The men began by drinking a glass of anise.

The virgin had been on a visit to Tixkokob, and the man to whom it was lent did not want to give it up for some reason or other. The virgin was prisoner[.] Immediately the Son of Dn Filipe was dispatched to fetch the lady in person. Meanwhile the musicians entertained the company. We went with a few few men to carry our box to the building called <u>Sucana</u>. This building, like that of the katuns is rough in the extreme— and so destroyed that Dr had found it difficult to make the plan. There is a sacrificial stone with a gutter carved in it and traces of walls forming rooms, which we had not found elsewhere in Aké. While taking views of this edifice a boy came to inform D. Felipe, who accompanied us, of the arrival of the virgin. Such an important call~~ed~~ must be obeyed before all, so the old gentleman started off to receive her, apologizing to us. After some delay we obtained two good views. The men carried the box to a senote which is about halfway between Sucana and the Casa principal. It was 11 a.m. All complained of hunger. So we went to breakfast.

The devotees had lit wax candels, and placed them in the doorway of

the small chapel inhabited by her ladyship, the doll. The day was passed by them in the following manner. All knelt before the altar and prayed in latin—first said, afterwards sung—not musically. The prayer concluded all took a drink of <u>agaardiente</u>. After which the men played and the women danced until all were tired, they they began again by praying. Again we had the occasion to see the emmense quantity of liquer the indians can take without getting intoxicated. Every half hour they swallow about 5 ounce, and at 3 P.M. no one showed signs of giddiness. A little after 4 o'clock when they began to totter they retired, at the suggestion of the mayordomo[.]

In the evening Dr felt symtoms of ague[.]

We sent word to Tixkokob to bring a bolan for us next day.

Sunday 26

The bolan arrived at 7 a.m. instead of 5 a.m. as we had asked. I asked the mayor domo how much we owed him for his assistance, and our board. "What your good heart tells you lady." Was his answer. A most unsatisfactory answer[.] I paid him what I considered a just price and told him: "If it is not enough, tell me so plainly at once"). So in the hacienda of one of the richest here we paid for a few tortillas and one or two chickens. <u>A propos</u>, I am told by a friend the following story of the P. family. A priest, (A.) who had done one Mr P many favors, went on a jurney. He had occasion to pass through two large haciendas of Mr P. He carried no provision, because, said his to his old housekeeper (M.) "I pass through the haciendas of my friend, & shall undoubtedly find plenty." At 11 a.m. he reached the first hacienda. The mayordomo received him "Good morning, friend. What have you got for me to breakfast?" "Nothing sir, but if you wait awhile, my wife will cook at 3 PM[.]"

"Thank you, I will pass on."

Shortly after 2 P.M. our friend reached the second hacienda, and congratulated himself when shortly after, the owner of the property arrived. Said he within himself "Now I shall breakfast, or dine, with Mr P." This gentleman called the servant.

"Have you got anything to eat here? A little meat or anything of the kind."

"No sir, but we can grill a hen."

"No, No, No, We are in an hacienda food is never wanting."

The gentleman forthwith gave order for two cattle to be castrated, and the severed members to be cooked and served for dinner. The dinner hour arrived. The priest then arose to take his leave[.] "No, No, No," said the host, "You must stay and eat with me. You have no idea how good a thing we are going to take."

"Sir," replied the priest, "You have seen my cook and know what kind of a table she puts for me, & for guests & how cleanly everything is cooked.

I have seen how carelessly your dinner has been prepared. I would rather go hungry than partake of it." He then started again on his journey.

On the road from Ake to Tixkokob, I had a severe attack of ague, & vomited repeatedly. The road was horrid, and my head ached severely. Every inch of the road was a martyrdom for me, and I shall never forget that ride. Arrived at the convent[.] I had all that the world could afford to make me comfortable, but the fever had got such a firm hold that it continued all day & night unabated.

27

Could not cut fever or headache. I took emetic[.] Dr hunted for quinine—was happy enough to find a quarter of an ounce. Administered it to me in frictions. Dr himself felt unwell[.]

The following is an extract by Alice from a book about the Chan Santa Cruz Maya who fought to maintain an independent territory in eastern Yucatán. Their capital in what is now the state of Quintana Roo was called Chan Santa Cruz and was renamed Felipe Carrillo Puerto.

28

Myself a little better. Dr took emetic. I read the following—& translated some parts of it[.]
"The Misteries of Chan Santa Cruz"
"A true story with novel episode" by "Napoleon Thefarra."
Extracts.
In the year 1849 Chan Santa Cruz was founded[.]

Feb 28

[Following is quoted by Alice]
In 1854 the rebellious masses were divided among themselves, and only the most barbarous remained to occupy the place they had chosen for their center. The others became pacified, although they lived and behaved always among themselves like wild beasts. At this time the war might have been brought to an end, but political disturbances, & individual selfishness, prevented it. Chan Santa Cruz is today the central barracks of the rebels. Its dependencies are[.] Derepente, or Chanca—Ocom, Santa Rosa, Panha, Pinché; and other ranches of less importance. In the first spot are gathered the chiefs, petty chief, and about a thousand indians[.] In the other places are scattered the rest of this barbarous people. Altogether they may number more than 4000 souls. As time has gone on they have made themselves famous, by their fortunate excursions, their encenderies, thefts etc. etc.
Notes on the rising of the natives of Yucatan.

On the 27 of July 1847 Colonel Jose Eulogio Rosado sent word to the Government of the State, from Valladolid, of which department he was then magistrat and military commander, that he had discovered an conspiracy of indians to exterminate the white race. Manuel Antonio Ay, who was ordered to be shot after investigations were made. The government, by date 31 of the same month approved this and other measures dictated by Colonel Rosado. On the 30 of the same month the indians of the pueblo Tepich of the department of Tiosuco. And in the same hour simultaneously killed with unheard of ferocity all the people they could find not pardoning Meztizos, mulatos, nor even those indians who were called hidalgos. Then cut the throat of the aged, & infants, and only left the women alive to satisfy their brutal passions.

The vecinage of the pueblo of Tiosuco justly indignant, in mass begged that five leaders should be shot. These five leaders were among twenty two prisoners, taken by Trujeque. This had to be verified in all due form. Trujeque and Don Vito Pacheco pursued the mutineers as far as until they drove them into the woods, but not for that did they fail to appear in various parts, for which the Government had to dictate severe ordinances.

On thursday, November 19, 1861 there was another rising in the pueblo of Quiestiel. And on monday the 14th of December, the celebrated said chief Jacinto Canek was destrozado in the public square of Merida; but his confessor, cura of Sn Cristobal, Dr Lorra, preached upon the scaffold, a discourse in which he said that Canek was more innocent than the spectators.

Extract from a letter written from Chan Santa Cruz to Belize.

"When those gentlemen come send me
6 skulls of cheese
1 Demijohn of Gin
1 Box of sweet wine
3 Dozen silver guitar strings
1 Box of Florida water
1 Quintal anise seed
6 Cases of sardines
1 Piece of manta
1 Cuerro Maroque marrocco leather (?)
3 Cases of Champagne. The worth which you will charge to
my account
Tunkas was taken in 1864
ADLP [Initialed by Alice]

March 6

Dr & Curate Ancona went to Merida. Started at 4 a.m. Returned in the evening[.]

9th ❧ *Katanchel*

We were invited to go with Cura A. to a quinta belonging to his brother Teodoro Ancona. A festival was to be held to celebrate the putting up of a steam engine, for working the henequen.

At 5 a.m. we left Tixkokob in bolan coché. A two league journey, over a very bad road, as usual. Two other bolans passed us at full speed, laden with young ladies going to the same place <u>Katanchel</u> of which San Juan de Dios is the Patron saint, is one of the prettiest haciendas we have seen here. A double open corridor forms the front part of the house, which is reached by a wide flight of steps. The lady of the house, a martyr to asthma, Da Chueka, received us with enthusiasm. We went to see the working of the henequen. The machine & boiler had been blessed two months before, and on that occasion a man had had his arm torn off. The benediction was a <u>curse</u> for him[.] We found in an inner apartment a gathering of ten or twelve young ladies, all in simple calico dresses, we remained in like costume. Cura A. had to commence the day by celebrating mass; the harmonium had been brought from the church of Tixkokob for that purpose, and put into the chapel of the hacienda. Mass was celebrated with great solemnity. Half an hour later everyone took wine. The orchestra of Tixkokob, of nine musicians, arrived, took their place in the corridor and at 9 a.m. dancing commenced. The gentlemen guests arrived <u>en masse</u> on horseback, & a joyful animation reigned through out. The intervals between the dance were occupied with singing and drinking. Each one thought it his and her especial duty to make the others take something[.] The ladies breakfasted first while the gentlemen waited on them. An abundant table of Yucatan dishes, all excellent, & some beefsteak <u>a lo ingles</u> for which we thanked our hostess. Then the gentlemen sat down to breakfast, & the ladies retired. Mrs Gorozica insisted on taking me back to the table to hear the toasts. Then the gentlemen called for a word from which were given & applauded. Dancing & singing were again commenced. At middle day some went to pray in the chapel, others took to the hammock[.]

Drinking began again. The gentlemen proposed bathing in a large tank, which adjoined the house. Dr did not want to bathe, & I told them he had no clothes with him for that purpose. It was no use; they had everything on hand ready for him—escape was impossible[.] Some remained a short time in the waters a long time. Dr wanted to show that he could do more than they. He was in the water more than an hour[.]

When Dr appeared I was disgusted, and horrified[.] Believing the water deeper than it was, he he had thrown himself in backward, & turned a somersault, striking his head upon stones in the bottom. The water had hurt his eyes very much. Dancing was recommenced & kept

up until dinner time. Dr had a very severe headache & went to sleep a little while[.]

Some of the gentlemen were very merry; others very sleepy, but all polite. After dinner they made everybody dance <u>torritos</u>, and there was great fun. One young lady, in a green muslin dress, danced particularly with, with the Dr for partner. Even I had to dance for a minute.

At 8 P.M. I was taking chocolate with some young ladies & gentlemen, among them <u>Apolinar</u> the son of the house who was then preparing to start for France & finish his medical studies* [Refers to note in margin, which reads "He never returned. Became a <u>Paulino</u> having fallen into the hands of the Jesuites."]

The following is an account of how Augustus defended his reputation as a "man of honor," by getting into a violent altercation with a drunk who had insulted his friend the Bishop of Yucatán. It was an occasion not soon forgotten by Alice.

While thus engaged the following occurred to the Dr. He stood at the window conversing with a <u>gentleman decidedly unsober</u>[.]

This gentleman began to speak of Masonry, declared himself a Mason, and told the Dr that he ought to have nothing to do with the curates, much less accept their hospitality, that all the honest Masons were vexed with him for doing so. Dr answered sharply —a young gentleman sitting near by began to whistle. Dr very politely, asked him to leave off—instead of which he came to sit on the windowsill & continue. The gentleman who had been speaking with the Dr wanted to throw the young insolent out of the window, who for his part told him to do it if he was not a coward. Dr prevented it, and taking the young man by the arm told him to come outside, and he would give him a lesson, that where the ladies were was not the right place to settle a dispute. They went to the corridor followed by several gentlemen. The young man, who was director of the orchestre, left the Dr & went to his instrument. The Dr then fell upon him and slapped his face, charging him with cowardice.

Blows were exchanged, and they came to the ground together. At this moment a brother of the young man entered, & called out to him, "Kill him, kill him." The Dr was choking with passion "Ah, kill him eh!" & turned to give his adversary a blow in the stomache but some one caught his arm from behind, & the young man was taken away. The Dr was in such a passion that some of the servants thought he had a fit; and came to me. "Go, go, the Dr is in a fit." I ran to the corridor & found Dn P. Ancona trying to hold the Dr who was almost choked with rage. After awhile things quieted down, & I learned the facts; we went again to the room where chocolate was being taken. The young man had been

told by the master of the house to keep out of sight. Dr pointed out to me, seated at the table, the one who had advised his brother to kill him. "Ah, Señora, excuse me" he said. And in all due form he apologized to the Dr. "We had spoken excitedly with out knowing the ins & outs of the case." I proposed a dance to remove all disagreeable impressions. The musicians had been removed—our bolan prepared—our hostess was nervous, and anxious to see the combatants separated. So without more ado we departed and left a most charming scene. The moon was brilliant, the place pretty, & the large space in front of the building, was strewn with artistic groups of indians[.] Men, women, & children. I should have liked to look a long time, but we were hurried away in consequence of that most disagreeable event, and because Cura Ancona had to be at daylight in Tixkokob to say mass. Like a flash Katanchel faded from my view, though not from my memory.

The rose must have its thorn,
And sorrow out of joy is born.
[Line two was edited by Alice—Sorrow was moved from after joy, to after "And"]
Life is thus, & shall be so.
Sweets and <u>bitters, hand in hand</u> must go.

10

After our departure, drinking & dancing were continued for awhile, then everyone went to sleep where he could find a corner. Meanwhile the servants prepared turkies & pigs, for the next day 10th which was to be their feast[.]

We were assured by friends who were present that it was a repetition of the first day, with the difference that the drinking was carried much further. One gentleman boasted that they all got drunk three times during the day. The band master had his lips in a bad condition owing to the blows Dr had given him. Cornet was his instrument, & though it made him suffer, Dn Theodoro caused him to play all day to punish his insolence. The indians & meztizos held their ball, & feasted. I am assured that the servants of the hacienda pay the whole expenses of these two days. I was also assured that because there were strangers present, the ladies had drunk very moderately the first day.

Augustus Le Plongeon learned medicine in the nineteenth century by what was called "riding with the doctor." He did not receive training in a medical school, but learned on the job under the guidance of a physician. In Peru, he opened a small clinic where his patients could soak in warm baths charged with small amounts of electricity from batteries. In recent years, this therapy has been found to be particularly helpful in the mending of slow-to-heal broken bones.

Dr was called to see the wife of Dn T. Ancona—She had a severe attack of asthma. He relieved her in a few minutes with magnetism & and the people were astonished[.]

The use of magnetism began to receive considerable acceptance in the eighteenth century with cures claimed by the Jesuit Maximilian Heil and later by the physician Anton Mesmer in Vienna. By the nineteenth century it had become popular and was used by many physicians, including Augustus, until discarded in the early twentieth century as ineffective. Augustus's knowledge of emergency medicine was more effective on the many occasions he applied it in Yucatán.

She had gone to accompany her son Apolinar as far as Merida; as he was about to start for France. There the attack had come on. All the physicians of Merida failed to relive her. So her son had come back with her to Tixkokob to see if Dr could do anything for her. She arrived in a state of insensibility, and knew nothing & knew nothing till Dr brought her to with magnetism[.]

Apolinar started for Paris, expecting to return in two years[.]

Dr is curing a sister (married) of Apolinar. She is astonished because he tells her all she feels, without questioning[.]

We learned that her fatherinlaw had the following conversation with young Apolinar.

Don Jose Cirerol said:

"This man is not a physician"

A. "He is the best we have in Yucatan. He has relieved my mother when all the others have failed[."]

C. "If he is a physician, why does he not declare it, & offer himself for practice[.]"

A. "Because he does not want to."

C. "Why don't he cure me? I am sick."

A. ["]If you go to see him, he will recieve you."

C. "No, No, No! He is someone sent here by a powerful company, who perhaps later will take Yucatan. He does not rob anybody, nor ask money for anything[.] He goes in all parts. He is paid by some powerful Company. I don't want to go near him."

I am teaching french to the Curate.

At break fast time D. T. Ancona came to show Dr a sore he had on the back of his neck. Dr attended to it.

Early in the afternoon his wife sent to Dr a very fine hammock, <u>in token of her gratitude</u> she said, for the reief he had afforded her.

25

While walking up and down the corridors, in the evening, we saw a great light. Went to the door & saw flames nearby. Maria the housekeep said it was the burning of rubbish. Rubbish indeed! She spoke more truth than poetry.

26

This morning an old man badly burned was brought to Dr by the <u>Jefe politico</u>. Dr undertook the cure, & when questioned about the <u>fee</u> said: "We will arrange that later." The old man had been to a wedding, & returned to his hut, where he lived alone, intoxicated[.]

Some indians pulled him out of his house when it was in flames, & he badly burnt—the old man objected. He did not feel the fire & wanted to be let alone. This was Marias <u>Rubbish</u>. At 6 o'clock in the evening a young lad had passed near the hut, & with his gun had killed a rabbit[.] At 8 o'clock the fire took place. The old man wanted the young one to pay the damage done to his property, for said he "The gun set fire to the house." The judge sentenced the boy to pay eight dollars. Father P. is parent of the boy, and very poor, but undertook to pay the money.

27

For two nights running Dr had the same dream—A fearful tempest in a city where the people speak english[.] Mrs Cadiz had part in the dream.

In 1854 Augustus deeded three lots and a dwelling in San Francisco, California, to a woman named Maria Eugenia Cadiz. The reason, he said, was that her deceased father had shown him "many acts of kindness and hospitality" over a number of years (Ramey 1966:6).

We keep the old man in the convent while we cure him[.] The whole of his back is peeled. Dr has used albumen & cold water[.]

April 3

Dr made a portrait of the curate. I printed it.

The burnt old man, has annoyed us very much by getting drunk, after coaxing a boy to bring him liquer. While thus he fell down, & broke his new skin. Although he had no home he wanted to leave the convent where he was so well attended. Of course Dr wrote to his father in law, the Jefe politico, telling him that the cure was completed, and he could no longer be responsible for anything that might happen to the old man.

Uxmal

April 1876–August 1876

April 3

The magistrate wrote back, asking for the Drs bill[.] Dr in return wrote him that had the patient been rich it would have cost him 100$, but as he was poor, it would cost nothing. In 26 years practice he had never recived from the poor.

4

We returned to Merida.

The Le Plongeons intended to travel the fifty or so miles from Mérida to Uxmul in one day, but it was more difficult than they anticipated, so they spent the night in the village of Muna. They chose the route to Uxmal via Abalá and Muna because it was shorter, but it required them to traverse the hills called La Sierra just west of Muna. The road over the hills was steep and difficult for the mules, and even the descent into the Puuc region where Uxmal was situated was no easier.

29th

The Bishop visited the family of Herrera, & we were introduced to him—Bishop Gala—When he retired he offered us his ring to kiss. But we, heretics, took his hand in our own. Poor old man!

May 3 ➣ *Avalá [Abulá], Muna*

We asked the Bolan coche for 3 a.m. hoping thus to reach Uxmal by night. So at 2–30 we dressed in a hurry, for we had to get a few things to arrange. Our kind friends abandoned their hammocks to see us off. At 5 o'clock we were tired of waiting for our tardy conveyance. Dr sallied forth to look up the coachman. At a short distance from house he met him coming leasurely, as these people do everything. It was near 6 o'clock when we started. We traversed eight stony uninteresting leagues, & reached a small place called Avalá. We did not go by Ticul route, though Palomino had given us letters, to have Espejo, magistrate of that place, to lend us men. The mules we had were wretched worn out beasts. We stopped that they might rest and take water. Unacquainted with the place, we drew up at the entrance, & sent the driver to a cottage by the roadside, to ask entrance to that dwelling. We were very welcome, but received advise to bring the bolan before the door because "The folks of the villages were rather light fingered[.]"

Remembering how we fared in Chichen & Ake, we carried a few provisions. The occupants of the hut kindly put it at our disposal. We

bought from them eggs & onions[.] These, with a can of lobster, & some bread, made a breakfast. The home of the villager in Yucatan is generally, dirty, the people clean. The home we took possession of was the dirtiest we had seen anywhere, and the people exceptionally unclean. The Matron, dirty & ragged was swining in a hammock, making paper flowers to adorn the <u>holy</u> cross. Running about the room were chickens, dogs, cats—the pigs were excluded during our visit; and the flower maker kindly left her important occupation to attend us. It appeared that no attempt had been make to clear the room for the last 6 months at least. Every corner was choked up with rubbish. Various people came while we where there to barter with our hostess who had a small collection of threads, sweetstuff, fruits, & such like things[.] I layed down in the cleanest looking hammock, about 18 inches wide, to try and take a nap, but was soon disturbed by a crawling sensation in the body. The good woman appeared perfectly astonished when I ventured to mention "bugs." At 3 P.M. the animals having rested we again started with a cordial invitation to return to the hut on our way back to Merida. All the country was dry & leafless. The dust, thick upon every twig appeared like frost. The road was bad, yet a trifle better than those of the East. About a league from the village we met a party of 20 to 30 men returning from a hunt called <u>Puk</u> [*P'uh*, hunt]. It is dangerous & prohibited by law, but the indians are loath to give up their old customs—it is like tearing a limb from their body. Stephens was mistaken when he said "That all traces of their ancient customs were lost[.]" Wherever we go we find traces of their ancient customs. The hunters had been successful, and carried home nine deer. Sold in Avala, each skin would fetch 25 cents, and the meat about a dollar. If carried to Merida, where deer is always dear, the profit would be much greater. The faces of the men were radiant with contentment. Further on we saw a party of at least a hundred dark skins, building a wall. The driver said they were the servants of one <u>hacienda</u>. The sight of these muscular, hardy men caused us to think for a moment of the day when from every <u>hacienda</u> they may rise in a body against those whom today they so humbly serve.

At 7 P.M. we reached Muna, and stopped at the entrance because the mules refused to pass over a sudden elevation of about 2 ft. that had been made in mending the road. Nevertheless, after some most inhuman sounds had proceeded from the lips of the driver, they pulled us over.

Dn Liborio Irigoyen had given us a letter of introduction for Dn Andres Maldonado, a favorite, and the hero of the country for twenty leagues around. Not knowing where to find his house, we stopped to inquire at a door were some ladies & gentlemen were coming. We had just passed the house of the gentleman, but he was absent, having been

called to his plantation to see a man whose hand had been hurt in the trapiche. The gentleman with whom we spoke apologized for the smallness of his house, and sent to inquire if there was a room for us in the convent.

There we were finally installed, in the same apartment that served the Empress Carlota, when she passed through Muna on her way to Uxmal. The convent is occupied only by the Cura Lizaraga, who was in Stephens' time "the best dancer in the country." He was not at home when we arrived. We were received by a young gentleman whom the Cura was amable enough to recognize as his son. He kindly prepared for us a cup of chocolate; and just as we were about to take it the Cura arrived. We conversed with him till 11-P.M. he being dressed in small clothes. During the evening a letter came from Uxmal, calling the priest to minister to some people of the hacienda, who were dying from inflammation of the lungs.

4th

At 3 a.m. the next morning we were up and ready to start, but our lazy driver found it hard to wake; and then had to feed and bath the animals[.] So Cura Lizaraga started on horse back at 6 a.m. leaving us as yet in the convent—He was going by a short cut of 3 leagues over the mountain; our bolan had to go round, thus lengthening the journey by two leagues. While waiting to go we passed our time gazing at the only natural hills of Yucatan. La Seranea is a range of hills that run from the coast towards Ascension Bay. The greatest elevation may be 1500 ft. Muna nestles at the foot of these hills that we had seen like clouds while yet three leagues distant.

The gentleman with whom we had spoken the previous evening, visited us, and we learned that he was an elder brother Andres Maldonado, Dn Pedro by name, and not quite sound in mind judging by his conversation, though very kind & friendly.

Our mules started lazily, and when we began to ascend the hill gave out altogether. We alighted & proceeded on foot. Dr pulled the animals forward with a rope, the driver shouted and used the whip so little by little we mounted the hill. To descend the other side was a very different affair, though I doubt if the mules liked it any better. The weight of the carriage forced them forward. Some parts of the road were good others very bad. The leagues were Yucatecan leagues, and the beasts slow to move so we were bored. I Left Muna in male attire believing that I could with propriety arrive at our destination in that dress, for our intention was to live altogether at the ruins.

We found the entrance to the hacienda pretty[.] A large Seybo [Ceiba] tree adorning the plaza. Plaza in this case is a piece of ground, in front of

the residence, around which the huts of the workmen are built. When we came to the gate, we saw that a front corridor was in course of construction, scaffolds were up and men working on them. In the unfinished corridor was a group of ladies and some children running about.

Dn Liborio Irigoyen had given us a letter of introduction for Manuel Betencourt, the representative of Dn Rafael Regil, to whom belongs Uxmal. He had himself offered a letter but Dr did declined with thanks. We had the bolan to stop in the middle of the yard, and Dr went to some gentlemen who stood in group examining a machine. He gave the letter to Dn Manuel. The driver took the mules from the bolan—I, as best I could, put a skirt over my pants! not to shock the ladies whom I had not the pleasure of knowing. There was no escape, just as I was I had to go on to the house. Dn Manuel presented me to his wife Da Catalina Agramonte de Betencourt, a name suited to her appearance, tall, elegant, genuine Cuba type.

According to that most strange of custom of Yucatan, the other ladies and gentlemen were not introduced to us. We saluted, and afterwards learned, as best we could, their respective names. Delightful custom (?) [.] Happily we had known them by sight. They were the Gutierrez family, three young ladies with their respective husbands, each with a fortune of her own, and none of the gentlemen poor. The ladies had been brought up in France, Mexico, Campeche; and were generally regarded as the belles of Merida. Don Augusto Peon married with Da Anita Gutierrez. Don Eduardo Gutierrez, I had not the pleasure of knowing his wifes name, as also the wife of Joaquin Gutierrez—but I believe they all one family. They had arrived only half an hour before us, and had come expressly to visit the ruins. I apologized for my dress, for although they also had come from the road, they were most daintily dressed having traveled in three commodious chaise, & bolan behind bringing the servant of each and a cook. The breakfast was in preparation. Don Manuel invited us but we could not go to the table as we were. In the midst of my perplexity I espied, passing in the corridor, a mulato woman, whom I had before known in the house of Señora Guzman in Merida. Apologizing I left the room and sought Belen[.] She took me to a chamber where I put on a half dirty white dress, the only thing I had on hand. Meanwhile breakfast was commenced and as the ladies had not personally invited us we preferred to breakfast where we were, so Belen served it to us, and later Doña Catalina visited us, and apologized for not being with us all the time, as the others were strangers to her, people of great ettiquette [Yucatecan] [brackets around "Yucatecan" by Alice]. During the day we made acquaintance with the whole party: in the afternoon they paid a running visit to the ruins[.]

Uxmal flourished for about two hundred years from AD 800 to 1000, and because of its outstanding architecture it is now listed as a UNESCO World Heritage Site. The ancient city is dominated by the Adivino Pyramid (also called the Pyramid of the Magician or the House of the Dwarf) with its spectacular Chenes-style temple jutting out from the west façade and Puuc-style temple that sits on the top. Oval in shape and not pyramidical, it has steep, broad, stairways on its west and east sides.

Other important buildings at the site are the Nunnery Quadrangle with four highly decorated buildings, the House of the Turtles, and the 320-foot-long House of the Governor that is considered one of finest Maya buildings ever built.

To photograph, measure, and draw plans of all the important buildings at Uxmal was a big undertaking for just two people, but the Le Plongeons were determined to record as much as possible. They worked at the site for almost three months and returned in 1881 to complete their work.

Earlier Dr had been alone, and returned saying that he had received a bucket of cold water[.] He was disappointed in the ruins. We all dined together in the evening, amiably enough.

Friday 5

Before breakfast we all went to visit the ruins; they in carriage, we on foot, and found the pretended half mile to be a good half league. The other visitors returned to the hacienda before us. After they left, I removed the skirts I had put over my pantaloons, and we ascended the mound of the Adivino. We discovered two figures on their hands and knees over the doorway of what we consider the Sanctuary [the Chenes-style temple on the west façade of the Adivino Pyramid], they are above two projecting stones. To examine better Dr climbed up by the ornaments[.] At 10–30 we returned to the house very tired. After breakfast Dr went again to the ruins to show the gentlemen the two figures he had discovered. I remained telling the ladies about Chichen Itza until 4 P.M. when the gentlemen returned, and the party left to visit another hacienda.

6th

The monuments were very much covered with bush, and all the hands at the hacienda occupied in sugar making. Rafael Regil had told us that Don Manuel would not be able to give him even one man, and so we found it. Some were dying from inflammation of the lungs, as many as two and three per day in a population of 400 or 500. The simple-minded people attributed this disease to the bringing of a figure from the monuments[.] Said figure was found in a ruined mound that is a short distance east of the Governor's house. They call it Casa de la Vieja (house of the old woman) because a stone that looks like an old woman lies in front of it. The figure found was a bust with an hieroglyph on the right

cheek. When found it was perfect, but bringing it to the house the nose got broken. It was placed at the foot of the staircase that leads up to the front corridor of the <u>Casa Principal</u>. Some one mended the nose to his own fancy, and the boys and girls who passed it every day on their way to the <u>noria</u>, for water, delighted in defacing it. [Margin note reads, "See description of Casa del Adivino."]

The sickness of the people was in fact due to their foolish habits. The weather very warm, and a constant strong wind. Nevertheless they slept in small huts, with fire burning close to their hammocks. Then before daylight, without putting any extra clothing over that which they wore all night, they went out. They took hot baths in a current of air, and did other equally foolish things. Being ill they refuse to take medicine, saying "The time has arrived for me to die." Dr Le Plongeon told them he would disenchant everything and everybody. Happily for his reputation only one more case presented itself, and that he cured. Their faith cured them.

We passed the afternoon emptying our dark box.

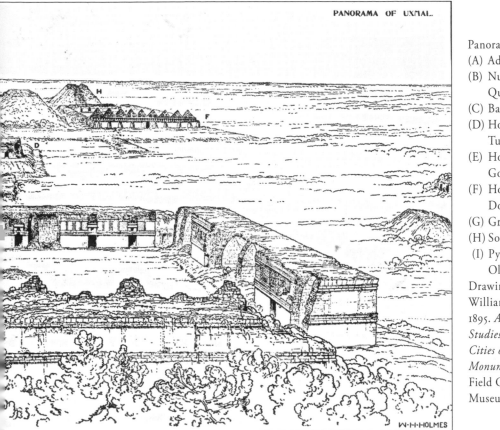

Panorama of Uxmal.
(A) Adivino Pyramid,
(B) Nunnery
 Quadrangle,
(C) Ball Court,
(D) House of the
 Turtles,
(E) House of the
 Governor,
(F) House of the
 Doves,
(G) Great Pyramid,
(H) South Temple,
 (I) Pyramid of the
 Old Woman.
Drawing by
William H. Holmes.
1895. *Archaeological
Studies among the Ancient
Cities of Mexico.* Part 1.
Monuments of Yucatan.
Field Columbian
Museum, Chicago.

The Le Plongeons photographed the full length of the south half of the east façade of the House of the Governor and what remained of the collapsed north half of the 320-foot-long façade. In addition to the overlapping 3-D stereo photos of the façade, they took 2-D 5 × 8 inch plates of a number of sections that they thought of particular importance.

The task was difficult because the camera had to be raised high enough to eliminate image distortion. And the camera did not have a shutter, so the exposure was begun by removing the lens cap, and then it was replaced when enough time had elapsed for a proper exposure. Of course, there were additional problems such as clouds that could block the sun during an exposure, and photography had to be done when the sunlight was at the proper angle.

They also began a survey of the House of the Governor for a plan. But the plan and section of the building were not completed until their second visit to Uxmal in 1881, because hand measuring all the rooms of the building was very time consuming.

After first living at the hacienda, they then moved into the spacious center

THE DIARY OF

ALICE DIXON

LE PLONGEON

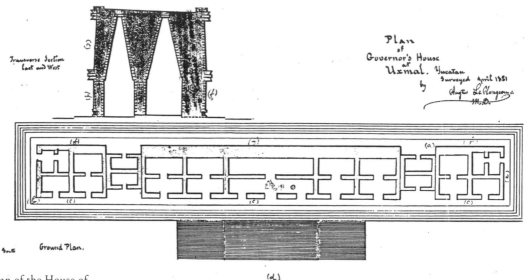

Transverse Section East and West

Plan of Governor's House at Uxmal. Yucatan. Surveyed April 1881 by Augustus Le Plongeon. M.D.

Ground Plan.

Plan of the House of the Governor. Drawn and signed by Augustus Le Plongeon. Augustus began the survey of the House of the Governor in 1876 during the Le Plongeons' first visit to Uxmal and completed it in 1881 during their second visit. By courtesy of the Latin American Library, Tulane University, New Orleans, Louisiana.

room of the House of the Governor and used it as their living quarters. Alice liked living away from the hacienda and in the solitude of the ruins.

May 7th

Left our hammocks at daylight and went to the ruins[.] Carried cold coffee, flask of water, a remmington to shoot what we might find, camara stand to draw upon: paper (prepared by us) for the plans, notebook and umbrella. Commenced the plan of Governors House. [Sentence crossed out—not readable] It stands directly South of the Monjas [Nunnery Quadrangle], on the uppermost of three terraces that run _ _ _ _ _ _ The lowest is 1.00 high, 10.00 wide, 175.00 long. The second is 5.50° high, 66.00 wide, 114.00 long. Upon this terrace there were many small edifices—At the N.W. corner of the terrace is the ex-private residence of the once famous Governor Aac (Turtle) its upper cornice adorned with stone turtles, and beneath them a row of columns, about 1.00 high. At the S.E. corner of the terrace is an oblong building with round columns fallen. At the foot of the staircase 38.00 wide, that is on the E. side of the third terrace, stands a large round column, phallus. Behind it is a mound from which Stephens dug out a double headed figure[.] Now in the hacienda—There are several other small mound, piles of stones—All thickly overgrown—There are _ _ _ _ _ steps in the staircase that leads to the third terrace; which is _ _ _ _ long, _ _ _ _ _ wide. There are 20 rooms

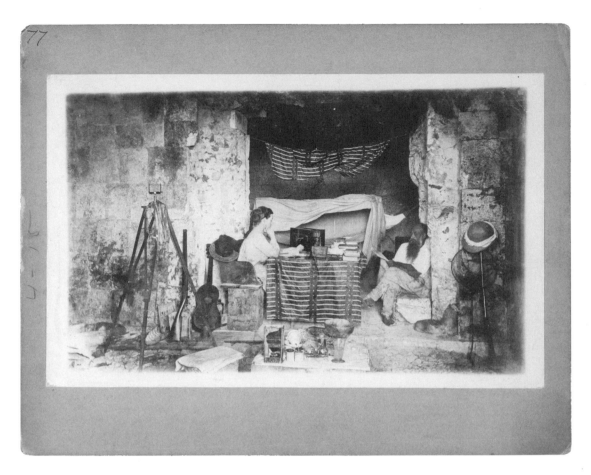

Alice and Augustus writing their field notes at their archaeological camp in the center room of the House of the Governor. Their hammocks are draped with mosquito netting; dishes and two wine glasses have been washed; their rifles are at the ready; and their butterfly net, surveying instrument, and photographic equipment are at hand. Their dog, Trinity, can be seen sleeping in the corner. 1876. Photo by Alice and Augustus Le Plongeon or their assistant Señor Loesa. Research Library, The Getty Research Institute, Los Angeles, California (2007.R.8).

in the building, all habitable[.] They are long and lofty, the floor covered with debris. The exterior is covered with finely carved stones.

The want of one or two men caused as much annoyance. Dn Manuel told us that sometimes indians came from the villages to seek work and we begged him to detain any such, on our account. The thorny brambles that embrace the monuments on every side made the work of surveying very tiresome and difficult. The high wind added to our miscomfort, for it carried the tape in every direction, and tangled it with the thorns. With our hands we had to break down the bushes in order to pass along

THE DIARY OF
ALICE DIXON
LE PLONGEON

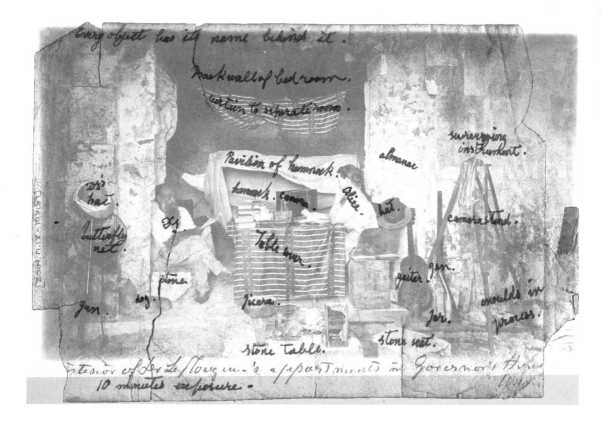

On the back of the photo of their quarters at Uxmal, Alice has written the identity of each object. Another note states that the exposure time required to make the photo was ten minutes. It does not seem possible that Alice and Augustus could remain absolutely motionless for that length of time, so she may refer to the exposure time required to make a print from the negative in the sunlight. Notes by Alice Dixon Le Plongeon. Research Library, The Getty Research Institute, Los Angeles, California (2004.M.18).

the walls. It appears that these people also used the meter, but we did not find the same exactitude of measurement as in Chichen. In a room 6.00 odd in length the width at one end is 3–83, at the other 3.88—The walls are generally 1.00 thick—sometimes 1–5°, sometimes 1.10[.] At mid-day we returned to the house; bathed, & breakfasted.

Monday 8

Before the stars had all disappeared we were among the ruins, with our provisions for the day. The center apartment of the <u>Casa del Gobernador</u> was chosen for headquarters for the time being. We finished the plan of the building; and afterwards passed to the <u>Casa de tortugas</u>. The heat was intense. That building measured, we went 14.00 South of the Turtle house, & 20.00 West of the Governors House—There we found a stairway 14.00 wide of 36 steps—It led to the mouth of a cave, now filled up

with large stones. By this we learned that the terrace was not all artificial. Turning to the right from the foot of these stairs we came upon rooms, on the West side of the terrace. In one we found a blocked up doorway, that someone had begun to open. Where the stones had been removed, a fine white plaster, a quarter inch thick yet covered the wall: written upon were the names of <u>Dn Jose Font</u>. <u>Regil y Peon</u>.

As we had carried but little water we suffered from thirst. On our return to the house, Dr was called to see the wife of the principal vaquero, who was sick with inflammation of the lungs [the one case after the des-enchanting business] [brackets around "the one . . ." by Alice]. We found the good woman in a hammock gasping for breath, and all ventilation stopped, all air shut out. At the Dr's order a door was immediately opened, and we saved the patient though she did her best to die, with their capricious customs. . . . Passed a sleepless night owing to the intense heat.

9th

At 4 o'clock we left the house, and at dawn reached the ruins. Don Manuel gave us 10 men for an hour to cut down some of the bushes that surrounded the rooms we had found under the second terrace of the Casa del Gobierno—We made a plan of them.

The men spoke of a serro that had a closed up door, one boy undertook to lead us there. The Mayor domo was present and accompanied us on the voyage of exploration[.] The boy led us to the <u>Casa de Palomos</u> (Barracks (?)[.] Here we came to a standstill as our guide declared his ignorance of the exact spot. Among so many mounds all covered with bush, a search was out of the question; & Don Jesus Maria Alvarez, Mayor-domo led us to see a small excavation that had been made in the West side of the mound upon which stands the Sanctuary, or <u>Casa del Adivino</u>. We commence plan of <u>Monjas</u>, [see description—page 220] [Brackets by Alice][.]

Brasseur de Bourbourg visited Uxmal in 1864 and had carried out extensive mapping of the city. While the Le Plongeons do not cite his report on Uxmal, "Rapport sur les ruines de Mayapan et d'Uxmal au Yucatán (Mexique)," they likely read it and learned about the large reservoirs, called aguadas, west of the city center that were used to supply water during the long dry season. Alice noted that he had inscribed his name on a wall in a room of the South Building of the Nunnery Quadrangle.

10th

In different parts of the monuments we find a diversity of names, verses, & ideas: some very foolish; others reasonable—We copied one or two of the best—"Dios sepulta el pensamiento de las generaciones

futuras bajo las ruinas de las generaciones pasadas. Quien se atreve a afirmar será un audaz"[.]

J. R. Sisneros [Chief of the Masonic Society in Merida & the oldest mason there. Died in that city in 1881] [brackets by Alice][.]

Translation "God buries the thought of future generations beneath the ruins of past generations. He Who dares to deny this will be audacious[."]

Pobres viajeros! Lola la muda admiraccion os queda ante la elecuente antiquedad de estas ruinas. F. Carillo

Translation "Poor travelers! Silent admiration alone remains to you before the eloquent antiquity of these ruins.["]

Mejor es contemplar y callar porque la verdad es muda[.] Ant o Fajardo

Translation It is better to contemplate and be silent, for truth is dumb.

	Translation
Ruinas del tiempo son	They are the ruins of time
Mas que del tiempo, del hombre	More than the time, of man
Ruinas por Caldon	Ruins to our shame
Y aprobio de mustro nombre	And the disgrace of our name.
Llgas—Copia	
J. Tio.	

In the South end room of the East wing of Monjas, we find the following names among the many—"James R. Hitchcock—of New York 23 of September 1846."

"E. S. Scripture of New York 23 of September 1846"

"J. M. Rebles 1876 [Rebles visited these ruins during March, when we were in Motul—He remained in Uxmal only half a day, & fell & hurt his hand] [Brackets around "Rebles visited . . ." by Alice.] In the last room but one E. end of S. wing of Monjas[.]

Bourgeois—1864. Dupuich 1864. Brasseur 1864. Don Manuel Bentencourt came to visit us in the ruins we showed him the closed up doorway under 2nd terrace of Governor's house—When on our way to it, we met a beautiful snake, 6 ft long, very slender, the only one we saw during our stay in Uxmal. We were outside of the building, and the snake occupied one of the small holes that penetrate the rooms. We entered instantly but found no trace of it. On our return to the hacienda Dr saw a man who had come from Muna to die. The woman who had inflammation of the lungs stood at her door.

Thursday 11

Commenced the survey of Monjas, and got very tired owing to the ruined condition of the buildings[.] Don Manuel sent men to open the

closed doorway—After working a few hours, they found on the ground part of an obsedian knife, that Dn Manuel expressed a desire to keep, & we delivered it to him—Now that the opening was larger, we re-examined the doorway, and found that it led, not into another room, but under the platform, so the work was abandoned. Upon the plaster in the doorway we found traces of small badly made naked figures—It was as if a school boy had done it with a bad pencil. The men were set to examine the mouth of the cave we had discovered, for we believed it might be a senote but as we did not remain with them, their superstitious fears prevented any search. At 12n they came to tell us that it was full of round stones and that they were going back to the hacienda having only undertaken to work half a day. Doctor wanted to pay for these men, but Dn Manuel told him not to speak of that until he asked him for it.

The pyramid described below is probably what is now called the Cemetery Group. It is comprised of a plaza enclosed by a number of midsized buildings and with a pyramid at the north end. The buildings around the plaza had collapsed and appeared to Alice as mounds of cut stone.

12th

The weather was cooler and we continued our work with more satisfaction. We went to a ruined mount. On the way there came across a veretable stone phallus, half buried in the ground: we did not disturb it because it was too heavy for us to carry away.

The mound we visited was 11–00 [meters] high, and measured at the base 76.00 × 60.00. It stands on the North side of a square platform 52.00 × 49.00. The staircase leads up from the platform; it is 15.00 wide, and has 42 steps, pretty well preserved. At the head of the staircase is a large broken stone, that may have served for sacrificial purposes. The top of the mound is square and measures 24.20° × 14.00. In the center are vestiges of two rooms. The only entrance to them faced the stairs. The front one was 8.00 × 3.00; the back 8.00 × 00.80. While we made these measurements the wind blew so hard, that we kept our footing with difficulty. As best we could, among so many thorns, we continued our examination & found that the mount had seven andenes or grades—After decending the stairs we examined the platform. On either side at the foot of the staircase, there originally stood three round columns: beyond them was one step that went across from one side of the platform to the other. At a distance of 4.00 from this step are three mounds 6.00 × 4.00—between each a distance of 4.00. They are surrounded by sculptured skulls and crossbones. All have been dug into more or less. Upon one we found a small kneeling figure representing death. It is very much destroyed, and has at

the back of it a large ring. In the middle of the platform was a big stone, but we could not decide upon its signification. About the middle of the E. side of the platform, was small mound with a stone on it, having three holes pierced through it, about 0.8° in diameter: back of this is a larger mound. On the W. side of the platform, and adjoining the S.W. angle of the big mound is another, about 5.00 high. At the base it is 50.00 × 28.00. A staircase of 14 steps leads up from the platform, and is 10.50 wide. Here were two rooms, the entrance of each facing the stairs, and a passage separates them from[.] One is 15,00° × 3,80°; the other 6,50 × 3,80°[.] The passage 1,57°. No adornment of any kind relieves the stark appearance of this building, and as the sacrificial stone is on the other mound, we think these rooms may have served as prison for those who were to be sacrificed. Emblems of death were all around us, and as that place had no name we at once called it <u>Temple of the God of Death</u>. The entrance was on the S. side. Around the platform was a thick low wall. Today we cannot tell, the wall may be a burial place, or perhaps an amphetheater from whence the people beheld religious rites; For want of men we made no excavation.

13 and 14

At the hacienda[.]

15

Monday we passed the day at the ruins with the family of Dn Manuel Betencourt. Tried our chemicals, and found they did not work. Lying on the ground in archway of Monjas, we saw 9 red hands on the walls of the arch.

16

Added acid to the bath, and expected everything to work well, but we don't always get what we expect. The colodion was made in Tixkokob, I measured the four salts <u>Iodide</u> & <u>bromide</u> of Cadmium, and Do. of Ammonium. Dr mixed them. The yellow Iodide of Amonium seemed be wanting in the colodion, yet I know I measured it; moreover if I had not, the Dr, in mixing, would have noticed the absence of such a conspicuously colored salt.

Stupidly the salts had been left in Merida. We sent for them, meanwhile the photography stood still[.]

18

Dr gave Da Catalina Betencourt a consultation[.]

20

Da C. B. better, cured without medicine given internally. Received a letter from Traconis in Ticul. Dr answered it[.] I wrote to invite Luisa to Uxmal[.]

21

Heartsick

At 1 P.M. the sun was encircled by a ring—In the orchard one of the boys caught a beautiful lizard said to be very poisonous, called in Maya Tolx. It had a crest, or rather a coronet around the head, ornamented with small points. The body measured 6, and the tail 16 inches[.]

The structure described below is now called the Great Pyramid, and it is near the southwest corner of the House of the Governor.

24

Visited a very large square, pyramidal mound, the N.E. angle of which adjoins the S.W. angle of the second platform of G. House. The mound is N. 5° W. It had 11 andenes each about 2.00 high. The top is level, covered with rough stones, and no trace of building; but small dentitions in regular rows are discernable. The uppermost andene was ornamented with the grec (sign of splendeur, in Egypt) and gigantic faces surround by small stones carved like those of the G. house. At each corner the faces had trunks, and engraved on them, something like two compasses that enlace each other and are enclosed by a square—we have called it a Toltec coat of arms.* [Refers to note in margin, which reads "We have since learned that it is monogram of Aac."] On the North side of the mound was a staircase supported by angular arches, as in Sanctuary. On either side of the staircase were rooms. The stairs led down to a courtyard between lowest platform of G. house, and barracks (Palomos [Palomas, Dovecote]). We called this mound the Castle.

Afterwards we went among the bush at S.E. corner of G. house to search for a building we had not yet seen mentioned by Stephens. We found it much destroyed.

25 *Thursday*

Two gentlemen came to visit the ruins, one a nephew of Dn Jose Font. They begged Dr to accompany them, but he was prisoner with a severe diareah.

28 *Sunday*

At 3 P.M. the wife of Vaquero Valencia came to invite us to her house, to witness the celebration of a festival, but as said festival was to take place under the seybo tree just outside the gateway of the Casa Principal, we prefered to remain in the corridor and use our field glass. No one could tell us how this amusement was called: it is always celebrated at the entrance of the rainy season. Those of the hacienda who wished and could, filled an earthenware jar with whatever they pleased, and painted the outside, generally white—At 4 P.M. each brought his cantaro [large pitcher], and put it in the house of Valencia. Afterwards

they were piled up under the seybo tree. When all the people and the jars were united the fun commenced. The orchester consisted of an instrument called <u>sacatan</u>, used also among the africans. Part of the trunk of a tree hollowed out with leather tied over the ends: it is used as a drum. A rope was thrown over a branch of the tree—a jar was tied to one end of it a man holding the other end pulled the jar up & down[.] The boys stood in a row, each with a stick in hand[.] One by one they then went under the jumping jar. The aim of each was to strike, and break it; some aimed so well that the broken pieces fell on their heads; then all the boys scrambled on the ground for the contents of the broken jar. They are supposed to contain something good; but disappointment is generally the result of the boys efforts to smash pottery [This may be figurative. From on high the rain falls, and causes the earth to produce good things] [Brackets by Alice] We made the following list of things contained in the jars.

Twelve <u>empty</u>. 2, <u>rubbish</u>. 1, two live <u>pigeons</u>: of course they flew away. 2, stones. 2, <u>insects</u>. 3, <u>food</u>. 2, <u>handkerchiefs</u>. 3, <u>Iguanas</u>. 1, live <u>butterflies</u>. 2, <u>plums</u>. 1, <u>dead bird</u>. 1, <u>tamalito</u>. 1, <u>boiled rice</u>. 1, <u>biscuits</u>: a hard scramble over this last. A bull was afterwards let loose for the men and boys to play with and torture to their pleasure. The poor beast thought only of how to escape its many pursuers; but he was brought back again and again, girted with ropes; and all the torments that cruel boyhood can imagine were inflicted upon it; finally a boy mounted it, and stuck on its back until he chose to get off again. . . . The carts arrived from Merida and brought us nothing; we dispatched a special messenger for the things. . . . Heartsick, brainsick, body sick.

29————————

30th

At last received a letter from Mexico—and a letter from Font, also chemicals—just in time to save us from the lunatic asylum[.]

3

Went to ruins—heat intense. June 1st 1876[.] Thirty men went to Ticul for <u>faginas</u> [*fajinas*, chores]—had we been told they were going we could have kept them in our service, by sending a letter of Palomino to the Jefe Politico of Ticul[.]

June 2nd, 3rd

At work in the ruins. Dr asked Dn Manuel to send to Muna for men on our account, as we could not get on without at least two, constantly by us. That gentleman would not hear of it, and understood to keep us always attended by two men.

Monday 5th

To take photos of the four façades of <u>Monjas</u> it was necessary to work from the top of a ladder, so we set the two men that Dn M. lent

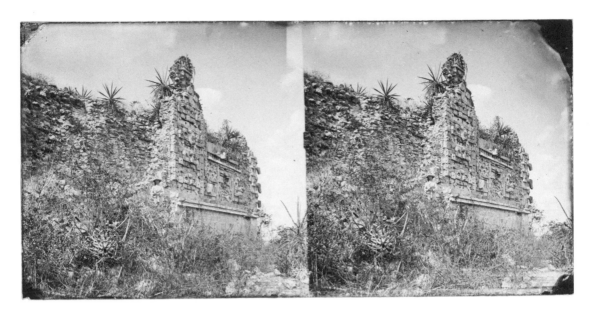

us, to make one. We could not have the tiresome fellows to understand that we required a double ladder to open and put the camara stand on the top. They made two ladders, and then tied them together all the way down. Dr undid their work, and reexplained, but not in Maya tongue so all he gained was to have them tied together more strongly than before. As we could not afford to lose more time, nor could we make them understand, it was allowed to remain so. These ladders were made of long poles cut from the bush, and sticks tied with vines, formed the steps. This <u>masterpiece</u> of indian ladder making was propped up with other poles and the men contemplated their work with apparent intense satisfaction: we did not. The tripod stand was tied up to this with what we had on hand—two small pieces of string, some loose henequen, and a kerchief[.]

Everything ready Dr put his head under the dark and found the camara too near the object. All had to be re-arranged, and meanwhile the iron point fell from one of the feet of the stand, among the stones and branches under the ladder. I only found it after moving all the stones and weeds—while doing so disturbed an ants nest. The inhabitants took speedy revenge on me. Dr was perched on the ladder working in a most trying position[.]

The ladder was so unfirm that standing on it the breathing was sufficient to move it spoil the plate. So after preparing the slide Dr came down, and from below, by means of along pole uncovered and recovered the lenses. The light changed during exposure, timing was impossible & the plate overexposed. The second gave a happier result. The sun was

fiercely hot, even the stones beneath our feet became like live coals. In the afternoon a few welcome clouds came to our relief.

6th

We remained in the hacienda because Dr wanted to answer the letter of Guerrero.

The Le Plongeons constructed a "monument" that they dedicated to the president of Mexico, Sebastian Lerdo de Tejada, because he had refused their request to export the Chacmool to the 1876 Centennial Exposition in Philadelphia. They located a large sculpture of a phallus and other carved stones that had been scattered about the ruins and erected the "monument" in the Nunnery Quadrangle plaza near the southeast corner.

7th

Two men accompanied us to move the ladder about from place to place. They did so, and afterwards, heaven knows why, began to pull it to pieces. They were of course scolded by the Dr, at which one of them cleared out[.] Dr took the other, one Dario Zib, the H-men of the hacienda, and much given to drinking, to fetch the Lingam we had seen on our road to the temple of death: it was but a short distance back of the west wing of Monjas. We had it brought in the courtyard. Dr took it from the back of the indian and in so doing strained his hip badly though at the time he did not notice it. We built a pedestal of various stones that were lying in different parts of the edifice, and placed upon it the phallus. On one stone there was an oval like those enclosing names among the Egyptians. This monument was then and there dedicated to Lerdo de Tejada. The clouds gathered fast, so we hastened home and escaped with a slight wetting[.]

8th

By good fortune Dn Manuel had a ladder[.] He lent it to us and sent two men with it to the Monjas. We passed a tiresome day. All possible photographic troubles came one after another, and to make matters worse the sun shone fiercely except when the plate was ready to expose. We took a photo of the Lerdo monument. The ladder was one block distant from the dark box. With much difficulty the ladder was arranged on the top of it to take a view of North wing of Monjas[.]

The light was good in this place only between 3 & 4 P.M. Dr prepared his plate and went up the ladder but O fate! the rain began to fall[.]

We came home under a heavy shower with three unvarnished plates in hand[.]

9th

Remained at home. Dr finished his letter to Guerrero. I printed a few

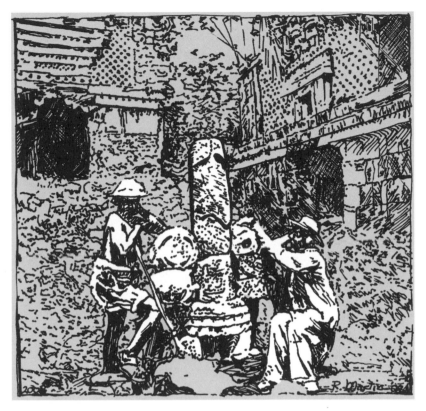

The "Lerdo Monument" was built by Alice and Augustus in the plaza of the Nunnery Quadrangle at Uxmal near the southeast corner. Sculpted phalluses were common at Uxmal, but most were removed and placed out of sight for the visit to the site by Empress Carlota of Mexico in the 1860s. The so-called monument was named in "honor" of President Lerdo de Tejada who had refused the Le Plongeons permission to export the Chacmool. Alice photographed the monument and made prints that were mailed to influential persons (Desmond and Messenger 1988:81 photo). 1876. Drawing by Robyn Martin.

views—could not do much, as I had only a flat oval shaped table dish to prepare paper in[.]

10th

Rained all day. I copied Drs letter. We sent pictures of Aké to Dn Alvaro Peon de Regil[.]

11

Rain. I translated Drs letter[.]

Monday 12

Rain. A regular <u>norther</u> that makes the heart of the <u>hacendados</u> rejoice, but not ours.

13th

Dispatched the letter to Guerrero[.] Wrote to Palomino, Font, and Mercedes Irigoyen. Wrote a letter to Bennett of the New York Herald, and sent him a translation of the letter to Guerrero.

14, 15

Drs hip very lame.

16

Beautiful day. Every bush with fresh green leaves. One man was lent to us to cut down a few trees that were most in the way at Gov. House. Dr

was at work on the ladder at Monjas when the indian came to tell him he had finished cutting[.] Dr shouted "descansa[.]" The man probably heard "a casa," for when we returned to our dark box we found to our vexation that he had retired altogether. We lost the afternoon in consequence for the ladder was too heavy for us to move alone & we had depended on his help. We moved it once, but I was a bad substitute for the man. After a hard days work Dr came home exhausted, with one plate. We invented and manufactured a moveable camara stand without legs, to be used on the ladder—a great success.

17

Happily the one man we had, Loesa, was good, willing and intelligent; but the work was very heavy for the Dr. He had to help to move the ladder from place to place, ascend and descend it, run back and forth under the sun, shut himself in the dark box; So he was alternately scorched and steamed.

Among the scattered stones we found a small headless figure, squatting turkish fashion—a belt around the waist and a strip hanging in front (uiit) [*huits*, loincloth]. The hands are gone, around the wrists are bracelets.

18

I printed 12 views—Not good because the fire given me to dry the paper, contained tallow. Tallow fuming causes the paper to print blue, and prevents the gold from affecting it. In the hypo they turn red.

19th

Don Luis Perez of Tekax arrived to take the place of Dn Manuel Betencourt, who wished to return.

20th

When we came from work Dr was asked to see a man with colerin. He ordered mustard plaster without and alcohol within. The interior dose was well received and kept, but as soon as the mustard began to affect the skin, the patient cast it from him. Dr advised a keeper, but the keeper deserted his post, and Dr abandoned the job. Salas was sent for. A ponderous meztizo who receive 4$ per month from the <u>house</u> to keep the people of Uxmal in good health. He is a quack Dr, just as good a tailor—Sometimes the clothes are spoiled sometimes the patients die—then at church, he sings the burial service for them. He is a <u>yerbatero</u> [herbalist] too. Salas put a blister on the sick man, and held him down while it took effect.

Preparations were being made in the hacienda for a festival, held every year in honor of El Señor de Uxmal. Everyone expected to put on new clothes; so Salas sat down in the office, and measured some of the <u>vaqueros</u> for new shirts. Philip was very deaf when he did not want to

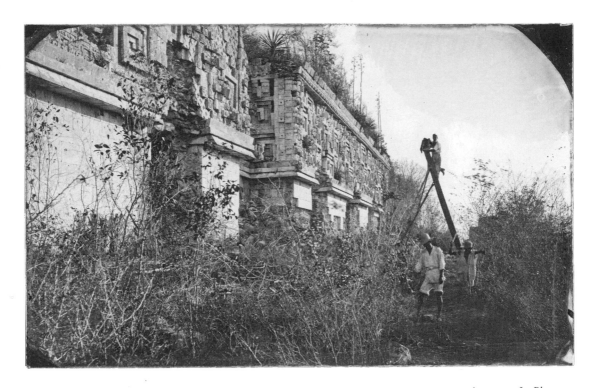

Augustus Le Plongeon photographing the east façade of the House of the Governor at Uxmal. The camera was positioned high up and square-on to eliminate distortion. 1876. Photo by Alice Dixon Le Plongeon. Research Library, The Getty Research Institute, Los Angeles, California (2004.M.18).

hear. Silverio did not understand Spanish, & spoke maya in such a low voice that no one could hear what he said[.] They were a fine pair, and poor Salas had a nice time of it with them.

21st

Took four plates to obtain one of the snakes snakes head on W. wing of Monjas. Camara fell from the top of the ladder. While it was falling Dr kicked it on one side to cause it to fall on the ground and not on the stones. One lens got bent on the edge.

We moved the things to the house of Governor—left the plate of serpents head in the Monjas. Arranged ladder at G. H. Returned to Monjas. Stood the negative on the stones of Lerdo monument. Went to visit a ruined mound. Found nothing of interest. Returned to Monjas[.] Carried home the plate unvarnished. Dr tied it to a glass—I carried with care and fear.

The House of the Turtles is located on the same platform as the House of the Governor and has carved turtles set into the walls near the roof line. Part of this beautifully designed building collapsed but has been restored.

22, 23rd

Took three plates, one from roof of Turtle house. Another of the archway in same building, or rather, a fallen roof that depended only on

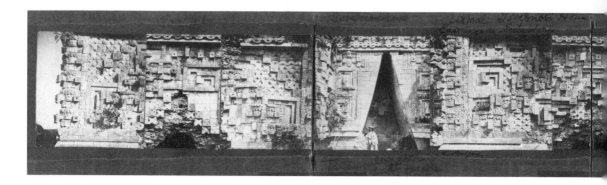

Panorama of the south half of the east façade of the House of the Governor, which the Le Plongeons made by cutting and pasting single photographs. Alice is seated in the arch. A section of the north half of the façade had collapsed, but what remained near the north end was also photographed. The Le Plongeons took a large number of additional photos with different overlaps so that no part of the façade would be missed. 1876. Photos by Alice and Augustus Le Plongeon. Research Library, The Getty Research Institute, Los Angeles, California (2004.M.18).

two stones. In carrying the instrument there, a small screw fell from the camara. Dr discovered his loss at the end of our road, and we had come three blocks in the bush. I despaired of finding it, but Dame Fortune <u>for once</u> favored me, and I rejoiced when I picked up the small brass screw as if I had found a diamond.

24th

Went very early to the ruins. No light until 9 a.m. proper for photography. Sent Loesa to hunt, Dr went in another direction for the same purpose. He killed a pigeon[.] I cleaned and cooked it. Loesa came with a dead rabbit, and radiant face, because he had wounded a deer. He wanted to go to Ux. to fetch his dog, and track the game. But we had to refuse him—The façade was only well illuminated until 11 a.m. we could not lose the day, even for a deer, and Loesa was needed to move the ladder. His wife came later with <u>posoli</u> [*posole*]. He then sent for his dog, and I sent the pigeon half cooked, to Da Catalina. We made five views—The dog arrived, and Loesa went in search of the deer, but was unable to track it[.]

The Le Plongeons took the next three days off to join into the hacienda fiesta. An enthusiastic Alice wrote a detailed description, and she and Augustus took photos of the people and events. It was an exciting time for everyone at the hacienda and included lots of feasting, dancing, a "tame" bullfight, and religious ceremonies.

25th

First holiday at hacienda. Before breakfast we took three plates and then had the things carried to the hacienda because D. Manuel had begged us to take a view during the festival. In the evening the musicians that had come from Ticul played in played in the corridor, as compliment to Dn M. & family. They were seven, and performed better than these village bands generally do. After dinner the people held <u>rosario</u>. The band concluded it with a lively march. Cura Lizaraga arrived: he was to sing mass three morning, at $1.50 each time. The servants paid

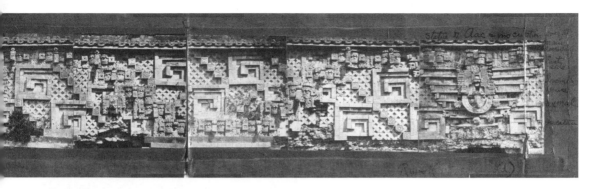

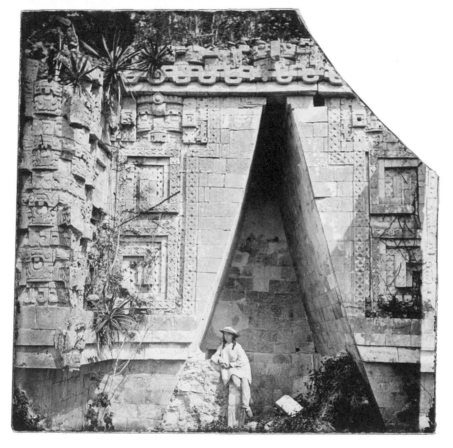

Alice in "pantaloons," sitting in the south arch of the east façade of the House of the Governor. The glass negative has been broken in the upper right corner. 1876. Photo by Augustus Le Plongeon. Research Library, The Getty Research Institute, Los Angeles, California (2004.M.18).

all expenses except orchestra—that cost fifty dollars & was paid by the Estate. For three days the casa principal was open to the people, and they could dance there. But we were invited to attend the first, at 8 PM, in another part of the hacienda. A thatched roof, about 40 yards square had been erected in front of one of the huts around it were seats of every description, occupied by people of all sizes and colors. Within the hut Cura L. was taking chocolate, by force. The musicians were doing

THE DIARY OF
ALICE DIXON
LE PLONGEON

their part, and the dancers were expected every moment. We had been told then it was customary to choose two or three to dance, & the rest looked on. It was 9 P.M. and no dancer had arrived, though two pretty girls were selected, so the masters of ceremonies dragged in some of the outsiders, and compelled them to open the hall. Toritas was the order of the night, but there was no animation[.] The dancers arrived dressed in showy uipils, and rosaries conspicuous for their size. It is customary to hire uipils and jewels for such affairs, when the chosen have only poor ones. Dn M. danced to encourage the others but everything and everybody was cold. Dr Le Plongeon did his utmost to make the Cura dance, but failed[.]

The cura was not careful of his language—smutty talk seemed to be his special talent. We left at 10–30 and the people of the hut gave us wine—a refusal would have been offensive to them[.]

26

At 5 a.m. Mass accompanied by full orchestra. Rocket were let off. A grand success made on the premises—one ounce of powder in each & exploded as though manufactured in the best pyrotechnic establishment of N.Y.

At midday the front corridor (in construction) was prepared for dancing. The people had decided to dance there by day, and at night, where fancy led them. A row of chairs were placed on either side of the corridor that is about a hundred feet long, and at one end a table with bottles on it containing wine and habanero. From Muna came two bolans full of white girls, who came to enjoy a dance if they got a chance. They alighted at the hut of Valencia Vaquero, but to see the ball came and sat in the corridor. The dancers looked like wooden dolls, they were so stiff. The ball closed at 3 P.M. Dr made two photos of it. Found the neg. of big snake head spoiled—a large piece of film gone from middle.

Bullfight commenced at 5 P.M. Da Catalina & her aunt Agueda Cisneros, had adorned some hats with colored papers, and made small flags of the same material for the fighters. The coral served as ring, and the corridor for amphetheatre. The fight was as tame as the ball. The men merely played with the animals, except one youth who mounted, and though the bull kicked furiously, managed not to be thrown[.]

The band played, and while the vaqueros went to get anothe bull, the fighters danced. The five men stood in a circle and went through various gesticulations waving their small flags over each others heads. They appeared as grotesque as any pantomime figures performing an imaginary incantation—We were told it is a genuine indian dance.

When at dinner, some of the men came to bring plates of turkey to Dn Manuel, as a mark of appreciation[.]

In the ball of the evening the white girls began to dance, so indians and meztizas refused partners. Dn Manuel arrived in good time to set matters right. Dr & Lizaraga argued upon the words time & eternity. The Cura was shut up in his creed, so made the best of his way out of the discussion[.]

27th

Received letter from Palomino—

Don Andres Maldonaldo came from Muna to see the last day of festival. The leader of the band presented three pieces of music, one to Dn Manuel, another to Da Catalina & the third to their youngest daughter. He said he had composed them all during the night. Mass was the first business of the day, after which the Cura left for Muna, having business there. Dr read to Dn Andrez the letter he had sent to Mexico. It pleased him. . . . The ball at midday was animated enough to compensate for the one of the day before. White girls danced vaqueria, and meztizas danced quadrilles, all in happy sociability. The bullfight at 6 P.M. was an undeniable failure, for even the bulls are tame here.

The band leader had been invited by Dn M. to dine with the family, but he wanted to lead his band that Dn Andres might dine in style. Don Manuel accepted the music upon condition that afterwards the conductor would allow him, Dn M. to attend him while he dined. With this amicable understanding the dinner and music commenced; Da Catalina standing to serve everybody, as usual. What a strange Cuban fashion! The lady of the house to wait upon the table. We dined in the back corridor at one end of which is the chapel. To our regret the music was soon replaced by some indian women who entered said chapel, and kept up a most dismal chant. The musicians were too polite to break in upon their devotions, but they took advantage of a momentary pause, to strike up a lively polka[.]

At its conclusion we heard that the women had meanwhile continued their song of praise (?) and they took care to make no second interval. Dr, D. Andes, & D. M. drank toasts, but they were very tame, owing probably to the piteous music within the chapel that in fact was enough to damp the spirits of anyone[.] After dinner Dn Andres left for Muna. Some of the visitors went to the hall, others remained in the house. We had a little singing, & D. Manuel sent for the conductor of the band who came to accompany with his violin. At 11 o'clock we went to sleep[.]

June 28th

Cura Lizaraga came very early from Muna, and sang Mass at 7 A.M. About a hundred and fifty people were present, not counting the numerous small dogs that knelt devotedly behind their owners, at our indication. Looking upon the crowd of kneeling figures we could only repeat

what we had said at Progreso "They are Japanese[.]" Mass over, preparations were made for the grand procession. Three men with crosses & mitre, and candles on the top led the way—the orchestra came next, afterwards the priest in his robes of office, and with him a man carrying the insence burner. Six men followed with a table on which was a cross, and black christ nailed to it—then the people, each with a candle the size and quality of which depended on the pocket of each individual. Lastly the procession was wound up by the dogs that had so devotedly attended mass. Before starting the priest made a polite bow to the image & offered up a prayer to the Virgin M. The procession went round the plaza of the hacienda and the priest stopped to offer up prayers and insenc, the people responding, at every house where they paid him two reals. The band played a slow march, and the bells of the hacienda rang. The 150 candles did did not burn owing to a fresh breeze that blew at the time—but christ was carried, so did not stumble by the way. Dr took a photograph of the group in the coral on their way home—The procession lasted half an hour—then christ was returned to the altar and everyone to his hut. The last individual to take his leave was a man who had had a table under the seybo tree, and sold there ornaments, particularly <u>rosarios of pure gold</u> of course. The place remained quiet, only a general disorder of things in the <u>casa principal</u>, told that two hours before it had been filled with holiday makers.

During the three days only one accident happened. A man had his head cut, but he was well before the visitors left[.] Intoxication was scarcely noticeable.

30th

Dr took a view of the shed where the sugar was made, also of the <u>casa principal</u>; and he mended the nose of "La Vieja" that is at the foot of the stairs, leading to the corridor—He obtained two very good plates of it[.] But alas! before night, the boys had recomnunced the work of destruction, and the new nose of the <u>old woman</u> that Dr had so kindly made for her was soon picked to pieces by naughty hands.

I sent a letter home & with it a translation of Dr's letter to Mex.

Saturday 1st

I printed negatives taken at hacienda. In a milpa near the house a man found a stone that caused us much admiration. It represented a bears head, and seemed to be the unfinished work of an excellent artist. The eyes were merely marked, not made, and the lower jaw wanting— The man was sent to search for the lower jaw, but did not find it[.]

July 2nd

Went to visit <u>La Casa de La Vieja</u> in the faint hope of finding some well preserved head, but were damned to disappointment[.] The edifice

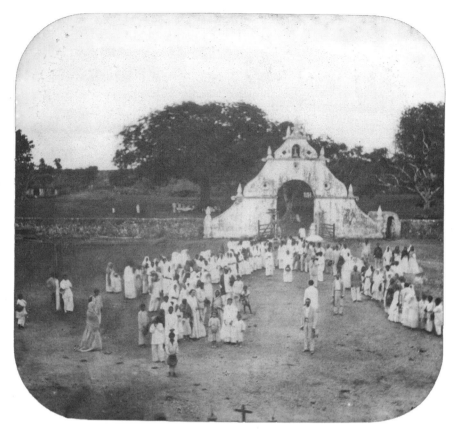

Members of the Uxmal community wait near the entry arch to the hacienda for the arrival of the approaching religious procession. The Maya women are in their best *huipils*, the men in white, and standing with them are the hacienda owner and manager. 1876. Photo by Alice and Augustus Le Plongeon. Research Library, The Getty Research Institute, Los Angeles, California (2004.M.18).

is much ruined—there are fallen rooms, one with an inner doorway. In a portion of wall that still remains are loopholes like those in the <u>barracks</u> called <u>Palomas</u>. The stairs faced the East side of Gov. house [sic]. When descending the mound, we heard some one shouting and going down found a man with a dead deer. We at once paid for a leg, and told the man to take it to the house (paid 36 cents for it)[.]

Alice printed the photos she and Augustus took during the fiesta of the hacienda and of the House of the Governor. Those prints may yet be in family albums in Yucatán.

3rd

Received a letter form Dn Alvaro Peon de Virgil.

I printed some views of the Governors house and gave them to Da Catalina, also views of hacienda.

4th

Took box back to Gov. house. On our arrival found that the visitors from Muna had destroyed the <u>Lerdo monument</u> carrying away a stone

turtle that formed part of it. They also had robbed our head quarters a tin drinking basin; a spoon of some precious metal, worth one <u>medio</u>, a small bottle vinegar, a large one of honey. I found on the walls what I took to be freshly written names, but as they bare no date, I did not take them lest I should do injustice to some innocent person. Dr made 16 views, from top of ladder, 4 of them were good—These were of the façade of the Governors house.

5th 6th

Rain—Rain—

7th

Thirteen plates, six good. All from top of ladder[.]

Alice and Augustus discovered a number of carved stone phalli that had been hidden away after having been removed from buildings for the visit of Empress Carlota of Mexico.

8th

On the road to the ruins between Sanctuary and Gov. H; looking, as we always did, in every direction, to discover curious stones, we distinguished in the bush what appears to be a large <u>phallus</u>. We pushed our way through & found it so to be, nor was it the only one. As the sun was high and we had plenty to do elsewhere we did not have to examine further. On our return at midday we went there, and counted 18 phallus, all more or less well preserved. There also was a head, but the features were very much destroyed . . . When Dr was at work on the ladder, he noticed in the distance South of Gov. H. a building that we had not visited. After taking four photos, the light was no longer good for our purpose, so we had Loesa to lead us to the house we saw in the distance. We walked about half a league, breaking our way as best we could through cattle paths, & reached the spot. The bush was very thick, but we got on to a large terrace over the loose stones. To survey the building would be impossible, unless cleared; and after examination we concluded that it was not worth that, even if we had men. This building was similar to <u>Monjas</u>, and where traces of ornaments remained we found gigantic faces, though the details were different—no phallus. The best preserved room had been monopolized by the cattle, who had turned it into a sleeping apartment. In the middle of the terrace is a large pyramidal shaped, or tapering column, thrown down. Around its base was an ornamental carving that might have represented entwined snakes, or merely coils, running around above it is a pattern like that on the dress of the queen of Chichen, where she sits at her house door. They call this house [blank space]. Dn Luis Perez received news from Tekax that his brother was

dying. The gentleman, not to leave Dn Manuel alone on the busiest of all days, Saturday, held his tongue until evening, when he mentioned it, and at once started on horseback. At the same time two bolan arrived to carry the Betancourt family to Merida. Dr Manuel decided to wait the return of Dn Luis. Dr offered to supply his place if he wished to leave Uxmal at once. At 7 P.M. we retired to our room. Two hours later Dn M. called up the Dr to see one of the men, Verde, who they said was dying. Dr visited him; the patient passed a good night, and was well next day[.]

Sunday 9th

Took the last five plates of Gov. H. Then took a flayed figure from over doorway. It was imbedded in the wall with a long prong, and very tiresome to get out[.] Loesa gave up the job and Dr finished it with barata[.]

We had no ropes with which to let it down, so with a piece of string it was tied to a pole that was planted in the ground. Dr descended the ladder on which he had been working, jerked the stick from the ground & jumped on one side—The stone fell unharmed[.]

Monday 10th

Dn Manuel sent two men to help Loesa to take the box back to Monjas. We kept one to help with the ladder. Remade snake head, also made plate of a figure South end of same façade: Loesa called it a priest (Kin)[.] It has a belt round the waist with a strip hanging down in front, and in the hand a scroll. There was a figure above it, but the ladder did not reach. When Loesa and the Dr arranged the ladder on this spot, two ~~partridges~~ quails flew from under the wall, and we found there a nest with 17 eggs. We ate 14 and left 3, but the birds never laid there again, and we used the other 3 to clean glasses. We were told that these birds lay in any nest they come across, belonging to their own specie, but when the time arrives for them to hatch, they seek the one they themselves made, although it probably contains eggs of several different birds.

Took a general view of North wing Monjas; also of a double figure with mountain cat heads; and one of men with hands tied across breast. This concluded our work in Monjas, and as we were varnishing the last plate rain began to fall heavily. When it abated somewhat, the two men went home, we told them to ask Dn M. to send us horses. The gentleman had sent a bolan to us before our men reached the hacienda, but the bolan went, heavens knows where, and did not come to us until an hour and a half later. The road was almost continuous lake. We reached home at 6–30.

11th

My shoes were fast going—I proposed to send for a pair to Muna, but Da Catalina told me that there they made them in such a manner as not to be worn. Dr made a caste to my foot, the first in his life, and on it

he made out of my old shoes a new pair: as he had no nails, he made some of wood, and as Da Agueda said, I was "remedied[.]"

12

Fine weather. At home because the last day that Don Man. & family would be in hacienda. Dn Luis Perez returned in the afternoon: his brother died the day after he reached Tekax[.]

July 13

Betencourt family left. The servants assembled to bid them farewel, and many of them wept at parting[.] Dn Luis, & two of his men accompanied them on horseback to the first stopping place San Jose, property of Dn Fillipe Peon of Ticul. The knives and forks were all locked up, so we breakfasted with our fingers, & then went to the ruins. Dr took a view of Sanctuary from roof of East wing of Monjas. The ascent to this roof was very dangerous, and Doctor had to make 7 plates before the results satisfied him: all were good but spoiled by small dust. At 6 P.M. we dined with Don Luis Perez. That gentleman was much alarmed by a heavy storm that lasted for more than an hour[.] Six or seven thunderbolts fell near the house. Two struck breaking the outer cornice back & front[.] No one was hurt. We conversed with Dn Luis on the products of the hacienda. The gentleman complained that he found it in a very abandoned state. That the expenses were 5000 to 6000 $ a year, and the profit 4000 $ which was very little for an hacienda of that size.

14

Loesa, our help, brought his little son to us. He had trodden on a stone three days previous & now the plant of the foot was much swollen & had an ugly black line. He wanted to cut it, but the child cried and the father, was soft hearted. We told them to fetch the Hmen [shaman] one Dario Zi but he was at work in the milpa. The foot was relieved by Malva [mallow, a plant of the genus malva]. In the evening we went to the hut and found the boy lying on a petate over the damp ground. His foot was better, but he howled piteously, and redoubled his cries when the Doctor appeared with his truss of surgical instruments.

Dr & Don Luis Perez went with four men to have the dark box moved to the Adivino.

15

Cut the boys foot. Before we began his teeth chattered with fear—while we did it he looked on coolly, & afterwards cried bitterly. X [Refers to note in margin, which reads "That boy was doomed for 3 years later he died from tetanus, produced by a wound in the foot."]

At midday we went to "Sanctuary[.]" Brought box from upper room to lower. It took some time to arrange the ladder out beyond the edge of the platform. The sun was very hot, and Dr barely escaped a sunstroke.

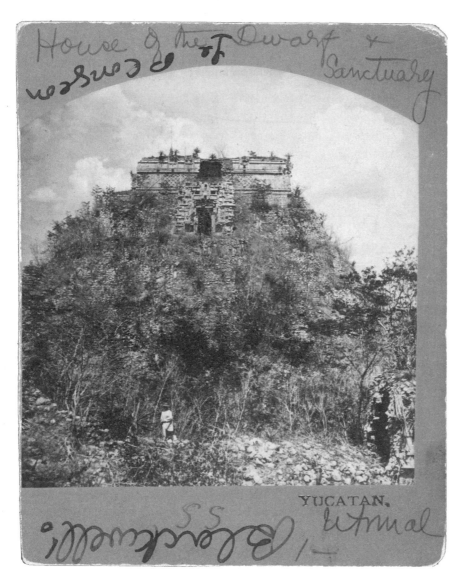

House of the Dwarf & Sanctuary

YUCATAN.

The west façade of the Adivino Pyramid taken from the roof of the East Building of the Nunnery Quadrangle. Figure in photo is not identified. 1876. Photo by Alice and Augustus Le Plongeon. Research Library, The Getty Research Institute, Los Angeles, California (2004.M.18).

We put plenty of coldwater on his head, and he afterwards took a view of the upper rooms. Preparing for a second second rain began to fall. We were prisoners & did not reach home till 6 P.M.

Sunday 16

Fine weather. At home. At 7–45 P.M. when conversing in the corridor we heard in direction of Seranea a cornet[.] Waited till 10–30 to see what might happen, but all was quiet, so we retired[.]

17

Made catalogue of negatives—Found façade of Gov. house incomplete[.]

From people that arrived at the hacienda learned that there was rumors of revolution in the state. In Merida no declared movement—but the Govr sneered at. In Tixkokob 25 Mexicans held the plaza against 600 revolutionists headed by Teodosio Canto who kept the town besieged for two days, when other federal troops arrived, and disbursed the Canto party after a hard fight, and much loss on both sides. T. C. pretended to second the movement of Porfirio Diaz. A band from the coast is going about sacking and killing—their chief unknown, and the only apparent object, robbery. In one village they killed the 6 employee, or authorities ~~of~~ and dragged one of them through the streets, tied to a horses tail.

The Le Plongeons continued their photographic documentation of the Chenes Temple (Sanctuary) on the west side of the Adivino Pyramid. This was a particularly dangerous undertaking because Augustus had to take photos of the façade from a ladder on the edge of the temple platform about sixty feet above the ground. Even higher up on the façade, the Le Plongeons managed to photograph in 3-D stereo two figures carved in bas-relief.

. . . . At the ruins today, Dr barely escaped a sunstroke, and could only work by keeping cold water on his head—Took six plates from front of Sanctuary, working always on the ladder, that is merely supported by two sticks, and held by ropes tied up in the room to two rings that once served to hang a curtain. The foot of the ladder merely rested against two tree trunks, ~~a be~~ on the very edge of the precipice. Dr had secured the ladder well—the danger consisted in any false movement of his own body, or a sunstroke, the fall, and _ _ _ _ a journey to the next world. On our return to the house we asked for a cup of coffee, but Philip had forgotten to grind it. I sent to buy some from the store: Dn Luis begged me not to buy anything there again. I told him I would not. I baked & ground some coffee, but it was old and tasteless.

Heard that some neighbouring ranches had been robbed of their weapons[.]

19th

When Dn. Manuel Betencourt was here it took the men two weeks to finish three arches. Under Dn Luis', supervision 9 have been completed in one week[.]

Dr sick with diarrhoea . . . Very little to eat. Dn Luis said "When shall we have a change from salt meat and rice?" I told him that the only change we might get would be to have nothing—and sure enough the salt meat was finished at breakfast, and for dinner there was nothing. Ignacio Loesa, our ever faithful help was famous at hunting rabbits, so

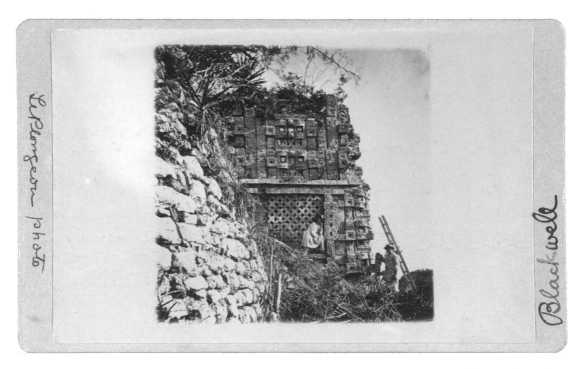

we asked to to look for some. He brought home two. Dn Luis gave one to him and kept the other for himself and us. In the evening went to cut the foot of Loesas child[.] On our way back saw, sitting on the floor of her hut, and old woman with a great number of eggs in-front of her. As best I could I asked her in her own language, to sell me a medios worth. I received in return a solemn shake of the head, and a most emphatic minan (there are none); the old witch at the same time extended her two arms over the eggs, as if she thought I was about to devour them with my eyes. I called out to her "que mala eres"—and left her to continue her business of setting hens. As a great favor, my wash woman Modesta gave us one egg, to clean glasses.

In the whole hacienda we could not obtain a fruit. Dn. Luis sent to San Jose to buy a real of alligator pears. They refused to sell, but sent two unripe ones as regalo (present) . . . Dr wrote to Dn Rafael Regil to ask permission to take down from over the front door of Sanctuary, two figures.

20

In order to take a picture of the two figures, object of letter to Regil, the ladder on which Dr stood had to be placed almost perpendicular—still on the extreme edge of platform. Then the ladder was not yet high enough, its top was not on a level with the figures—We had given Loesa permission to hunt for two hours—so remained without help. Dr had

Alice on the north side of the Chenes Temple near the top of the Adivino Pyramid. The ladder was used by Augustus to photograph a bas-relief above the door to the temple. The ladder is tied to prevent it from accidentally falling back, because a few feet to the right is the edge of the pyramid and a sixty-foot drop to the ground. 1876. Photo by Augustus Le Plongeon. Research Library, The Getty Research Institute, Los Angeles, California (2004.M.18).

THE DIARY OF
ALICE DIXON
LE PLONGEON

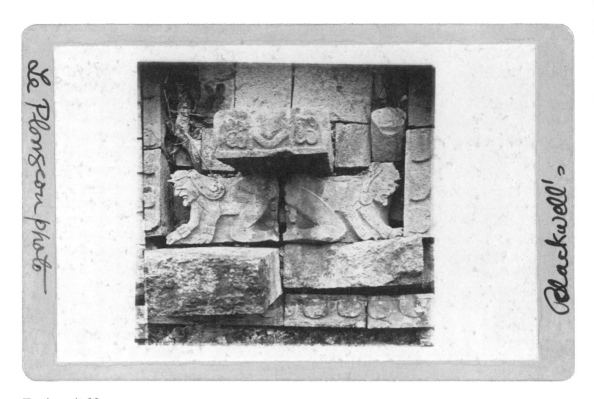

Two bas-relief figures above the door to the Chenes Temple on the Adivino Pyramid that required a ladder to photograph. 1876. Photo by Augustus Le Plongeon. Research Library, The Getty Research Institute, Los Angeles, California (2004.M.18).

only a small knife—with it he cut a long pole planted it at the base of the ladder, then he carried up his three legged camara stand, and tied the ends of the feet, two to the top of the ladder, and one to the pole he had planted—The half hour that he passed to arrange this was terrible for him, it was an exceeding difficult and exhausting task as well as perilous—depending altogether, as he had upon standing steadily on a round stick—Owing to dust, and other petty trifles (8) eight plates were taken by the Dr before he was satisfied—and each plate endangered his life. He got his back baked black, as he worked without shirt, to have freer movement. We took a plate from lowest part of North side of sanctuary, it being different to the south side: the upper part was equal . . . Loesa hunted no more game, and we were sorry, for in the <u>Casa Principal</u> there was very little to eat. He brought one small <u>chachalaca</u> (a kind of wild hen)[.] Dn. Luis procured with some difficulty a small chicken and three eggs for breakfast. Dr. received a letter from D. Emelio Canton. and a copy of the "Pensamiento" No. 81.

21

Rain. Dr wrote to D. Traconis. In the afternoon we had a severe tempest. In many of the huts, the people were knee deep in water. These huts have been built very, though there is a rising ground at the back of them

that would have served well to build on. The families were flooded. Don Luis sent for the family of Valencia head herdsman, because the women was expecting to be sick. He gave them a room.

Alice enjoyed writing fanciful short stories about birds, and the following account of the short life of Chack is similar to three articles she published in New York in the late 1890s about two birds named Loulou and Dick that lived in their apartment.

Sat. 22

Weather unsettled. Did not go to the ruins—The bird that Loesa gave me had a very sad experience. He lived in the bush cared for by his mother, loved by his brothers—early showed his roaming disposition, and went astray—was caught, and put into a <u>sabucan</u>, and hung up near the photographic box in the <u>Dwarfs house</u> [Adivino Pyramid]. <u>Chack</u> was not contented, so jumped out upon the floor, looked round, and found himself on strange premises: he was frightened and ran screaming round the room—He was recaught, and tied with a piece of string, to a stone that he might run round but not escape. Poor Chack! Already tired of life he tried to commit suicide by dashing out his young brains upon the stones, but his time had not come[.] With thorns he was pinned up in the pocket of my blouse; there he remained, much against his wish, till we reached home. He was set free in the room and looked about him in despair. He set up a desperate race round and round. When tired of that he began to jump in one corner, perhaps thinking to leap the wall. To show him how impossible it was, I stood him on my hand, and passed it up the wall as far as I could reach. <u>Chack</u> never tried to jump the wall again. Should not this be called intelligence? To the best of my ability I imitated his song of pi-i-i-i, pi-i-i, pi-e-pi and he came running to eat from my hand[.] He grew so fond at last that he was worse than a tiresome infant. The only bed that pleased him was my hand, and he would keep up a continual pi-i-i until I put him there. I would stand him on my shoulder; five minutes later he was entangled in my hair—I had only to utter a soft pi-i pi and he would come from any part of the room, look for the best means of reaching me, jump from one point to another, and come to pick my lips with his beak. His next sad experience was to find his way under my feet; but he escaped death—his time was not yet come. Having occasion to go away I made him a good nest between two small rabbits. On my return I called pi-i, but pi-i had no echo. Candle in hand I searched the room, but found him not. Next morning he was discovered stiff and cold in a pail of water. His fatal restlessness, and his curiosity to see what was in the pail, had caused him to commit suicide.

The Nunnery Quadrangle West Building and east wall of the East Building taken from the roof of the Chenes Temple of the Adivino Pyramid. This is photo seven of ten images (five pairs of 3D stereo photos) that were taken to create a panorama of the Maya city. Beyond the West Building can be seen a reservoir built by the Maya as a source of water for the city. 1876. Photos by Alice and Augustus Le Plongeon. Research Library, The Getty Research Institute, Los Angeles, California (2004.M.18).

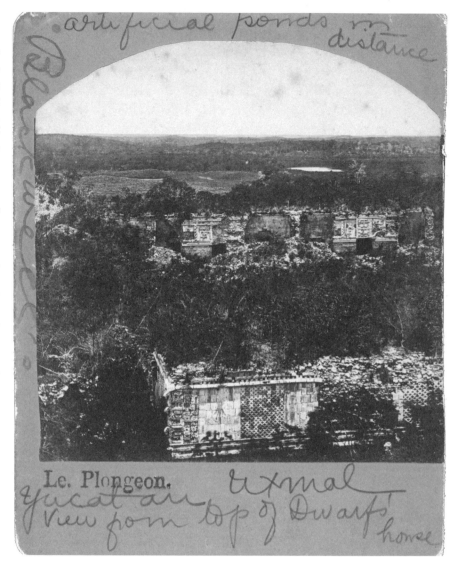

Le. Plongeon.

23

Fresh meat twice a week Saturday and sunday—feast day for the Casa Principal, and day of rejoicing for the people.

We discovered some egg plants in the orchard, cooked and enjoyed them for dinner. The people regard it as unhealthy food. We thought it just as well not to undeceive them, lest they should rob them, as they had robbed 100 water melons. In the afternoon Dr, D. L., and I went on horseback to the Temple of Death. The bush there was very thick. The tavano or horsefly were so numerous that we had to constantly brush the horses with a branch[.]

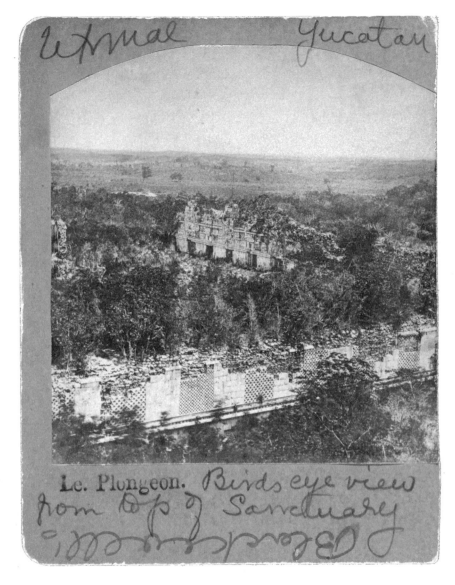

Uxmal — Yucatan

Le. Plongeon. Birds eye view from top of Sanctuary

The Nunnery Quadrangle North Building and east wall of the East Building taken from the roof of the Chenes Temple of the Adivino Pyramid. This is photo nine in the series of ten photos for the panorama. Between the West and North Buildings is a glimpse of a Maya built reservoir. 1876. Photos by Alice and Augustus Le Plongeon. Research Library, The Getty Research Institute, Los Angeles, California (2004.M.18).

24

 Fine weather. Took a panoramic view of the ruins, from roof of sanctuary. Came home at 10–30. Salt meat and rice—Dr went again to the ruins Dn L. accompanied him, and took four men to move the box to the governors house.

The Le Plongeons erected the Lerdo Monument again, and this time Alice took charge of all the photography including the camera work.

25

 Made the plate that was wanting to complete the façade of the Gov.

house. Happily the first was perfect[.] Dn L. went to road of Sn Jose to have it repaired[.] It rained hard, and that gentleman came back drenched to the skin. We received a letter from Rafael Regil[.]

26

Salas, the tailor—doctor—chanter came from Muna[.] He brought from Cura Lazaraga "El Pajaro, Verde" of Mexico N° 254—May 29, 1876. Someone, signing himself Erasmo, had attacked us in said paper, implying that we were occupied by Lerdo . . . I made two views of the Lerdo Monument. Dr went to ruins to get some hypo, and was caught in the rain. The horse was such an old hack that it fell twice on the road. Dr answered the article signed Erasmus and put with a view of Lerdo Monument—one of Chaacmol in the hole, another just out of the excavation, and one of its arrival at Piste.

27

Dr sent letter to "Pajaro Verde" Emilio Canton, and wrote one to Mr. Regil, but did not send it because Dn Luis begged him not to do so. Did not go to the ruins[.] Received news of an action that had taken place in San Sebastian—Merida.

28

Dr and Dn L. went to Muna to learn the true state of affairs. Philip thought "Cats away, mice may play." and did not care to prepare breakfast for me. He got whipped; not by my order, I was sorry for it. A new man came to distill aguardiente, and got drunk to begin with. At the close of the day D. L. dispatched him. Dr got a letter from Betencourt and some chemicals[.]

29, 30, 31

Fine weather—Brought photographic aparatus back to hacienda—
Discovered a head on mound at S.W. corner of Gov. house. Dr and Loesa got it out—but had some difficulty in getting it up to the top of the serro—it had adorned one of the andenes. Loesa called Pacheco from below, and tied the stone in his mecapal [basket with tumpline]. Loesa carried it down with great risk of falling. We had it taken to the house on the cart that had come to fetch stones from building purposes—also flayed trunk, and a head for Dn. Luis, that we had found among the nest of P On our way home we were very thirsty—We knew of a sartineja [sarteneja or haltun, Yucatec Mayan; limestone pool or rainwater pool] and from there drank water turning the camara caps into cups. When we reached the house we gave Loesa a dollar, and he was very contented[.]

Aug. 1

Before breakfast went to ruins with small cart, one ox without a tail, Loaser and Pacheco, to fetch a few stones that we had gathered

from different parts of the debris. Dr and I started before the cart, and not to go on foot we waited for it at the corner of the road. A block a head of us stood <u>Sosa</u> the <u>Mayoral</u>. We waited fifteen minutes—so did Sosa. The cart arrived and we got in. When we came up to where Sosa stood—he said "Good morning" so did we. Sosa followed the cart. Dr said "are you going to the ruins with us?" Sosa replied in the afirmative, and shortly after got on the cart. Dr told him he was welcom, and asked if he had been to the ruins before. He said "yes." The idea occured to us that Dn Luis Perez had sent him as a spy. When in the ruins, Dr told him that he could inform he who sent him that no monuments we touched by us, that the stones we gathered were found among the debris. Sosa held his tongue and Dr changed his idea into a certainty. Dr showed the men what stones he wanted carried to the cart[.] While the did it we went up to see if among the ruins of the Turtles house, we could find a turtle since the one we had had was robbed by the people of Muna—But even those yet on the cornice were imperfect. The arched roof that had been supported so many years on two stones had fallen since our last visit on the 25th of July[.] Had we known it before taking the box to the hacienda, we would have made another photo of it. We returned to the cart. I went with Loesa to get another snake head that we had seen among the bushes under N. terrace of the Monjas (These head have ph. earrings). Meanwhile Dr himself tied the stones on the cart with great care. He sent Loesa to see the fallen wall of Turtles house. Returning from that place, in coming down the ladder he cut his hand. Dr wound it up in a piece of rag that I had in my pocket ready for any emergency. We started home on foot and left Sosa and the men to bring the cart. It tarried on the road between two and three hours, & brought only two snake heads. They had been put face down, and were much scratched. Sosa said that the bull was not able to bring the other stones. The Dr gave Dn L. to understand that he comprehended why Sosa had been with us. At the dinner table he spoke more plainly yet. The gentleman sent for Sosa, and asked him why he had been to the ruins—He had been to "cut a stick" (but no stick was cut)[.] Dr apologized for having believed Dn Luis was <u>capable</u> of sending a spy (but when we had treated Sosa as such, he did not say "I am not sent")[.]

In the evening Loesa started for Tekax to fetch the family of Dn Luis Perez. We were sorry to part with Loesa; he had helped us so faithfully. Dn Luis looked very astonished because we shook hands with an indian that had served us.

2

Dr pass the day sawing stone; he wanted to diminish the weight as much as possible. We found the stone to be very hard marble. In the

afternoon the servants of the hacienda came to buy meat, and when told that nothing had been killed, were very much disgusted. Dn Luis told them they must "aguantar" [bear with it] till next day.

Thurs. 3

One or two cases of pulmonia—Salas sent for. Dn Luis talked to us about the ingratitude of the indians, and gave us an example. "One year," he said "I had a very excellent harvest, due to the fidelity and hard work of my men. To repay them I deducted something from the debt of each, making an expense of about 400 dollars. A few days later the Majordomo came to tell me that the indians were alborotados [restless], because they said "If he gave us that how much must he have robbed from us?"

Dr asked Luis when the carts would return from Merida, and how much it would cost to carry our photographic apparatus to Muna and th stones to Merida. The gentleman said it would not be impossible for the cart to take our things, but yes very difficult; there was so much corn to be carried, and the roads were very bad. In the Casa Principal, there was for breakfast, three eggs, a little rice, and some tortillas. D. L. promised us a man to saw the stones, we had asked it several times. The man did not appear during the whole day[.] In the afternoon a young cow was killed: it took five men to bring her, bellowing, to the poste. At the second blow she fell. After the men had killed her the heart was yet beating———In the afternoon we had a heavy storm for about 15 min. Dr stood at our room door washing a glass funnel a thunder bolt fell, and threw up some dust into his eye. At dinner—Dr told D. L. that he could not understand why he had set his nephew to spy every movement. The gentleman denied it; but did not jump at the Dr, as might have been expected. Dr asked if our things could be carried to Muna in a cart of the hacienda. And Perez said "I have promised, am I not a gentleman?" The Major Domo came to consult Dr for a man who had pulmonia. Dr told him there was no emetic in the house except a little that belonged to us, and he did not wish to give that lest D. L. P. should say of us what the indians had said of him— Perez wanted to know if Dr compared him to an indian, and Dr replied "You have been much among them, Sir.["] Dr spoke thus because a few hours previous Perez had said that "many medicines had disappeared, and only Dr L. P. and Salas knew anything about medicine[.]" Dr told the gentleman not to compare him with Salas . . . We proposed to go on foot to Muna—Dn Luis did not propose horses[.]

4

Daniel Traconis came to see us, and the ruins. His horse Chel is thin, because he had been half fed lately, unavoidably.

5

Daniel left for Muna. We asked him to look after Chaacmol, and

send us word about it. Perez, in presence of Dan. promised to send the stones for us to Ticul, where we resolved to go instead of to Muna— Received a communication from one who called himself Julius—Truth— Strength—Firmness—I packed negatives[.] [Alice may be referring to what she considered a psychic communication.]

6

A beast was brought to the post, to the slaughtered, but was not killed, the indians were not glad. D. L. recieved word that his family had left Tekax. We packed our box. Dr sawed part of Aacs head, stone very hard. A mexican sawed a while, but the work went very slow[.] Dr took a hammer and tried to break away some of the stone. A piece of the face broke, the stone was red marble.

Return to Merida

August 1876–September 1876 DIARY PAGES 258–61

Their work was not quite complete, but the Le Plongeons were more than ready to depart from Uxmal. With all their belongings packed into a small <u>volan</u> <u>coche</u>, they had to travel slowly over the very rough road, and even went on foot to San José. Finally they arrived at the village of Ticul. They would return again in 1881.

7 ⟶ San Jose

At 6 a.m. Perez started on horseback for the hacienda of San Jose, where he expected to breakfast with his family. At mid-day part of the family arrived—they had not come by San Jose—an hour later D. L appeared, angry and tired. Not finding his family at San Jose he had gone on to Ticul: of course they were not there. He returned to the hacienda after a run of 16 leagues, in six hours. At 2 P.M. the rest of the family arrived with the husband of the eldest daughter—Don Manuel Galera Jefe Politico of Tekax. We engaged the bolan that first arrived to take us to Ticul. When the driver saw the box he began to grumble. Dr caught the man, lifted him up in the air, and set him down again. The man went to tell that Dr had kicked him[.] Dr wrote a letter to Muna asking the cura to send a bolan. He did not send it because D. M. Galera offered us the bolan that had brought him, which belonged to the <u>Jefe Politico</u> of Ticul—Espejo. Dr had shown D. Manuel a letter of recommendation that he had from Gen. Palomino for this Espejo in which Palomino told him to supply the Dr with men to clear the ruins of Uxmal . . . None of the ladies came to bid us good night. At 9–30 the moon was bright, and we ready to start. I gave to D. Luis the key of the room, and told him the stones were there. He again promised

to send them to Ticul—I said to him ["]Pues, Senor, las niñas han ido cogiendo las hamacas insensiblmente y no nos hemos despedido, de modo que U. hara mis veces. Deseo a u., y a su familia, toda clase de felicidad en ese hacienda." [Well, Sir, the girls have thoughtlessly taken to the hammocks and we haven't said goodbye, so you'll have to say goodbye for me. I wish you and your family every kind of happiness at the hacienda.]

He returned the compliments and we parted. How glad to leave that spot! where all had been suffering and disgust. In the toldo was our box—the iron headrest—camera stand—bears head—flayed trunk, two buckets, our clothes, and we. Bolan and road both heavy: bolan very small. A most uncomfortable journey—Sea sick all the time. Passed the Serania on foot. San Jose at 2 AM. Every body up—Dn Philip Peon just started for Merida. Good room—good hammock.

8 ❧ *Ticul*

Up at 4 o'clock—Chocolate, medio a cup—14 eggs boiled hard to eat on the road cost 13 cents[.]

Major domo could not change a <u>peseta</u>, so we took aguacate for the other real—In Ticul arrived at the house of D. Demetrio Traconis. Sent to inquire price of bolan[.] While at breakfast received the bill for four dollars, from Mr Espejo—double the usual price. Paid at once. Found one of the buckets missing, sent to house of Espejo to inquire for it— coachman said it had been lost on the road[.]

9, 10

Making a tent: the people asked for portraits. D. Demetrio delivered the letter of Palomino, to Espejo. The gentleman did not visit us. Dr visited Benjamin Cuevas. Don Lib. Irigoyen had given us a letter of introduction to him; he did not return the Dr's visit.

11

Studio ready—Not a sitter of any kind.

12, 13

Señor Antonio Fajardo lent us the work of Cogolludo[.] We looked through the official papers of Yucatan of 1856–57, but found no law to impede the removal of Chaacmol . . . The people wanted to see some portraits before coming. Dr tried some of the family, and of D. Jaime Tio, a cuban friend of the family. The plates fogged, and it was not strange, for by mistake Dr put alcohol in the developer, instead of acid[.]

15

Good pictures of Demetrio, Jaime, Juanito Traconis. The people wanted to see <u>portraits of ladies</u>. Espinosa was expected to arrive of Thursday. The people of Ticul had sent for him, and they did not want our photos. . . . The square of Ticul is overgrown with weeds—Nearly all the houses belong to Don Filipe Peon, who is said to be father of

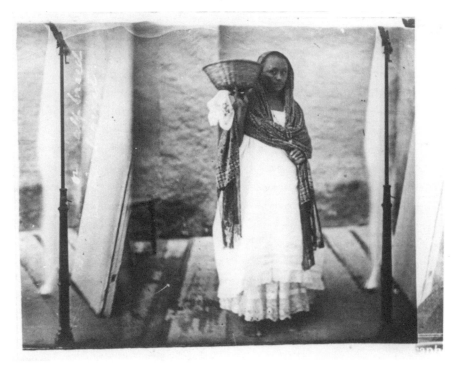

This portrait, labeled "market woman" by Alice, shows a woman in the traditional Yucatecan *huipil*. The photo includes sunlight reflectors used by the Le Plongeons to provide even illumination of the woman. Before the print was delivered, it was cropped by Alice to remove the reflectors. Circa 1876. Photo by Alice and Augustus Le Plongeon. Courtesy of the American Museum of Natural History, New York (AM145).

more than 100 children, and over 1000,000$. Some one loaned a horse to Juanito, for two hours. They charged him one real[.]

17

Espinosa arrived. Antonio Fajardo visited us.

19

Dn Dometrio brought Espejo to visit Dr at the door. A bolan came from Merida to fetch Luisa Traconis. We paid to Mr Faraiz 10 dollars for a bolan to take us to Merida. For the evening we were playing a borrowed guitar; and singing with some young ladies of Merida. In the midst of our amusement the guitar was sent for because a gentleman a few doors off wanted to sing himself. Ticul manners.

Sun. 20th ➣ *Merida*

Dr read receipt for 10 dollars and found that we had the bolan upon condition we did not carry more than 6 arobas of luggage. Dr sent word that we would take what we pleased, or have the money returned to us. The gentleman wisely listened to reason. We ordered the bolan to be at the door at 11 a.m. but had to wait until 1 o'clock . . . The road was a continuous swamp half of the wheels being submerged in mud . . . The bolan that carried Da Loesa, and Don Demetrio who accompanied her, went ahead, because they had good mules[.] The road was animated by drivers who were doing their best to get their carts along.

At 3–30, after 3 terrible leagues we came to the pueblo of [blank space][.] We passed on with intention of reaching the hacienda of D. L. Irigoyen 2 1/2 leagues off. But the family of Traconis had drawn up here, and obliged us to stop and dine with them. It was near five when we started again, so we went six leagues in the dark. At 10–30 we came to Guayalque, a fine hacienda belonging to Rafael Regil. The Mayor domo did not appear, and as we were two families, and only one room was open to us, the ladies occupied it, and the gentlemen slept in the corridor[.] Doctor woke us a 2 a.m., the hour agreed on for starting. The night was very dark, and the rats had carried away our long candle. Happily I had a piece of sperm in my pocket. After starting we saw no more of our companion. The road was bad, and I very sick. . . . At nine o'clock we reached the house of Herrera at Merida—

21

Font delivered to the Dr a letter from home, and one from Lerdo de Tejada[.]

22

Seeking for means to make a magic lantern.

Sep.

Sent 125 views mounted on varnished boards, to Ramon Aznar in N.Y. that he might forward them to the exhibition in Philadelphia—Dr wrote to the committee—Sent also 12 green arrow heads, and 12 white. Some fossil shells—and a jar, and two plates of pottery.

The governor, Eligio Ancona saw the collection of photos and ordered one for the Museum.

The photos made by Alice for the governor were given by him to what is now the Regional Museum of Anthropology in Mérida in the Palacio Canton. It is under the direction of Mexico's National Institute of Anthropology and History.

18th

Completed and delivered the views for the museum. That they might have them all on boards—we remade the 50 they had before had from us. The boards were fourteen in all—the bill 150 dollars. They offered to pay 75 one month, and 75 the next[.]

22

Filled up the album that Dr made, with 180 views to send to the states for copy right. Sent home 60 views of Chichen—No silver bath to go on printing[.]

The September 22 entry on page 261 is the last in Alice's diary. It should be noted that pages 262 to 334 were cut from the diary volume, and while the Le Plongeons'

explorations of Yucatán continued, there is no conclusive evidence that Alice continued writing on those pages. In the space remaining below her last entry, her friend Maude Blackwell added her own written comment.

Here ends the Diary of Madame Le Plongeon, but there is so much of interest to add, for she & the Doctor often talked & gave directions to Harry & myself.

[signed] Maude A. Blackwell
[End of Diary]

On November 20, 1876, two months after the last entry in her diary, Alice and Augustus set sail from Progreso in a small sailing vessel to explore Isla Mujeres, Cozumel Island, and the archaeological sites on the east coast of Yucatán. Their final destination was British Honduras (Belize), but they would spend about seven months on the islands. Alice was particularly interested in Isla Mujeres and Cozumel Island because they were known to have been pilgrimage destinations for Maya women who sought the help of the goddess Ix Chel.

⤚⤙

Transcription credits:

Transcribed from Alice Dixon Le Plongeon's handwritten manuscript by Lawrence G. Desmond, PhD

Editing and transcription assistance by Beth A. Guynn, MA, Getty Research Institute, Special Collections Cataloger—Rare Photographs.

Additional assistance by Peter L. Bonfitto, MA, Research Assistant, Getty Research Institute.

*The Islands,
Belize,
Mexico City,
and the Return to Yucatán*

Many thanks for the compliments you pay to my poor attempts at writing; I fear it is hardly merited. Time and study may make a third rate writer out of me. My only diary is a copy of the letters I send to England. If the reading of them afford pleasure to my friends, I am more than repaid.

ALICE DIXON LE PLONGEON, letter to Jacob Dixon, 1875

THREE

Life on the Islands

1876–80

AFTER THREE YEARS IN YUCATÁN, ALICE AND AUGUSTUS SPENT THE next seven months, from late November 1876 until June 1877, exploring archaeological sites on Isla Mujeres, Cozumel Island, and the east coast of Yucatán. They then departed for what was then called British Honduras (Belize), but the final leg of their journey aboard a schooner turned out to be more of an ordeal than they expected. Fortunately, after their arrival they quickly integrated into the British colony and took up residence for two years writing and photographing before returning to Mexico.

They were satisfied with their accomplishments during their three years in Yucatán. "[Augustus] reported that he had taken more than five hundred stereographic views in Yucatan" (Palmquist and Kailbourn 2000:366). Because the glass-plate negatives were fragile, they carried only paper prints with them when they sailed from Progreso and stored the negatives in Mérida. While they were in Belize they mailed more than two hundred photographic prints to Alice's father in London.[1] On their departure from Belize two years later, they carefully packed and transported the negatives they had made back to Yucatán.

The Le Plongeons began their explorations by booking space on the small sailing vessel *Viva* that was scheduled to depart from Progreso on November 20. Alice took notes (she called them "memoranda") during their voyage to Isla Mujeres and Cozumel and later used them for articles and for her book *Here and There in Yucatan* (1886a).

Augustus, a seasoned sailor, showed little concern for the small size of the vessel or the rough ride. He wrote in a letter, it was a "small boat about

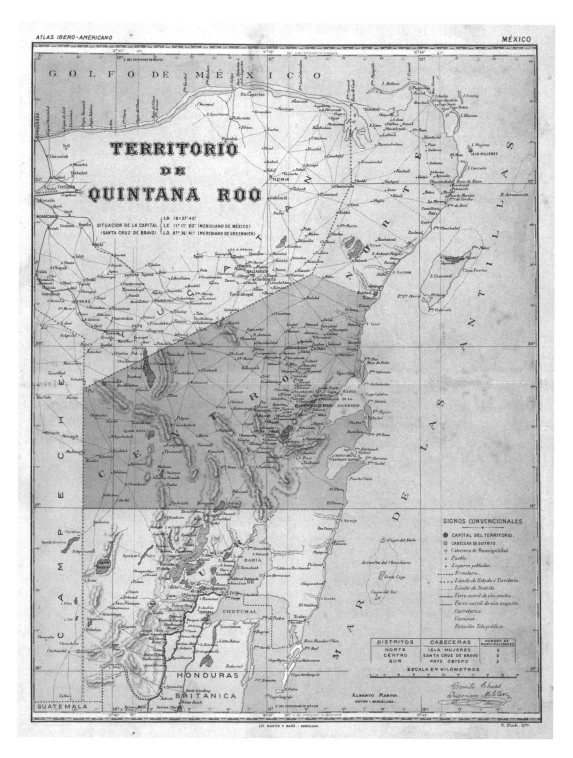

Map of the Territory of Quintana Roo, north and eastern Yucatán peninsula and northern part of Belize. No date. Martin y Bañó, Barcelona. Research Library, The Getty Research Institute, Los Angeles, California (P840001).

15 tones caliber". . . and [other] than the "danger of capsizing . . . we did not fare as bad as we expected" (ALP 1876).

Augustus spoke only for himself. For Alice, every hour of plowing into the swells and the constant danger of "capsizing" was pure misery.

> [November] 21. At dusk anchored a short distance from land at a place called Telchac. How stupid I was to come in this miserable boat!
>
> [November] 22. Stopped at Sacrisan, and again at Hocum. Don't know why.
>
> [November] 23. Stopped at Dzilan. Wish the water would stop. Head wind. Heavy thunderstorm. Very rough. Extra sick. Wish I was dead!
>
> [November] 24. Stopped at Holbox. Feel a little better. Ate a cracker. Fine weather.
>
> To those who have been seasick I need offer no apology for such a diary, they will fully understand that I am not responsible [ADLP 1886:2].

Telchac and Dzilan have no harbors, so the vessel anchored off shore and the Le Plongeons rode out the constant rolling of the boat. They stayed two days at the sheltered Holbox anchorage. It took most of the following day to round Cape Catoche and sail to Contoy Island. On the tenth day they finally anchored in Dolores Bay at Isla Mujeres, and Alice was the first ashore!

Isla Mujeres was a paradise for her: "the perfect stillness made us almost imagine that we beheld an enchanted island awaiting the touch of a magic wand" (ADLP 1886a:5). She not only thought it was a beautiful island, but she also knew a Maya temple at the island's south end needed to be photographed and plans of it drawn.

Alice was particularly interested in Isla Mujeres because she had learned it had been a pilgrimage destination for women who venerated the Maya goddess Ix Chel. To get to the temple, the Le Plongeons packed their camera and developing equipment in a small boat and, in-spite-of the threat of seasickness, they sailed south along the island's west coast with Augustus at the helm.

The temple was easily located, but they were disappointed because it had been severely eroded by the sea. During some exploratory excavations in the vicinity, they uncovered a ceramic figurine and took photos of the artifacts and temple. While their portable darkroom had occupied a good part of the small boat, the inconvenience was warranted. They couldn't be without it because the glass negatives had to be processed on the spot. Determined to do a thorough job, they returned to the temple a number of times to draw a plan and to map that part of the island.

Augustus's report to the American Antiquarian Society about the Le Plongeons' explorations of Isla Mujeres provided a detailed description of the

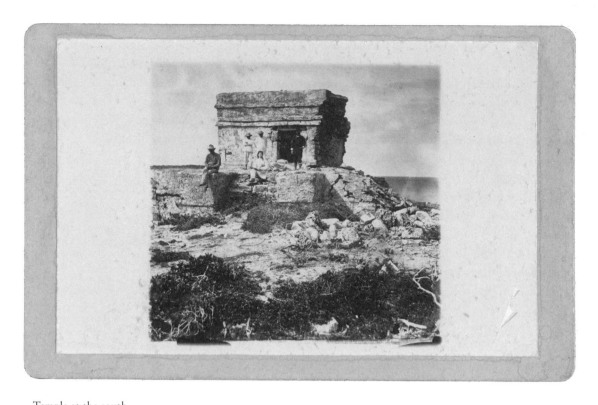

temple, the shrine, and other cultural features. It was published by Stephen Salisbury Jr., president of the society, as a ten-page addendum to his article, "Terra Cotta Figure from Isla Mujeres," in the American Antiquarian Society's *Proceedings* (Salisbury 1878). Augustus was careful not to mention any Maya connections with Egypt in his report because of strong opposition to any speculative ideas by the *Proceedings'* editor, Samuel K. Haven. Even twenty years before, Haven had fully backed the Smithsonian Institution's insistence that archaeologists keep only to the facts: "in the state of archaeology, all labors should be a contributions to that store of facts" (Mayer 1857:2).

While Haven managed to control most of what Augustus published in the society's *Proceedings*, he had little control over the published opinions of Stephen Salisbury. In the 1870s Salisbury fully supported Alice and Augustus and published Augustus's reports by attaching them as appendices to his own articles.

That worked well enough, but in 1877 Salisbury published an article, "Dr. Le Plongeon in Yucatan," in which he not only included Augustus's field report but also a controversial letter that had been previously published in the *London Times*. In the letter Augustus proposed Yucatán had been visited at some time in the distant past by peoples from Asia and Africa who sailed across the Atlantic with the help of "the . . . Carians. . . . They are the most

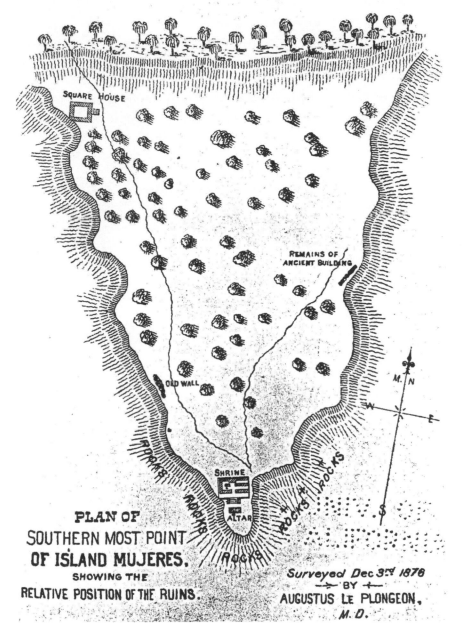

Map of southern part of Isla Mujeres with archaeological sites. Survey dated December 3, 1876, and signed by Augustus Le Plongeon. It was published to illustrate the article "Terra Cotta Figure from Isla Mujeres" by Stephen Salisbury, 1878.

ancient navigators known. They roamed the seas long before the Phoenicians" (Salisbury 1877:119).

The paragraph about transatlantic contact and the Carians was deleted from the published letter, but on someone's orders the paragraph was stuck back in *Proceedings* on a separate page at the end of the article. Using the excuse that they were helping Augustus not to repeat himself, the editors

Plan of the temple at the south end of Isla Mujeres. The survey is not dated, but the date is probably the same as the map by Augustus Le Plongeon. It was published to illustrate the article "Terra Cotta Figure from Isla Mujeres" by Stephen Salisbury, 1878.

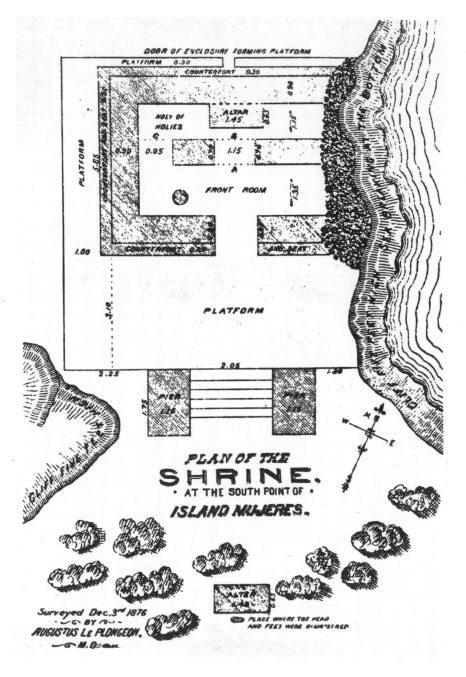

stated, "The omission (as indicated) at the close of Dr. Le Plongeon's letter is a repetition of what he has previously stated in other communications" (Salisbury 1877:119).

In addition to the attempted censorship, Haven infuriated Augustus by stating, "The principle paper is an effort on the part of our associate,

Mr. Stephen Salisbury, Jr., to present in an intelligible and appreciative manner, the claims of Dr. Augustus Le Plongeon" (Haven 1877:96). And even stronger, "Like Brasseur he [Le Plongeon] is an enthusiast, but less guarded and more impetuous" (Haven 1877:97).

In contrast to Augustus, Alice focused on the culture and history of Yucatán. In her lengthy article "Notes on Yucatan," written in while the couple was in Belize and published in the *Proceedings of the American Antiquarian Society*, Alice clearly was in her element and wrote a lively description of the people and customs of Yucatán, with no mention of the diffusion of Maya culture to Egypt. She saw herself as an observer and stated, "As travelers, we must speak of things as they are" (ADLP 1879b:78).

Her reporting skills must have been sharpened when she came face-to-face with the Chan Santa Cruz Maya who fought the Caste War to maintain a homeland in eastern Yucatán. In her later articles about the Caste War, she condemned the extreme violence on both sides, but in the end concluded that the war was the result of the more than three hundred years of colonial Spanish and Mexican government oppression of the Maya.

Unaware that opposition to their conclusions about the ancient Maya was growing within the society, Alice and Augustus continued their work along the coast of Yucatán undaunted. They rented a canoe from a resident, and the three paddled the five or so miles from Isla Mujeres to the coast to investigate the Maya archaeological site of El Meco. Alice's interest in the life of Maya women had grown, and when she was told that El Meco was a stopping-off point for women pilgrims on their way to Isla Mujeres, she convinced Augustus that they should investigate.

But in the 1870s, El Meco was in Chan Santa Cruz Maya territory and that area was patrolled, so Alice and Augustus could only safely stay a short time. The ruins were situated near the coast, and like other small trading towns built around AD 900, El Meco had been under the control of Chichén Itzá. It flourished because of the seaborne trade in honey, salt, ceramics, obsidian, jadeite, and beeswax. Alice noted copal incense and other small offerings in some of the buildings. The buildings' small size intrigued Alice and Augustus. After cutting down the brush, they "succeeded in measuring a temple: it was ten feet in height, built on the summit of an artificial mound forty feet high, with stone steps on the east side" (ADLP 1886a:11).

They then visited another small Maya outpost a little further down the coast that they called Niscuté. Alice noted in one of buildings, "a square pedestal one foot high, on which was a symbol of Phallic worship" (ADLP 1886a:13). They spent a night at the site because the owner of the canoe needed additional time to collect "lime and wood." Alice enjoyed the warm evening by the campfire, but sleep was impossible because of the millions of mosquitoes—"and no amount of smoke annoyed them" (ADLP 1886a:15). After

returning to Isla Mujeres, she and Augustus explored the ancient ponds the Maya had built to collect salt for trade.

In early February, they decided to leave Isla Mujeres and sail for Cozumel Island, about seventy-five miles south of Isla Mujeres and ten miles off the coast. Today the island is a tourist destination complete with an international airport, but in the 1870s only a few travelers visited the island, and Alice noted it had only "five hundred inhabitants" (ADLP 1886a:28).

While Alice was a little disappointed that the principal village of San Miguel had only a "thatched church" and a "grass-grown square," she savored the tropical environment "where there is perpetual spring, and to live in the open air is a delight" (ADLP 1886a:28). In those days the island had considerable forest cover, and "the thickets are alive with pheasants, quails, pigeons, and other game." Alice was captivated by the tropical bounty: "With little care every kind of tropical fruit, of very fine quality, grows abundantly" (ADLP 1886a:30).

Cozumel Island, like Isla Mujeres, became an important Maya economic and religious center after AD 900. In addition to the traders with their long canoes filled with goods, pilgrims from all over the Maya region visited the temple of the goddess Ix Chel. Even today, the more than thirty archaeological sites that have survived modern development attest to the island as a once-thriving center for trade and pilgrimage.

Alice wrote articles, kept notes, and made copies of her letters during their four months on Cozumel Island. In the relaxed tropical world she wrote "Beautiful Cozumel" and articles about Isla Mujeres for professional and popular journals. "Beautiful Cozumel" was first published in the *New York Tribune* in the 1880s and later edited and published again around 1890. That article and her other stories about life in Belize, on Isla Mujeres, and along the coast of Yucatán were published in her book, *Here and There in Yucatan*.

Meanwhile, the Chacmool statue had been confiscated by the government of Yucatán, but soon was snatched from the Yucatecans by the Mexican army and taken to Mexico City. It was now completely out of the Le Plongeons' hands, and its loss was a serious financial and psychological setback.

In a letter to the president of Mexico, Sebastián Lerdo de Tejada, requesting export of the Chacmool, Augustus had stated, "This statue, Mr. President, the only one of its kind in the world, shows positively that the ancient inhabitants of the Americas have made . . . sculpture, . . . equal at least to those made by the Assyrian, Chaldean, and Egyptian artist" (Salisbury 1877:85). Clearly impressed by Augustus's description of the Chacmool, Lerdo de Tejada quickly realized it was a national treasure and refused to allow its export. He was replaced as president by General Porfirio Díaz a short time later, and it was Díaz who ordered the army to remove the Chacmool from Yucatán and install it in the National Museum in Mexico City.

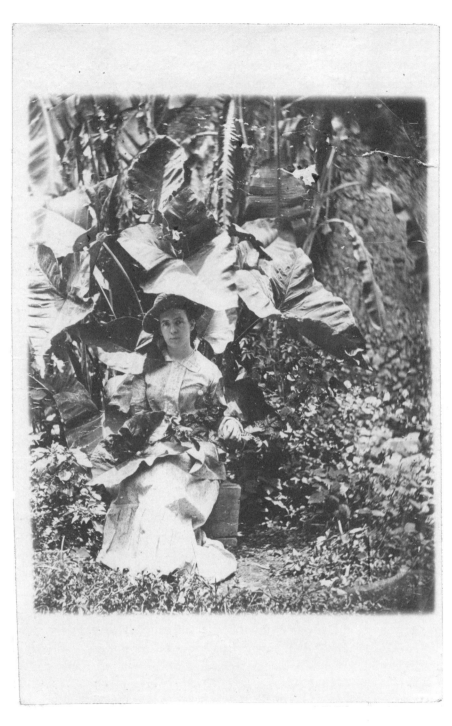

Alice enjoying a moment of relaxation. From Yucatán she had written her mother and father, "If you were here . . . you would know the pleasure of life in the wilds" (ADLP 1875b). Photo was taken in Yucatán or on one of the islands. Circa 1877. Photo by Augustus Le Plongeon. Research Library, The Getty Research Institute, Los Angeles, California (2004.M.18).

After the enormous amount of work to excavate and transport the heavy Chacmool to Pisté, Alice was angered by its confiscation. She wrote from Cozumel to a friend in New York, "We have suffered from extreme indignation and sorrow, and have been quite unwell in consequence of what has happened. The best and most beautiful fruit of our knowledge, labor, suffering, and heavy expenditure, stolen" (ADLP 1877). In spite of the setback, they continued with their explorations, photography, and writing.

Alice and Augustus visited a number of archaeological sites on Cozumel Island, and, as at El Meco, the small size of the buildings intrigued them. Unable to understand why the buildings would be built so small, the Le Plongeons attributed them to an unknown but diminutive race. The Le Plongeons were told about ruins on the southwest side of the island called Buena Vista and employed a Maya guide to take them there. They rode part way on horseback, then had to walk an additional five miles over broken stone in the heat of the day—and ultimately didn't make it to the ruins because their "boots were falling apart!" (ADLP 1886a:33). They happily borrowed horses and had a wonderful ride back along the beach to San Miguel. Along the way, Alice marveled at the "wonderful fertility of the soil" and concluded the island probably supported a large population in ancient times (ADLP 1886a:34).

Hearing about more ruins at the south end of the island, they joined with a few other visitors and sailed down the west coast in a small boat. It took them almost two days to reach what Alice described as a large shell mound and a nearby "shrine" at the end of the island, which were the archaeological site of either Celerain or Caracol.

Their comrades turned out to be amateur sailors, and on the way back, to the frustration of Alice, they ran the boat ashore five times. Finally, the group "unanimously" elected Augustus, the old salt, as their captain—he took charge and got them quickly back to San Miguel. Alice reported that they were fortunate to have reached the shelter of their house by nightfall because a heavy thunder and lightening storm was breaking.

One of the local characters was Father Rejon, the village priest. He befriended the Le Plongeons and often acted as guide for their explorations. While he was a good neighbor and went out of his way to help everyone, he openly admitted that he had one serious defect—"an evil eye; I do not know how it happens" (ADLP 1886a:46).

One afternoon they walked with Father Rejon and a Maya villager to visit an old Maya building situated on the edge of a cenote about a mile away. After Alice and Augustus measured the dimensions of the building, Augustus searched for a break in the brush so that they could see the cenote. Trying to get a look, he leaned forward while holding on to a branch—it broke, and he fell a good fifteen feet onto the rocks below. Augustus managed to climb

back up the rocky sides, but had blood streaming down his face from a deep gash across his forehead.

Alice knew that cool water from the cenote would slow the bleeding, so she tried to climb down its steep sides to fill a gourd. She slipped and barely saved herself by grabbing a rock. The water remained out of reach, the priest was too old to climb down, and their Maya companion, fearful that he might disturb a sacred place, refused to touch the water. In desperation, Alice drew her revolver and ordered the man to fill the gourd. Alice said later that he admitted "he was afraid of the spirit of the *senote* [cenote]" (ADLP 1886a:51). She soaked a cloth and pressed it onto the cut, which slowed the bleeding, She later wrote, "it bled for six hours, in spite of perchloride of iron. . . . After a new skin formed I had to cut it to extract splinters that worked their way to the surface" (ADLP 1886a:51).

After a few weeks, Augustus recovered from his injured forehead, and by mid-June Alice had convinced him it was time to continue on to British Honduras. She was a British citizen and knew they would be welcome in the colony, so they purchased passage on a small sailing vessel that was traveling down the coast to Belize. But the captain of the twelve-ton schooner *Triunfo* turned out to be a smuggler, and, worse, he was a poor mariner.

One night, in the vicinity of Ascension Bay, Alice was in the ship's hold, squeezed between "twenty-five sea turtles" and "members of the cockroach colony that seemed to have selected me as a site to hold a mass meeting" (ADLP 1886a:67). Captain Antonio had put an inexperienced sailor at the helm, and late that night, between snapping turtles and cockroach assemblies, Alice was awakened to Augustus's shouts from on deck. She scrambled from the hold and recounted:

> [I] saw my husband holding the tiller, giving orders in not sweet Spanish. His attention had been attracted by a strange sound; peering through the darkness he saw that the boat was sailing straight toward the breakers, but a few yards ahead. . . . [T]he man at the helm was sound asleep, he pushed him aside and veered the boat. . . . Daylight showed . . . [W]e . . . had been close upon the reefs at the entrance of Ascension Bay, where the water is very deep and alive with sharks [ADLP 1886:67].

After three days they reached the "Island of Ambergris," and the smugglers did their work. "[A]t dusk about 20,000 cigars were slyly put into a small dory, and taken ashore with many precautions" (ADLP 1886a:68). The *Triunfo* set sail early the next morning. By four in the afternoon they reached Belize City, where the captain, unfamiliar with the shallow channel, grounded the schooner three times.

Photographs of a Maya incense burner and carved stone heads pasted on cardboard. Alice's experience in museum photography was useful in photographing the many small artifacts they discovered during their explorations. Circa 1880. Photo by Alice and Augustus Le Plongeon. Research Library, The Getty Research Institute, Los Angeles, California (2004.M.18).

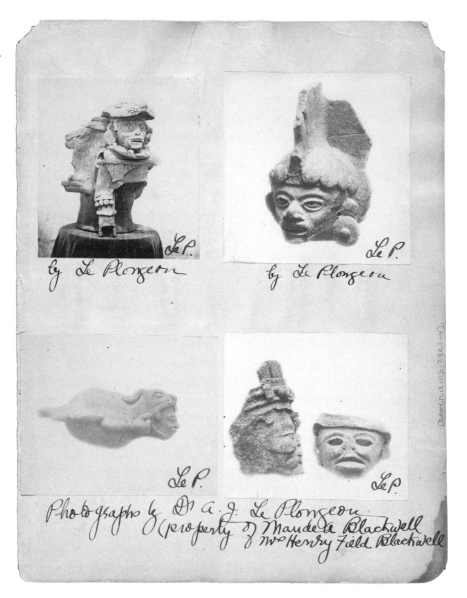

Finally, unable to reach the docks, he decided to anchor off shore in order to "smuggle a few thousand cigars . . . and several demijohns of Havana rum" (ADLP 1886a:69). Later that night they left the schooner by skiff and landed at a remote wharf. The only place they could find to sleep was at the house of the cigar dealer who had bought the smuggled cigars from Captain Antonio. It was not the welcome Alice had expected, but life soon improved. In fact, during their more than two years in Belize, they became good friends with most of the important colonial officials, including the governor Henry Fowler, lieutenant governor Frederick Barlee, and the chief justice William Parker. But their archaeological explorations were limited.

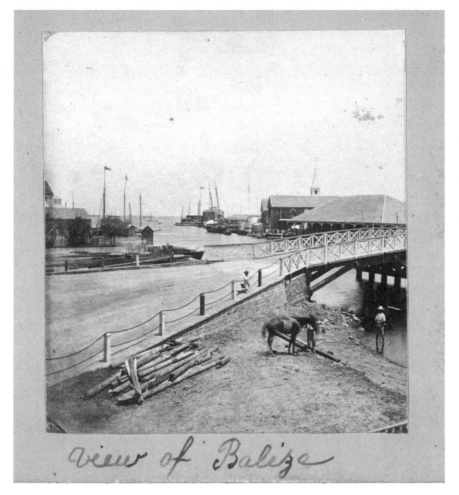

view of Balize

Different from northern Yucatán, the Maya archaeological sites in Belize were overgrown by heavy tropical vegetation, which made them much more difficult to locate. Alice noted, "We speak of these lands [Belize] as being archaeologically unexplored" (ADLP 1879b:77). They had heard there were ancient ruins, but the difficult access through the rain forest either on foot or on horseback must have discouraged them. So, instead, they purchased interesting artifacts, such as incense burners, ceramic figurines, arrowheads, pots, plates, and other small objects, which they first photographed and then brought back to New York.

In Belize City, Alice and Augustus set up a portrait studio and a thriving business developed, but only a few portrait prints were kept by the Le Plongeons. The prints were given to their clients, and the glass negatives were cleaned of emulsion and reused. Fifty photos taken of the landscape and towns have survived, and they may be some of the earliest

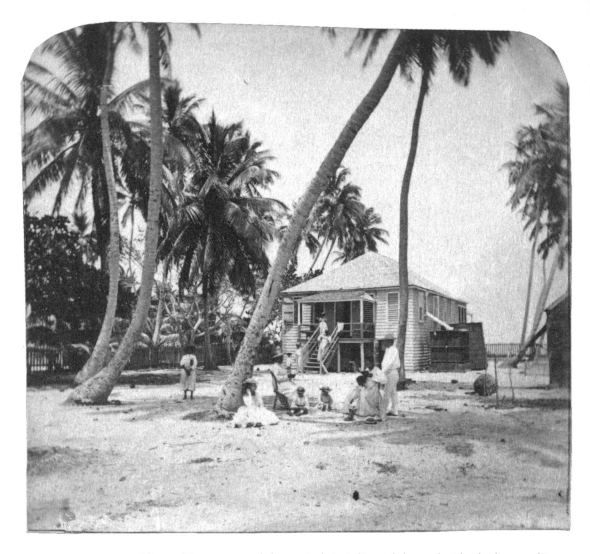

Alice and Augustus traveled extensively in Belize and the nearby islands photographing people and the landscape such as St. George's Cay. Alice can be seen enjoying life in the tropics sitting under a palm tree. In a note on the photo, Alice wrote, "A few days at St. George's Cay" and "McDonald's house." Circa 1878. Photo by Augustus Le Plongeon. Research Library, The Getty Research Institute, Los Angeles, California (2004.M.18).

photos of Belize. They give an interesting glimpse into life in the tropical English colony.

Alice took advantage of her quiet time in Belize to edit her articles about Isla Mujeres and Cozumel Island and piece together her diary for the years 1873 to 1876 from copies "of the letters I send to England" (ADLP 1875a). Her first published article was printed in the scholarly *Proceedings of the American Antiquarian Society* in 1879. That article, "Notes on Yucatan," was first written

as a lecture and read by Alice "in Belize, British Honduras, for the benefit of the Catholic school . . . 1877" (ADLP 1873–76:44). A draft article, based on the lecture, was sent to the society for review and approved for publication.[2]

Alice lacked experience writing for a scholarly society, but the American Antiquarian Society was so impressed with her work that the editors of the *Proceedings* helped her keep her article focused and diplomatic. For example, the following lines were removed before the article was published:

> From New York to Havana we made the best of it, for we were only a few on board, and happily all well mannered. But at Havana we took up a crowd of Spaniards, by no means of the first quality, and a number of babies. These made day and night hideous with their cries, their attendants being prostrated; and the Spaniards did their best to keep every one away from the table but themselves, by disregarding knife and fork, and thrusting their fingers into the dishes to take . . . whatever pleased them. (ADLP 1879a:2)

In the same vein, Alice described how she and Augustus wanted to go ashore in Havana, but were prevented by the Cuban officials because of yellow fever. Alice was riled when "one of the Spaniards proposed to get us ashore if we were willing to gild the palm of his dirty hand" (ADLP 1873–76:1). Needless to say, the line was also removed before publication.

In addition, Alice took issue with an assertion made by the well-known travel writer John L. Stephens concerning the Maya of Yucatán in his book, *Incidents of Travel in Yucatan* (1843). Stephens's work set a high standard, and his description of Yucatán and the Maya ruins was considered nearly flawless. Yet Alice noted correctly in her manuscript: "Mr. Stephens in his work 'Travels in Yucatan' asserts that no traces of the ancient customs exist among the present inhabitants of the country. After four years careful study I must say that such an assertion is without foundation" (ADLP 1873–76:32). That comment did not appear in print.

Alice also had strong views about the protection of Maya archaeological sites and important historical monuments. She saw the article as an opportunity to spread her message, and wrote with the approval of the society editors, "It has been proposed to pull down the Castle of San Benito [where Augustus had been jailed for two weeks], and build a new theatre in its place. It would be regretted, for . . . it is a historical monument that ought to be preserved" (ADLP 1879b:101–2).

As the editors predicted, the article did "receive most careful attention from historians and antiquaries" (ADLP 1879b:77), and it became an important contribution to knowledge about Yucatán of the 1870s. It was also an extraordinary moment in the society's history because it was the first article

by a woman published in the *Proceedings* since it began publication in 1812. But it would be seventy years before another article by a woman would see print in the *Proceedings*.

The Le Plongeons remained in Belize until the spring of 1880, and they again appealed to the Mexican government for compensation for loss of the Chacmool. Augustus indignantly wrote a friend that the Mexican government "refuses to pay us the value of the statue and damages" (ALP 1877a). In a letter to president Porfirio Díaz in 1877, he appealed to have the "statue returned . . . or if the government wishes to keep it, to see that I am paid that which is very just—its value—together with my expenses, and the damages" (ALP 1877b). The confiscation of the Chacmool was a tragedy for the Le Plongeons, who honestly thought they could export it from Mexico. In the long run, the loss of the Chacmool caused them financial difficulties that were made worse by the collapse of the United States economy in 1893.

After almost two years in Belize, Alice and Augustus became anxious to return to Yucatán and began to consider financial arrangements. Augustus wrote Alice's father, Henry Dixon, "the time is coming when we must be on the move again, and shake the dust off our feet in leaving Belize, where we are losing precious time. In order to travel, we must have money" (ALP 1878b).

Augustus had entrusted Henry Dixon with two Spanish paintings he had bought in Peru. One was by the well-known painter and sculptor Alonso Cano (1601–67) and the other by the painter Juan del Castillo (1590–1657). He asked Dixon to ship the paintings to Stephen Salisbury, hoping that Salisbury would sell them. "Please ship, by first opportunity, to the address of Stephen Salisbury, Jr., Worchester, Mass. . . . Care of R. S. Lewis, Esq. Scovill Manufacturing Co . . . One by Alonso Cano, representing St. Anthony of Padua—the other by Castillo, representing St. Austin" (ALP 1878b).

Henry Dixon had delayed shipment of the paintings, and in December Augustus wrote Salisbury again, "If among your rich friends, anyone has sufficient confidence to lend me 1000$ on the pictures I have in England, I will immediately send orders to have said pictures forwarded to you as security" (ALP 1878d). The paintings were not purchased by any of Salisbury's friends, and they remained in England.

At this same time, in a tantalizing letter to Salisbury, Augustus wrote, "Thanks for the trouble you have taken to put our works and investigations before the world. These investigations we are desirous to continue; but are prevented, for the time being, by the lack of funds. We have however written to London to sell some property of ours, in order to obtain the means of bringing to light the libraries of the Maya sages" (ALP 1878c). The line about Maya "libraries" must certainly have caught the notice of Salisbury and his archaeologist colleagues.

Alice and Augustus never asserted they knew exactly where ancient Maya

books were located, but like most archaeologists, they had a good idea of where the books might be found. Within one hundred years of the burning of hundreds of Maya books by Bishop Diego de Landa at the town of Mani in Yucatán, it had been the hope of historians and other scholars that some surviving books might be found. Brasseur located a few important Maya and Mexican manuscripts in archives, but the Le Plongeons thought they might find a large number secreted away in the ruins. In recent years, there have been occasional discoveries of Maya books in excavations, but what was found has been no more than a pile of moldering vegetable matter that laboratory analysis identified as a once magnificent Maya book.

Alice had enjoyed her years in Belize where she had the time to write about the explorations and archaeological work she and Augustus had carried out in Yucatán. Her first published article, "Notes on Yucatan," may have brought in a small amount of money, but additional income from writing would have to wait until after 1881 when her submissions to professional journals, popular magazines, and New York newspapers would be published.

The time had finally come for the Le Plongeons to return to Yucatán to continue their archaeological investigations. With mixed feelings, "on the 25th of April 1880" (ALP 1881a), Alice and Augustus sailed for New York in order to talk directly with Stephen Salisbury and other patrons of archaeology about funding for their projects.

Mrs. Alice Le Plongeon . . . is a pale, slender, delicate-looking woman—the last one would select as having a physique fitted to undergo the perils of the wildernesses, and waste places of the earth as she has done.

THE NEW YORK TIMES, October 22, 1883

Fêted in Mexico City

1880–84

WHEN THE LE PLONGEONS STEAMED INTO NEW YORK HARBOR DURING the spring of 1880, after being away for seven years, Alice knew it would be a busy two months before they could return to Mexico. They had brought all their negatives and other research materials, and Alice began making

> lantern slides, not only because we needed them to illustrate our lectures on the ruined cities of Central America, but because if any disaster happened to the negatives we could reproduce them at any time from the transparencies. For this work we used both Eastman's and Carbutt's dry plates, obtaining very pretty pictures, though not often of crystalline transparency [ADLP 1888e:582].

They had made an appointment with Stephen Salisbury at the American Antiquarian Society to discuss a strategy for recovery of the Chacmool and met with the cigarette manufacturer Pierre Lorillard IV to discuss funding. Understanding the great financial loss the confiscation of the Chacmool had caused the Le Plongeons, Salisbury contacted his friends in Washington, D.C., to see what could be done. Alice and Augustus were advised that an approach to President Porfirio Díaz through the American ambassador in Mexico City might have better results than appeals made directly.

Through diplomatic channels they soon heard that that Díaz considered the Chacmool a national treasure, and that it would remain in its place of honor in the National Museum of Mexico. They also learned they would not

receive any financial compensation from the Mexican government. Augustus had hoped that the politically well-connected Salisbury would accompany them to Washington, D.C., to meet with senators, but was disappointed. "I truly deplore that you [Salisbury] are unable to accompany me to Washington" (ALP 1880b). But he would have been of little help since the decision to retain the Chacmool had already been made, and no amount of political pressure could change it.

The Le Plongeons did learn that President Díaz had a very high regard for their archaeological work and that Ambassador Philip Morgan said he could arrange for a personal meeting with the president in Mexico City. Alice was likely to have convinced Augustus that the Mexican president's favorable opinion of their archaeological projects in Yucatán could work to their advantage and that he should not continue with his unyielding demands.

They were also successful in their funding appeal to Pierre Lorillard who "advanced the necessary funds to enable me [Augustus] to pursue my studies" (ALP 1881b:282). The support from Lorillard helped fund Alice and Augustus's studies at the Maya archaeological site Mayapan and allowed them to expand their photographic recording of the ruins and make molds of bas-reliefs.

By mid-June 1880, the Le Plongeons began packing their equipment. Augustus then wrote to Salisbury on June 14, "I hope to be able to start [for Yucatán] within 15 days, if there is a steamer leaving about that time" (ALP 1880c). By the first week of July they were back in Mérida. On the advice of Morgan they decided to remain in the vicinity of the city and "do nothing of importance in Yucatan without the permission of the Federal Government of Mexico" (ALP 1880d).

After about two months in Mérida, they departed for Veracruz aboard the *City of Alexandria*, and then traveled overland to Mexico City. After so many years in tropical Yucatán and Belize, Alice marveled at the change in landscape as they rode from hot and humid Veracruz into the dry highlands. They had views of the snowcapped volcano Orizaba and passed through the colonial city of Puebla, just east of the 17,000-foot volcano Popocatepetl and rugged Iztacihuatl.

The Le Plongeons arrived in Mexico City on September 21 near the end of the rainy season, a beautiful time to be in the city. They rented an apartment in the city center, and their social life blossomed—they were "surrounded . . . by friends, <u>old</u> and new . . . and have placed at my disposal their personal influence with the government" (ALP 1880d). Ambassador Morgan gave a dinner party at the embassy three days after their arrival "expressly to welcome Mrs. Le Plongeon" (ALP 1880d), and then a week later they were invited to a ball at the embassy "in honor of Mrs. Le Plongeon" (ALP 1880e).

Well prepared for the social events Alice had packed her white satin dress and pinned on the Maya jade brooch she called Queen Móo's talisman. It

was quite a conversation starter. She was even more welcome because of her facility with Spanish, which pleased the Mexican officials, but she also had a good command of French—the language of diplomacy and culture in the nineteenth century. Attending the ball "were part of the diplomatic corps, and some of the most prominent members of the American . . . Colony of the City" (ALP 1880e).

Augustus had heard that President Díaz was anxious to talk with him, and within four days after their arrival he and Ambassador Morgan had an appointment at the presidential palace. Augustus wrote that Díaz was "grateful that I should have come to Mexico and have paid my respects—my name and fame he said were well known to him" (ALP 1880d). That Augustus spoke fluent Spanish and understood the cultural protocol must have been an immense help with the negotiations, and in the end Díaz agreed that "all objects that you may find underground will be yours provided you leave a small part for our museum" (ALP 1880d; underline by Augustus).

Clearly, Alice knew that her important accomplishments at Chichén Itzá and Uxmal warranted her presence at the meeting with Díaz, but to her aggravation she was excluded. Her article "Notes on Yucatan" had just been published by the American Antiquarian Society and Augustus proposed that she be present at the meeting, but it was impossible to breach the cultural protocol of the times.

After more than a month in Mexico City, Alice and Augustus became "anxious to return to Yucatan, with proper authorization from the government" (ALP 1880d) to begin their work at Mayapan. Augustus wrote Salisbury, "I have much to do, even to take moulds of the inscriptions [at Mayapan]" (ALP 1880d). As part of the Mayapan project, the Le Plongeons had decided to make molds of hard-to-photograph iconographic bas-reliefs just as they had done at Uxmal and Chichén Itzá. In fact, he had asked Lorillard to ship him "one or two barrels of powdered paper—which . . . is the best thing for making the moulds quick and well" (ALP 1880d).

Before departing Mexico City, the Le Plongeons also wanted to make molds of artifacts in the National Museum they would need for their research. Because Augustus was on good terms with the museum director, he was given almost complete access to its holdings. He and Alice decided that they would begin by making a mold of the head of the Chacmool. In addition, Augustus wrote, "I have also taken moulds of inscriptions brought from Palenque by Cap. Dupaix, and of other stones extant in the Museum" (ALP 1880e). The casts from those molds were later photographed by the Le Plongeons for use as illustrations in their articles and books.

After a series of farewell dinners, Alice and Augustus departed the city for Yucatán on October 26. In Veracruz they boarded the *City of Alexandria* again, and it was on shipboard that Augustus wrote Salisbury about their

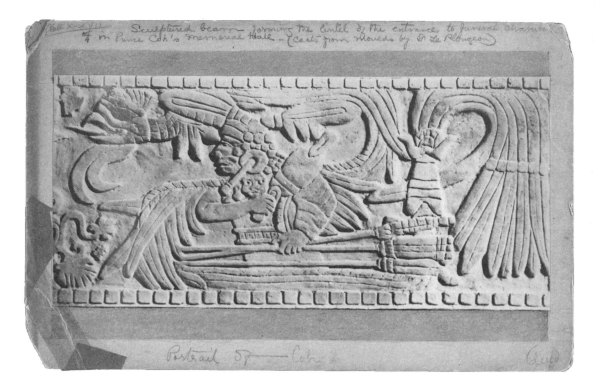

This cast is an example of how the Le Plongeons used molds to supplement their photographic record. Molds and rubbings of bas-reliefs can often show more detail than photographs. Written on the photos is the note "Sculptured beam forming the lintel of the entrance to funeral chamber in Prince Coh's memorial hall—(Cast from moulds by Dr. Le Plongeon)." The photo of the cast is also published in *Queen Móo and the Egyptian Sphinx* on page 122. Circa 1880. Photo by Alice and Augustus Le Plongeon. Research Library, The Getty Research Institute, Los Angeles, California (2004.M.18).

accomplishments in Mexico City. They felt they had received recognition for their archaeological work at long last, and their month in the city, with its festivities, meetings with the president, and the adulation of their friends and colleagues, would long remain the high point of their years in Mexico.

In his letter, Augustus not only wrote to Salisbury about his successes in Mexico City, but he also sought to blunt the influence the explorer and photographer Désiré Charnay was gaining with Salisbury. He pointed out that Charnay did not measure up to his standards of honesty and professionalism, and he advised Salisbury to be cautious of Charnay's plans for an expedition to locate an undiscovered Maya city.

The Charnay expedition was to be funded by Pierre Lorillard, and Augustus warned Salisbury, "Do not fail to take my hint—have as little to do or say as possible with Charnay's grand French Lorillard expedition, for

without being a prophet, I can prophesy it will turn to be a great HOAX" (ALP 1880e). Augustus's "prophesy" was borne out by subsequent events, but Salisbury probably dismissed his "hint" as just a competitor's reaction.

The well-funded Charnay expedition started out on a high note, and his long baggage train, complete with a private secretary, covered considerable ground through the jungle of southern Mexico. But once he reached the wide and fast-moving Usumacinta River, he became stranded across from the "lost city." No canoe was available to take him across the river so that he could make his "discovery," and to make matters even more frustrating, he had planned to name it Lorillard City. After a week of waiting, a canoe finally came down river and pulled in, but Charnay was in for an unpleasant surprise.

Archaeologist Ian Graham captured the exciting moment for Charnay in his biography of the English archaeologist Alfred Maudslay (1850–1931).

> [A] canoe did come into view, and Charnay's excitement, now at a fever pitch since he was on the point of adding lustre to his name as discoverer of the Phantom City, turned to gall as he caught sight of the European belongings in it. Asking whose they were, he was told they belonged to Don Alfredo [archaeologist Alfred Maudslay], who was working at the ruins [Graham 2002:101].

Maudslay later wrote in his journal, "[Charnay] does not strike me as a Scientific traveller of much class—he is a pleasant talkative gentleman, thirsting for glory and wishes to be professor of the history of American Civilization in Paris" (Graham 2002:103).

Charnay never became a professor of history, but continued his explorations and photography in Mexico and remained an annoyance to Augustus because of his friendship with Louis Aymé. Aymé was an aspiring amateur archaeologist and photographer and through Stephen Salisbury's influence had been appointed American consul in Mérida.

In a letter to Salisbury, Charnay fully backed Aymé, and diplomatically put Augustus at the disadvantage:

> If Mr. Aymé wishes to accompany [me] this far, it will be a great fortune for me, because he is an experienced traveler, an amateur with a passion for ruins and a tireless worker; I do not know any man more suited to carry out a scientific mission and I'm astonished that a society as highly regarded as that of Worcester or that of Boston does not utilize these remarkable qualities.
> In truth I regret not finding here Mr. Le Plongeon and his valiant companion [Alice], even though everyone says he is very irritated

with me. We are scarcely rivals and I cannot understand such enmity [Charnay 1881; letter translated from French].

Aymé's appointment as American consul rankled Augustus, but what most disturbed him was that Aymé had important diplomatic immunities from Mexican customs inspections and had used that immunity to ship archaeological materials out of the country without a permit. The trouble began when Augustus heard in Mérida that Aymé was trafficking in looted artifacts and human remains.

Augustus became determined to expose Aymé. He not only wrote to Salisbury but also used the newspapers in Mérida. Aymé in turn complained bitterly to Salisbury that Augustus had made accusations against him in the *Eco del Comercio* and had alerted the Mexican customs authorities that human remains were being exported illegally. But Aymé would not let public exposure deter his activities and wrote Salisbury, "I have arranged for 12 or 24 Indian skulls and as soon as the noise of the article in the 'Eco' ceases I shall send them in a box with the moulds to Agassiz" (Aymé 1882). Agassiz probably refers to Harvard University's Museum of Comparative Zoology that had been founded in 1859 by the brilliant Swiss scientist Jean Louis Rodolphe Agassiz who had died in 1873. Whoever the skulls were sent to, Aymé used the paper molds as packing and cover for shipment through diplomatic channels.

Alice realized that Augustus's public statements that exposed trafficking in looted material would raise the ire of museums and collectors in the United States, and that he could be blacklisted. She also saw that Augustus's strongly worded letters to inform Salisbury about the shortcomings of Charnay and Aymé would not work in the rarified halls of the society. While she clearly saw the problem, there was nothing she could do because Augustus believed honor and ethics demanded strong and immediate action.

Yet Alice admired Augustus for his fearlessness and resolve, and she knew underneath the hard exterior was a kind and completely honest man. While his confrontational style was troublesome, living with Augustus was living life to the fullest and always a little on the edge. In the end, Augustus resigned from the American Antiquarian Society because Aymé had been given membership.

In early November 1880, two years before Augustus's resignation, the Le Plongeons were back in Yucatán and quickly made arrangements to travel to the Maya archaeological site of Mayapan. They finished their research in less than two months. Augustus's report of January 16, 1881, "Mayapan and Maya Inscriptions," was mailed to Stephen Salisbury. It was published in the *Proceedings* of the society, and at thirty-six pages was a major contribution.

In the article Augustus acknowledged the support of Pierre Lorillard, Stephen Salisbury, their old friend in Belize Frederick Barlee, and Señor Don

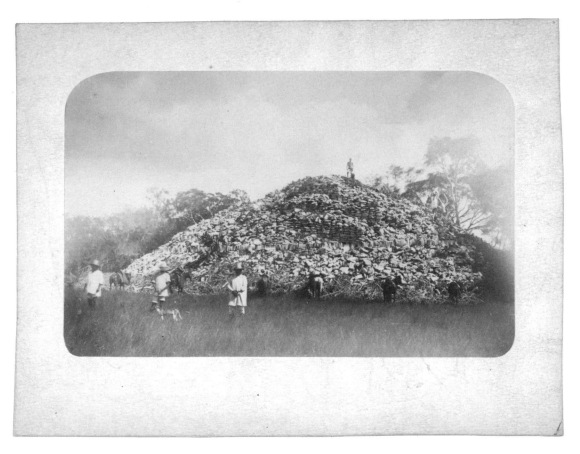

Augustus Le Plongeon standing atop the Castillo, the largest pyramid at the Maya archaeological site of Mayapan.[1] The Le Plongeons' dog Trinity, at the left, can be seen enjoying a day of exploration. 1880. Photograph by Alice Dixon Le Plongeon. Research Library, The Getty Research Institute, Los Angeles, California (2004.M.18).

Vicente Solis de Leon, owner of the hacienda X-canchacan where the ruins of Mayapan were located. The editor's comments that preceded the report were so insulting to Augustus that it was the last article he would publish in the society's *Proceedings*.

Using rather convoluted nineteenth-century wording, the editor all but stated that Augustus was in the same league with previous scholars whose theories had ended up on the scrap heap of history. The implication was that the society had published it only to preserve it as a historical curiosity.

> The following paper from Dr. Augustus Le Plongeon, communicated to the Society through Mr. Stephen Salisbury, Jr., is published under his supervision. In the existing unsettled state of archaeological science in this country, the observations and opinions of explorers are of great value, and should be deliberately considered. The advantage to the archaeologist, of possessing the original statements of the views of investigators of different periods, formulated by themselves, may be seen on comparing the theories of Haywood, Rafinesque,

Priest, Brasseur de Bourbourg and others with more abstract speculations [ALP 1881b:246].

Alice was mentioned because the committee remained impressed with her recent article in the *Proceedings*, but she was not credited for her writing.

Dr. and Mrs. Le Plongeon have the rare advantage of an almost continuous residence among Maya ruins for more than seven years, and of constant relations with a class of Indians, most likely to preserve traditions regarding the past history of the mysterious structures which abound in Yucatan [ALP 1881b:246].

As a farewell to publishing in the *Proceedings*, Augustus came out swinging in his reply, making the following statement that was placed at the end of "Mayapan and Maya Inscriptions":

The main cause of my unwillingness to say more on the subject is, that my former writings, when published, have been so curtailed and clipped, to make them conform with certain opinions and ideas of others, that my own have altogether disappeared, or have been so disfigured as to cause me to be taken for what I am not—an enthusiastic theorist following in the wake of Brasseur de Bourbourg. The true FACTS presented by me were considered as mere vagaries, scarcely worth the notice of cool-headed men, who notwithstanding know absolutely nothing about the subject upon which they pretend to pass an opinion [ALP 1881b:281–82].

In December 1881 Augustus went forward and published his book *Vestiges of the Mayas* and an article, "An Interesting Discovery: A Temple with Masonic Symbols in the Ruined City of Uxmal," for *Harper's Weekly*. *Vestiges of the Mayas*, an "essay" of eighty pages, was dedicated to Pierre Lorillard and set forth that "the Mayas and Egyptians had many signs and characters identical; possessing the same alphabetical and symbolical value in both nations" (ALP 1881c:66). This conclusion would eventually lose all support, but for the Le Plongeons it always remained one of their most important discoveries.

While Alice and Augustus were in New York City, Alice made arrangements with the *New York World* to publish her articles about their explorations in Yucatán. The editors welcomed her stories with great anticipation because she had already gained considerable readership. In 1881, as "special correspondent of *The World*," she published an account of the annual carnival in Mérida and three articles about their explorations.

"A Carnival at Yucatan," described the annual festival with its lively balls

that were sponsored by various social clubs of Mérida. After more than eight years away from England, Alice began to view her own culture from a distance and poked a little fun at English travelers: "An Englishman arrived during carnival. He was a figure of fun, as Englishmen abroad often are, and had the typical umbrella, carpet bag, and spectacles" (ADLP 1881a:3). While she made light of her origins, she happily reported that "here in Yucatan the noisiest festivity is carried on with propriety and moderation." (ADLP 1881a:3).

Alice was shocked by the poverty she saw in Yucatán, but was surprised by an egalitarian attitude evident during the time of carnival in Mérida: "Poverty is not regarded as a reason for having individuals uninvited. Among those who attend are some who go half fed for many days" (ADLP 1881a:3). Later, she would write increasingly about the injustices women and the Maya faced in Yucatán, and how the Caste War erupted.

A year or so before Augustus's resignation from the society, and before his exposure of Louis Aymé's trafficking in human remains, Alice gave Aymé a positive note in her article about the carnival. Apparently he enjoyed a good party, and she noted that "Our amiable American Consul, Mr. Aymé, who appeared . . . dressed in uniform, was made Judge" in a mock trial. And his wife joined into the festivities, "Mrs. Aymé, the wife of the American Consul, represented the Goddess of Liberty. The red and white stripes of the American flag were draped over her blue silk skirt. On her head she wore the red satin liberty cap, with a belt of stars around it" (ADLP 1881a:3).

Alice's three other articles focused on their archaeological work at Uxmal. In the two titled "Ruined Uxmal" she tried to make the Le Plongeons' life in the ruins come alive, "We are settled for the present in what is called the 'Governor's House.' . . . The place swarms with life and perfect silence never reigns for every tiny insect has something to say for itself" (ADLP 1881b:1). She sprinkled archaeological details here and there: "Fourteen metres south of Turtle's house and twenty from the west edge of third terrace is a stairway 14 metres wide, of thirty-six steps" (ADLP 1881b:1).

In these articles, written in June 1881, she not only provided her New York readers with a good sense of the Le Plongeons' life in Yucatán, but she also presented their archaeological conclusions about the ancient Maya at Chichén Itzá. Those conclusions included an interpretation of the iconography at Chichén Itzá, a description of their excavation of the Platform of the Eagles and Jaguars, and an account of the lives of Maya Queen Móo and her husband Prince Chacmool. Alice wrote with confidence: "there is no doubt that our Móo existed" (ADLP 1881b:2).

She then stated that during their explorations they had uncovered another statue that "was placed ages ago where we have discovered it, according to our interpretation of the inscriptions" (ADLP 1881b:2). She does not explain what inscriptions they interpreted, but emphatically stated, "We shall take good

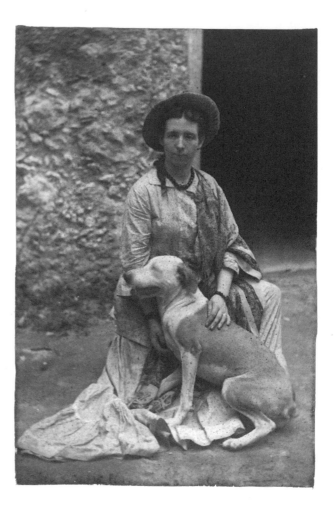

Alice with her dog Trinity. Probably outside their quarters in the House of the Governor at Uxmal. Circa 1876. Photo by Augustus Le Plongeon. Research Library, The Getty Research Institute, Los Angeles, California (2004.M.18).

care so to hide it as to have the gratification of knowing that it is not roughly handled." And, "because the statue which we found before [Chacmool] has been taken from us, and we consider this discovery far more valuable than the former. The statue of Chaacmol cannot be compared with this in finish" (ADLP 1881b:2). Alice's next article for the *New York World* provided more details about the statue.

Louis Aymé and Porter Cornelius Bliss, another diplomat visiting from Mexico City, came to Uxmal see the statue, and Alice reported they "pronounced it the finest American monument ever discovered" (ADLP 1881c:2). The balance of the article describes their work, and the four buildings that make up the Nunnery Quadrangle complex. On the façade of the North Building are numerous stone motifs of the rain god Chac stacked one above the other. Like many in the nineteenth century, the Le Plongeons interpreted those Chac motifs as mastodon or elephant heads because of the curved element protruding forward like an elephant's trunk. They used those motifs as

proof that the Maya ruins were many thousands of years old, and Alice wrote that "The mastodon's head tells us of the approximate date of the building of these edifices, . . . the age of the Maya monuments" (ADLP 1881d:10).

Her last article, "Yucatan's Buried Cities," published in November 1881, returned to the statue they had discovered. The description was written in a question-and-answer format, with Alice as the questioning reporter. She asked Augustus to describe the statue, and he replied that it was a "monument 3 metres 30 centimetres high by 2 metres wide, made, of course, of several pieces" (ALP 1881d:10). Why Alice called it a statue is unclear because a Chac motif (also called a Chac mask) has many sculpted elements that are tenoned into a building façade. Taken as a whole they create a motif—it is not a free-standing statue.

The Chac mask Alice described was probably located under the west stairway of the Adivino Pyramid. If that was its location, then it was well preserved because it was protected from the weather. Today the west stairway of the pyramid is no longer accessible because about ten years ago the passageway was filled with stone and concrete to stabilize the west side of the pyramid.

The iconography they found at Uxmal was described by Augustus as "an inscription in Egyptian and Etruscan letters forming Maya words" (ALP 1881d:10). Augustus's reply to Alice's next question about the meaning of the inscriptions resulted in a misunderstanding that lasted well into the twentieth century: "If my interpretation of certain inscriptions is correct, the place where lies hidden libraries of the ancient wise men and priests of the Mayas [can be found]" (ALP 1881d:10). While Augustus never stated he had found Maya books, rumors persisted among archaeologists that the Le Plongeons actually had found them.

Alice then began a series of articles in the *New York World* on Maya archaeology. She would present the Le Plongeons' conclusions to a public that had little knowledge of the Maya and that found Alice's lectures and articles immensely interesting. The Le Plongeons received little critical feedback about their conclusions, at first, because of their reputations as important explorers and writers. Further, they could easily dismiss any opposing opinions by scholars who had not been to Yucatán as the work of "armchair archaeologists." As a result, they would be unprepared for the large volume of contradictory evidence that would emerge by the turn of the century.

From late 1881 to February 1882, they were again in New York City to put their finances in order, and Alice met with the editors of *Scientific American*, *Magazine of American History*, *Harper's*, *Home Journal*, *Literary Life*, and the *Photographic Times* to secure contracts for articles she would write once they were back in Yucatán. For the immediate future, Alice decided that her articles on the history of Yucatán and modern Maya life would minimize any references that linked the Maya to Egypt.

Her articles about their explorations along the coast of Yucatán, written for

New York World and a variety of other magazines, were so successful that she proposed to publishers that they be combined into one volume. J. W. Bouton, a New York book publisher, jumped at the chance, and her eighteen articles were published in 1886 as *Here and There in Yucatan*.

Motivated by the success of her lecture in Belize two years earlier, Alice gave what may have been her first lecture in the United States at the home of Daniel Tredwell in Brooklyn on December 27, 1881. The lecture was titled, "Yucatan, Its Ruins and the Ancient and Modern Customs of the Mayas," illustrated with the Le Plongeons' photos, maps, and artifacts and delivered to a "select company of ladies and gentlemen" (Brooklyn Daily Eagle [BDE], 28 December 1881:2).

In the lecture, Alice provided considerable background on Maya life before the arrival of the Spanish and explained that when Yucatán was invaded, the Maya "were brave and determined in the defense of their country" (BDE, 28 December 1881:2). She added that the Palace building at Aké was "5,760 years old," explaining that she and Augustus had come to that conclusion by counting the number of stones in the columns of the palace (BDE, 28 December 1881:2). Alice would stubbornly stick to that conclusion even in the face of overwhelmingly contradictory evidence.

Alice continued her lecture by describing their work at Chichén Itzá and Uxmal and proposed that the small Maya buildings they had seen along the coast of eastern Yucatán were built by "a dwarf race [that] occupied part of the country" in ancient times (BDE, 28 December 1881:2). The lecture received a glowing full-column review in the *Brooklyn Daily Eagle*.

In 1882, the American Archaeological Exhibition in Madrid displayed a set of Alice's photographic prints of archaeological sites in Yucatán. By this time she was widely known for her expertise as a photographic printer, and the *Photographic Times* asked her to write a short article that might help photographers faced with the complicated process of printing from a glass negative. The editors wanted it published as soon as possible, but she decided to tackle that writing project in Yucatán when she had more time.

The Le Plongeons had also made molds of the motifs on Maya buildings and had hoped to supplement their income by selling some of the more interesting casts to the Metropolitan Museum of Art in New York. Two years earlier they had met the director, Luigi Palma de Cesnola, who enthusiastically asked for casts that could be included in an exhibit. They made them, but to their dismay they not only learned that Cesnola had cancelled the exhibit, but also that some of the casts had been badly damaged. The Le Plongeons were infuriated by the lack of care given the casts and expressed their "chagrin" to Cesnola. In a letter about the incident to Phoebe A. Hearst, Alice stated, "[He] never forgave us for expressing it, although our remarks were more than moderate and self-contained" (ADLP 1900a).

In January 1882, a year after the editors of the *Proceedings* made their

negative comments about Augustus, he wrote again about the Maya connection to Egypt in an article for *Scientific American* in which he openly stated, "The founders of the first Chaldean Monarchy were Maya, and probably the people who colonized Egypt and brought civilization to that country" (ALP 1882a:5042). *Scientific American* enhanced the article with selected photos from the exhibit in Madrid, proudly noting that they had been previously published in Spain by *La Ilustración España*.

By April Alice and Augustus had returned to Yucatán. They spent more than a year writing in Mérida before returning to Chichén Itzá. During their long stay in Mérida, Alice enjoyed a very rich social life and began writing a major article for *Harper's Magazine* about life in Yucatán, which she titled "The New and Old in Yucatan." She also worked to fulfill her commitment to the *Photographic Times* by writing the article on photo printing and continued to edit her forthcoming book, *Here and There in Yucatan*.

While they were living in Mérida, the Le Plongeons made numerous short trips to visit nearby Maya villages because Alice had become intrigued with the cultural and religious traditions of the Maya. She kept detailed notes and used them as reference material for her many articles on Yucatán after she returned to New York City in the mid-1880s.

Before leaving for Chichén Itzá for their second field season, Augustus began writing his book *Sacred Mysteries among the Mayas and Quiches, 11,500 Years Ago*. In this book he sought to show that Freemasonry had its origin with the Maya of Yucatán and planned to have it ready for his New York publisher by 1886.

At Chichén Itzá they planned to excavate the Platform of Venus (they called it the Mausoleum of High Priest Cay), make additional tracings of the murals in the Upper Temple of the Jaguars, and carry out more photographic documentation. While they had received permission from the president of Mexico to do archaeological projects in Yucatán, they needed to inform the local authorities, and through their friendship with General Guillermo Palomino they received his commitment to provide armed protection while they were at Chichén Itzá. But it took until November 1883 before all the arrangements could be completed.

In July 1882 Augustus finally mailed his letter of resignation to the American Antiquarian Society. The resignation had been long brewing because of the society's acceptance for membership of Louis Aymé, but it may have been prompted by the comments made by the editors of the *Proceedings*. While Alice supported Augustus's actions, she likely sensed that separation from the society would result in the loss of Salisbury's support, and in the long run isolate them. She was right, but she stood by Augustus's decision, no longer submitted her writings to the society, and published her lengthy historical articles on Yucatán in the *Magazine of American History*.

As one might expect, Augustus did not withdraw quietly from membership. In his ten-page letter addressed to George F. Hoar, vice president of the society, Augustus lodged a number of serious complaints against Aymé. He declared that Aymé was "dishonest" because he had defaulted on loans, was "guilty of a breach of trust (petty larceny), in keeping monies confided to him," had committed fraud by the unauthorized wearing "on his breast the red ribbon of the Légion d'Honneur of France," and had "obtained titles and monies from scientific societies, under false pretenses" (ALP 1882b).

Augustus, always the gentleman, took it no further, and ended his letter with, "Accept, gentlemen, with my heartfelt regrets, for having been compelled to resign my membership in your illustrious Society, the assurance of the high consideration with which I have the honor of subscribing myself" (ALP 1882b). In spite of the harsh language and seriousness of the accusations, Augustus did maintain his friendship with Salisbury long after his departure from the society, but all professional connections with the society were discontinued.

In November 1882, the *Photographic Times* published Alice's article, "A Few Hints on Printing." She wrote with the self-assurance that comes from full command of the subject. Alice had mastered the art of printing wet collodion glass negatives and proudly stated, "I always take upon myself the printing" (ADLP 1882:427). While Augustus climbed to precipitous locations with the camera, Alice had the responsibility to make the negatives, and then to be certain that the exposed negatives were sharp, had the right density, and were without defects. She then proceeded with the equally complex process of printing the negatives on handmade sensitized paper.

In the article she described her printing methods and even compared manufactured dry glass-plate negatives with handmade wet collodion negatives. Alice had learned photography when nothing was manufactured, and each step in making a photograph required hand preparation.

Finally in 1882, she began using both manufactured photographic paper that printed faster and dry plates for negatives: "[The use of] ready sensitized paper . . . as well as the dry plates, requires a little different management to the paper I used to sensitize for myself. . . . [I]t prints very fast, half a minute to a minute sufficing" (ADLP 1882:427).

But for Alice, the dry plates were no match for the wet collodion plate with its even density: "With all the immense advantages of the dry plate process, collodion has also its good points. The negatives are more equal in density" (ADLP 1882:428). This was important because uneven density required considerable dodging (lightening) and burning (darkening) of a print, plus numerous changes in printing time, and the manipulations could only be learned from years of experience. "Some parts [of a dry plate] print faster than others, and manipulation is necessary to produce a perfect copy" (ADLP 1882:428).

Because most photographers were already using dry plates that had

varying density, Alice explained how to make a good print by burning and dodging parts of the print using a variety of tools and techniques. The techniques used today in the darkroom are basically the same as the nineteenth century, except the photographer then had the added complication of making a print in constantly changing sunlight, as well as developing chemicals that were usually of inconsistent strength.

With a kind of nonchalance, she described how she printed negatives in the tropical heat and humidity of Yucatán, and even used "banana leaves" as a tool to lighten parts of the print.

> Here in Yucatan, I have the advantage of a fierce tropical sun, and I utilize the shadows cast on the ground by the broad leaves of the banana trees that so pleasantly shade my face while I am printing in the open air. To print from a negative of the kind just described, I expose the plate in such a manner that the edge of the shadow of a leaf just quivers on the line that divides the ruined pile from the sky, so as to get the latter in the sunlight while the rest of the picture is in shadow. If the lines are very broken, I assist the shading with my hand or a piece of cardboard, which I keep moving all the time. When the sky is nearly done, I next expose the building to the sun; then, just for a few seconds, the entire picture, and the result is excellent [ADLP 1882:428].

Like Augustus, Alice found photography to be "enchanted ground." She ended her article with, "If these few remarks should serve a useful purpose to any of my fellow workers in this beautiful art, my desire will be accomplished" (ADLP 1882:428).

In November 1883, the Le Plongeons finally began their journey to Chichén Itzá, and Alice received a complimentary notice in the *New York Times*: "[She] is a pale, slender, delicate-looking woman—the last one would select as having a physique fitted to undergo the perils of the wildernesses, and waste places of the earth as she has done" (New York Times [NYT], 22 October 1883:18).

Their travels over familiar ground did not have the same excitement for Alice as when she saw Yucatán for the first time. Regardless, Alice wrote her family about their second journey to Chichén Itzá, but only two pages of her field notes and rough sketches that record their excavation of the Platform of Venus have been found.

The sketches, drawn in cross section and plan, show the bidirectional trench they excavated into the platform and the artifacts they uncovered. She noted the colors of the many cone-shaped stone sculptures they encountered and included "measurements, descriptions, and a sketch coded by numbers to the items found" (Desmond and Messenger 1988:92–93; Desmond

2008:159–163). In 1884, Alice reported on their work at Chichén Itzá for *Scientific American* in an article titled, "Dr. Le Plongeon's Latest and Most Important Discoveries among the Ruined Cities of Yucatan."

The editors of *Scientific American* introduced the article with a complimentary note on the photography of the Le Plongeons and fully accepted Alice and Augustus's conclusions about the Maya: "Both Dr. Le Plongeon and his lady are superior photographers, and they have brought home hundreds of negatives of remarkable objects, and also many impressions [molds], illustrating the history of the Maya race, the ancestors, as the Doctor shows, of the Egyptians" (ADLP 1884c:7143).

The article was illustrated with eleven of their photos and began with a summary of their previous field work at Chichén Itzá. It included the discovery of the Chacmool and described in detail the murals in the Upper Temple of the Jaguars. Alice noted that "these are the only mural paintings we have found during the ten years study in the ruined cities of ancient Yucatan, . . . the last remnants of the art of painting (mural) among the Mayas" (ADLP 1884c:7144).

Upset at damage to the murals, Alice reported that a witness told her "the Americano Consul [Aymé], who accompanied M. Charnay . . . had tried to clean the wall by *scratching* off the dirt" (ADLP 1884c:7144). After exposing Aymé and Charnay's lack of judgment in trying to clean mold from the delicate frescos, she described the excavation of the Platform of Venus. While the article was primarily about their archaeological work, she occasionally added interpretive comments on Maya cultural similarities to Egypt such as "the color of mourning among the Mayas . . . was also the color used much at Egyptian funerals in ancient times, according to Sir Gardiner Wilkinson" (ADLP 1884c:7145).

The article continued in full archaeological style with a description of the positioning of other artifacts in the excavation: "twelve serpent heads, . . . [t]hree on the west side of the excavation looked west, three on the south looked south, and two others looked southeast. From the top of each rises a kind of plume or perhaps flame." The sculptures were painted in a variety of colors that had religious significance for the ancient Maya, and Alice quickly recorded the colors before they faded: "The upper part of the body of the serpents are painted green, the scales, well defined, are yellow, as also the edge of the jaws. . . . The horn-like ornaments on the front of the head are painted green and tipped with red" (ADLP 1884c:7146).

She characterized the ancient Maya as a "polite people who enjoyed the refinements of life; . . . had laws and upright judges; . . . honest, . . . clever actors, remarkably witty, and very sarcastic, often telling hard truths to their superiors" (ADLP 1884c:7146). Similar romantic generalizations about ancient Maya society were supported by most archaeologists until the last quarter of

the twentieth century when they were brought down to earth by the work of Mary Miller and Linda Schele in their book *The Blood of Kings* (1986).

Her final article about living at Chichén Itzá, "A Plague of Locusts in Yucatan," was also published in *Scientific American*. Alice wrote that she and Augustus were overrun by billions of locusts that passed through Chichén Itzá. She was astounded to see "a procession of locusts, perhaps and mile in width, passed by one spot for seven consecutive days" (ADLP 1884d:7174). She continued, "When flying, the great number of wings makes a strange noise, like the roaring of the ocean from afar . . . when the sun shines on their transparent wings they look, fluttering in the air, like golden snow, but sometimes they are so numerous as to obscure the light of the sun" (ADLP 1884d:7174).

She also expressed her concern for the poor farmers of Yucatán whose crops were being devoured by the locusts. Nothing stopped them from eating the crops, and all efforts to kill them had failed, so "the question is, What will become of Yucatan? The locusts decline to be exterminated, and seem unwilling to move on" (ADLP 1884d:7174). In frustration she suggested, "why not try to starve them out by planting nothing but palma Christi [Ricinus communis] they never touch . . . and henequen? . . . At any rate, the plan could be tried, for since crops cannot be raised, why plant?" (ADLP 1884d:7174).

In June 1884 Alice had completed the manuscript of her second book, "Yucatan: Its Ancient Places and Modern Cities" (ADLP 1884b). The book was about Yucatán as she saw it in the 1870s, and much of it is based on her diary entries. She wrote in the introduction: "The pages of this book are culled from a diary written in situ and the Author's aim has been, without any pretention [*sic*] of exhausting the subject, to represent the land of the Mayas as it appeared to her" (ADLP 1884b:1).

The book is historically important, but what is surprising is her inclusion of several dreams she experienced while living at Uxmal and Chichén Itzá. Before the completion of "Yucatan: Its Ancient Places and Modern Cities," her published writings make no mention of dreams, psychic phenomena or Spiritualism. As she grew older, those concerns would become more central in her writing.

The first dream occurred at Uxmal and came from Alice's belief that she and Augustus had been reincarnated from Queen Móo and Prince Chacmool. Alice wrote, "Shortly before we left the old city, I had a strange dream, and its vividness impressed me" (ADLP 1884b:457). In the dream she was reincarnated as Queen Móo and was confronted by one of her brothers, Prince Aac, who had murdered her husband and brother Prince Chacmool. He spoke to her of wandering at Uxmal and hoping for her forgiveness. At the height of his pleading the dream ended suddenly on a very earthly note when Alice was awakened by their Maya assistant Loesa with a rabbit prepared for dinner.

The other three dreams are equally important because Alice now put herself on record as taking paranormal phenomena seriously. She must have realized she would face skepticism, but she also knew she was not alone in her beliefs. Rigorous investigations of the paranormal began in the 1880s with organizations such as the Society for Psychical Research in London, and many eminent scientists became involved. Even the famous author Arthur Conan Doyle (author of Sherlock Holmes mysteries) was a believer in Spiritualism.

In this dream Alice saw "men of the National Guard marching in single file along the foot of the terraces upon which we lived [at Uxmal]. As they passed I counted . . . thirty" (ADLP 1884b:494). When she told Augustus about the dream, he insisted that only fifteen men were assigned to them. But the dream was fulfilled, and "at 10 o'clock that morning thirty men emerged in single file from the forest. . . . [F]ifteen remained with us; the other went to another outpost" (ADLP 1884b:494).

In the next dream she watched from a hiding place as three men passed by wearing distinctive clothing. She recalled, "Three men pass . . . but I was unseen by them. One was very tall and wore neither vest nor coat. Another had a brown linen coat; the third wore the native dress of white cotton." She continued, "Five hours later . . . I saw my three dream men, exact in every detail, and was unseen by them" (ADLP 1884b:495).

The final dream was associated with their archaeological excavation of the Platform of Venus at Chichén Itzá. That day Alice had taken charge of the excavation and recounted that "nine snake-heads had been unearthed, and we believed there were no others, but just before waking I saw our men bring to light three more. . . . Dr. Le Plongeon was at the time too ill to leave his hammock, but under my direction the men that day removed a great mass of stones, and found the heads which completed the twelve" (ADLP 1884b:495).

During the next fifteen years she would continue to edit "Yucatan: Its Ancient Places and Modern Cities," and even added a lengthy historical update in 1897 about the Caste War. She hoped that she could find enough money by the 1890s to have it printed, but the United States economy collapsed in 1893, and along with it the Le Plongeons' personal finances, so the book remained unpublished.

In spite of Alice's strong ties to Yucatán, after she and Augustus completed their work at Chichén Itzá, they began to seriously consider returning to New York City. She had learned about the work women were doing in New York for the right to vote and for better wages, and she planned to join them. She also thought that lectures would increase the impact of her convictions about social justice, the women of Yucatán, and the ancient Maya. It was difficult for Alice to leave behind the beauty of Yucatán and the friendships she had made during her many years there, but in June 1884 she and Augustus departed for New York, and she sensed she had made the right decision.

PART FOUR

New York

Light comes to earth from regions distant far—
E'en from those orbs that roll no more in space—
Perchance the history of this little star
Lives yet in ethery realms that shall not bar
O'er long the knowledge thou dost seek to trace.
No eye save thine hath found the way to read,
Graved on the crumbling walls, those records old,—
Erstwhile inscribed by those who sought to lead
Out of the shadow to the sunlit mead,
Nearer each day to Wisdom's radiant fold.
Alicia

ALICE DIXON LE PLONGEON, "To A. J. H. LeP.," ca. 1880s

FIVE

Washington Street

1884–92

Soon after their arrival in New York City in June 1884, the Le Plongeons found a residence at 204 Washington Street in Brooklyn that was spacious enough to house all their books, photos, molds and casts, and other materials from Yucatán. Washington Street was a creative time for Alice—she lectured, wrote sixteen articles about Yucatán, Peru, and photography for popular and professional journals, and published her book *Here and There in Yucatan*. The successful lecture in Belize encouraged her to seek speaking engagements in New York, and she soon was sought by both private parties and institutions such as the Cooper Union Institute and the New York Academy of Sciences. As a result she became well known for her knowledge about the ancient and modern Maya.

The Le Plongeons traveled to New Orleans in mid-November 1884 and stayed through February 1885. Augustus was there to meet the with organizers of the North, Central, and South American Exposition in New Orleans to work out a plan for the construction of a Maya temple from their molds and to exhibit the artifacts and other materials they had brought back from Yucatán. They needed five thousand dollars "to construct the building of fireproof materials [required by the insurance company]. President Diaz offered space already allocated to the Mexican government" (Desmond 1983:179), and while the influential Spencer Baird of the Smithsonian Institution recommended the project to his director John W. Powell, the funds could not be raised.

Between meetings with exhibition officials in New Orleans, Alice had speaking engagements "at the Exhibition held in that city" (ADLP 1886c),

and a reviewer for the *New Orleans Picayune* enthusiastically commented, "The audience gave her their undivided attention, and when she finished would have demanded more" (ADLP ca. 1890s a).

During 1885 she continued her writing and published five articles. "The New and Old in Yucatan" was a popular piece written for *Harper's Magazine* and illustrated with photographs she and Augustus had taken in Yucatán. Alice included a wide variety of topics, including the market in Mérida where "one must understand the mysteries of medios, cuartillos, chicas, and vientes [units of measure]" (ADLP 1885a:373), a Maya dance called *Ixtol*, and the musical instruments of Yucatán, including the *tunkul* (drum), which sounds "like a great rumbling in the earth . . . heard five or six miles" (ADLP 1885a:384). From firsthand experience, she described the preparation of tortillas that "appears easy, but requires both practice and strength" (ADLP 1885a:386).

She also made reference to Freemasonry and Egypt and stated that the iconography on the west façade of the Adivino Pyramid at Uxmal had "a fair chance of being deciphered, thanks to the perseverance of Dr. Le Plongeon" (ADLP 1885a:377). Alice continued by summarizing what Augustus had written in his article, "The Maya Alphabet," about decipherment of Maya writing (ALP 1885c). In the following year she would make the same claim, but in stronger terms, to the New York Academy of Sciences.

At this same time, the Le Plongeons hoped to publish a book that Alice had helped Augustus write, titled "The Monuments of Mayax, and Their Historical Teachings." They mailed flyers to interested researchers such as Spencer Baird, and the 1885 publication in *Scientific American* of "A Chapter from Dr. Le Plongeon's New Book, 'Monuments of Mayax'" served as additional promotion (ALP 1885a). While the full manuscript was never published, Alice read a summary of it in a lecture to the Albany Institute in 1896 (ADLP 1896d).

Alice had finished editing her book, "Yucatan: Its Ancient Palaces and Modern Cities: Life and Customs of the Aborigines," and advertised it with a promotional flyer as "Containing about 500 pages. Bound in cloth—uncut— and profusely illustrated with photographs" (ADLP ca. 1880s a). She hoped that prepublication orders for the book would raise the money needed for printing, but sufficient funding was not developed. She considered it a small setback and remained confident that over the next few years enough money could be raised by her lectures and contributions.

In New York in April 1885, Alice lectured to "about 200 members of the Long Island Historical Society . . . on 'The present-condition, ancient palaces, and the natives of Yucatan.'" The lecture was reported to have lasted one-and-a-half hours, and "Mme. Le Plongeon was unable to finish the subject chosen," so a "continuation" of the lecture was planned for "within two weeks" (NYT, 25 April 1885:8). The *Brooklyn Daily Eagle* commented, "Despite the

inclement weather, a large audience assembled last evening in the hall of the Long Island Historical Society to listen to a reading of a paper by Madame Le Plongeon" (29 April 1885:1). The *Eagle* then printed a portion of Alice's paper on its front page (ADLP 1885f:1).

While she was living in Yucatán, Alice learned as much as she could about Maya customs and realized that a lot of what she saw had its origin before the coming of the Spanish. In her articles "Baptism in Ancient America" and "New Year's Day among Some Ancient Americans," she gave *Harper's* readers a brief description of a number of Maya practices and ceremonies having strong links to the past.

Her fourth article, "Remarkable Wells and Caverns," is an exciting first-hand description of her descent, via seven rickety ladders, to the deepest level of the Bolonchen cave. It is a year-round source of water for people living in its vicinity.

> After an exhausting journey we reach a vast chamber, from which crooked passages lead in various directions to wells, seven in all, each named according to the peculiar kind of water. One, always warm, is called Chochá (hot water); another, Oɔichá (milky water), and Akabhá (dark water). About 400 paces away from the chamber, passing through a very narrow, close passage, there is a basin of red water that ebbs and flows like the sea, receding with the south wind, increasing with the northwest.
>
> To reach the most distant well, we go down yet one more ladder, the seventh. On one side of it there is a perpendicular wall, on the other a yawning gulf, so when one of the steps, merely round sticks tied with withes, gave way beneath our feet, we tightly grasped the stick above. Having reached the bottom of the ladder, we crawl on our hands and feet through a broken, winding passage about 300 feet long, then see before us a basin of crystalline water, and how thirsty we are! This basin is 1,400 feet from the mouth of the cave, and about 450 feet below the earth's surface [ADLP 1885d:8105].

In "Dialogues of the Dead," Alice created a fictional debate between the Spaniard Hernán Cortés and the Aztec king Montezuma in which each took jabs at the other over issues of science, superstition, and art. Alice drew upon her education in the classics for Montezuma's criticism of the ancient Greeks. For example, Cortés says, "Admit the truth. You were very stupid, you Americans [Aztecs], when you took the Spaniards for men descended from the sphere of fire because they had cannons" (ADLP 1885e). Montezuma replied, "But you will agree that the Athenians were more foolish than we. We had never seen ships or cannons but they had seen women, and when Pisistratus

undertook to reduce them to obedience by means of his [impostor] goddess he assuredly held them in less esteem than you did us" (ADLP 1885e).

For Alice, all civilizations had some kind of science. The article ended with, "Unquestionably arts and sciences were known in America, only the application of them was different from what it was in Europe. India, China, every county in fact, has developed the arts and sciences according to its peculiar idiosyncrasy" (ADLP 1885e).

Her interest in the paranormal was again stimulated shortly after she and Augustus returned to Brooklyn in 1884. Alice "had an exceptionally remarkable experience during a visit to an acquaintance who was an excellent psychic" (ADLP 1908). The "excellent psychic" was Anna Read, and Alice described Read's séance in considerable detail.

During the séance Alice's deceased cousin Robert appeared to her. Alice wrote that Read declared, 'Just back of you is a young man who gives the name of Robert. Had you a brother of that name?' I replied, 'No, a cousin'" (ADLP 1908). Read continued by describing Robert as wearing "a clerical coat, but gives me to understand that he was not going to enter the church" (ADLP 1908), and then he gave the date of his death. Alice was unable to verify Robert's date of death or any of the other details because she was a young child when he died. But she immediately wrote her uncle Jacob Dixon in London for the information.

> Without delay I wrote to Dr. Jacob Dixon, asking the year of his son's death, and his style of dressing. His reply verified the vision in every detail, and he was greatly pleased at the identification of his son, which he considered as complete as any thing could be, and particularly gratifying under the circumstances—Mrs. Anna Read, the psychic in question, having never heard of the existence of the young man who had died when she was a very young child [ADLP 1908].

Other people in Brooklyn reportedly had extraordinary psychical powers, and Alice got to know one of them quite well, the famous Mollie Fancher (1846–1916) who was known as "the fasting girl." During her late teens, Fancher was paralyzed in a horse riding accident and permanently bedridden. Soon seizures and trances developed, and it was reported that she totally gave up eating. Later she became blind, yet observers stated she was able to describe events and persons in the room. She soon became known for her abilities as a clairvoyant, and those extraordinary powers, along with her ability to "live on air," drew thousands of visitors to her house, including the Le Plongeons.

In 1894, Brooklyn judge Abram Dailey, a firm supporter of Mollie, published *Mollie Fancher, the Brooklyn Enigma*. One chapter was devoted to

testimonial letters, including Alice's, in which she stated, "I have frequently visited her with my husband, Dr. Le Plongeon, who, as a physician, was much interested in her case" (Dailey 1894:122). Alice continued in her three-page letter, "On one occasion we took photos to show her. With closed eyelids, and the room nearly dark, she passed comments on the pictures, even pointing out a portrait of myself in a very small group where my face was hardly bigger than the head of a common pin; we had not told her that my figure was there" (Dailey 1894:122).

Alice was invited to give a lecture on Monday night, March 1, 1886, before the New York Academy of Sciences. She was honored to be asked to speak before the important society. Her lecture, titled "Yucatan, Its Ancient Temples and Palaces," drew a good crowd, and the society minutes stated, "One hundred and thirty persons present, in the east lecture room of the Library Building, Columbia College" (ADLP 1886b:169).

The lecture was not a traveler's account but described Uxmal and Chichén Itzá from an archaeologist's point of view. She began by highlighting the architecture of Uxmal, and described how the Maya had adapted to the seasonally dry environment of that part of northern Yucatán where there are no lakes or rivers.

She explained that she and Augustus had found near the public buildings what are called a *chultúnes* (cisterns) that the Maya used for water storage. To get a firsthand look at the interior of a *chultún*, they climbed down into it and took some measurements: "[It is] shaped like a bell, or large round bottle with a flat bottom. They are 13 feet deep, and 19 1/2 feet at their widest diameter. They are lined with square hewn stones fitted close together, and thickly coated with fine plaster, making them perfectly watertight" (ADLP 1886b:170). It must have been an adventure for Alice to squeeze through the narrow opening into the claustrophobic *chultún* where there was a good chance of coming face-to-face with a bee's nest or a trapped snake.

They also realized that even the many *chultúnes* could not hold enough rainwater to supply a large population through the long dry season. Using their machetes, Alice and Augustus hacked their way through the thick brush and located one of the large *aguadas* (reservoirs) located west of Uxmal city center. The *aguadas* had been noted by Brasseur in 1864 when he was at the site (Brasseur 1865), and recent archaeological research at Uxmal has confirmed Alice's statement, "It is quite likely that the inhabitants depended entirely upon rain-water, for they even constructed artificial lakes that served as reservoirs; these yet exist, and are lined with hewn stones" (ADLP 1886b:170 and Huchim 1991).

Alice next discussed the meaning of the motifs they found on the east façade of the Annex to the Monjas building at Chichén Itzá. She based her interpretation on Augustus's 1883 article, "Are the Ruined Monuments of

Yucatan Ancient or Modern." For example, Alice stated, "The egg in the tableau likewise has a figure in it; and on each side of the egg there is an inscription that is written in Egyptian letters in the Maya language" (ADLP 1886b:174). In the article, Augustus wrote that he could read the name of the "figure" because the inscriptions were "written with Egyptian characters in Maya language" (ALP 1883:6468). Alice continued by giving more examples of Maya cultural attributes found in ancient Egyptian civilization.

She ended her lecture as follows:

> Our labor of twelve years has not been in vain, for we have found a key that will unlock the door of that chamber of mysteries, the hitherto incomprehensible American hieroglyphics. After long and patient study of mural inscriptions Dr. Le Plongeon has discovered what were the various signs or letters of the ancient Maya hieratic alphabet, and how similar many of them are to the Egyptian hieratic alphabet [ADLP 1886b:178].

The hieroglyphic "key" they had discovered at Chichén Itzá was later applied to Uxmal, and the Le Plongeons gave the following translation to the iconography they found carved on the Adivino Pyramid: "*The Cans now fallen are crouching like dogs, without strength; the land of Aak, Oxmal (Uxmal) is securely fettered*" (ADLP 1886b:173; italics and "(Uxmal)" by Alice) (ALP 1885c:7573).

The Le Plongeons had access to a considerable body of Maya writing at the sites they visited and recognized hieroglyphics in the Akabdzib and the Chichanchob at Chichén Itzá. But neither the hieroglyphics in those buildings nor the iconographic symbols on the Adivino Pyramid had any connection with Egypt. Their "key" had put them completely on the wrong track, and like many others after them, they failed to crack the Maya hieroglyphic writing system. Epigraphers continued to work for the remainder of the nineteenth century and for most of the twentieth to develop the tools needed for the decipherment of Maya hieroglyphics. Only in the last twenty-five years has Maya hieroglyphic writing been translated with any certainty.

The Le Plongeons forged ahead, working alone, ready to convince the world that iconographic symbols could be translated like writing, and that they had made a formidable breakthrough in deciphering Maya writing. They took it as a given that their "translation" of the iconography at Uxmal would be readily accepted, but thought there might be skeptics who doubted that the "alphabetic" writing was really carved on the pyramid. They solved that problem by taking 3-D stereo photographs of the iconography from a sixty-foot drop off on the edge of the pyramid—and putting their lives at risk in the process.

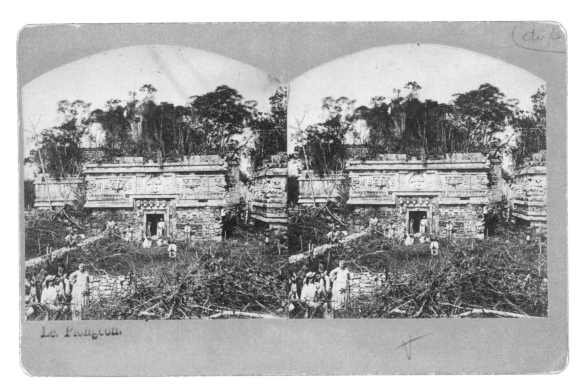

Le Plongeon.

The façade of the East Annex of the Monjas at Chichén Itzá. Alice, in the left lower corner, sits holding her rifle and Senora Díaz stands next to her. Augustus placed other visitors and soldiers in the photo to enhance the 3-D perspective. 1876. Photo by Augustus Le Plongeon. Research Library, The Getty Research Institute, Los Angeles, California (2004.M.18).

Alice's successful lecture before the New York Academy of Sciences led to a lecture at the Cooper Union Institute in New York on Saturday evening, December 4, 1886, that was "illustrated with lantern slides," (*Photographic Times* 1886:589). The Cooper Union (as New Yorkers call it) remains an important educational institution to this day and has preserved its brownstone Foundation Building on Astor Place.

Alice's talks on Yucatán fit in very well with the progressive objectives of the Cooper Union, which offered free lectures and courses in the sciences and art. This influential educational institution, founded in 1859 by inventor and industrialist Peter Cooper (1791–1883), included a reading room, offices, the Great Hall where Alice lectured, and a school of art for women. Susan B. Anthony, leading advocate for a woman's right to vote, had her offices at the Cooper Union, and Alice might have first met her there during one of the meetings she held in the Great Hall.

About a year later, on November 7, 1887, Alice gave a second lecture before the New York Academy of Sciences about the explorations she and Augustus carried out in Yucatán. The lecture was again delivered on a Monday evening to a very large audience of "About three hundred persons," in the "East Lecture Room of the Library Building of Columbia College" (ADLP 1887c:44). Her lecture was based on her book *Here and There in Yucatan*, and

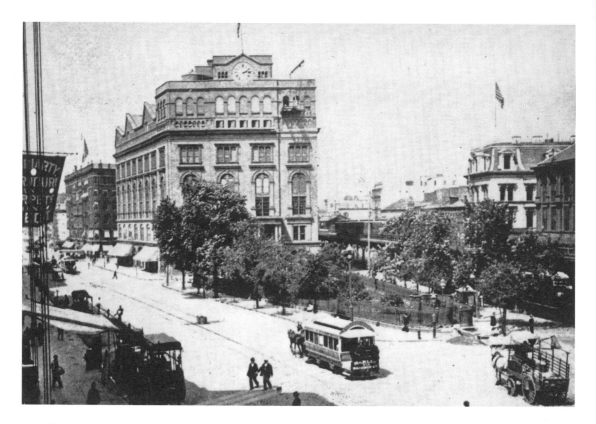

The Foundation Building of the Cooper Union Institute at Astor Place, between Third and Fourth Avenues in New York City. 1893. By courtesy of the Cooper Union.

she titled it, "Eastern Yucatan, Its Scenery, People, and Ancient Cities and Monuments." The lecture was illustrated with lantern slides she had made from their photos. A book signing likely followed the lecture.

While the abstract of the paper does not mention a Maya or Egyptian hieratic alphabet, Alice did comment on the antiquity of Maya civilization. She pointed out again that she and Augustus had discovered that the age of the Maya city of Aké could be calculated by counting the number of stones in columns in the Palace building. She never explained why they chose that particular building or its columns in their count. The number of stones piled in columns simply indicated to the Le Plongeons that the "terraces were built at least 7000 years ago" (ADLP 1887c:46). In her lecture at the Tredwell residence in Brooklyn in 1881 she stated the ruins were 5,760 years old; therefore, they probably counted again the stones in each column by carefully analyzing their 3-D stereo photos.

Alice did explain that they had learned from the local Maya residents that, "People reckoned their age by these stones. A man 60 years old would say: 'I have three stones of years'" (ADLP 1887c:46). Thus, they thought one would only have to count the number of stones and multiply by twenty to determine the age of the monument and, by implication, the age of Maya

civilization. This unfortunate conclusion reinforced even further their earlier conclusion that Maya civilization was many thousands of years old, and they refused to consider any alternative.

In the same lecture, Alice drew upon her many years of personal contact with the Maya to tell her New York audience of their economic and social plight.

> The natives of Yucatan . . . are the descendants of the Mayas . . . At the time of the conquest . . . they became slaves, remaining so for many years, and when finally made free citizens, they suffered just as much oppression. A rebellion, in 1847, was the result . . .
>
> All the field laborers are natives. . . . The comforts of life are almost unknown to them. The scantiness of their apparel awakens the pity of occasional tourists, but the climate makes much clothing undesirable. . . . They are not educated, because the white people fear that instruction would make them ambitious, unwilling to work in the fields and to carry burdens [ADLP 1887c:45–46].

In addition to her lecture to the Academy of Sciences, in 1887 Alice wrote two articles about the Maya of Yucatán. In her first article, "Babies of the Maya Indians," she gave detailed observations about a Maya ceremony called *etzmeek*. In this excerpt one can see Alice's intense interest in Maya life and customs.

> As soon as the child is of an age to be held upright it is subjected to a rite called etzmeek, considered far more important than the baptism. This is the act of placing the child for the first time in the posture in which it is henceforth to be carried; that is, astride the hip.
>
> The naylah puts the baby astride her hip and walks nine times round the outside of the hut, while five raw eggs are placed in hot ashes so that they may burst, and the child thus have its five senses awakened [ADLP 1887a].

In her article for the *Magazine of American History*, "The Mayas: Their Customs, Laws, and Religion," Alice described Maya life before the arrival of the Spanish. Her intention was to stimulate some interest and to educate an uninformed North American public about the Maya.

> There is a tendency on the part of some writers to class all the ancient nations of Central America, Mexico, and surrounding countries as one people. This is an error that serves as a stumbling block in their investigations, because a variety of race and language existed no less there than in other parts of the world [ADLP 1887b:233].

Some of her statements about the ancient Maya are now dated ("they were long-lived"), as is her idyllic view of Maya civilization. This led her to be critical of reports of human sacrifice by the Maya: "Nor is there any proof that they made cruel sacrifices of human beings. Nevertheless, some did voluntarily throw themselves into the large senote (natural well), considered sacred firmly believing that such an act would gratify the deity" (ADLP 1887b:234). As was mentioned previously, this same opinion was held by most archaeologists through the 1970s—the ancient Maya were thought to be a peaceful society of farmers with an elite that occupied itself with astronomy and philosophy. Alice thought the women were, "loving and loveable, but exceedingly modest, and always industrious, as they are at the present time" (ADLP 1887b:235). The men were "good-looking, strong, athletic" (ADLP 1887b:235).

The annual meeting of the American Association for the Advancement of Science (AAAS) was held in New York from August 10 to 17, 1887, and Alice proposed to read a paper before the association about the Le Plongeons' work in Yucatán. Daniel G. Brinton (1837–99), professor of archeology and linguistics at the University of Pennsylvania, was the meeting chairman, and he replied to her request with enthusiasm. "The officers of the section desire to express their recognition of the value of such a lecture & would gladly assign it an hour when the views could be exhibited" (Brinton 1887a). But the response was not received by Alice until well after the AAAS meetings were concluded. After reading the letter, she began to wonder if they were ever serious about the invitation.

Brinton continued: "We find, however, all the evening hours of the association occupied, and there are no facilities for darkening the lecture room during the day" (Brinton 1887a). That would have prevented Alice from showing any slides. But they would be "much pleased" for her talk to be given "on Tuesday at 2 PM" about the "remains in Yucatan, limiting the length to 30 minutes. There are conveniences for placing diagrams, etc. on the walls" (Brinton 1887a). Brinton likely insisted that the lecture be limited to 30 minutes because that is the usual length allowed for professional meetings, but he may have also been concerned because he knew Alice would bring to bear all her evidence for Maya cultural diffusion to Egypt.

In a follow-up letter to Alice, Brinton explained that he had "entrusted [the letter of invitation] to an assistant, who place an erroneous address upon it." He begged Alice to understand that her request to read a paper "was not treated with neglect" (Brinton 1887b).

Alice felt insulted by Brinton and disappointed that she had missed a chance to speak before the association, but those setbacks spurred an even greater resolve. In 1888 she wrote two major historical articles for the *Magazine of American History* with the titles, "The Discovery of Yucatan" and "The

Conquest of the Mayas." They were published serially in three parts for a total of twenty-six pages. For the *Photographic Times* she began a technical piece, "Collodion vs. Gelatine," comparing the two kinds of glass negatives.

Augustus published an article in the *American Antiquarian and Oriental Journal* about Egypt and the Maya titled, "The Egyptian Sphinx" (ALP 1888). The journal was important in the field of antiquarian studies, and Augustus again explained the many similarities he found between the Maya and Egypt, using the Sphinx as the centerpiece of his argument.

Alice's article "The Conquest of the Mayas" was written to explain why the Maya continued their struggle for economic and political rights. Her views about "Indians" were not always welcome, yet she would continue to write and lecture about injustices. She relied on the work of earlier historians for her articles and noted that "The various historians, principally Spanish friars, who have written about the conquest of Yucatan, differ in their way of telling the story, some showing marked partiality for their countrymen, others evidently sympathetic with the natives" (ADLP 1888b:325).

Although she considered Spanish accounts valuable, she also consulted Maya sources. "Before examining the Spanish records of events that occurred in Yucatan between the years 1527 and 1560, it will be well to glance at the manuscript written on the same subject by one of the Pechs" (ADLP 1888b:326). Nakuk Pech, from an aristocratic Maya family, had written his own account of the conquest. She continued, "The Spanish statements are probably exaggerated to make the unquestionably brave Spaniards appear as marvels of valor and strength, for a very different light is thrown on the matter by Pech's manuscript" (ADLP 1888b:326).

She was not educated as a historian; however, as a dedicated researcher she made every effort to be certain that her historical writings were accurate. On the one hand she wrote of the inhumane tactics of the Spanish: "every time the people resisted their yoke, the Spaniards treated them so cruelly that the population became greatly diminished" (ADLP 1888c:450). And while she had an idealistic view of ancient Maya civilization, she realistically noted that "At the beginning of the 16th century Yucatan was by no means a terrestrial paradise . . . the country divided into many principalities, the inhabitants continually at war with each other" (ADLP 1888b:326).

She explained that the Spanish were "very cunning" and "did not enter the country as declared foes" (ADLP 1888c:453); therefore, the Maya mistakenly welcomed them and paid a big price. Once the Maya understood that the Spanish were determined to take control, warfare began. But, according to Alice, the Maya were at a great disadvantage on the battlefield because they had few firearms and virtually no armor: "a few wore tunics padded with cotton and salt, this would be a poor protection against firearms. . . . The horses [of the Spanish], too, also partly covered with armor, trampled many of the

natives under foot" (ADLP 1888b:325). In spite of this, the Maya drove the Spanish from Yucatán in 1535, but as they withdrew, the Spanish destroyed their crops and spread disease, which considerably reduced the ability of the Maya to resist.

Alice pointed out that the Spanish did not completely abandon the peninsula, and the "friars, wishing to teach the Christian doctrine to the people of the peninsula, . . . arrived at Champoton" (ADLP 1888c:458). The soldiers came again, but were so few that they could not penetrate Yucatán for "three years" and were again on the verge of withdrawing. Alice wrote that more soldiers were sent with orders to gain as much territory as possible in the direction of Mérida. They founded Campeche and then attacked and finally captured Mérida, which reduced the Maya to sporadic resistance until the Caste War broke out in 1847.

In his book *Historia Antigua de Yucatán* (1883), Crescencio Carrillo y Ancona (bishop of Yucatán), proposed that the Maya were better off after the Spanish conquest. Carrillo y Ancona and Alice were good friends, but she completely disagreed with him. "[He] expresses himself concerning the conquest as follows: 'The victims of it, however great their number, were certainly fewer than would have resulted from the wars that the Indians had among themselves. . . . [T]hey suffered less than when enslaved beneath the tyrannical sway of their old oppressors'" (ADLP 1888d:119). Alice retorted, "Nevertheless, many a happy home was destroyed, and untold cruelty inflicted. If some were bettered by the coming of the white man, it was not manifest for a long time. The natives became in fact, if not in name, slaves, even the upper classes" (ADLP 1888d:120).

Alice concluded, "Since the sixteenth century . . . the people have from time to time renewed their vain struggle, till, in 1847, after a long contest and many scenes of horror, a few thousand freed themselves. . . . From that time to this they have urged war . . . and though many expeditions have been organized against them, they have not for one moment been reduced to obedience" (ADLP 1888d:120).

After the publication of her article, "Conquest of the Mayas," Alice spoke at the Plymouth Church in Brooklyn on "Central America" to raise money for the Willow Place Free Kindergarten (BDE, 11 March 1888a:1). Later that year she gave a lengthy lecture at the Cooper Union to "a large audience, including many teachers," mentioning again the system of counting the years at Aké (NYT, 25 November 1888:6).

Alice then began to schedule her lectures for the following year, because she had consistently drawn a good crowd and her speaking engagements were an important source of income. In December 1888 arrangements were finalized "for a series of four Sunday night lectures to be given in the Park Theater by Mrs. Alice Le Plongeon" (BDE, 6 December 1888b:1).

CHAPTER
FIVE

At this same time Alice finished her article on photography for the *Photographic Times* titled, "Collodion vs. Gelatine." She was critical of man-ufactured dry glass-plate negatives and wrote, "The dry plate had serious disadvantages" (ADLP 1888e:581) because "the pictures were wanting in that exquisite sharpness . . . so very essential in copying sculptured inscriptions" (ADLP 1888e:582). The article concluded with an explanation of the results of the Le Plongeons' successful experiments with "collodion emulsion" to make transparencies (ADLP 1888e:582).

While Alice's writings continued to focus on the ancient Maya, her heart was with the women and the poor she had come to know in Yucatán. Her chance to write about young Yucatecan women came in 1889 with an article she titled, "The Maidens of Yucatan." She set the stage by stating, "The mes-tiza women of that most interesting country are famed for their beauty of form and features, abundant silky black tresses, large dark eyes, and easy, graceful features" (ADLP 1889a). She then presented the economic realities: "Owing to great excess of female population . . . a large number of women depend entirely on their own exertions, and their field of labor is limited. They are not employed in stores, such places being monopolized by white-handed youths who think coarser toil beneath them. . . . They may suffer everything except actual starvation, yet must submit if they would be respected" (ADLP 1889a). Her final paragraphs demonstrate her deep connection and affection for the women she had gotten to know during her many years in Yucatán: "In spite of their cheerless homes, monotonous lives, and continual toil, there is a winsome refinement and amiability about these maidens that surprises and charms" (ADLP 1889a).

What inspired Alice to write her article "Pizarro's Death and Burial" was a short comment she read in the *Home Journal* about an inscription on a plaque in Linares, Spain, that stated: "Herein lies the pretended corpse of Francesco Pizarro" (ADLP 1889b). She quoted extensively from historian Agustín de Zárate's book *Historia del descubrimiento y conquista de las provin-cias del Peru* (1577) to back her contention that Pizzaro was buried in Peru. Since Augustus had spent nearly ten years in Peru, he was able to provide Alice with additional background. Recent forensic analysis has identified bones and a skull found in the Cathedral of Lima as those of Pizarro.

By June 1889 Alice had worked several years with women's organizations in New York. She met with 375 women for the "inaugural dinner and recep-tion of the lately organized Seidl Society at the Hotel Brighton. . . . Men are excluded from the banquet" (BDE, 16 June 1889:2). Alice and her colleagues were guests of the women who founded the society to honor Anton Seidl (1850–98), who was a distinguished conductor of German opera in Europe in the 1870s and 1880s. He had come to New York in the late 1880s and directed the New York Philharmonic from 1891 until his death.

At eight in the evening on Saturday, March 29, 1890, Alice was again at the Cooper Union where she presented "The Development and Spread of Ancient American Architecture" to a large and appreciative audience in the Great Hall (NYT, 28 March 1890:7). Shortly thereafter she took the long train ride to Ohio and "lectured . . . in Cincinnati" (BDE, 1 April 1890:1). No further information about why she traveled to Ohio, or to what group she gave her lecture, is available.

In that same *Brooklyn Daily Eagle* article was an account of how Augustus "was not very cordially treated by the Brooklyn Institute" (1 April 1890:1). The reporter credited Augustus with having "recently delivered a course of lectures on 'American civilization,' before large audiences, in Boston, under the auspices of the Lowell Institute" (1 April 1890:1). To have given lectures at the prestigious Lowell Institute was an important honor, and it must have motivated Augustus to contact the Brooklyn Institute to arrange for more lectures closer to home.

The report continued that the Brooklyn Institute, rather than replying directly to his request, sent him a "subscription ticket" for membership. "He felt that the notice taken of his request for a hearing was in the nature of a slight, in view of the fact that his own lecture and those of Mrs. Le Plongeon had gained them considerable notice outside of their city of residence" (BDE, 1 April 1890:1). The reason for the Brooklyn Institute's evasive action is unknown, but what is known is that Augustus did not receive a "hearing." As a result, he remained in the background writing while Alice continued to make public appearances.

During the early summer of 1890, Alice proposed to give a lecture before the Blavatsky Lodge of the Theosophical Society in London and was welcomed with great anticipation. The lecture was scheduled for early September, and she began to make preparations for it as well as a long overdue visit to her family.

Alice likely had met members of the Theosophical Society's New York lodge, and while there is no record of Alice's membership, the society had been active from the time Helena Petrovna Blavatsky (affectionately known as HPB) founded it there in 1875. She also had established the society's European headquarters in London in 1890, and the lodge was named in her honor. It is possible that Alice had proposed the lecture not only to honor HPB, but also to convince her that the Maya were the source of world civilization. But HPB had already made up her mind that the Maya had no part in founding world civilization and that it was not worthwhile to search for a single source.

Before going to London, Alice submitted an article, "Ancient Races," to the society's London journal *Lucifer*, and the editors agreed that it would be published in the November issue. She began the article with a general

overview of Maya civilization, and then described Maya religious beliefs and the difficulties the Maya faced in practicing them. "Old rites, that they cling to, have to be performed in secret, to avoid reproof and punishment. Moreover, it pains them to see the customs of their forefathers derided" (ADLP 1890b:236).

Alice then fearlessly contradicted HPB when she wrote that the sculpted representations of mammoths (now known to be the rain god Chac) she and Augustus identified on Maya buildings represented the "God of the ocean," which was proof that "worship in India [was] an outgrowth of mammoth worship in America" (ADLP 1890b:236). That assertion gave the New World primacy in the development of world civilization, and it elicited a strong negative footnote from the editor of *Lucifer* (HPB or Annie Besant): "We should rather say that it is the other way about. The Aryan Hindu is the last offshoot of the first sub-race of the fifth Root-race which is now the dominant one—[Ed.]" (ADLP 1890b:236).

In her 1888 book *The Secret Doctrine*, HPB had agreed with the Le Plongeons that Maya civilization was contemporary with Atlantis, but they were dismayed because she would not agree that the Maya founded world civilization.

Blavatsky wrote,

> The author of this work [Sacred Mysteries among the Mayas and Quiches, 11,500 Years Ago] is Augustus Le Plongeon. He and his wife are well known in the United States for their untiring labours in Central America. It is they who discovered the sepulcher of the royal Kan Coh, at Chichen-Itza [*sic*]. The author seems to believe and to seek to prove that the esoteric learning of the Aryans and the Egyptians was derived from the Mayas. But, although certainly coeval with Plato's Atlantis, the Mayas belonged to the Fifth Continent, which was preceded by Atlantis and Lemuria [Blavatsky 1888:2:34–35].

On the other hand, HPB agreed with the Le Plongeons that there was a connection between Egypt and the Maya because of similar "rites and beliefs." And the Le Plongeons were pleased to read that she agreed with them that the "hieratic alphabets of the Maya and the Egyptians are almost identical." Of course, this convinced them further that their "key" to decipherment of the Maya hieroglyphics was correct.

> [I]t is difficult to understand how all the peoples under the sun, some of whom are separated by vast oceans and belong to different hemispheres, such as the ancient Peruvians and Mexicans, as well as

the Chaldeans, could have worked out the same "fairy tales" in the same order of events.* [* HPB added the following footnote: "See the 'Sacred Mysteries among the Mayas and the Quiches, 11,500 years ago,' by Auguste le Plongeon, who shows the identity between the Egyptian rites and beliefs and those of the people he describes. The ancient hieratic alphabets of the Maya and the Egyptians are almost identical" {Blavatsky 1888:1:266–67}].

In late August 1890, Alice sailed with Augustus for London after having been away nearly twenty years. The Le Plongeons' time in London was important professionally because of Alice's lecture at the Blavatsky Lodge, but they also planned a wonderful reunion with her family. Her brothers and sisters were now adults, some had married and had children, and Augustus was welcomed as part of the family. Any doubts they might have had about Alice marrying a man twenty-five years her senior were now gone.

Alice's lecture was titled "The Mayas," and it was later published in *Lucifer*. She delivered it on Saturday, September 6, at HPB's residence in South London. Those Saturday meetings with HPB holding forth often went late into the evening; therefore Alice was only part of the program.

Alice's family was present, and they were highly honored to hear their now mature and well-traveled Alice speak. Her lecture was well attended by the membership, but was limited to about an hour because HPB needed time for discussions about theosophy and her book *The Secret Doctrine*. Showing slides to illustrate the lecture might have taken too much time, so Alice lamented, "This evening we cannot have the satisfaction of illustrating our subject and thus making clearer our remarks, but if future occasions offer, we have several hundreds of lantern slides ready" (ADLP 1890a:3).

Overestimating her influence on HPB and the society membership, she began, "This occasion is especially gratifying to us, for beside the pleasure and honour of addressing you, we have the happy certainty of speaking to those who rejoice in acquiring knowledge, and who will easily grasp the many facts" (ADLP 1890a:3).

Alice then explained that they went to Yucatán to "study the ruins" and that their work was "a continuation of archaeological studies begun by the Doctor as early as 1862, in Peru. There he had reached certain conclusions, and it was in search of further corroboration that he went to Central America" (ADLP 1890a:3). That introduction was followed by a summary of the economic and social forces behind the Caste War of Yucatán: "After a long and fearful struggle a few thousand [Maya] freed themselves completely from the white man's control, and built their stronghold in the south-west part of the Peninsula" (ADLP 1890a:4).

Alice then sought to bolster Augustus further by crediting him with

deciphering the iconography carved on the Adivino Pyramid at Uxmal. As in most of her lectures, she gave Augustus credit for their joint discoveries and avoided any mention of their collaboration or her own work. "The grammatical forms and syntaxis of the Maya and Egyptian tongues are almost identical. . . . Dr. Le Plongeon's discoveries have proved that the hieratic alphabets of the learned men of Egypt and Mayax (as Yucatan was anciently called) are almost identical" (ADLP 1890a:5). Since, according to Alice, Mayan was spoken in Egypt, she took it a step further and asserted that the Mayan language had spread north from the Middle East to Greece.

The Greek language, according to the Le Plongeons, derived from Mayan, and as proof she explained that Augustus had discovered that each letter of the Greek alphabet (alpha, beta, gamma, etc.) had a meaning in Mayan. When the letters were translated sequentially, a short poem emerged about the destruction of what Alice called "Mu" (Atlantis). For example, alpha means "heavily break—the—waters," beta means "extending—over the—plains," gamma means "They—cover—the—land," etc., ending with omega, which means "then—come forth—and—volcanic sediments" (ADLP 1890a:6).

Alice then returned to an explanation of the decipherment of the iconography at Uxmal: "It began by Dr. Le Plongeon one day finding that certain signs were exactly like those of old Egypt, which led him to think that others might also be. Nor was he disappointed, and by giving them the same value, he found that they resulted in words in the Maya language. A key to those mysterious hieroglyphs was indeed found!" (ADLP 1890a:6).

She continued her lecture with a description of their excavation of the Chacmool from the Platform of the Eagles and Jaguars, and how that led them to conclude that Prince Chacmool and Queen Móo were historical personages and connected to Egypt. "Startling as it may sound, I assure you that that personage seems to have been the living origin of the myth of Osiris in Egypt. There are so many facts pointing to this conclusion that . . . when Dr. Le Plongeon's new work [Queen Móo and the Egyptian Sphinx] is published, many readers will probably agree with us" (ADLP 1890a:12).

The final pages of the lecture discuss the excavation of the Platform of Venus (Mausoleum of High Priest Cay) and describe the many sculptures they found within it. At the end of the lecture, Alice apologized again for not illustrating the lecture with slides and for not speaking longer. With pride she noted that Augustus had lectured at the Lowell Institute. "To give you an idea of the vastness of the subject, I may say that when Dr. Le Plongeon, in March last, delivered seven lectures, he and his audience would have preferred fourteen" (ADLP 1890a:15).

Then she boldly predicted, "Dr. Le Plongeon's MSS. [Queen Móo and the Egyptian Sphinx], now ready for publication, have been examined by scholars, who affirm that it will create a sensation among historians and scientists, and

they are kind enough to add that it is bound to be recognized as one of the great works of the age" (ADLP 1890a:15).

Warning signs that *Queen Móo and the Egyptian Sphinx* would not be "recognized as one of the great works of the age" came from the Theosophical Society itself. A few months after Alice's lecture, an unexpectedly devastating review was published in *Lucifer*, the same journal that had published Alice's lecture "The Mayas" and article "Ancient Races." It was edited by HPB or Annie Besant and began with a summary in which Alice and Augustus were praised for making important discoveries, overcoming "difficulties in prosecuting their researches," and for being the cause of such "a good attendance" (Lucifer 1890–91:165).

The Le Plongeons must have been pleased with the review—until they read the "judgment":

> The judgment of the assembled Theosophists was that although these discoveries were of the greatest interest, still the conclusion arrived at by the discoverers erred on the side of claiming too much. Evidence and experience shows the futility of tracing the development of peoples and traditions from one particular historical root. We are afraid that "Maya" will never prove the universal solvent of all anthropological, mythological, and philosophical puzzles [Lucifer 1890–91:166].

No reply to the review is known, and it is likely that the Le Plongeons considered the opinion of HPB, Besant, and the "assembled Theosophists" in error. Alice had failed to convince the theosophists, and of particular interest is that the review also mirrored an important change in archaeological research. By the turn of the century, archaeologists would no longer consider "tracing the development of peoples and traditions from one particular historical root" to be a research objective worth pursuing.

While they were visiting her mother and father, Alice was happy to see that the large number of photos of Yucatán and Belize she had printed were now neatly pasted into a large family album. Her father's approval of her work in photography was important to her, and the whole family was fascinated by her stories about their months living at archaeological sites and their near escapes from "enormous" snakes.

Alice, in her turn, had questions for her brother TJ and her father about their photographic methods. Dixon and Son was well known for photographing works of art for insurance, publication, and catalogs, and she realized this would be an interesting subject for other photographers. Out of many discussions and observations came an article for the *Photographic Times* called "Art Photography in London."

In the article, Alice noted the international scope and success of the company and that the Albany Street studio had "a large staff of operators . . . always present. But all the work is not done on the premises; the employees attend at galleries, studios in any part of the country, England, Ireland, Scotland, and France being visited to customers [sic] orders" (ADLP 1890c:648). Alice was also impressed by the latest in darkroom equipment, which included "various contrivances for speed and accuracy, the many lenses by different makers each to meet special requirements. It is no secret that colored screens [filters] of different degrees of density are used in making pictures" (ADLP 1890c:648).

After their much-needed vacation, the Le Plongeons were back in New York before the end of 1890. Alice returned to her writing and lecturing and expanded her network in the very active community of New York women. Their visit to Alice's family was much too short, so they planned to return again in August 1891 to see more of England and visit members of her family that lived outside of London. After they had made the arrangements, they received word that both of Alice's two younger sisters, Sophia and Agnes Clara, planned be married on May 30, 1891, in a double wedding at Regent's Park Chapel. Sophia, who worked as a housekeeper for the family, planned to marry Arthur Constance, a commercial clerk. Agnes Clara, a bookkeeper for Dixon and Son, was to marry Ernest Biles, a hotel keeper. Alice was disappointed that she would miss the wedding, but decided she couldn't return to England sooner.

During the seven-month interval, Augustus endlessly edited the manuscript of *Queen Móo and the Egyptian Sphinx*. He was on his guard after the surprisingly negative review of their conclusions in *Lucifer*, and he checked and rechecked everything to be certain that all his arguments were unassailable.

Subscriptions to publish *Queen Móo* lagged, but the Le Plongeons thought something might develop when they heard that Herbert Adams, a professor of history at Johns Hopkins University, had given a paper before the American Antiquarian Society titled, "The Life and Work of Brasseur de Bourbourg." They hoped that any credit given to Brasseur's writings and theories would carry over to Augustus's book. They were disappointed when they learned the focus of the paper was simply a chronology of Brasseur's life and travels with an extensive bibliography and personal impressions, but virtually nothing about his theories.

Adams was an important historian in his day and clearly admired Brasseur, whom he had met in Rome. Adams wrote, "He was a strikingly handsome man, with a good head, keen eyes, a very intelligent and attractive face, tall stature and courtly manners" (Adams 1891a:13). Adams's paper did little or nothing to help with the publication of *Queen Móo*.

In the late 1880s, Alice had begun writing poetry, and she not only dedicated short poems to Augustus, but in the next twenty years she would also

write two lengthy epic poems. A few of Alice's personal poems were preserved, thanks to her friend Maude Blackwell, and one signed "Alicia" was dedicated to "A. J. H. LeP" (Augustus Julius Henry Le Plongeon). Probably written in Yucatán, the poem honored his discovery of the "key" to decipherment of Maya writing: "No eye save thine hath found the way to read, / Graved on the crumbling walls, those records old,—" (ADLP ca. 1880s b).

Around mid-July 1891, Alice and Augustus sailed for Liverpool, and then took the London and North Western Railway to London during the evening of July 29. Alice scribbled on the ticket that they "had an excellent dinner" in the dining car. Still disappointed at missing the double wedding, Alice minimized her professional involvements so that she could have more time with her sister Lucy and her recently married sisters and their husbands. The day after their arrival they visited Westminster Abbey and museums, heard the Band of the Royal Horse Guards during the afternoon of August 8, and then Alice and her father toured the Crystal Palace on August 11 along with her sisters and some friends.

After her return to New York, Alice quickly focused on preparing for lectures and spent long days writing popular and historical articles on Yucatán, Peru, and the Pacific and three fanciful pieces about their two adopted sparrows, Loulou and Dick. But also, she immersed herself in the women's suffrage movement and worked to help the New York City poor. What little extra time she had was devoted to preparing to move their residence. The move was a large undertaking, but by March 1892 they had relocated from Washington Street to within a few blocks of the East River at 18 Sidney Place, where they lived for the next fifteen years.

August the souls that comprehend the Past

Justly, and in its ancient records find

How fleeting are the labors of mankind—

Let these be great or small—for none may last!

Each high conception of human mind

Persuadeth skilful hands such thoughts to bind,

Like treasures they would safely keep,—soon cast

On Time's rude wave to sink and disappear,

No more to rise unless in ruined state—

Gathered by relic-hunters who debate

Each flotsam they behold, but never hear,

O Soul of all that is! th'inspired thought,

Nor find the meaning which the artist wrought.

Alicia

ALICE DIXON LE PLONGEON, "To an Antiquary," ca. 1880s

Working for Women's Rights

1892–95

IN ADDITION TO LECTURING AND WRITING ABOUT THE MAYA, ALICE was committed to working with women's organizations in New York to secure voting and working rights for women. The most well-known group she became associated with was Sorosis, a professional women's organization. The organization had been founded by Jane Cunningham Croly in 1868 after the male-dominated New York Press Club had blocked Croly and other women journalists from attending an event honoring Charles Dickens. She and her colleagues were fed up and joined together to fight against discriminatory practices and for their economic rights.

Because the membership was drawn from a cross section of New York professional women with widely differing interests, the right to vote and equal pay were not the only causes advocated by Sorosis members. By the 1870s, cremation had become acceptable in England and other European countries, but it saw only limited practice in the United States. Several influential Sorosis women, including Alice, saw burial practices in the United States as overly elaborate and unnecessarily expensive and therefore advocated a wider acceptance of cremation.

In 1892 Alice published an article, "Incinerating the Dead," that explained the use of cremation and the funerary practices of a number of other ancient civilizations. She provided historical support for the use of cremation and reported that while the Maya had buried the "deceased in the house or else at the back of it" around the time of conquest in the sixteenth century, they had practiced cremation during an earlier period before the Spanish arrived (ADLP 1892).

The article was written in support of the work of Sorosis member Charlotte J. Bell. Bell was an advocate of cremation and hoped that Sorosis would put its stamp of approval on it. She was well known in New York because of her many organizational activities including "Sorosis, . . . the society for Political Study, . . . two Unitarian Societies, Vice President of the Home Hotel Association, and [she was an] enthusiastic believer in woman's suffrage, and a house-mother besides" (NYT, 16 September 1894b:18).

In addition to working with Sorosis, Alice lectured to help fund the New York Diet Kitchen Association, founded in 1873 to feed the poor. The association's work was particularly important during the severe United States economic crisis that began in 1893. The crisis was triggered by a run on the gold supply and quickly became the worst economic collapse the United States had ever faced. Unemployment reached almost 20 percent by 1894, and Alice and Augustus were seriously affected. It was also a difficult time for Augustus, who was almost seventy years old and had hoped that subscriptions to print his book *Queen Móo and the Egyptian Sphinx* would raise enough money for its publication. To help them get through the economic recession, Alice continued to write for the newspapers and magazines and to lecture.

On March 1, 1893, Alice spoke to a "large audience" at St. Augustine's Church at Fifth Avenue and Bergen Street in New York City. An article in the *Brooklyn Daily Eagle* stated it was "an illustrated lecture on the life and voyages of Columbus. The lecturer was Mme. Alice D. Le Plongeon, a woman who has traveled and explored and written about the countries of Central America. . . . Mme. Le Plongeon is the only woman who has lived among the deserted old cities in the forests of Yucatan" (2 March 1893:2). Apparently, Alice's London "accent" found approval with her New York audiences, and the article went on to note that "Madam Le Plongeon has an easy and self possessed manner and a particularly pleasant accent" (2 March 1893:2).

As the economic crisis deepened in 1894, Alice continued to arrange for speaking engagements to raise money for the Diet Kitchen Association. A *New York Times* article about feeding the out-of-work poor noted Alice's efforts to raise more money: "Not Yet Enough for the Poor. Mme. Alice Le Plongeon's lecture on Yucatan for charity" (28 February 1894a:9). And while she made every effort to help others, within a few years her own sources of income would be seriously reduced, and she would also be appealing for help.

To broaden her appeal and increase her income, Alice soon expanded her lecture topics to Peru, Hawaii, London, Pompeii, religious doctrines, and what she called "occultism" practiced by people in Yucatán as well as Burma, China, Egypt, India, Persia, and Polynesia. Further afield were her talks on "Modern Spiritualism," "Colors in all Departments of Being, as an aid to health and harmony and beauty," and "A Talk regarding the Powers of the

CHICHEN. G.V. *N. B.*

wild creatures Populous towns around when Sp. invaded ,1517, *now*
Y. very level. Ancients built heights to defend settle-
ments —

CASTLE Quadrangular, solid, about four and a half of our city
blocks around base, 244 by 238 ft. Its 4 sides face cardinal p.
90 steps to summit — W. ascent least destroyed.
Military stronghold for defence of bldgs. around great sq.
whose centre it occupied.

PORTAL Inside grand portal leading into corridor that surrounds
room, only entrance N. — corridor has entrance at head of
each stairway. Ceiling of room 3 upright arches, supported
on two massive beams, resting on square pillars. Beams
finely sculptured, spoiled by machete cuts. Women with
enormous hats!

WALLS N-W. of the castle-pyramid was a public gym.. Its parallel
Acoustics walls are each 270 ft. long, 42 h., 20 thick - 120 ft. apart.
Run N. &S. faced with sq. stones beautifully fitted.
Bldg. on S. end of E. wall a Mem. H. raised to memory of
SHRINE Warrior prince by widow.
nearer view - climb, 40 ft. by stones and tree trunks. Tell.
Fallen portico. Excavate. Altar top 6ft. on each side,
8 inches thick. On its border figures of priests performing
Altar sacred rites - on broken surface two life-size figures. A
priest seated and a chieftian standing before him. Altar
was for making offerings to the deceased warrior. At the
doors of Eg. tombs altars were erected for the same purpose.
Atlantes had shell eyes and toenails, but these had fallen.
Photographed, reburied, rediscovered, in Mexico. (*border-moulds*)

FRESCO To our delight wall paintings - floor to apex of arch,
21 ft. Room 26 ft. long. 15,00 sq. ft. - Figures 6 to 9
in. high - red, yellow, blue, green, maroon, lines dark brown.
No shading or perspective. A series of tableau divided
by horizontal blue lines - battles, processions, religious
rites, domestic scenes, —made facsimile of best preserved.
and these will be a treasure for the museums that
acquire them — much more destroyed now.

A page from Alice's lecture notes. She spoke to her New York audiences extemporaneously, using her notes to keep her lecture on track and to remind her about slide changes. She has penciled in a note to mention the unusual acoustics of the Great Ball Court at Chichén Itzá that she and Augustus had noticed after they had cleared the thick vegetation. Research Library, The Getty Research Institute, Los Angeles, California (2004.M.18).

Mother" (ADLP ca. 1890s a). Alice knew her subjects well and spoke from short lecture notes with slide prompts in the margin so that she would know when to signal the projectionist.

During 1892 Alice received a number of worrying letters from her family about her father's health, and during the Christmas holidays they wrote to tell her that he seemed unable to recover from an ongoing illness. Henry Dixon died on January 20, 1893, and while Alice desperately wanted to attend his funeral, she did not have the money for a trip to London. She was determined to visit his grave as soon as possible, but it would be another three years before it became financially possible.

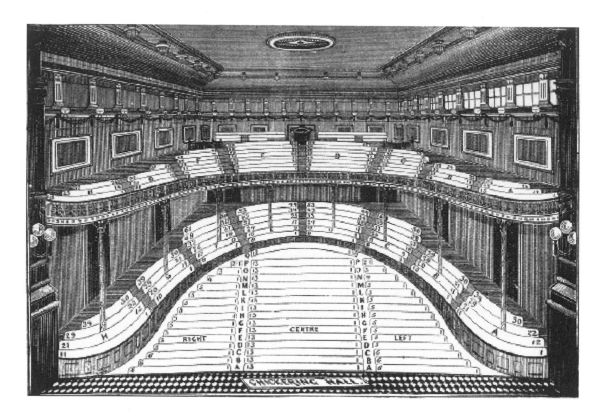

The interior of Chickering Hall as viewed from the stage where Alice spoke on a number of occasions. Located at the corner of Fifth Avenue and West Eighteenth Street in New York City, the hall had a seating capacity of around 1,200 people. *Pictorial Diagrams of New York Theatres.* 1880. Lansing and Company, New York.

Around this time a young woman from Toronto, Canada, named Maude Blackwell introduced herself to Alice after one of her evening lectures. Alice's accomplishments in archaeology and writing had inspired Maude's interest in the Maya, and her friendship with Alice would be lifelong. After Alice's death, Maude took on the enormous responsibility of arranging for the final disposition of the Le Plongeons' photographs and papers.

Alice's work for women's rights became well known, and as a result she was invited to attend an exclusive breakfast to celebrate the twenty-fourth anniversary of the Brooklyn Woman's Club. The event was held on March 4 "in the ballroom of the Pouch Mansion, and was" attended by members and a select group of about fifteen invited guests (NYT, 5 March 1893d:4).

She continued to give her Saturday evening lectures at the Cooper Union. The previous January the *New York Times* had announced "Columbus" for January 7 (6 January 1893a:7). The American Geographical Society must have been impressed with her lectures because they sponsored her for a Saturday night talk about Yucatán at Chickering Hall in New York City for March 25 (NYT, 28 March 1893b:5).

Chickering Hall was built in 1875 by the Chickering Piano Company at the corner of Fifth Avenue and West Eighteenth Street with a seating capacity

of more than 1,200. To be asked to speak there must have been a great honor. Mark Twain had filled every seat in 1884, Oscar Wilde had given a reading there in 1882, and Alexander Graham Bell made the first interstate phone call from the hall in 1877.

Some of Alice's writings remain in undated manuscript form, but the following were likely written after 1890: "An American Prince" (ADLP ca. 1890s b), "A Hammock Story" (ADLP ca. 1890s d), "Carnival Days" (ADLP ca. 1890s c), and "Spanish Discovery of Yucatan" (ADLP ca. 1890s e). "London" (ADLP ca. 1896), and "Paris" (ADLP 1896a), were written shortly after her travels to those cities, and "Hawaii Long Ago" (ADLP ca. 1899) was based on a visit Augustus made to the islands in the 1850s.

Her article "London" has considerable historical background about the city and was written as a very detailed walking tour. Alice probably wrote parts of it during her visits in 1891 and 1896. Although only the last nineteen pages remain of the fifty-six-page typed manuscript, Alice's pride and historical knowledge about *her* city is evident.

> To form an idea of London's magnitude one must make a trip up the Thames & a tour through the docks. Floating along the river we have a panoramic view of the great hotels on the Embankment, Somerset House, Cleopatra's Needle, the Temple, London Bridge, with its great bascules [ADLP ca. 1896:55].

In the early 1890s, Alice became known to Mary Newbury Adams, a Unitarian and member of the National Women's Suffrage Association. She wrote Alice in February 1893 to request that she present a paper at the Congress of Women to be held at the World's Columbian Exposition in Chicago later that year. More than two hundred accomplished women came together to give papers at the congress, and the papers were later published as a book.

Adams, who was born in Peru, came from a long line of ministers, judges, and physicians. She was very active in working to secure women's rights and was known in the Midwest for her many essays, lectures, sermons, and newspaper articles. She had read Alice's papers, heard about her speaking ability, and asked that she give a paper on the history of Yucatán. Alice replied, "I will do my best to cover the ground you have laid out for me in 'Hist. of Y.' etc—" (ADLP 1893a). But when the volume was published, Alice's paper was not included. She apparently did not have the money to travel to Chicago.

Alice wrote Adams that her book, "Yucatan: Its Ancient Palaces and Modern Cities," was "ready in my hands, completed long ago, but awaiting a Publisher who will permit me to have some share in the proceeds" (ADLP 1893a). She and Augustus had been losing ground financially, and that was

costing Alice professionally. Further, she realized that Augustus's writings were not receiving the acceptance she expected. In her frustration she wrote:

> Personally I am so bitterly indignant at the little recognition which Dr. Le Plongeon's remarkable discoveries have received in this country, that I have no words with which to express it. My chief aim and desire is to live long enough to see his great work (now in ms.) [*Queen Móo and the Egyptian Sphinx*] published. This is the first time I have permitted myself to express something of what I feel on this matter, & it will probably be the last. . . . Perhaps I ought to take comfort in the knowledge that all the truly great men have been ill appreciated by their contemporaries [ADLP 1893a].

Yet Alice's setbacks did not prevent her from continuing to be supportive of other women's successes, and she noted to Adams that she was "exceedingly glad that Mrs. French Sheldon is meeting with success—she well deserves it!" (ADLP 1893a). Sheldon, a well-educated woman with political views similar to Alice's, had single-handedly led an expedition to Lake Chala near Kilimanjaro in 1891 in order to bring "about peaceful, humane methods of would-be colonizers, and banish forever the military attitude of aliens" (Sheldon 1894:131).

Like Alice, Sheldon developed friendships with village women. Both women realized that male ethnographers had little or no access to the women's sphere in traditional societies. The result was serious gaps in the description of those societies. Sheldon wrote, "the inadequate accounts of the women and children, the home life, have ever been portrayed from a superficial, biased point of view; for the white man has, by his own confession, been denied a full and complete acquaintance with the more intimate lives of the East African women" (Sheldon 1894:131). Along with Alice, Augustus praised Sheldon for her success because, as Alice put it, "All his life through he has been a earnest worker and advocate for the advancement of women" (ADLP 1893a).

With hope that the sale of their paintings might bring them some money, Alice confided to Adams at the end of her letter, "In my brother's house in London . . . we have two valuable paintings by Spanish masters" (ADLP 1893a). Adams provided Alice with a list of people who might be interested in the paintings and a source of funding for Augustus's book, but the paintings were not sold and publication of Augustus's book would be delayed further.

Alice continued her writing for popular journals to supplement their income. A number of the articles were based on observations she had made while she lived in Yucatán, but they remain as drafts. The first, "An American Prince," a nine-page handwritten piece about the excavation and confiscation of the Chacmool, was compiled from previous articles and entries from

her diary. "A Hammock Story" was based on Alice's many years of travel in Yucatán where the "hammock is the most delightful of all couches if one knows just how to use it" (ADLP ca. 1890s d). Alice began with a short historical overview of the hammock and its construction, and then finished, in dark humor, about a traveler's misfortune.

The story went, roughly, as follows. A tourist new to Yucatán arrived at a village one evening, but had trouble finding a place to sleep for the night. He finally located a house that had space, but the Maya man who owned the house told him all the hammocks were occupied. He pleaded and begged and argued that there was, in fact, space for a hammock, yet the Maya man continued to refuse. The traveler pleaded and demanded louder and louder, and in the end the exasperated householder relented.

A hammock was slung for him next to a man who was lying peacefully in his hammock. The night was quiet and the traveler slept well, little realizing that a surprise was in store for him in the morning. "In the grey light of early dawn, I saw two men in the doorway. One was explaining—'We have come for the dead man.' The Indians pointed to the hammock where I lay . . . 'There he is'" (ADLP ca. 1890s d).

The Maya men must have had a good laugh from his flustered reaction to their first joke. The traveler then grumbled, "Imagine my disgust! I jumped up repeating the words—'Dead man.' Then I swore; but those fellows only grinned." Then they doubled their fun: "As the hammock and its occupant were carried out, they coolly remarked:—'He died yesterday afternoon; you slept well and he has not hurt you'" [ADLP ca. 1890s d].

Still unable to cope with the joke, he whined, "There was nothing an Indian would not do to a white man." If anything could rile up the Le Plongeons, it was that attitude, and they immediately set him straight. Alice finished with: "Our reply was an interrogation—'And the white man to the Indian?'" [ADLP ca. 1890s d].

Only one manuscript page remains of "Spanish Discovery of Yucatan." That page is likely a fragment of a manuscript for an article published in the *Magazine of American History*. In her historical article "Carnival Days," Alice described a number of festivals including those held in ancient Rome, Naples, Paris, Malta, Peru, and Yucatán. For Yucatán, she reported that "At Carnival time the Maya Sun-dance can be seen in Merida" (ADLP ca. 1890s c). A handwritten note in the corner of the typewritten article, "1,500 words," informed the editors of the length of the manuscript.

In 1893 Alice wrote an account of the Caste War of Yucatán titled "Yucatan Since the Conquest" for the *Magazine of American History*. She based a good part of her article on an 1879 history, *Ensayo histórico sobre las revoluciones de Yucatán desde el año de 1840 hasta 1864*, by the Yucatecan historian Serapio Baqueiro.

Giving Baqueiro full credit, she stated, "One of the most complete works on the subject [the Caste War] is that of Señor Don Serapio Baqueiro, published in Merida in 1879." For Alice, Baqueiro was one of Yucatán's "many gifted musicians, artists, and writers" (ADLP 1893b:159). She drew on her own observations and those of friends in Yucatán, "since that time [1879], we have our knowledge from personal observation and from those who have lived among the hostile Indians" (ADLP 1893b:159).

The article began philosophically: "history . . . is a guide that points out the pitfalls into which others have fallen and which we should therefore avoid" (ADLP 1893b:158). She placed full blame for the Caste War on "those who had always been the aggressors, the descendants of the Spaniards" (ADLP 1893b:162). As Alice had written before, the trouble began with the invasion of Yucatán by the Spanish in 1527, but the Maya "were vanquished only after twenty-five years of brave resistance" (ADLP 1893b:158). For the next three hundred years there followed a series of brutally suppressed revolts culminating in the Caste War that began in 1847.

The Maya "had first thought of uprising because of the injustice they suffered, and because exorbitant taxes were exacted of them by Church and State. But the war was decided by the white people and mestizos [*sic*] killing their families and burning their homes" (ADLP 1893b:164). Once the revolt began, Alice wrote that the Maya were driven by "The martyrdom of their forefathers . . . not forgotten! They could feel no mercy or pity; too long had they endured" (ADLP 1893b:162). While Alice blamed the outbreak of the Caste War on the actions of the "descendants of the Spanish," she did not hesitate to write about the atrocities committed by both sides. The Maya "burned rancho, village, and town, murdering the inhabitants and robbing what they could lay hands on. One of the leading traits of their character was, and is, honesty. But they had adopted the tactics of their enemies" (ADLP 1893b:164).

By May 1848, the Maya were close to capturing Mérida, and the city was about to be abandoned. But, Alice stated, the Maya hesitated to attack Mérida because their leadership and troops had suffered heavy casualties, and they were short of men and weapons ready for battle. Their hesitation resulted in their being driven back. "Inch by inch, body by body, they contested for the soil, which was strewn with heroes dead and dying. Equal courage was displayed on both sides" (ADLP 1893b:167).

After a massacre of more than four hundred Maya at Tizimin in 1853, the Caste War slowed to sporadic warfare that moved back and forth across the Line of the East. As Nelson Reed pointed out in his book *The Caste War of Yucatan*, "This is the point [1855] where its major historians, Serapio Baqueiro and Eligo Ancona . . . turn their attention away from the eastern forest. . . . There had been no victory, and there would be fighting for years to come" (Reed 1964:155–56).

In 1884 Yucatecan General Theodosio Canto had attempted to arrange for a treaty with the Chan Santa Cruz Maya, that would "guarantee against invasion, and retaining complete local authority" (Reed 1964:221). Alice ended her article with a detailed account of Canto's negotiations with the Maya leadership in Belize and their eventual collapse. Her information about the negotiations is attributed to her friend Henry Fowler, governor of Belize, who acted as an official witness.

On November 25, Alice gave her final Saturday night lecture of 1893 at the Cooper Union on the subject of Peru (NYT, 25 November 1893c:7). It was a good crowd, and Alice enjoyed speaking again in the Great Hall.

In 1894 the annual meeting of the American Association for the Advancement of Science (AAAS) was held in Brooklyn, and while Augustus was not on the program, he was determined to have his views heard. He had failed two previous times to draw Daniel Brinton into a public debate about the Maya and was angered that Brinton's letter of invitation to Alice in 1887 had been sent to the wrong address. The 1894 meeting of the AAAS was an important one for Brinton because he was scheduled to be inaugurated as president on August 16, and so Augustus decided to challenge him again.

Trouble had been brewing as far back as 1885 when Brinton refused to accept Augustus's proposal that the Maya used the meter as their standard unit of measure and that ancient Egyptian language had derived from the Mayan language. For Augustus, it was not enough that Brinton had conceded that "the magnitude of his [Augustus's] discoveries and the new and valuable light they throw upon ancient Maya civilization . . . correct, in various instances, the hasty deductions of Charnay." Brinton would not debate him, and in the end, Augustus labeled him as "a mere closet archaeologist" (ALP 1896a:203).

Augustus also charged that he, like Alice, had been prevented from speaking at the AAAS meeting in 1887 because his invitation had also been sent to the wrong address. He wrote that he had not received it "until three weeks after the closing of the sessions" (ALP 1896a:204). So in 1894, he publicly challenged Brinton to a debate and had the challenge published in the *Brooklyn Daily Eagle* on August 19. Detailing eight points for debate, the published challenge was titled, "Dr. Le Plongeon to Dr. Brinton. An open letter which contains an invitation to a scientific duel" (ALP 1896a:204). The letter "was placed in his [Brinton's] hand on August 20th, while he was standing with other members of the association in a reception room of the Polytechnic Institute" (ALP 1896a:204). It must have been a dramatic moment in the quiet world of academic archaeology when Augustus strode up to Brinton and made the challenge.

Augustus mistakenly thought he could goad Brinton into a "scientific duel" by ending the letter on a sarcastic note:

Hoping sir, that you will gladly improve the opportunity to show that you are really superior an authority, with right therefore to criticize others on such an important subject, to all Americans scientists, and afford me one for displaying my extravagances or eccentricities before the members of the American Association for the Advancement of Science, I beg subscribe myself [ALP 1894b].

Brinton refused to be drawn into the debate, and that infuriated Augustus even further. Therefore, when *Queen Móo and the Egyptian Sphinx* was published in 1896, he included the entire episode in an appendix. Augustus considered Brinton's failure to meet him on the field of debate as not only dishonorable, but also proof of his lack of knowledge about the Maya.

At this same time, Augustus finished editing *Queen Móo*, and in a letter to curator Marshall H. Saville at American Museum of Natural History about the sale of their molds, he announced that his book would soon be published.[1] In addition to offering the molds to the museum, Augustus wanted to generate interest in his book: "I have made curious additions to the M.S. of my book, 'Queen Moo'—that is now ready for publication. These additions will interest Indianists as well as Americanists, as I show who were the civilized inhabitants of Hindustan previous to the Aryan invasion of that country" (ALP 1894a). Those "curious additions" were Augustus's previously published theories that the ancient Maya diffused civilization through "Hindustan" to the Middle East.

While Saville found Augustus's theories out of touch with mainstream archaeology, as a fellow archaeologist he remained sympathetic to the Le Plongeons and attempted to have the museum purchase the 264 molds. But the attempt failed, probably due to the difficult economic times. Alice was then approached by Joseph Florimond, duc de Loubat, a New York philanthropist, who suggested that Alice should give a lecture at the museum. Loubat recommended that Morris K. Jesup, another wealthy New Yorker, along with his wife and friends, be invited to the lecture to raise money for the purchase.

The lecture was a great success, and "Prof. Putnam [Fredrick W. Putnam—then curator for the department of anthropology—later professor of American archaeology and ethnology at the Peabody Museum, Harvard University] rose and stated that my lecture was the best exposition of the subject he had lever listened to" (ADLP 1900a). But for Alice, the evening soon turned into a personal and financial disaster.

[N]o one attempted to start a subscription, and the only result of the lecture was a severe illness for me. This was induced by extreme depression through disappointment at seeing no action taken at the

close of the meeting, and also by a severe chill, because we walked under a drenching rain with umbrella from the Museum to the elevated railway, and I was at the time only convalescing from grippe [ADLP 1900a].

Records indicate that the molds eventually were stored at the American Museum of Natural History as a favor to the Le Plongeons, but they were never purchased.

In spite of her illness and depression, Alice fought back and published three articles in 1894. *Engineering Magazine* published "Early Architecture and Engineering in Peru" in April. The article gave an overview of the architecture of several geographical regions in pre-Columbian Peru and Bolivia and was illustrated with photographs taken by Augustus when he lived in Peru. Alice described the building methods employed from the coast to the highlands and included cities such as Tiahuanaco, Chímu Canchu, Sacahuaman, Ollantaytambo, Cuzco, Pachacamac, and features like Inca highways, rope bridges, and monolithic stone tombs.

She began with a summary of the civilizations of Peru, reiterating that the people of Peru, like the Maya of Yucatán, had suffered under Spanish colonization. "Peru, up to the time of the Spanish conquest, was densely populated, although the people rapidly diminished in numbers under the harsh treatment of the invaders. Many thousands perished in the mines, and these were only one portion of the hapless victims of the Christians" (ADLP 1894a:46).

Alice brought Augustus's name into the article with a few notes on the antiquity of the Maya, stating his conclusion that the Maya had built the ancient city of Tiahuanaco in Bolivia. She defended the proposal by observing, "Montesinos [Antonio de Montezinos] claimed hundreds of centuries for some of the Peruvian structures, but his work is not credited." She then added that in his book *Sacred Mysteries*, "Dr. Augustus Le Plongeon has explained that Tiahuanuco was probably the work of Mayas, and may therefore be coeval with the early civilization of Assyria" (ADLP 1894a:47).

In a footnote Alice added that more proof that the Maya were the source of world civilization could be read in Augustus's "forthcoming book." That book would be *Queen Móo and the Egyptian Sphinx*.

Modern researchers are leading to the belief that the points of resemblance between Egyptian and Peruvian architecture were due to the fact that the builders of the two were kindred peoples. Dr. Le Plongeon is proposing to show, in a forthcoming book, that in remote times the Mayas . . . were a colonizing and civilizing people, just as the English are to-day. . . . They reached both Peru and Egypt [ADLP 1894a:53].

In her article "Customs and Superstitions of the Mayas," Alice began, "Among all people, civilized or uncivilized, superstition exists, though the former are more careful to conceal their peculiar notions" (ADLP 1894b:661). She continued the theme by comparing some Maya beliefs to those found in Europe: "The reputation of the Alux (dwarfs) is not much better than that enjoyed by the 'little people' of Ireland and Scotland" (ADLP 1894b:661). The *Alux* "disturb tired laborers by shaking their hammocks, lash those who slumber too heavily, throw stones, and whistle" (ADLP 1894b:662). Alice explained that the phenomenon was a result of "vague knowledge that several centuries ago a race of remarkably small people did live in those parts [of Yucatán]" (ADLP 1894b:662). Yet today, they are reported from time to time by people working in the forests of Yucatán and Quintana Roo.

Alice then recounted stories of mythical beings said to be found in Yucatán, such as the gigantic *Iluahuapach* that injures travelers, the *Xtabai* "a wicked, deceitful phantom, said to haunt highways at night" (ADLP 1894b:664), and the *Balam* that "walks in the air and whistles as he goes" (ADLP 1894b:664). She described the ceremonial tunkul (drum), healers, herbalists, and what she called a "medicine man," who is called upon when the evil *Ez* (witch) causes illness.

In a popular article for the *Home Journal* called "Golden Flower," Alice wrote an account of the tragedy that befell the Taino people who lived on the island of Santo Domingo in the Caribbean when Columbus landed. In her article she explained the genocidal policy of the Spanish who enslaved, worked to death, and murdered hundreds of thousands of the Taino, including their beloved Queen Anacoana, or Golden Flower. Clearly angered by the destruction of the entire Taino nation, Alice ended by quoting the American writer Washington Irving: "The Europeans found Xaragus a perfect paradise, and by their vile passions filled it with horror and desolation" (ADLP 1894c:2).

On Friday afternoon, November 16, Alice spoke at the "Hotel St. George, Clark Street" in Brooklyn about "Social life in Eastern Mexico." A note in the *Brooklyn Daily Eagle* announced that she would introduce "native melodies and [show] . . . Maya costumes and lace work" (14 November 1894:7). Alice may have sung the lyrics to the "melodies" and accompanied herself on the guitar. Those "melodies" would later be included in her 1902 book, *Queen Móo's Talisman*.

For Alice, 1895 was a year of honors, writing, and fund-raising. She continued working with Sorosis and attended its twenty-seventh annual breakfast in March to honor its newly elected officers. The breakfast was given at the elegant Sherry's restaurant in New York City, which along with Delmonico's and the Hotel Savoy catered to an elite clientele. Alice was seated at the head table along with the newly reelected Sorosis president "Mrs. William Tod Helmuth." The serious business of officer installation was reported to have been dispensed with quickly, and after that "Mrs. Mary B. Spaulding gave two

songs to restore the gathering to a proper mood of holiday lightness" (NYT, 19 March 1895:8). The festivities continued with poetry, more songs, and a number of the members gave short but inspired speeches that rallied the women to continue their work in support of the right to vote. Alice fit in well, even if her finances were no match, and she was honored for her accomplishments by the politically powerful, educated, and well-organized women of Sorosis.

Her accomplishments in archaeology were noted again in an article in the August 10 issue of *Scientific American*. It began with a typically narrow nineteenth-century view of women, "In those sciences, such as archaeology, antiquarianism, genealogy, and heraldry, where the chief elements of success are infinite patience, conscientious study, a fine memory and broad general culture, women have always manifested signal ability" (SA 1895:83).

Alice was then mentioned, along with other women of "high talent and of genius, who have contributed vastly to the knowledge and culture of the age" (SA 1895:83). The article continued by placing Alice alongside the talented archaeologist Zelia Nuttall who had already carried out a number of important investigations in Mexico. "There now appears to be every reason for believing that we shall soon have an accurate knowledge of the ancient Mexican life. What with Mrs. Nuttall attacking the subject directly, and Mme. Le Plongeon indirectly through the Mayas and Yucatecanese" (SA 1895:83).

In 1895 Alice published two articles about the Maya, "The Yucatan Indians: Their Struggle for Independence—Their Manner of Living and Method of Warfare" and "Occultism Among the Mayas." "The Yucatan Indians," written in journalistic style as a one-page summary of the Caste War, was published in the *New York Evening Post* (ADLP 1895a). Similar to her previous writings about the war, the article was another attempt to explain its historical basis.

In "Occultism Among the Mayas," Alice wrote for the special readership of *The Metaphysical Magazine*. She began philosophically with a new romantic writing style,

> Glittering reptiles glide over fragments of sculptures more than half buried in the ground; the agile deer speeds like the wind, pursued by bounding leopard; the owl hoots dolefully; but no human voice there breaks in upon nature's harmonies, nor adds to her discords [ADLP 1895b:66].

And,

> We are possessed by an acute perception of the littleness of man and all his efforts to perpetuate his name. His work endures for a while, but he himself—his name—Oblivion.

We realize the folly of the mad passions that urge us to all manner of desires which, gratified or not, come to such a swift ending. . . . [T]he great First Cause alone continues to be throughout the eternal years. . . . With joyous freedom we revel in the thought of Eternity [ADLP 1895b:67].

Alice then stated, "There can be no doubt that the Mayas were, of old, much addicted to the study of occult forces" (ADLP 1895b:67). She presented evidence of what she thought were metaphysical practices represented in the mural paintings in the Upper Temple of the Jaguars at Chichén Itzá, such as shamanism, use of the "magic mirror" for divining, and the reading of animal entrails to foretell the future. She also proposed that the Maya believed in reincarnation and induced sleep with magnetism or hypnosis. Alice was right that shamanism was part of Maya religious practice, but her interpretation of the murals has not been borne out by archaeologists and art historians.

Psychic phenomena and metaphysical methods were well known to Alice, and she revealed that one of her sisters was diagnosed "in the consultation-room of a well-known London physician who employed a clairvoyant. . . . [A]nd by this means the life of one of my own sisters was saved" (ADLP 1895b:68). That physician may have been her uncle Jacob Dixon who was a strong proponent of Spiritualism and probably employed such methods.

While Alice continued to write historical and journalistic articles, she found that she enjoyed a more literary approach to self-expression and began to experiment more with poetry.

To Doctor Augustus Le Plongeon,

whose works inspired these pages, their author

dedicates them: not as a worthy offering, but as

a Small Token

of loving endeavor to gratify his oft expressed desire.

Brooklyn, N.Y. May 1902

ALICE DIXON LE PLONGEON, dedication from *Queen Móo's Talisman*

To my wife,

Alice D. Le Plongeon,

My constant companion during my explorations

of the

ruined cities of the Mayas,

who,

in order to obtain a glimpse of the history of their builders,

has exposed herself to many dangers,

suffered privations, sickness, hardship;

my faithful and indefatigable collaborator at home;

this work is

affectionately and respectfully dedicated.

AUGUSTUS LE PLONGEON, M.D.

Brooklyn, February 15, 1896

Dedication from *Queen Móo and the Egyptian Sphinx*

The Talisman

1895–1907

ALICE REMAINED CONVINCED THAT AUGUSTUS'S BOOK *QUEEN MÓO AND the Egyptian Sphinx* would "be recognized as one of the great works of the age" (ADLP 1888a:15) and that soon her "aim and desire . . . to live long enough to see his great work . . . published" (ADLP 1893a) would be fulfilled. Augustus had repeatedly edited the book, and it was now ready for publication, but by mid-1895 funds were still short.

Dr. Albert Shaw, founder and publisher of the widely circulated *Review of Reviews*, gave his readership a prepublication look at *Queen Móo and the Egyptian Sphinx*. The review was written anonymously and given the catchy titled, "A Fairy Tale of Central American Travel. How Cain and Abel Were Found in the Lost Atlantis." Shaw, the anonymous author, wrote that Augustus must have had

> a certain pleasurable feeling in publishing so ingenious and audacious a speculation . . . [that] America is the real cradle of the race, and that Europe, Asia, and Africa must humbly fall in behind their elder sister . . .
>
> [And that] . . . the ancient Egyptian mysteries were transported bodily from Yucatan, and the Greek alphabet is simply a Yucatanese version of the destruction of the lost Atlantis . . .
>
> . . . the sooner M. Le Plongeon gets the results of his astonishing research published . . . the better. At present the reader will half

suspect that he is being made the victim of a stupendous practical joke [*Review of Reviews* 1895].

The impact of the review is not known, but it probably stirred up a fair amount of public interest. One sad consequence is that his style would be imitated later by writers more interested in the denigration of Augustus's character than taking on the question of cultural links between Maya and Egyptian civilizations. Alice's writings were never subjected to Shaw's kind of personal attack, likely because of the gentlemanly rules of the nineteenth century, but she saw the effect it had on Augustus.

Alice sought to find funds for publication of the book through her connections with Sorosis and other New York women's organizations, and then decided to appeal directly to socialite Phoebe A. Hearst. Hearst was well known for her philanthropic work in education, and responded positively: "I will make the payments excepting that I cannot pay the sum indicated in Mr. Le Plongeon's letter. I am willing to pay $250 or $300 per month and will sign a guaranty if the publishers wish it" (Hearst 1895; underlines by Hearst). Payment was sufficient, the book was published in 1896, and Alice mailed Hearst copies so that she could distribute them to libraries.

Augustus's dedication pleased Hearst, and she wrote Alice, "I was much gratified at the dedication. I thought the Doctor did exactly right in thus acknowledging the brave part which you sustained in his researches. Hoping that the book may meet with continually increasing appreciation, I am, yours very sincerely, Phoebe A. Hearst" (Hearst 1896).

To earn the money to visit her father's grave in London, Alice spent long hours writing and editing articles. The Le Plongeons planned to leave in late fall 1896. Alice hoped that the money she saved would allow for a trip not only to London but also to Scotland and Paris. Most of Alice's friends had been to Paris, her brother Harry had studied art there, and from their stories Alice began to dream of a visit. For her, it was an exciting city of artists and writers, and for Augustus it would be a return to the city of his youth with the woman he loved.

Alice's informative and popular article on ceramics, "The Potter's Art among Native Americans," was published in the spring of 1896. In it, she reviewed the wide variety of ceramic styles and production techniques in Peru, Central America, and Yucatán and the role ceramics play in archaeological investigations. Alice wrote that in Panama, "the Chiriquians made a great variety of objects, including many shaped vessels, drums, whistles, rattles, stools, spindle whorls, needle cases, toys, and other small objects" (ADLP 1896b:646). She demonstrated her knowledge of the use of ceramics for archaeological analysis by pointing out that "the thousands of [ceramic] specimens

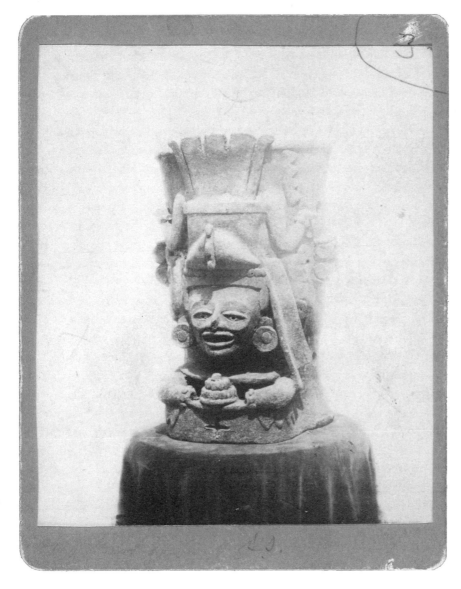

This Post Classic (after AD 900) Maya incense burner called the Bee God was found on the Island of Cozumel by Alice and Augustus. Today it is on display in the Regional Museum of Anthropology in Mérida. 1877. Photo by Alice and Augustus Le Plongeon. Research Library, The Getty Research Institute, Los Angeles, California (2004.M.18).

yet existing are an aid to archaeological studies, particularly when found intact and unblemished" (ADLP 1896b:646).

While she was in Mexico she had also seen forged antiquities, often very skillfully made, and wrote, "It is never easy to decide on the age of any piece, as this is not necessarily indicated by its appearance, least of all in places where, as in Mexico and Peru, cunning artificers manufacture antiquities" (ADLP 1896b:646). Most of the illustrations for the article were made from photos of Peruvian pieces taken by Augustus in the 1860s and of the famous Maya Bee God incense burner they had found on Cozumel Island.

Working to keep Augustus's name in the public eye, Alice stated again that he had deciphered Maya writing: "In the State of Oaxaca funeral urns have been found inscribed with Maya hieroglyphics which have been interpreted by Dr. Le Plongeon" (ADLP 1896b:654–55). This is an unusual claim because Mixtec or Zapotec funerary urns from that area are not known to be inscribed with Maya hieroglyphics.

For the *Metaphysical Magazine*, Alice wrote "Occultism Among the Tahitians" in which she described shamanistic religious practices, and then explained how the islands had come to be inhabited. She pointed out that some scholars "are of the opinion . . . that a vast continent once existed in the Pacific Ocean whose many islands are but the mountain tops of the submerged land" (ADLP 1896c:275). The long period of time it took to populate the islands by people migrating across the Pacific and the complex navigation skills that were required were unknown to anthropologists in the 1890s. So Alice wrote that after the breakup or submergence of one large continent in the Pacific, the original inhabitants became isolated on the many islands that remained. The idea of an Atlantis of the Pacific, often called Mu, did not originate with Alice, but it was made popular in the 1920s by James Churchward in his book *The Lost Continent of Mu* (1926).

Augustus sent complimentary copies of *Queen Móo and the Egyptian Sphinx* to important archaeologists hoping for positive reviews. He received a request for copies from Charles Bowditch of the Peabody Museum at Harvard University. In a letter that accompanied the payment for the books, Bowditch questioned Augustus about the condition of the Maya ruins in Yucatán. Augustus replied that he had not been to Yucatán for many years, but he did point out that "Many beautiful carvings which I had discovered and recovered carefully have been uncovered again and left ot [sic] the mercy of the first fool who may chance to see them, and take a fancy to destroy" (ALP 1896b).

Reacting defensively to those who had contradicted the conclusions in *Queen Móo*, Augustus wrote, "Yes! Mr. Bowditch I have been kept well informed of what has been going on in the Maya ruined cities since I have left—and I fear not contradiction on that point" (ALP 1896b).

Then, a review in *The Athenaeum* of London brought more bad news:

[I]t must at the outset be admitted that he [Augustus Le Plongeon] has spent both time and money in his attempt to increase our knowledge of prehistoric American and Egyptian antiquity, and for his honest intention in this respect our thanks are deservedly due.

This well-printed and well-illustrated book is extremely disappointing, for, although it professes to discuss and explain a subject of which but little is known, the reader finds himself at a very early stage

confronted by statements, made in all seriousness, which show that the author is more often led by imagination than by knowledge.

It is in vain that Assyriologists and Egyptologists rise up so early and so late take rest if self-asserting, pseudo-scientific works like Dr. Le Plongeon's are to issue from the press in all the glory of good printing and illustration to lead simple people astray [*The Athenaeum* 1896].

Augustus always saw himself as a scientist who laid out the evidence to prove or disprove a hypothesis; therefore the comment that his book was "pseudo-scientific" must have been devastating. Reviewers would in the end see that the evidence for the conclusions in *Queen Móo* had been carefully and accurately recorded, but the problem was with its interpretation.

Thanks to Hearst, the financial burden of publishing *Queen Móo* had been lifted, and Alice had finally saved enough money so that she and Augustus could travel to England, Scotland, and Europe. She was probably anxious to take a holiday to get her mind off the poor reception *Queen Móo* had received. The Le Plongeons left New York in the late fall of 1896, and during the first part of their trip, Alice spent time in London and Kent visiting her family. One afternoon was spent at her father's grave; then she and Augustus traveled to Glasgow for a holiday. After returning to London they took the train and ferry to Paris.

Alice knew their days in Paris would be an exciting adventure and kept copious notes. They left by train from Victoria Station, and while she was impressed by the improved rail system, she was distinctly put off by the shipboard class structure.

[W]e went in a very comfortable second class carriage. . . . The train was an express. Starting at 10 a.m. it stopped at no intermediate station. The woods & fields were as fresh & green as in early Spring. At midday we transferred to the boat. Only first class passengers were allowed on the upper deck, and on the lower there was no parlor. Below the second deck there was a room for ladies and another for gentlemen. Third class passengers could not enter those [ADLP 1896a:1].

Once they crossed the English Channel the ferry docked in Dieppe, France, and they then went by rail to Paris. After a very long day, they finally checked into "the Hotel Fete Cite du Retiro, Rue Boissy d'Anglas, at 8–30, host, hostess & very pretty daughter hasten to the entry, as they do to receive each newcomer, & also to see them depart" (ADLP 1896a:6).

The Le Plongeons immediately went to the Trocadero Museum to assess an exhibit about the ancient Maya. Alice found the casts made from Désiré

Charnay's molds of Maya iconography of poor quality, and she thought that the cast of the Chacmool was mislabeled "Rain God." "[The] casting had been carefully done, but the molds of Charnay were very poor to work from. . . . They have there a poor representation of Coh, a rough plaster cast and on it is a placard giving it the foolish name of <u>Rain God</u>" (ADLP 1896a:11; underline by Alice).[1]

Alice wrote about her visit to Paris twenty years after she had written her diary, but the style is similar, and she had not lost her critical outlook. She remained direct and outspoken, and even more certain of her convictions about women, politics, and religion. As Augustus took her to visit to his favorite haunts, Alice kept extensive notes that were used later to write her article "Paris."

Religion
On our way home we saw in the Rue Petit Champs a man selling a paper printed sheet headed Le fin du Monde and shouting "Prophecy of the celebrated clairvoyant Mmlle Coesdon, the end of the world." We are awaiting the fulfillment [ADLP 1896a:14].

[After visiting the Church of St. Coque] On our way out we were accosted by an aged female who said to Dr. Le Plongeon (of all people!) "Will you not light a small candle to the cross?" We would not [ADLP 1896a:15].

[Inside the Cathedral of Notre Dame] The interior of the edifice is gloomy, depressing and cold—in no respect to be compared with Canterbury Cathedral. Even the stained glass windows are not very beautiful [ADLP 1896a:36].

Politics
Over the portal of every church as well as other public edifice, three words are inscribed. <u>Liberty</u> <u>Equality</u> <u>Fraternity</u>
Meanwhile, Is any living being free?
 Does equality exist anywhere?
Will the President treat the pauper as a brother? [ADLP 1896a:22].

After an hour or two we went to the apartments occupied by Henry IV, Henry of Navarre, whose memory is dear to the people of France & who through the wickedness of the Jesuits was, like President Carnot, killed in his carriage.

But our thoughts rebound to the other extreme, the dire wretchedness of the luckless poor, very poor, and contemplating the many joys of a royal personage we wonder only that the people wallowed through so many centuries before lifting its hideous irresistible paw which, in the end, has made the Louvre its own,

an art school for all instead of a pleasure house for a few [ADLP 1896a:28–29].

Women
We have learned that there is in the Quatier Latin an American Girls Club, a boarding house for students or other unmarried ladies. . . . Two women can there have a room for about $15 a month, and pay for their meals separately, in that house or elsewhere. Such a hen coop is very convenient for staid lone females [ADLP 1896a:13–14].

Perhaps if my pet heroine had been less cruelly treated she would now be less venerated. There is an equestrian statue of Joan in the Rue Rivoli, always decorated with costly garlands of artificial flowers, preserved, in glass cases, from the rain [ADLP 1896a:26].

Paris is rich in fine sculpture ancient and modern, in many cases the human form is represented absolutely nude—In this respect the French approach the Greeks more nearly than the English or Americans. They have no false shame of the beauties of natural forms [ADLP 1896a:18].

How is that men, not compelled to wear skirts, like going about the streets in them, as all the priests do in Paris. The sight of so many petticoated monks is irritating—

A contrast is found in the women who don their bloomers to work the streets in stormy weather [ADLP 1896a:22–23].

Alice had put into practice her strong opinion about fashion and women's clothing during her years in Yucatán. In the 1870s she had decided to wear pants in the ruins, simply because it was more practical. From that experience she came to a number of other conclusions about the effects of women's attire on "consciousness of independence and ability." In her 1884 book manuscript, "Yucatan: Its Ancient Palaces and Modern Cities," she included her thoughts about the effect of "conventional feminine garb" on women's "health and strength" and suggested some changes.

Dr. Le Plongeon insisted upon my riding astride, contending that the side saddle was unsafe in the forest among thorny bushes and on very rough ground. Regarding the subject of masculine apparel, not to be again alluded to, a few remarks may not be out of place. Wide Afghan trousers, an ample blouse, and high boots—a requisite precaution against snakes—constituted an attire which enabled me to walk, run, or ride wherever duty called, and to climb dangerous places with confidence in my own movements. Furthermore, the freedom of action made me fear less, conferring a consciousness of independence

and ability to escape danger by active agility. I grew stronger and less nervous, although taxed by being always obliged to carry a rifle, ready loaded for inimical bipeds or quadrupeds. The open air life had something to do with the physical improvement, but the dress was the principal factor. When, on our return to civilization, it was necessary to again adopt conventional feminine garb, this produced a depressing effect which lasted some time. I understood then how a bird feels when caught and caged. The close fitting bodice and long skirts were for many days so trying that I found nothing in city life to compensate for the discomfort of petticoat and whalebone; and therefore came to the conclusion that woman's mode of dressing is prejudicial to health and strength, irritating to nerves and temper, and that it undoubtedly makes her timid in action [ADLP 1884b:218].

The Le Plongeons returned to London, and within a few days departed in mid-November aboard the transatlantic passenger-freight vessel *Massachusetts* for New York. They arrived at Ellis Island on November 27 accompanied by the important writer, artist, and publisher Elbert Hubbard (1856–1915).[2] Traveling with them across the Atlantic, he had been stimulated by Alice's shipboard lecture and discussions with Augustus about *Queen Móo and the Egyptian Sphinx*. Within a few months he wrote a lengthy review for *The Arena* magazine.

Hubbard started by putting Shaw's review in perspective. Not amused by a joke made at another's expense, he pointed out that the review was a minor, self-serving way to increase the circulation of *Review of Reviews*: "That America should be the first home of man and birthplace of civilization was considered by some as very funny, by others the statement was taken as heresy; but the result was that Dr. Shaw's little mention of Dr. Le Plongeon's forthcoming book had a wide circulation" (Hubbard 1897:342–43). In his review, Hubbard gave a rare firsthand look at seventy-one-year-old Augustus:

It has been my good fortune to read the book, and better still to read it with the learned author at my elbow, ready to answer all questions and meet all objections. . . . Dr. Le Plongeon may be sixty, seventy, or ninety years of age. He is becoming bald, has a long snowy, patriarchal beard, a bright blue eye, and a beautiful brick-dust complexion [Hubbard 1897:343].

For Hubbard, Alice, possessed that "excellent thing in woman":

For twenty-five years Dr. Le Plongeon has made a continuous study of archaeology in America. In all his work and all his travel, his wife has

been his faithful coadjutor, collaborator, and companion. Madame Le Plongeon is a rare woman; she is possessed of that "excellent thing in woman," and when she gave us a little lecture on board ship it was voted a great treat [Hubbard 1897:343].

In the balance of the review, Hubbard, who had little knowledge of archaeology, simply summarized *Queen Móo and the Egyptian Sphinx*, and so avoided any analysis of the conclusions presented in the book. "[T]he piling up of proof, intricate, complex, requiring a knowledge of six languages to be comprehended, is of a nature that places the book quite beyond the range of a magazine review" (Hubbard 1897:343). Hubbard ended his review on a prophetic note, "Anyway, the work is intensely interesting, even to a layman, and in its bold statements is sure to awaken into life a deal of dozing thought, and some right lively opposition as well" (Hubbard 1897:345).

In May, Alice published her lighthearted article "Our Feathered Foundling," the first of three articles about two sparrows that lived with Alice and Augustus in their residence at Sidney Place. It was published in the outdoor magazine *Forest and Stream*, and Alice wrote about the birds' antics in a style similar to her diary story about Chack, the little bird she befriended in Yucatán (ADLP 1896e).

In early December she began preparations to read a paper before the Albany Institute (now the Albany Institute of History and Art) in Albany, New York. The paper was presented on December 22 and printed by the Le Plongeons with the title, "The Monuments of Mayach and Their Historical Teachings" (ADLP 1896d). In the Institute's minutes of the meeting, the secretary noted that after the "regular" meeting in the study room of the academy, "there was a large attendance . . . to listen to the lecture of Mrs. Alice Le Plongeon, illustrated by Dr. Augustus Le Plongeon's lantern slides" (Albany Institute of History and Art 1896). Alice had actually made the slides, but continued to bolster Augustus whenever she could.

The lecture included most of the findings described in *Queen Móo*, and Augustus had accompanied Alice to Albany to be on hand should the audience have questions for him. The minutes of the institute stated that she presented "the important discoveries made by them [the Le Plongeons] in Yucatan in the ruins of Maya edifices and in the translation by Dr. Le Plongeon of the inscriptions found thereon" (Albany Institute of History and Art 1896).

She hoped that her popularity as a lecturer might convince the educated members of the institute of their conclusions. To emphasize her irritation at the lack of response to Augustus's book, she told her audience: "his fellow workers in the field are tardy in acknowledging what he has accomplished and the importance of the alphabet which he has discovered, and by which

all scholars may learn to read the Maya inscriptions if they apply themselves to it" (ADLP 1896d:11).

Alice again explained their conclusion that the source of world civilization was in the Americas.

> There is a vast amount of evidence tending to show that a few thousand years ago civilized people lived in the tropical parts of America, and that from among them, colonists went out in various directions, introducing their language, traditions, customs and religion, traces of the same being now found in many parts of the world. Dr. Le Plongeon's discoveries have forced him to the conclusion that civilization on this American continent antedated that of the oldest Eastern countries [ADLP 1896d:28].

After the lecture, the members of the institute gave "a cordial vote of thanks to Dr. and Mrs. Le Plongeon," but it is uncertain if she convinced many in the audience (Albany Institute of History and Art 1896).

By 1900 Alice had published seven articles on quite divergent subjects. Two were, again, about her adopted sparrows Loulou and Dick, one about the celebration of Christmas in Yucatán, another a romantic story about a Yucatecan girl, Alice's thoughts about laws and government, an article on tropical ecology inspired by her years in Yucatán, and a short piece about ancient China.

She continued to edit her book manuscript, "Yucatan: Its Ancient Palaces and Modern Cities. Life and Customs of the Aborigines," and added a chapter on the Caste War, titled "Epitome of the War of Races in Yucatán. The Maya Indians." Basically a social history of the Caste War, the chapter did include a summary history of Maya resistance to colonial rule from the time of the conquest to the late nineteenth century.

Alice modestly stated the chapter was "a brief outline of the principal facts, gathered from the works of native historians, particularly that of Sr. Serapio Baqueiro, published in Merida in 1879. For our knowledge of events since that year, we are indebted to persons who had had individual experience among the Indians, and also our personal observation" (ADLP 1884b:506).

Clearly sympathetic with the Maya, Alice ended her manuscript as follows:

> There still exists between the Indian [Maya] and his adversary a deep chasm—thousands of victims flung therein are the fuel which feeds their long cherished hatred; if the Mexican leaves the Indian undisturbed the Mazeuals will probably remain on their own ground,

for not one of those who started the struggle for independence now survives [ADLP 1884b:535].

And later, in pencil at the bottom of the last page, she wrote: "Overcome by Mex. Federals May 5, 1901. Chan Santa Cruz taken" (ADLP 1884b:535).

Her stories about her little sparrow friends for *Forest and Stream* seem to have captured the imagination of her readers, and by 1900 she had published two more articles. The 1898 article had the charming title "Muffins and Ragamuffuns" and began, "They are quite well those same two sparrows, and now the summer is dead and buried beneath autumn leaves, and wintry snowflakes, it amuses us to recall incidents connected with a big three-storey cage" (ADLP 1898a:68).

Alice delighted in describing how the birds lived freely in their house, their courting habits, and how Loulou finally succeeded in laying three eggs, only to have Dick knock them out of the nest. Loulou died two years later. Alice's last article in 1900, "That Famous Foundling," is an obituary for her little friend.

It must be confessed that we had learned to love this Loulou exceedingly, for her many little graces, her sweet voice, and her intelligent response to every attention paid to her; all visitors declared her to be a very uncommon sparrow. Therefore when she was dead there was general lamentation [ADLP 1900c:5].

Alice honored Loulou with a poem, but it was really written for Dick who she knew was also in mourning.

Forget! Forget! So brief thy day—
Fill not the hour with plaintive woe;
Thy mate was just a singing ray
Of God's own light—'tis all we know.

How dear little friend of somber wing,
The unshed tears are in thine eyes;
No more for thee will Loulou sing
Beneath these azure summer skies.

Thy wings appeal with tremulous grief;
Thy pleading cry by us is heard;
Would that we might bring sweet relief!
With thee we mourn our Loulou bird.
(ADLP 1900c:5)

Alice continued to write articles such as "Christmas Eve in Yucatan" from her notes taken years before. Published in the *New York Evening Post* on Christmas Eve 1897, the short article gave readers a lively and detailed description of how she and Augustus spent a Christmas Eve in the village of Espita.

> When we arrived at our destination there was a great crowd before the house, which looked as if it might have been imported from old Spain, for it was a large one storey residence, with a great doorway, whose green-painted wooden doors stood wide open. It was noticeable that the crowd which surged around it was gentle and kindly disposed, and that it consisted of the poorest townspeople. They all seemed to get much pleasure from looking at the festivities within, where all was brightly lighted with lamps and candles [ADLP 1897:11].

But in the midst of the festivities, the alarm sounded, warning of a Chan Santa Cruz Maya attack. "This time, luckily for us, the rumor proved to be a false alarm, but on previous occasions Indians really had invaded and partly plundered the town" (ADLP 1897:11).

Because Alice had always admired the young women of Yucatán, she decided to write two light romances, "A Maiden of Yucatan" (ca. 1900) and a similar story, "A Yucatecan Girl" (1901c). Other than a few changed names, the stories are almost identical. The plots revolve around family obstacles faced by rich young women seeking permission to marry working class men. In each case, the father is opposed to the marriage, but as one might expect, the girls, by their unrelenting determination, convince their fathers of the match, and love, in the end, wins.

The stories required a change in her writing style—a challenge for Alice. In the first story, "A Maiden of Yucatan," her stiff descriptive style remained largely intact.

> A very pronounced brunette, perhaps having a slight tinge of Indian blood; this was particularly noticeable in her exceedingly dark eyes, and obstinate straightness of her luxuriant black locks [ADLP ca. 1900].

A year later for "A Yucatecan Girl" she was more successful:

> Her soft, dark eyes and the absence of any wave in her luxuriant black hair suggested a trace of Maya blood; but Lolita had the grace of an Andalusian and an attractive piquancy all her own [ADLP 1901c:14].

Returning to a serious vein, Alice's article "A Thought on Government," in *The Woman's Tribune*, is a short but intense historical overview of the development of government and law, economics, and how the societal roles of men and women evolved over millennia. The article summarizes the evolution of society, then discusses economics and the role of women in society. In 1899 Marxist economics was a much-discussed topic; Alice's sympathetic comments on labor and capital indicate her familiarity with the literature: "[T]he united industry of the masses created wealth, not for themselves, but for the powerful few. . . . [T]yrant and slave, conqueror and conquered, were the two great divisions of humanity. At present the struggle is between capital and labor." And, "The masses are not yet sufficiently instructed to know what is best for them." The tone of the article ends on a note of hope that is founded on Alice's strong belief in the women of America: "Will the wisdom and goodness of its remarkable and noble women help to make this Republic more enduring and more perfect than all the nations that have preceded it?" (ADLP 1899:4).

Alice then took a different direction in her writing. She was always fascinated by the tropical plants and animals of Yucatán and showed little fear of even the dangerous ones. She came very close to being struck by a rattlesnake at Chichén Itzá in 1875. In another incident, she proudly reported, "[the] Dr returned with a rattlesnake 6 ft long, and 11 years old, if each rattle means one year. The men had killed it, Dr chopped off the head. I held it while Dr skinned it" (ADLP 1873–76:147). Drawing upon her many observations, she gave the rattlesnake a favorable review in her article, "Creatures of the Tropics," for the *New York Evening Post*.

> The rattlesnake, for instance, is not half as dreadful as some people imagine; he is, in fact, good-natured, and he also gives notice of his presence. Unless cornered or fearful of attack, the rattler will attend strictly to its own affairs, particularly if in search of a tender rabbit, or hurrying to its hole-in-the-earth home to tell its adventures to its bosom friend, armadillo [ADLP 1898b].

Her unpublished article "Hawaii Long Ago," written around 1899, was probably inspired by Augustus's visit there in 1854. It began with a physical description of the islands' geography and a general overview of what was known about the life of the Hawaiians prior to European contact. She discussed Captain Cook's explorations and death, and in an interesting twist based on interviews made by Augustus, she wrote,

> It is not true that his [Captain Cook's] flesh was eaten; all was incinerated except the heart and other internal organs which, after being extracted, were stolen by hungry children who, not knowing that

they were part of a human body, ate them. The children were named Kupa, Mohoolc, and Kaiwikokoole. Sixty years ago the three were still living, and in 1854 Dr Le Plongeon, while at Hawaii, spoke with one of them, then a very old man [ADLP ca. 1899].

Sales of Augustus's book, *Queen Móo and the Egyptian Sphinx*, had failed to bring in much additional income, so Alice continued "her morning lectures on 'Famous Ruins of Yucatan'" that helped to cover some of their expenses (BDE, 2 April 1899:21). In the announcement about the lecture series' continuance, the author of the item, Betsey Todd, attached Augustus's long-discarded aristocratic family title to Alice: "Alice D Le Plongeon—Lady Coqueville—" (BDE, 2 April 1899:21). Todd would have had no knowledge of the title; perhaps Alice encouraged her to use it in the hope that it might help to increase attendance at her lectures.

There is little doubt that Augustus opposed the use of the aristocratic name, but in the face of a desperate financial situation, Alice may have gone against his wishes. The title was not mentioned again until 1909, after Augustus's death. Alice wrote, "[T]he title of comte [*sic*] de Coqueville is believed to have belonged to Dr. Le Plongeon . . . who never used any title, nor did his father before him" (ADLP 1909:276). "The name Le Plongeon had been adopted during the Reign of Terror, but he was the Count de Coqueville" (*Philadelphia Record*, 17 January 1909).

The final lecture in the "The Famous Ruins of Yucatan" series was scheduled for February 1 "at 11 o'clock by Mme. Alice D. Le Plongeon at the residence of Mrs. Egbert Guernsey, The Madrid, 180 Central Park South, Manhattan. The subject will be 'The downfall of Maya Empire'" (BDE, 31 January 1900:9). The importance of the lecture is that Alice planned to personally read about "a subject which, it is said, has not heretofore been touched upon in verse, and entitled 'Queen Moo's Talisman'" (BDE, 31 January 1900:9). *Queen Móo's Talisman* had been completed, and she had decided to give a kind of "sneak preview" to generate interest in the book. She planned to use any prepublication orders that might result from her reading to defray the cost of printing.

Alice published three more articles in 1900, but the income did little to alleviate their financial problems. She wrote Phoebe Hearst, "While the book [*Sacred Mysteries*] was in the market we managed, with very strict economy, to live from its proceeds." And although his *Queen Móo* was selling, it was becoming clearer to Augustus that its conclusions were finding almost no acceptance.

At this same time Augustus began to suffer from serious heart problems that were probably made worse by the stress associated with the rejection of more than thirty years of his research. Alice wrote Hearst that he suffered from "<u>angina pectoris</u> which causes him acute pain. . . . [H]is condition is

undoubtedly the result of prolonged disappointment and anxiety" (ADLP 1900a; underline by Alice). She wrote again the following day and explained that Augustus's angina could "affect his heart . . . and coupled with all this we are <u>entirely without means</u>" (ADLP 1900b; underline by Alice).

To make matters more difficult for Alice, Augustus was advised by his doctors to avoid most physical activities, even travel around the city. His long, slow decline had begun and within only a few years he required continual care. Alice was now forty-nine years old and at the peak of her writing and lecturing skills, but she soon had to cancel some of her many speaking engagements and reduce the time she spent writing.

Two months later, in a letter of "vital importance" to Morris K. Jesup, president of the American Museum of Natural History, Alice asked Jesup if he would purchase their copies of the "fresco paintings from Chichen Itza, twenty tableaux, copied by Dr. Le Plongeon in 1875" (ADLP 1900d). She began by explaining to Jesup how she and Augustus were "situated,"

> [Y]ou know what we have sacrificed to our work in archaeology, and how we have suffered in consequence. Early in March, Dr. Le Plongeon was attacked with angina pectoris caused by prolonged anxiety and many disappointments. Several times he was at death's door. I alone nursed him, and had to cancel all my engagements, and spend everything we possessed. My patient is convalescing, but he needs change of scene and air, and above all peace of mind [ADLP 1900d].

Alice, in an emotional appeal, asked Jesup to "have [copies of the murals] bought by the <u>Museum</u>, or personally donate them, you will, besides making a valuable addition to the Ethnological Department, be helping me to save a life which is more value to me than all the world. Begging you not to let me appeal in vain for one who is as noble as he is learned" (ADLP 1900d; underline by Alice). The Le Plongeons asked twenty-five hundred dollars for the "twenty tableaux," but, unfortunately, the acquisition was never made.

Yet, Alice managed to publish "A Maiden of Yucatan," and "That Famous Foundling," and then in September 1900 her short piece on China called, "Splendors of Kinsay: A Chinese Metropolis of the Middle Ages" was published by the *Commercial Advertiser* in New York City (ADLP 1900e).

Alice wrote several short poems including "A Battle Prayer" that is dated February 1900.

> God of battles, nerve our arm;
> Lend thy aid to vanquish wrong;
> Let no peril us alarm—
> May the Right be ever strong!

God of mercy, touch our heart
In the day of victory won;
Valor now hath played its part—
Fallen foe and we are one.

God of wisdom, lend Thy Light;
We would make our brother free—
Not upon his land cast blight—
Friend, ally, and helper be.
(ADLP 1900f)

In June 1900 Alice received another recognition for her many years of work in archaeology. An article titled "Women in Science," published in the *New York Tribune*, was written after the annual meeting of the American Association for the Advancement of Science and focused on the scientific accomplishments of a number of women, including archaeologist Zelia Nuttall. The article stated that Nuttall thought "a promising field is open to women in archaeology, and [she] cites a few whose success is unquestionable as proofs of her assertion. . . . Mrs. Alice Le Plongeon, too, has done some good work in the study of Mexican antiquities, Mrs. Nuttall's own chosen field" (New York Tribune, 30 June 1900:5).

Alice's writing in 1901 returned to the subject of Yucatán. When she read that the capital of the Chan Santa Cruz Maya had been overwhelmed by Mexican troops, she was inspired to write for the *Commercial Advertiser* "Chan Santa Cruz's fall." Alice knew the Yucatecan generals who fought against the Chan Santa Cruz Maya, and she had even met some of the Maya leaders in Belize. "While in British Honduras the writer was invited by chiefs of Chan Santa Cruz to visit that place, and these chiefs, as well as several persons who had visited the territory to trade with the Indians, talked freely about the settlement and its inhabitants" (ADLP 1901a:1). She immediately noted the difference between the independent Chan Santa Cruz Maya and the Maya who worked for the haciendas.

We were impressed by the striking difference between the bearing of these people [Chan Santa Cruz] and that of the Indians working for the planters of Yucatan. The latter have a downcast appearance, and in their eyes is a look of hesitation, as if they doubted their right to assert themselves under any circumstances. But the men of Chan Santa Cruz are self-possessed and unembarrassed at all times, and their dark eyes steadily encounter the most searching gaze.

Such, then are the people who have just been overcome by the Mexican federals [ADLP 1901a:1].

Alice's second article for the *Commercial Advertiser*, "Mexico's Mayan War," was published about a month after "Chan Santa Cruz's Fall," and while it covered much the same historical material, it highlighted General Felipe Yama of the Chan Santa Cruz Maya. Alice stated that Yama attempted to convince his lieutenants "that it was quite useless to continue opposing the forces commanded by Sr. Gen. D. Ignacio A. Bravo" (ADLP 1901b:1). The other leaders considered any peace overtures to the Mexican government treason, and he was assassinated. In the end, the capital of the Chan Santa Cruz Maya was finally overwhelmed by an enormous Mexican army ordered in by president Porfirio Díaz.

In a last statement to honor the fallen Chan Santa Cruz Maya, Alice wrote,

> While the great northern American nation is rapidly advancing along every line that tends toward supremacy, an ancient American nation is in its death throes; . . . these people were admittedly the most civilized found by the Spaniards when they invaded the continent, and also the most valiant, as was manifested in their heroic resistance during a quarter of a century [ADLP 1901b:1].

Enough time had passed; no longer put off by the Brooklyn Institute's lack of interest in sponsoring a lecture by Augustus, Alice made arrangements for a lecture of her own. The *Brooklyn Daily Eagle* noted in September 1901 that "Three Brooklynites are to lecture before the department of archaeology. They are Mme. Alice Le Plongeon, on 'The ancient monuments of Yucatan and the civilizations they represent'" (30 September 1901a:6). In all, Alice and six university professors spoke at the institute that fall on subjects ranging from the Pacific Islands and ancient Nippur to "primitive art" and Greek vases.

Alice spoke on December 23, and the lecture was delivered at the Institute's Art Gallery "to an audience of friends, who evinced hearty enjoyment in all she told of the little known portion of America." She received another compliment for her voice and that she spoke extemporaneously: "She had no notes and spoke in a clear, musical voice that was easily heard in the large hall" (BDE, 24 December 1901b:13).

In early March 1902, she delivered a lecture titled "Some Famous Ruins of Yucatan" at "Public School No. 60 corner of Fourth Avenue and Twentieth Street" in Brooklyn (BDE, 7 March 1902a:5). While the lecture was primarily for adults, it is likely that a number of school children attended.

Alice's epic poem *Queen Móo's Talisman* still lacked enough prepublication subscriptions to pay for the printing. Therefore she decided to sell some of the Maya artifacts they had brought back from Yucatán. On March 25, 1902,

she wrote Frederick Putnam at the American Museum of Natural History. She offered the museum two pieces of sculpture from the east façade of the Governor's Palace at Uxmal, plus a "bear's head," a flint spear point and the "stone head of a mace" from Cozumel, and two wooden sapote "beams," one from the Akabdzib at Chichén Itzá with a "sculptured ornament" and the other from "the 'Castillo' in Merida" (ADLP 1902a).

She wrote Putnam again the next day to offer the tracings made of the murals in the Upper Temple of the Jaguars. Alice had tried to sell them two years before and now pleaded with Putnam that selling them "will thus be doing me a great personal service, giving Dr. Le Plongeon the gratification of publishing my narrative poem [*Queen Móo's Talisman*] of the cause of the fall of the old Maya empire" (ADLP 1902b). In a memorandum to museum president Jesup, Putnam wrote, "The Le Plongeons are in straitened circumstances and I know how hard it is for them to offer to dispose of these objects which they brought from Yucatan many years ago" (Putnam 1902). The museum did not have funds, but funding ultimately came from two wealthy New Yorkers, and while the artifacts were purchased, the tracings were not.

Queen Móo's Talisman, published in May 1902, was a beautifully printed book. Alice dedicated it to Augustus, "whose works inspired these pages, . . . not as a worthy offering, but as a small token of loving endeavor to gratify his oft expressed desire" (ADLP 1902c:iii). The poem was written for Augustus, and at first she had no intention of "allowing the verses to go into print; they were penned only for the one whom they are dedicated" (ADLP 1902c:ix).

In the introduction she summarized the conclusions she and Augustus had come to about the diffusion of culture from the Maya to Egypt. She stated again that Augustus had found "a clue to the hieroglyphic signs covering the walls of ancient palaces and temples" (ADLP 1902c:xiii), and this "convinced Dr. Le Plongeon that he had succeeded in tracing certain incidents which occurred in the last family of the CAN family, and which led to its downfall" (ADLP 1902c:xiii–xiv).

Then Alice stated for the first time that she and Augustus were reincarnated from Queen Móo and Prince Coh, and that the power of Queen Móo's jade talisman was behind it all.

> For Cay had affirmed its [the talisman's] force could bind
> Two souls thro' time, if she the way would find.
> Coh gone, could Móo rejoice on sovereign throne?
> Ah no? far rather than a Queen alone,
> A fugitive she'd be in boundless space,
> Assured she would at last behold *his* face.
> (ADLP 1902c:54)

Móo chose love, and as prophesized, as soon as she placed the talisman in Prince Coh's funerary urn she was driven from Yucatán by her brother Aac. Then, centuries after the deaths of Móo and Coh, Coh was reincarnated as Augustus and Queen Móo as his sister Natalie. Natalie died as a baby, and Alice believed that Móo's spirit then migrated to her at her birth.

> After many centuries have passed away, in a land far distant from that of the Mayas, Death snatches a baby girl from a loving brother. He stays on earth; his lost sister again takes mortal form in another family [Alice Dixon]; they [Alice and Augustus] meet and are united. . . . Together they journey to the land of the Mayas, where, in the tomb of Coh, they find his heart and Móo's talisman, in the urn in which she had deposited it many centuries before [ADLP 1902c:xxiii].

It all began for Alice and Augustus when unseen forces brought them together in London.

> A girl of lightsome heart [Alice]
> Was told, "He comes! With him thou must depart." [Words of the psychic, Hearn]
> To find her in the East, he sailed from the West,
> Responsive to the power of soul's request.
> Resistless forces bade her to fulfill
> The part that she, by her own human will
> Had planned upon a day, when swayed by love
> She would her consort find, on earth, above,
> Wherever might he dwell there too would she:
> Attachments deep can bind like stern decree
> [ADLP 1902c:70].

For Alice, the talisman had additional powers. It "brings visions of long ago, voices of the Past" (ADLP 1902c:xxiii). She clearly believed that certain stones have the power to retain information about the people who wear them, and individuals with psychic powers are able access that knowledge. This practice is called psychometry, and Alice was convinced that she could learn about the past through the talisman.

> Again the Talisman, now set in gold,
> Was worn by woman as in days of old.
> She asked herself, "Doth mystery lurk herein?
> Can we from this some hidden message win? . . ."

And,

> 'Twas thus the dreamer meditating thought,
> Till by her strong desire some rays were caught.
> A mystic clue this stone of magic, yea,
> To scenes of long ago—but find the way.
> Like other million forms, stone hath a soul,
> A spark divine of God the Perfect Whole.
> Then heard the woman toying with the stone:
> "With power was this endowed for thee alone"
> [ADLP 1902c:77–78].

A section of the book was dedicated to the music and lyrics she had collected in Yucatán. Some of the music was later published separately as sheet music, and Alice had printed on the cover of each sheet:

Maya Melodies of Yucatan. Taken from the Indian airs. By Alice Dixon Le Plongeon. With Musical Settings by Susanne Vaughn Reed Lawton. For harp piano or organ and violin (AD LIB.). Introducing weird effects of native music. Adapted to stanzas In "Queen Móo's Talisman" A poem on The Prehistoric Mayas by Alice Dixon Le Plongeon. I. The Lover's Song. Accompaniment by Ida Simmons. II. Invocation to the Sun. III. He and She. IV. The Dancer's Song. V. Funeral Chant [ADLP 1903].

In July, *Queen Móo's Talisman* received a lengthy notice in the "New Books" section of the *Brooklyn Daily Eagle*. The anonymous author stated that Alice and Augustus had been reincarnated from Queen Móo and Prince Coh, and that Alice's poem was about "reincarnation of the human soul, [and] its perseverance in seeking union with the kindred soul loved in a previous era of existence" (5 July 1902b:8). The writer's only critical comment was that "Mrs. Le Plongeon has sought to make the poem interpretive of Mayan ideas and beliefs, and it is possible has idealized them somewhat" (5 July 1902b:8).

The author explained further that Alice had

composed a narrative poem, taking for her subject certain legends or histories relative to the Maya people and their rulers, which have been deciphered from the hieroglyphics. . . . It is believed that Queen Moo was a genuine personage, and that the talisman discovered really belonged to her, and was used in connection with the religious rites of the Maya people [BDE, 5 July 1902b:8].

Alice's poetic style was characterized as "somewhat like Scott's 'Lady of the Lake,' and at times is broken by reproductions of Maya sacred songs. The author's effort is to preserve in another tongue, so far as possible, the spirit and sentiment of the ancient Maya hymn" (BDE, 5 July 1902b:8). The article concluded with compliments to the publisher "who has given the book a handsome dress, printing it on heavy plate paper." And that "An excellent portrait of Mrs. Le Plongeon forms the frontispiece to the book" (BDE, 5 July 1902b:8).

In August 1902, Joel Benton, well known in the nineteenth century as a poet and essayist, reviewed *Queen Móo's Talisman* for the *New York Times*. More of a summary than a critique, Benton's review was favorable in a neutral style.

> We have in 'Queen Moo's Talisman' a poetized story of Maya incident and superstition, to which the author and her husband have given years of study. The particular tale here presented deals with royal characters, and introduces not only the talisman referred to in its title . . . but also the doctrine of reincarnation. . . . The author, who has been a diligent co-worker with her husband, the Central American Archaeologist, presents in a well written and condensed introduction of their joint belief in a unity of origin and tradition between the Mayas and the Hindus and Egyptians. Numerous similarities that testify to this conclusion are cited . . . and are set forth with considerable skill and with persuasive effect . . . and, in addition . . . with music, of the words of several Maya songs [Benton 1902].

Soon after the publication of *Queen Móo's Talisman*, William J. McGee, then in charge of the Bureau of American Ethnology for the Smithsonian Institution, requested a copy. In a note included with the book, Augustus wrote to McGee: "'Queen Móo's Talisman' . . . forms a supplement to my own work 'Queen Moo and the Egyptian Sphinx.' The narrative she wrote in verse for sake of brevity" (ALP 1902a).

Augustus had included a flyer in the letter to promote his new book "Immigrations to America," and McGee asked that a copy be sent to him. Augustus quickly wrote back that it had not yet been published, and complained, "My work 'Immigrations to America' is still in M.S. No publisher is willing to undertake the publication of it, <u>in the way I want</u>, with numerous illustrations necessary to prove the facts mentioned in the text. This is composed of 700 closely written pages" (ALP 1902b; underline by Augustus). The manuscript was never published and has not been located. Publishing such a book was probably wishful thinking on the part of Augustus, who knew his years were limited and hoped to write just one more book that would

demolish any criticism of the conclusions in *Queen Móo and the Egyptian Sphinx*. But, he never published again.

McGee had also asked for a copy of Alice's book *Here and There in Yucatan*, but Augustus presumptuously pointed out, "This small volume contains nothing scientific. I do not know if it be of interest to the Bureau of Ethnology. It is composed of magazine and newspaper articles on customs and beliefs of the natives of Yucatán, written in a very light style" (ALP 1902b). Not put off by Augustus's comment about "light style," McGee again requested a copy because he knew that Alice often included the Maya point of view in her writings. McGee was considered a progressive, and some historians contend that he was eventually forced out of the Smithsonian because he took the side of Native Americans.

Around this same time Alice participated in a séance and "witnessed remarkable materializations of hands through the mediumship of Hatfield Pettibone" (ADLP 1908). She was so convinced by Pettibone's performance that she was confident the "laws governing psychic phenomena" would soon be explained by science.

> In the presence of about 30 persons and while my own hand rested on Pettibone's head, two of the many materialized hands that were visible in a strong light, gave a beautiful demonstration of power by holding my hand, the left one, and out of its palm producing a piece of pencil two or three inches long, the color of my own flesh. The hand that had produced it then held it quite steady before my eyes while I gazed in wonderment. It was then by the same hand taken into the cabinet and used to write upon a slate which was given to me. The pencil was then brought back to my hand, shorter, and worked back into my hand where it disappeared. . . . The question is, could all the scientists upon earth, uniting their efforts, produce at a moment's notice a full-sized, strong, in fact, warm, living hand, out of the primitive gases? Assuredly not. Their knowledge has not yet attained to the point of being creative to this extent. But the disembodied intelligences certainly know this same creative law.
>
> At this date I am inclined to believe that even before I pass from this state of life it will be my part to see some great developments in the laws governing psychic phenomena [ADLP 1908].

Alice does not explain why she consulted Pettibone, but she may have wanted to contact her father and her deceased sisters (Jessie, Nellie, and Agnes Clara) in the hope that they might comfort her, because Augustus was now in his late seventies and required almost constant care. Alice's young friend Maude Blackwell helped as much as she could, but Alice could not afford

to pay her or hire a nurse. Seeing the once strong and vigorous Augustus no longer able to care for himself was especially difficult for Alice.

Yet Alice continued to work with professional women in New York. The *Brooklyn Daily Eagle* ran a column on November 29, 1902, under the heading, "Club Woman's Plans for the coming Week." The Professional Woman's League announced a "Literary Day" would be held "on Monday . . . at the Society's home on West Forty-fifth street, Manhattan. . . . Mme. Alice D. Le Plongeon will speak of Mexico and her literature" (29 November 1902c:10). In addition to Alice, a number of other women read from their writings, and the day was topped off with songs by Margaret McCalmont and Benjamin Chase and a recital by Ida S. Hilton.

Then in 1904 another negative review of *Queen Móo and the Egyptian Sphinx* was published by Charles Staniland Wake in the influential *American Antiquarian and Oriental Journal*.

Wake first asked, "Why, then, have they practically agreed to taboo the work he has done? . . . 'the so-called learned men of our day,' who he says, 'are the first to oppose new ideas and the bearers of these'" (Wake 1904:361).

Wake replied to his rhetorical question,

We sympathize with Dr. Le Plongeon in this remark, but, then, we must add, that the new ideas, if true, will gradually force acceptance. . . . Perhaps the time for this has not yet arrived, but surely, if it is to be so, we ought to see signs of its approach. Dr. Le Plongeon's ideas have been before the public ever since the publication of his 'Sacred Mysteries Among the Mayas and Quiches' [published in 1886][Wake 1904:361].

Wake was generous because Augustus actually had begun publishing on the diffusion of Maya culture even before *Sacred Mysteries*. Wake continued by suggesting that the "very boldness" of Augustus's conclusions "may have prejudiced learned men against them." Searching further for an answer about the discovery of the "key" to the decipherment of Maya writing, he lamented,

And yet surely there must be some specialist sufficiently open minded to investigate the truth of the statement [made by Augustus that] . . . "anyone who can read hieratic Egyptian inscriptions will have no difficulty in translating said legend by the aid of a Maya dictionary." If no such person has done so, we think it must be because there is something radically wrong in the author's explanation of the facts [Wake 1904:361].

With regard to Maya colonization, Wake then pointed out that the

Maya could not, with "a few million inhabitants in its palmist days" (Wake 1904:362), civilize almost the entire ancient world. Further, in response to Alice and Augustus's contention that the Maya had left Atlantis just before its destruction, Wake flatly refused to accept the existence of Atlantis: "There may have been a catastrophe destroying much land in the regions of the Antilles, but the 'destruction' of Atlantis, was probably only a metaphor denoting that America had been lost to navigators" (Wake 1904:362).

Wake completely disagreed that Maya civilization was much older than Egyptian civilization and finished his review stating, "It is now known that Egypt and Babylonia were great centers of culture six thousand years before the commencement of the Christian era, and there is nothing whatever in Central America to justify the assignment of half that period to its culture" (Wake 1904:363). Like others before him, Wake praised Augustus's many years of work, stating, "None the less Dr. Le Plongeon is to be congratulated on the good work he has done in collecting information which will aid largely some-day in deciding the important question of American origins" (Wake 1904:363).

While the Le Plongeons found enough money to have a second edition of *Queen Móo and the Egyptian Sphinx* printed in 1900, sales did little to off-set the cost. Even though their income had become very limited, Alice still refused to consider selling the hundreds of photos they had taken in Yucatán and Belize. The only remaining materials that could be sold were the tracings of the murals in the Upper Temple of the Jaguars.

Finally, after a hard winter, Alice wrote Phoebe Hearst in March 1905 asking if she would consider purchasing the tracings. She began her letter by reporting that "Dr. Le Plongeon since his severe illness has been less well than before that event, and this winter has tried him severely" (ADLP 1905). Alice's health had also changed. "Unfortunately I too have been less strong and able during the last two years, so that life is a distressing problem" (ADLP 1905).

In a direct plea she then wrote,

> I beg you to let this be my apology for troubling you with this letter, for it has occurred to me that you might be willing to acquire, for donation to some public institute, Dr. Le Plongeon's facsimile copy of the ancient American frescos. . . . [Most of the tracings were made by Alice] Should you consider this matter favorably it would be to us a great consolation [ADLP 1905].

The tracings were never purchased, and the Le Plongeons' finances became even more dire.

The English artist and illustrator Adela Breton (1849–1923), an acquaintance of the Le Plongeons, had been anonymously sending them "fifty dollars twice a year" (McVicker 2005:133). Breton began her work in Mexico in 1887,

and she quickly became an important contributor to archaeology with her illustrations of pre-Columbian architecture. She lived at Chichén Itzá in 1900 and had made accurate, full-scale, color copies of the murals in the Upper Temple of the Jaguars. Alice and Adela were about the same age; therefore the two English women had much in common.

Breton probably began sending money to support the Le Plongeons during the economic collapse in the 1890s, but the exact date is unknown. "[Frederick Putnam] may have told Adela about their problems," and money was sent for many years (McVicker 2005:133). But, unknown to the Le Plongeons, in 1906 Breton began to be concerned about her own finances, and in a letter to a friend she wrote, "Perhaps when the January remittance comes [the Le Plongeons] might be told they will only get it once an year" (McVicker 2005:133). She was not in direct contact with the Le Plongeons and had not seen how Augustus had deteriorated, so she may have thought Alice's letters were overly dramatic. That all changed after Augustus's death when she heard from colleagues how difficult the Le Plongeons' life had become.

Breton was a scholar in her own right, and she collaborated with archaeologists at the Peabody Museum. Nevertheless, she was perplexed by the rejection of Augustus's work by the people she knew well. Two months after his death she wrote, "Poor Man [Augustus]! why are some people accepted & not others? Dr. Seler [an important German scholar] often makes mistakes, & changes his opinions, but he founds a school & is thought a shining light" (Giles and Stewart 1989:18).

For Alice, the stress of caring for Augustus affected her fragile health, and in turn, her writing. During the years 1904 to 1908, with Augustus practically bedridden, she no longer wrote for newspapers and magazines, but when time permitted she concentrated on her epic poem "A Dream of Atlantis." The lengthy poem was published serially by the Theosophical Publishing Company in *The Word* magazine beginning in 1908, just a few months after Augustus's death.

In spite of his illness, Augustus carried on a lively correspondence in 1906 and 1907 with the Peabody Museum's Charles Bowditch. Much of the discussion revolved around Augustus's claim that he was able to translate the Maya Troano Codex, his interpretation of Maya direction glyphs, and the Le Plongeons' proposal that the Maya stacked stones in columns to keep track of the years. Bowditch remained unconvinced of any of their conclusions, but knew Augustus was seriously ill and probably hoped to learn what he could from Augustus about his archaeological work in Yucatán before he became totally incapacitated.

By May 1907, the Le Plongeons had moved from their Sidney Place residence to 90 State Street, just few blocks away. Probably a less expensive location, that was where they would live until the end.

Eternal Heart of Life! Thy presence glows

Upon the face of all that is, from steep

And snow-capped mounts to where vast oceans keep

Their bounds. Omniscient Life its gift bestows;

Unmeasured, indestructible, it flows

From sphere to sphere, while ages fall asleep

Within the silence of Creation's deep—

And death brings but one day unto its close,

Each fleeting shape that vanishes revives

In other forms—repose can but endure

Till life to action shall again allure.

Each atom of the worlds that gem the sky,

Enfolded in the Infinite, survives

To know the soul of immortality.

ALICE DIXON LE PLONGEON, "Immortality," ca. 1900–1910

EIGHT

An Enduring Bond

1907–10

THE LE PLONGEONS' NEW RESIDENCE ON STATE STREET WAS ONLY A short distance from Sidney Place, but Augustus was much weaker and the move from Sidney Place was not easy. Regardless, their living expenses had to be reduced, so Alice called upon Maude Blackwell and her other friends to help transport their considerable amount of household belongings and all of their books, photos, artifacts, and papers. Once there, she continued work on her epic poem "A Dream of Atlantis" and cared for Augustus.

The rumor that the Le Plongeons had found ancient Maya books in Yucatán had persisted, and Charles Bowditch wrote a final letter from the Peabody Museum to Augustus in May 1907 in the hope that Augustus would tell him where he thought they were hidden. Augustus replied that he had a good idea where Maya books might be found, but that he had not located them.

> Mrs. Le Plongeon has asked me to reply to your query of yesterday, whether Dr. Le Plongeon could be urged to reveal the localities where he suspects ancient Maya Mss. lay deposited. No! Dr. Le Plongeon cannot be urged, but he may be induced perhaps to mention some of the places where such records may still exist and where, some years ago, I began to look, when my researches were interrupted by events beyond my control [ALP 1907].

Bowditch was one of the few archaeologists respected by Augustus, and he continued, "I would have no objection to telling you where I think the

MSS. can be found, because I believe you to be a man of honor, but I would tell no other" (ALP 1907).

Further, he insisted that any information be given in person "lest the letter should fall into the hands of other parties and not in yours" (ALP 1907). Because of his illness, Augustus could not travel to Harvard, and there is no record that Bowditch visited Augustus in New York.

On a different track, Augustus continued in his letter by explaining, "I kept much of my knowledge to myself. . . . During the thirteen years of explorations no one in this country or anywhere else has helped us—All the expenses have been defrayed by Mrs. Le Plongeon and myself" (ALP 1907).

He then vented his anger at the American Antiquarian Society because he felt he had been treated poorly. He pointed out to Bowditch that he had never been reimbursed by the society for all the "communications, I had, from time to time, forwarded to that Society." He also stated that the society had made him a member "without [his] being consulted" hoping that it would be an "honor sufficient to pay" for the reports he and Alice had sent to the Society about their work in Yucatán (ALP 1907).

Alice and Augustus's finances had become desperate, so his frustration is understandable, but researchers are not normally paid by learned societies for the publication of their work. Nevertheless, having reports published by an important society gives legitimacy to an archaeologist's work, which in turn makes it easier to generate funding for additional research. Another way an archaeologist can be recognized is by membership in a learned society, and apparently the American Antiquarian Society considered Augustus's work of sufficient importance that he was offered membership. Both of those factors may have led to Pierre Lorillard's funding of the Le Plongeons' project at Mayapan.

By the summer of 1908 Augustus's health had declined to the point he was "unable to lie down" and had to sleep in "an arm-chair" (Anonymous 1908–9). He required assistance in walking and had gained considerable weight during the year because of his immobility. Alice's devotion to Augustus was unshakable, and while she was helped by Maude Blackwell, she almost single-handedly cared for him.

By the second week of December Alice thought Augustus was close to death, but he rallied for a while, only to slip again into a crisis.

> Suddenly his face grew very statuesque, and after a few minutes he said, "I am in a dreadfully negative magnetic condition! Take me out of it, if you please!"
>
> He showed her how to do it, and she imitated him, but her efforts were quite uneffective [*sic*]. She asked him, "Can I take you out of this condition?" And he answered, "Yes, If you try long enough." She continued her efforts.

He remained in what seemed to be a cataleptic state, she renewing her efforts from time to time. Suddenly, several things occurred at once—he opened his eyes very wide, a fierce, quick breath came from his mouth and nostrils, he seemed thrilled with overwhelming life, and his tongue enunciated in a thunderous tone the name, "SARDOU!" She, the wife and nurse of the patient, exclaimed in her turn, "You!" But the patient instantly resumed his former passive condition. [The name "Sardou" may refer to Victorien Sardou (1831–1908), a well-known French dramatist who died about one month before Augustus.] Soon he spoke again,—not in English, but in Italian:—

"Madam, I, like him, gave my thought and energies to medicine and to archaeology, and I tell you . . ." Here followed a long argument upon the subject of archaeology, to which the tired woman listened patiently until she involuntarily fell asleep. From this she was aroused again by the patient saying, "Try to free me from this condition" [Anonymous 1908–09].

Alice followed his instructions and succeeded in reviving him. But, in a state of delirium, he complained at having been revived and then demanded that she promise to let him die. During this episode, Augustus told Alice that he had been in contact with his deceased mother, and that Alice's father and sister Jessie told him they would help make his passing as easy as they could. Even if Augustus was delusional, what he said must have been some consolation to an exhausted Alice.

With renewed efforts, the wife at last brought the sufferer to a normal state, when he immediately exclaimed, "O, how could you be so cruel! Why did you not leave me to die in that condition? Do you realize what it means for a man of my active temperament to be unable to help myself? O, promise me not to do this again!"

She was greatly distressed and troubled, and replied, "But you yourself begged me to awaken you from that strange condition; I was only complying with your request."

"Ah! well," he returned, "you will promise me not to detain me next time. You must let me go."

She clung to him, "If you assure me that this is your most earnest wish; if you are certain that your freed soul will also approve, then I am strong enough to promise, and to act as you desire."

He answered, "Yes, I want your solemn promise." And then he added, without a pause, "I shall pass away soon; it may be a few hours or days. In that state from which you aroused me, I have spoken with my Mother, with your Father and with your sister Jessie."

With eager tenderness she said, "O, I entreat them to make your going very sweet, peaceful and painless! Can they do this?"

After a moment's pause he replied, "Not always; there are cases when they cannot, but they tell me they will do their best. I think it may be very sudden at last, because I am seeing now that one valve of my heart is in a most peculiar condition" [Anonymous 1908–9].

Augustus improved for a week, and his attending doctors thought there might be a chance he would recover, at least partially. But the evening of December 12 Alice became alarmed because his condition suddenly deteriorated. He died the next day at age eighty-two.

On the night of December twelfth, the patient suffered so much from the weariness of being unable to lie down, that the morning of the thirteenth found him exceedingly feeble, and he did not like to take spirituous stimulants, disliking the taste of those the doctors had ordered, and in fact of all such things. At nine he took a very little breakfast, and at one o'clock he again took a small amount of food; after which he dozed for awhile. A few minutes before three, a friend, a woman of noble character, called, and he shook hands with her;— The visitor stood by his side, his wife just in front of him. Before two minutes had elapsed, his countenance suddenly assumed a most noble expression of dignity and repose; he put is head back a few inches until it came in contact with the pillow; closed his eyes—nor did these open again—and with one soft breath was liberated, without the faintest expression or movement of agitation or distress. It was as if the spirit of his Mother had kissed his eyelids down, and he had felt too well pleased to open them again [Anonymous 1908–9].

Within a few minutes of Augustus's death his physician arrived and stated, "Madam, do you recall the promise exacted from me by <u>him</u> in your presence, to have these remains removed at once and reduced to ashes at the earliest possible moment?" (Anonymous 1908–9; underline by writer). Alice replied that she remembered the promise. The doctor then departed for about an hour; when he returned he prepared the death certificate.

Five days after Augustus's death, Alice was suddenly awakened from sleep by a "mental consciousness" of Augustus reassuring her that he was in a "joyful" state.

[Alice] . . . who had been his constant attendant, had one thought night and morning "I wonder if he is happy—I wonder what he looked at so earnestly beside me just before closing his eyes"—On the morning of

the eighteenth when her emotions were somewhat under control, she was awakened by a mental consciousness of his addressing her—"My child, (he had always called her thus, she being much his junior) I perceived that you were standing by a very lofty portal through which a marvelous light was streaming. I was going to tell you about it, but fell asleep suddenly"—and then, "Happy? O it is unspeakable! Unspeakable! The joy of this state. If only you were here! But though I take you to me at night, I must still lend you to the earth by day. Your happiness is still my ardent wish—Rejoice! Rejoice!" [Anonymous 1908–9].

A lengthy obituary for Augustus ran in the *Brooklyn Daily Eagle* along with a photo. It noted that Augustus's "remains will be cremated at Fresh Pond today," which was not far from their residence (14 December 1908a:16). The obituary went on to describe Augustus's life and work in detail. A simple statement at the end summarized what the Le Plongeons had hoped to prove by more than thirty years of archaeological work: "Dr. Le Plongeon sought to show that in ancient history the American continent played a much greater part than had been generally supposed" (14 December 1908a:16).

Obituaries also appeared in out-of-town newspapers such as the *Philadelphia Record*. Alice wrote the obituaries for the *New York Times* and the *Brooklyn Daily Eagle* and was interviewed in January 1909 by a reporter who wrote an obituary for the *Philadelphia Record*.

Her friends insisted that she should take a short break and visit her family in London in order to relieve her emotional stress. In their opinion "[she] had been the center and the circumference of <u>his</u> universe; it was not strange that her health was affected by the withdrawal of that constant love-force" (Anonymous 1908–9; underline by writer). She took the advice of her friends and just after the new year left New York for London with Augustus's ashes.

Madam Le Plongeon, wife of Dr. Augustus Le Plongeon the learned archaeologist, who died recently in Brooklyn, at 83 [*sic*] years of age, sailed from this city for Europe a few days after New Year's, taking with her the ashes of her husband, to be scattered before reaching the other side to the four winds of heaven [Philadelphia Record, 17 January 1909:2].

The night before she sailed Alice unexpectedly encountered a "German lady" with a "message" from Augustus.

By the merest coincidence she came in contact, the night before she sailed, with a German lady, of good society who had, a short time back, commenced to see and hear strange things. In the presence of a third

party this lady now said to the widow, whom she did not know even by name, "Madam, you must have suffered a bereavement very lately; the presence is that of an elderly man, and it imparts to me such a feeling of elation, that I would to heaven I might always feel as I do at this minute. A bright host seems to come with him and to invade this room. It is his wish that I say to you "Rejoice! Rejoice!" [Anonymous 1908–9].

The *New York Times* listed Alice as scheduled to give a lecture on the evening of January 14, 1909, titled, "Famous Ruins of Yucatan" (10 January 1909:C8). It may have been planned as a memorial lecture to honor Augustus, but Alice cancelled it because she had decided to leave for Europe.

At sea, "[o]n January thirteenth, at mid-day his ashes were cast upon the winds of the Atlantic ocean" (Anonymous 1908–9). Augustus was again in his element, and for Alice, "the sturdy old man trod the upper deck and laughed at the storm as the winds sang through the cordage of the trembling ship" (Hubbard 1897:342).

The obituary in the *New York Times* noted that "Dr. Le Plongeon had spent a fortune of half a million upon excavations and archaeological research" (14 December 1908:9). Most of that money had been earned by Augustus as a surveyor, land speculator, and photographer in California and as a photographer and physician in Peru. It funded Alice and Augustus's more than ten years of expenses for international travel, photographic equipment, clearing of the ruins for photography and excavation, armed protection by the army at Chichén Itzá, and living expenses in Belize.

Once they returned to Brooklyn, their finances were stable until the economic collapse of the 1890s and the onset of Augustus's illness. They had a steady income that supplemented their savings because Alice had developed into a full-time writer and had gained popularity as a lecturer. After Augustus became ill, Alice had to curtail her writing and lecturing. They then drew upon what little savings they had left after the economic collapse, sold their artifacts, and were helped by friends such as Adela Breton.

Probate of Augustus's estate began at the end of December 1908, but little cash and no real estate remained. He left "not more than $2,000 of personal property to the widow, Alice Dixon Le Plongeon. . . . Dr. Le Plongeon left no real estate" (BDE, 30 December 1908b:2).

After her return from London, Alice wrote a memorial to Augustus that was published in the *Journal de la Société des Américanistes de Paris*. It began with a short biography and finished with a summary of Augustus's archaeological accomplishments in Yucatán that included what Alice considered to be his important discoveries. They were: "a true Key to the Maya inscriptions and . . . a translation of paragraphs from Maya books" (ADLP 1909:278), that the "mastodon has been venerated in America as the elephant in India," and

that Maya "architects had used a lineal measure corresponding to the meter" (ADLP 1909:278).

Alice had been deeply hurt by attacks on Augustus's character, and in the memorial she did her best to set the record straight. For her, Augustus was "above reproach, he was a man of high ideals and lived up to them, fearless of results, and willing to set aside personal interests, a dominating characteristic was his unfailing courage, moral and physical. . . . By all those who had the privilege of his friendship he was esteemed and loved" (ADLP 1909:279).

Aside from the defense of Augustus's character, by 1909 new archaeological evidence had made their conclusions obsolete. Nevertheless, Alice remained adamant that "when all that he has bequeathed to us is published it will be seen that he accomplished a great work toward the elucidation of a mysterious past" (ADLP 1909:278–79). No mention was made by Alice of the photographic record they had made of the ruins because, for her, decipherment of Maya writing was of much greater importance.

Alice finished her book-length poem "A Dream of Atlantis" shortly after Augustus's death, and by April the first chapters were published in *The Word* by the Theosophical Publishing Company in New York. It was written in the same poetic style as *Queen Móo's Talisman*, but at more than 170 pages it was three times as long.

In the introduction she stated she was certain that Atlantis had once been a thriving continent and credited Augustus with providing her with linguistic and archaeological support for that conclusion: "In this work the author accepts the story of Atlantis as bequeathed by Plato, and also the corroborative evidence offered by the discoveries of Le Plongeon" (ADLP 1909–11:15).

In the preface, Alice presented her own conclusions about the Maya that went far beyond those in *Queen Móo and the Egyptian Sphinx* and stated that Atlantis had been founded by the Maya "[i]n remote times." In other words, the Maya had "gone forth from the West [Yucatán] to people Atlantis" (ADLP 1909–11:14). Further, sometime before the destruction of Atlantis, the Maya sailed to Egypt where they founded Egyptian civilization. For her, the Maya were still the source of world civilization, albeit colonizing from Atlantis.

Alice then set the stage for her story by stating that Atlantis "had reached its climax of power and arrogance but was degenerate in its morals" (ADLP 1909–11:15). Her central characters were Atlantean aristocrats: King Atlas (a widower), his daughter Nalah, Pelopa his betrothed, his brother Can, and the evil Prince Gadeirus. The plot thickened when Atlas was warned by Can, "who is gifted with great intuition" (ADLP 1909–11:15), that Prince Gadeirus was determined to become king and had planned to poison him. At the "annual rite" at the Temple of Poseidon, Gadeirus carried out the assassination and was made king. He then demanded that Pelopa marry him, but she cleverly escaped by finding "refuge with the priestess" (ADLP 1909–11:15).

In short, Atlas's daughter Nalah and her uncle Can, along with a large number of emigrants, then departed Atlantis for Yucatán to found a new dynasty. Within a few years of their migration, Atlantis was "destroyed by a stupendous cataclysm" (ADLP 1909–11:16). The Maya in Yucatán were then isolated from the rest of the world, but slowly built new cities. At Chichén Itzá and Uxmal, the Le Plongeons pieced together their history from what they found in the ruins.

Less than a year after his death, Augustus's character was again under attack, this time by two aristocratic Englishmen. Channing Arnold and Frederick Frost proposed in their book *The American Egypt* "that America's first architects were Buddhist immigrants from Java and Indo-China" (Arnold and Frost 1909:viii). One visit to Yucatán convinced them that the Maya were incapable of developing their own civilization and needed the help of Buddhist architects from across the Pacific.

Contrary to the assertions of Arnold and Frost, by 1908 most archaeologists had concluded that Maya civilization had developed independently of any help from Asia, Africa, or Europe. The record was in the ground, and excavations had uncovered the proof that the Maya themselves had steadily developed their own unique civilization over a very long period.

Arnold and Frost neither debated their proposal with anyone nor attempted to argue against the conclusions in *Queen Móo and the Egyptian Sphinx*. While Augustus's flawed book could have been easily demolished point by point, they likely didn't have the knowledge and saw Augustus himself as an easier target.

> [Le Plongeon] invited the world to believe that the Mayans or Mayax, as he insisted upon calling them, were the first of all races in the world to become architects, and that they taught the art to the ancient Egyptians and everybody else. In pursuance of this perfectly lunatic suggestion, he dated the civilisation of Central America 11,500 years back. This preposterous proposition was received with the Homeric laughter it so richly deserved [Arnold and Frost 1909:258].

There is no way to know if Arnold and Frost had read Alice's biographical sketch of Augustus published in the *Journal de la Société des Américanistes de Paris*, but their mockery closely parallels what she wrote. For Alice, Augustus was "a man of high ideals and lived up to them, fearless of results, and willing to set aside personal interests, a dominating characteristic was his unfailing courage, moral and physical" (ADLP 1909:279). Intentionally or not, the writers turned what Alice considered Augustus's most important strengths into objects of ridicule.

> He belonged to the class of theorists who at all hazards wish to give America the glory of having produced the very remarkable building

skill shown to have existed in her central territories. The only difference between him and his fellow-theorists was that he had the courage of his convictions, and they had not. A few thousand years were trifles to a man who could theorise so bravely as Le Plongeon; and courage is always admirable. The good doctor was at least no craven, no timorous, afraid-of-his-own-shadow type of theorist; he was a Titan among the theorising minnows, a genius in the art; for he possessed the genius of enthusiasm [Arnold and Frost 1909:258].

Alice's health continued to deteriorate even after her days of relaxation in London. She continued to write, but was sadly reminded everyday of Augustus by their books and papers, their immense photo collection, and what remained of their mementos from Yucatán. By mid-1909 she knew she was seriously ill, and she then called upon Maude Blackwell to help her organize their notes, correspondence, unpublished manuscripts, and photos. Maude even typed the manuscripts so that they would be ready for publication. Alice had full confidence in Maude and decided that, in the event of her death, she would be responsible for all their professional materials.

Alice no longer lectured in the big auditoriums, but did continue to speak to small groups of friends in their homes. Her final article, "The Mystery of Egypt: Whence Came Her Ancestors?" was published by the *London Magazine* in 1910, only two months before her death.

William Comyns Beaumont (1873–1956), an editor for the *London Magazine*, agreed that Alice's article warranted publishing, but imposed some strict guidelines. He wrote Alice in December 1909:

I beg to confirm our arrangement your article of 4000 words to include illustrations from your photographs, at the price of twenty 25 guineas. It will, I take it, be able to carry some very interesting & unpublished photographs. Before you write the actual article, so as to save alteration—because we must do it in a way that the public can understand—it would be better, don't you think, if you would send me a short synopsis of your argument & the points you intend to elaborate [Beaumont 1909:2–3].

Beaumont supported Augustus's professional work and was familiar with the personal attacks on his character. As far as he was concerned, Augustus had been "maligned and sneered at" by people such as Arnold and Frost who had no credentials and were simply "self-constituted authorities" (ADLP 1910a:122).

In his introduction to the article, Beaumont backed the Le Plongeons' conclusions.

[L]ong prior, to any date known to history, there existed a power in that part of the world termed "The New World," but which could more truly be called the Old World, where the monarch ruled over a people accomplished in all the arts and sciences. Their architecture was the precursor of Egypt, and Babylon. . . . Dr. Le Plongeon . . . mastered the writings and hieroglyphics which had hitherto baffled every scientist [ADLP 1910a:121].

He then demanded Alice receive an apology from those "self-constituted authorities."

Those who have read his books . . . realize the extraordinary work he accomplished. But he died a little over a year ago, maligned, sneered at by self-constituted authorities. . . . It rests with the world, ere too late, to make amends, as far as can be made, to his widow, Alice Le Plongeon [ADLP 1910a:122].

In the article, Alice again listed the similarities she and Augustus had found between Maya civilization and the ancient Egyptians. She defended their decipherment of Maya writing by stating Augustus "had one great advantage in that he had a knowledge of the alphabet used by the priests of Egypt . . . and this knowledge enabled him to recognize Egyptian letters . . . on many of the elaborate sculptures adorning the walls of the Maya buildings at Chichen" (ADLP 1910a:123).

While she had no way to know it, her hope that archaeologists would focus their research on Mexico to "unravel the mysteries past" (ADLP 1910a:132) would be fulfilled. Within twenty years, Mexico itself would take the lead in archaeological investigations with the formation of the National Institute of Anthropology and History, with additional research carried out by archaeologists and historians at the University of Yucatán and the National University in Mexico City.

As early as the 1920s the Carnegie Institution of Washington began its lengthy project at Chichén Itzá, followed in the 1930s by Tulane University's Middle American Research Institute at Uxmal, and then a number of other important projects in the Maya area supported by the Peabody Museum at Harvard University.

In this last article, Alice remained optimistic that evidence would be found that the Maya were the source of world civilization:

In Yucatan perhaps we find the beginning of the vast conceptions which culminated in the magnificent Pyramids and other wonders. . . .

It may be that in Central America these ideas originated; and it is an extraordinary reflection upon those who profess a wish to unravel the mysterious past that they ignore the immense possibilities which might reveal themselves to scholars who would give to research in Mexico one tithe of energy now devoted to Assyria and Egypt [ADLP 1910a:132].

Nothing helped alleviate Alice's illness, which she thought, at first, was due to the shock of Augustus's death. She did overcome her depression, but in February 1910 her doctors diagnosed her illness as advanced breast cancer. As her condition worsened, it became apparent the cancer had spread; therefore her doctors suggested she begin making arrangements for institutional care. She was still strong enough to travel and decided to return to London to confer with doctors and family members and to write her will.

She departed in early April, and after she arrived in London she met with three physicians, but their diagnosis held no hope of recovery. From the family home at 117 Chetwynd Road in London, Alice wrote a short letter to Hermon Carey Bumpus (1862–1943), assistant to Morris Jesup, president of the American Museum of Natural History, concerning the final disposition of the molds that were stored at the museum.

April 21st 1910

Dear Dr. Bumpus,

A trio of physicians have just pronounced me to be in a very precarious condition.

This will be forwarded to you only in case of my death. I would then ask you to do me the favor to regard the interests of my heirs as my own. My executors are my brothers Mr. T. J. Dixon of 117 Chetwynd Road London N.W. and Mr. Harry Dixon, now residing at 2 Pine Road, Cricklewood London N.W.—

With much appreciation of your courtesy I am
Yours very truly
Alice Le Plongeon ∴ [ADLP 1910b]

The will also included instructions about the molds: "At the American Museum of Natural History, 77th St., New York City, USA are 260 moulds of sculptures of the Maya ruins in Yucatan. They were placed in the museum with a view to their purchase by that institution" (ADLP 1910c). After Alice's death, Maude Blackwell may have taken custody of the molds, but there is no record of their final disposition and none have been found.

She assigned her brothers, Harry and Thomas J., as her executors, and they were instructed to divide "any money" between her brothers and sisters.

She also directed them to place "at the disposal of Mrs. (Alice Maude) Henry Field Blackwell" manuscripts by Augustus, her "typewritten work, 'Yucatan—its ancient Palaces,'" and wrote "that [Maude retain] such books on archaeology as she desires and also the negatives and plates for illustrating any of our books" (ADLP 1910c).

She ended the will with, "Any personal apparel left by me in England shall be disposed of by my dear sister Lucy as she may please. In New Jersey USA I own a plot of land (see papers) that may be disposed of as my elder brother shall decide" (ADLP 1910c).

Alice remained in London for another two weeks and then took the train to Liverpool where she boarded the steamer *Celtic*. Her condition became so serious en route that she became bedridden and required the attendance of the ship's doctor for the entire voyage. A telegram was radioed to friends in New York that stated Alice would require assistance when the ship arrived. Somehow James Churchward, later known for his writings about Mu, the "lost continent" of the Pacific, was contacted. He in turn sent a telegram to anthropologist Herbert J. Spinden (1879–1967) at the American Museum of Natural History asking for his assistance.

Spinden, a brilliant Mayanist and specialist in the history of art, had received his doctorate from Harvard in 1909, and shortly thereafter began his career as a curator at the museum. He did not know Alice well, but in a letter almost forty years later recalled, "I was in the American Museum of Natural History and received a telegram asking me to meet Mrs. Le Plongeon on her arrival from England" (Spinden 1947).

He then wrote a short critique of Augustus's accomplishments, but like most Mayanists of the next generation he had little knowledge of Alice's work. "Le Plongeon did some really good excavating work at Uxmal [Chichén Itzá] in the seventies, and we found his name and that of his wife in some of the less accessible chambers of that city. He made a remarkable series of photographs, now hard to find. Harvard must have some, and there used to be a set in the Museum of Merida" (Spinden 1947).

Spinden was right. Today the Peabody Museum at Harvard University has 135 prints made by Alice from the same negatives she used to make prints for the governor of Yucatán, Eligio Ancona, in 1876. Ancona deposited them in the Mérida Museum, and Spinden reported he looked them over in 1910 during one of his trips to Yucatán.

Spinden attributed all the Le Plongeons' conclusions about the Maya to Augustus and found that "there is [not] the slightest archaeological justification for . . . [the] theory" that "free-masonry," and "Greek civilization originated in Yucatan" (Spinden 1947). While Spinden's letter was written in 1947, it reflected the majority opinion of archaeologists as far back as 1910.

On the morning of May 16, the *Celtic* docked in New York. On a slip of

paper Maude Blackwell scribbled: "May 17th [May 16], 1910. She arrived from England on S.S. Celtie [*Celtic*] White Star Line from Liverpool" (Blackwell 1910). Alice's "[f]riends were waiting the arrival of the vessel and they went on board as soon as the gangplank was in place" (NYT, 17 May 1910a:18). But Alice was "so ill that she was unable to leave the vessel at the pier. Mrs. Alice Le Plongeon, famous as an archaeologist . . . was under the care of Dr. A. E. Hopper, the ship's surgeon, nearly the whole voyage. Late in the afternoon she was removed to a private sanitarium" (NYT, 17 May 1910a:18).

Alice was transported to Woman's Hospital at 141 West 109th Street in New York City where she fought to overcome the cancer, but nothing could be done beyond controlling the pain. She lived another twenty-three days and died on June 8.

Obituaries submitted by Maude Blackwell ran most prominently in the *Brooklyn Daily Eagle* and *New York Evening Post*, with Alice noted as the "widow of Augustus Le Plongeon, and herself an author and lecturer. . . . Her lectures were on Central and South American subjects, and she was the author of 'Here and There in Yucatan,' and other works" (New York Evening Post, 9 June 1910:9).

Her occupation was listed as "lecturer" on her death certificate (New York City Archives 1910). In the end, she may have realized that her many articles, written to convince archaeologists that the Maya were the source of world civilization, had not succeeded and felt she had failed as a writer. But she could still remember the loud applause of appreciative audiences and thus decided her real success had been in the lecture hall.

Others would remember her differently. A notice in the *New York Times* stated: "Mme. Alice Le Plongeon, widow of Augustus Le Plongeon, . . . and herself *a writer of note* . . . was born in London, and married when she was 19 years old" (10 June 1910b:9).

A handwritten note in the margin of the death certificate stated, "The funeral expenses are being defrayed by Mrs. M. A. Blackwell" (New York City Archives 1910). A draft obituary written by Maude Blackwell notes:

LePlongeon [*sic*]. In New York City N.Y. June 8th 1910.
 Alice Dixon widow of the late Dr. Augustus LePlongeon [*sic*], in the 59th [58th] year of her age. Cremation at the Hudson Bergen Crematory, North Bergen N.J. on June 9th 1910 [Blackwell 1910].

Maude and a few friends released her ashes at sea to join Augustus's. Not surprising is that the jade talisman has never been found. Alice was certain of Cay's prophecy and likely instructed Maude to cast it into the sea along with her ashes so that "Wherever might he dwell there too would she" (ADLP 1902c:70).

Unmasked and unwanted the Veiled Lady came to live with me.
She handed me a precious jewel and at the same time lifted her Veil
and I beheld the shining face of "Sweet Adversity."

MAUDE A. BLACKWELL, "The Veiled Lady," 1935

Epilogue

AFTER THE DEATH OF ALICE, THE PAPERS, PHOTOGRAPHS, AND manuscripts that she and Augustus had accumulated over a period of more than forty years were passed on to Alice's close friend Maude Blackwell. Maude Alice Kane was born in Toronto, Canada, in 1873 and moved to New York City around 1893 where she met Henry ("Hal") Field Blackwell. Hal and Maude were married in 1895, and it was at about this same time that Maude introduced herself to Alice after one of her lectures.

Alice and Maude were like-minded and quickly developed a close friendship. As Augustus's health declined, Maude spent much of her free time helping Alice with his care. While they were together, Alice took the opportunity to explain to Maude her conclusions about Maya civilization and also confided the details of the psychic events she had experienced in Yucatán.

Alice had appointed her brothers as executors of her estate and stipulated that Maude should receive all her professional materials. Maude promised Alice that she would care for the photos and see to the publication of Augustus's articles, the "Pyramid of Xochicalco" and "The Origin of the Egyptians," and Alice's book, "Yucatan, Its Ancient Palaces and Modern Cities."

The Dixon family had full confidence in Maude, and shortly after Alice died, she received a letter from Lucy Dixon that expressed her "heartfelt gratitude for all your care & loving kindness to my sister Alice" (Dixon 1910). Lucy was very close to Alice and her death was a great personal loss, but she wrote to Maude that she was comforted that Alice's suffering had ended: "It is impossible to regret her release & I do trust she will now be at rest for ever"

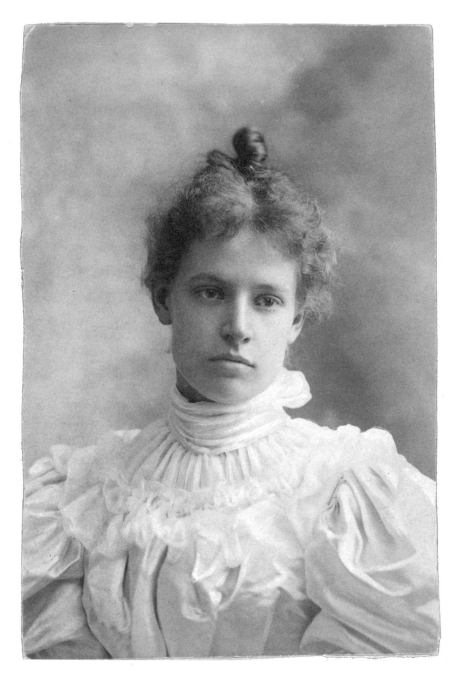

Maude Blackwell near the time of her marriage to Henry Field Blackwell in 1895. Photo was taken in Brooklyn, New York. Photographer unknown. Research Library, The Getty Research Institute, Los Angeles, California (2004.M.18).

(Dixon 1910). She emphatically expressed the family's confidence in Maude to carry out Alice's wishes: "<u>Pray carry out any wish of Alices</u> [*sic*] <u>as to keep-sakes</u> . . . [k]eep everything she wished you to have" (Dixon 1910; underline by Lucy).

Lucy and her brothers knew that the years of caring for Augustus were a great burden on Alice. Lucy wrote, "But I may just say that we could not help

thinking for some long time past that Alice must be suffering a[nd] nearly done with that (old sick Dr). She never once wrote or spoke of him but with the deepest affection, but we read between the lines" (Dixon 1910).

While Alice had received Maude's pledge to care for all their photographs and papers, she directed her to destroy everything unless the American people showed an interest in the Maya. Fortunately, she gave no deadline, and Maude did nothing precipitous. To raise some money, Alice also told Maude to sell what remained of the artifacts that the Le Plongeons had collected in Yucatán. Four months after Alice's death, the projectile points and jadeite beads the Le Plongeons had excavated at Chichén Itzá were sold to the American Museum of Natural History. Maude also knew that the Le Plongeons had stored 260 molds in the museum "with a view to their purchase by that institution" (ADLP 1910c). But assistant museum curator Pliny Goddard saw it differently and stated they were stored "for sixteen years as a matter of accommodation and courtesy" (Goddard 1910b).

Maude had to reclaim them, along with the tracings Alice and Augustus had made of the murals in the Upper Temple of the Jaguars. Presumably the molds were returned to Maude by the museum, but when she contacted archaeologists in the 1930s about selling the remaining Le Plongeon materials, the molds were not included in the inventory. Nor is there any museum record of their having been transferred to Maude. A search of the museum storerooms in the 1980s by this author and emeritus curator of anthropology Gordon Ekholm (1909–87), uncovered no molds. To date, none of the molds have been located.

Goddard wrote the director that anthropologist Herbert Spinden had told him the tracings "had all been published and were therefore accessible and that the originals had value only on sentimental grounds" (Goddard 1910a). Spinden, who had just received his doctorate from Harvard University, was wrong. Not all the tracings had been published, and fortunately the museum returned what they had to Blackwell.

In January of 1911, seven months after Alice's death, Frederick Putnam, at Harvard University's Peabody Museum, wrote Maude about the Le Plongeon "curios and Manuscripts" (Putnam 1911). Putnam asked, "[W]hat has become of the several strips of copies of the mural paintings on the walls of the Chichen Itza (Yucatan) ruins . . . ? If you could give me any information to help locate these copies . . . or if you know who has purchased the whole collection, . . . I would be greatly indebted to you for the information" (Putnam 1911). It is not known if Maude replied to Putnam, but the Peabody Museum did not acquire the tracings, molds, or any other materials from Blackwell.

Around 1912, Maude submitted Augustus's manuscripts "Pyramid of Xochicalco" and "The Origin of the Egyptians" to *The Word* magazine in New York for publication, and both were in print by 1913. But she was unable

to find a publisher for Alice's book, "Yucatan, Its Ancient Palaces and Modern Cities." The 535-page manuscript, made even longer by illustrations, was just too great of a commitment for publishers.

Under her own authorship, in 1913 Maude published in *The Word*, "Xochicalco. A Study of the Name and Its Possible Meanings." The article was based on previous writings by the Le Plongeons, and most of it was quoted directly from Augustus's book-length article "The Origin of the Egyptians," interspersed with Maude's short commentaries. She must have learned from Alice about the important work at Xochicalco by Adela Breton, because in the article she quoted two pages from Breton's article, "Some Notes on Xochicalco." Maude commented that "Miss. Breton's interesting discussion of this pyramid is amplified by carefully executed drawings and further descriptions of the designs" (Blackwell 1913).

After this initial flurry of publishing and correspondence with archaeologists, Maude, along with her association with the Le Plongeons, was quickly forgotten. Unknown to archaeologists, she stored the vast collection of Le Plongeon photographs and written materials in her Brooklyn residence at 280 Clinton Street only a few blocks from the Le Plongeons last residence on State Street. Then, after the death of Hal in the 1920s and near the beginning of the Great Depression, she moved to Los Angeles with almost all the Le Plongeon materials.

In 1929 the famous aviator Charles Lindbergh, his wife Anne Morrow Lindbergh, also a pilot, and archaeologist Alfred Kidder flew over Chichén Itzá to carry out an aerial photographic reconnaissance. A photo from that flight appeared in the *New York Times* and was seen by Maude. For her, the American people had, at long last, shown an interest in the Maya, and she tried to contact two well-known archaeologists, Frans Blom and Sylvanus Morley. She did not know their addresses, but had somehow heard of anthropologist Fay-Cooper Cole, founder of the anthropology program at the University of Chicago in 1929, and asked Cole to forward her letters to Blom and Morley.

Her first letter was to Blom, who was director of the Middle American Research Institute at Tulane University in New Orleans. She began by stating she was in possession of all the Le Plongeon photographs, letters, and manuscripts, and then continued with a lengthy explanation of how the Le Plongeons had found Maya books. Maude was fully convinced they had discovered them, and in her packet of materials to Blom she included a drawing of a "secret room in the Maya ruins" where she thought the books had been found. She then stated "the Le Plongeons . . . really discovered the secret records. . . . The records were in a wonderful state of preservation (1875). Le Plongeon sealed them up again & swore the natives to secrecy" (Blackwell 1931a).

Sylvanus Morley, as director of the Chichén Itzá Project for the Carnegie

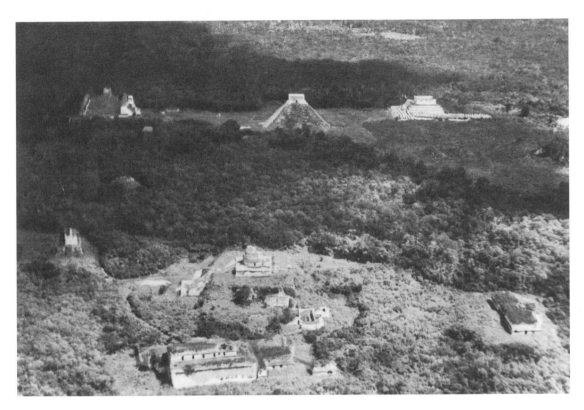

Aerial photograph of Chichén Itzá taken in 1929 from an airplane piloted by Charles Lindbergh and his wife Anne Morrow Lindbergh, with archaeologist Alfred Kidder on board. Courtesy of the Carnegie Institution of Washington.

Institution of Washington, was a public figure and often commented about the Maya for newspapers and in newsreels. He and Kidder had made the arrangements for the Lindbergh flight over Chichén Itzá. After receiving Maude's letter, he moved quickly to see if the collection might be acquired, and drove to Los Angeles from his home in Santa Fe, New Mexico, to interview her. He asked Maude why she had waited so long before coming forward with the materials. In a letter to John C. Merriam, president of the Carnegie Institution, Morley wrote that Maude had stated,

> [O]n her death bed, Mrs. Le Plongeon had left material to her with the understanding that it was not to be made public until the American people evinced a greater interest in the ancient Maya civilization than they had done in her lifetime and that of her husband. Mrs. Blackwell was enjoined to destroy the material before her death if the American people gave no evidence of awakened interest in the ancient Maya civilization up to that time [Morley 1931].

It became apparent to Morley that the Le Plongeon materials had been preserved only by the most lucky of circumstances.

[W]hen I took archaeology under Alfred Tozzer at Harvard twenty-six years ago, Tozzer told us that Dr. Le Plongeon had decided to burn all his notes and photographs just before his death to prevent their falling into the hands of such an ungrateful world.

When I asked her why, then, she was making it public, at this time, she replied that she felt Colonel Lindberg's [*sic*] flights over the Maya area two years ago, and the wave of interest which these had aroused, was sufficient evidence of awakened interest on the part of the American people in the Maya field [Morley 1931].

Morley and archaeologist Karl Ruppert then tried to make arrangements for the acquisition of the collection. During the negotiations, Morley, like other archaeologists, credited the excavations and photography at Chichén Itzá solely to Augustus. Maude was pleased that Morley complimented Augustus, but he was unprepared for her reaction when he stated the value of Augustus's conclusions were "nil":

The importance of his [Augustus's] conclusions is nil, but the fact that he had been in Chichen Itza so early and had done digging there . . . would have made his photographs and any excavation notes he may have left of utmost importance to our work [Morley 1931].

In anger, Maude wrote to Blom, "Of course I ought to have been prepared to find that the two archaeologists are <u>too conservative</u> to pay much attention to Dr. Le P's theories, etc. In more ways than one I was disappointed in their visit here. TIME will prove as to which set of 'theories' lies nearest the truth" (Blackwell 1931b; underline and capitals by Maude). She refused to talk further with Morley about selling the materials.

Morley found Maude equally impossible.

Like Dr. Le Plongeon, Mrs. Blackwell is a mystic, believing in numbers, signs and symbols, Atlantis, and all the complex of associated absurdities. I believe that it was her devotion to these mystic sciences which finally reconciled Le Plongeon first, and second, permitted Mrs. Le Plongeon to leave it all to Mrs. Blackwell [Morley 1931].

Maude continued her long and friendly correspondence with Blom who, ironically, had a similar opinion about the Le Plongeons' conclusions, but he was respectful of Maude's views. In their correspondence, Maude continued to try to bolster the Le Plongeons' reputations, and Blom expressed an intense interest in the drawings Maude had sent.

Your tracings of the Le Plangeon's [*sic*] drawings from the Adivino is very interesting. Underneath the west stairway of this great pyramid runs a tunnel which is an ancient passage opened again by Le Plangeon [*sic*]. It gives access to a beautifully carved façade, and it was here that Le Plangeon [*sic*] found the famous piece of sculpture called the Queen of Uxmal. . . . Underneath the place where Le Plangeon [*sic*] extracted the sculpture, is the doorway blocked up by stones and it is probably here that he penetrated. The tracing you have sent me is probably of this place. He must have blocked the entrance again after having investigated here. It would take a considerable amount of shoring to get there now, and would not be without considerable danger, but I am quite certain that we would be fully repaid by such an exploration [Blom 1931].

Maude had also told Morley about the "secret" chamber in the Adivino Pyramid where she claimed Augustus had found Maya books. Morley was unimpressed and informed Merriam:

Do you remember the Casa del Adivino at Uxmal, on the west side, there was a passage running under the stairway and emerging on the opposite side of the stairway, and further, that in the center of this passage there was a sealed door way which obviously gave access to a room? She claims that Dr. Le Plongeon told her that he had penetrated into this chamber and found that it led to another, and, going into this second chamber still farther into the hearting of the pyramid, he found these same hieroglyphic archives of Uxmal codices, which were folded like screens and written in hieroglyphic characters; that he had no facilities at that time to take these manuscripts out, and that he walled them back up, and pledged his Indians to secrecy.

Much as I wish this might be true, I believe it to be unadulterated "blah"—although Mrs. Blackwell obviously believes every word of it [Morley 1931].

In December 1931, Blom thoughtfully mailed Maude a photo, taken by Tulane University's Middle American Research Institute archaeologists, of the East Building of the Nunnery Quadrangle with the Adivino Pyramid looming in the background. Maude recognized immediately that it was where the Le Plongeons had worked almost sixty years before and carefully stored it with her important papers. But shortly thereafter, their correspondence ended because Maude's negotiations to sell the collection to the Philosophical Research Society in Los Angeles were about to be concluded.

Manly P. Hall, the charismatic founder of the society, at once saw the historical importance of the Le Plongeon materials. Late in 1931 he purchased hundreds of the Le Plongeon glass-plate negatives, prints, tracings of the murals, and some of the Le Plongeon written material. Included with the Le Plongeons' writings were "two hand written volumes described by Hall as those which Blackwell took back a week after the Philosophical Research Society had acquired the Le Plongeon collection" (Desmond 1983:11–12). Maude had mistakenly included Alice's diary and another volume as part of the material acquired by the society. The diary published in this book was one of the volumes, and while the contents of the second volume are not known, it is possible that it was a continuation of the first volume. Unfortunately, the second volume has not been located.

Maude had sold Hall only part of the collection and retained a large number of photographic prints, lantern slides, stereo cards, and glass negatives. The photographic material had wide-ranging subject matter and included archaeological and ethnographic subjects, mammals and birds, portraits, landscapes, and photos of Yucatán, Belize, Mexico, Peru, London, New York, and Hawaii. She also kept the original tracings of the murals, Alice's unpublished book "Yucatan: Its Ancient Palaces and Modern Cities," her diary and unpublished papers, Augustus's writings from his years in Peru, and his unpublished papers.

It was the Great Depression, and Maude, a middle-aged widow of fifty-eight with few professional skills, could only find occasional employment. As Morley observed, "The lady [Maude] is in very reduced circumstances, though obviously a gentlewoman—of about fifty-five, I should judge" (Morley 1931). Yet she held back part of the Le Plongeon collection, even though she knew Hall had the funds to purchase it. She may have even regretted selling any of it, but she needed to find a secure place for the difficult-to-transport and easily damaged glass negatives.

As the Depression dragged on, Maude changed residences in Los Angeles almost yearly. To make matters worse, she could not pay for commercial warehouse storage; therefore she had to keep the entire archive in her apartment, and it became more and more difficult to care for the materials. Fortunately, she had become an "associate" of the United Lodge of Theosophists in Los Angeles (Blackwell 1935a), and her friends with the lodge pitched in to help her.

In 1933 Maude moved all the remaining Le Plongeon photographs and written materials to the lodge at Thirty-third and Grand streets. It "was built in the early 1920's and is a grand building with a beautiful theatre and library. It is a gem of early twentieth century architecture" (McCloskey, personal communication 2007). The beautiful art deco building has been well maintained and is still in use by the lodge.

Two years later, at age sixty-two, Maude, desperate for employment, applied to the California Association for Adult Education to attend a class in "Authorship, Senario [sic] writing & so forth" (Blackwell 1935a). Finally, at age sixty-five, she applied for financial assistance. On September 7, 1938, Maude received a letter from the Los Angeles Office of Social Service stating she would receive thirty-five dollars a month in "old age assistance" (Los Angeles Social Service 1938). The money was not enough to live on, even by Depression-era standards. Sometime after 1938 Maude moved to San Diego where she probably found work when the United States entered World War II. She died in San Diego on January 24, 1957.

Around the time of Maude's death, another large component of Alice and Augustus's photographic work surfaced in New York City. Before she moved to Los Angeles, Maude had packed almost two hundred of their negatives, prints, and lantern slides in a trunk. While she probably stored the trunk with friends at first, at some point it was put in commercial storage. Following her death, rent must have become overdue, and on the initiative of the storage company the trunk was delivered to Professor William D. Strong at Columbia University.

Strong thought a museum would have better facilities to care for the materials and had the trunk transferred to Gordon Ekholm in the department of anthropology at the American Museum of Natural History. Ekholm, who had directed many archaeological projects in Mexico, immediately recognized Maya archaeological sites in the photos and carefully stored everything in his office. In addition to photos of Yucatán and Belize, the trunk held some surprises, such as copies of a few of Henry Dixon's photos of London, photos of Ireland and works of art, and quite a number of the Le Plongeons' photos of plants, animals, and insects. The trunk also contained a copy of *Queen Móo and the Egyptian Sphinx* and "an experimental telephone with the name Henry Field Blackwell (Maude Blackwell's husband) inscribed on it" (Desmond 2005:xi).

For about twenty-five years the collection drew almost no notice. In 1980, however, this author by chance asked Ekholm if the museum had any Le Plongeon archival materials. He replied that a few letters might be in the archives, but stored in his office were a large number of their photos. Those materials are now in the photographic archives of the department of anthropology at the museum and available to researchers.[1]

In the mid-1980s, about fifty years after Maude placed the Le Plongeon materials with of the United Lodge of Theosophists, Leigh J. McCloskey, artist-philosopher and actor, was the next person to take responsibility for their care. The lodge decided to pass the Le Plongeon collection on to McCloskey because they knew of his great interest in the Maya and that he had already become familiar with the work of Alice and Augustus from the books in his

library. He gladly accepted the responsibility; he knew the materials were not only historically important but also fragile, and he wanted to make certain that they would be properly cared for and receive recognition.

McCloskey recalled, "[T]here were five cardboard boxes and a trunk that I received. The material was known about and was safely stored in the basement until it was entrusted to me through the auspices of the late Dallas Tenbroeck (he died in 2007 at the age of 85), and the existing ULT oversight committee" (McCloskey, personal communication 2007). Maude's imposing script was written on the boxes to identify them as containing the work of the Le Plongeons, and one can find her comments and name in black ink written on almost every item in the collection.

McCloskey diligently saw to the protection of the Le Plongeon photos and other archival materials.

> I was the delighted inheritor . . . because I had always expressed a profound fascination with all things Maya. I knew nothing about the material until I was asked if I wanted it. A decision had been made that I should be the one entrusted to create and or find a permanent home for the work [McCloskey, personal communication 2007].

He cared for the collection with help of his colleague and friend Stanislas Klossowski de Rola, a Hermetic scholar and author, and together they cataloged and put "the materials into some semblance of order" (McCloskey, personal communication 2007). McCloskey offered the entire collection to the Getty Research Institute in Los Angeles in 1999 in order to make it available to researchers and to be certain it received professional conservation. His first call was to Claire L. Lyons, collections curator for the history of archaeology and ancient art, who then initiated the long and detailed process required for acquisition.

> I had decided to not seek auctioning the material, which would have been quite profitable, because I felt it my responsibility to the Le Plongeons that their life work not be cannibalized, and profiteered from; but kept cohesive and in tact for scholars and historians. I put myself in their shoes and hoped that should someone receive my work after my death that they would do the same for me and the integrity of my life work.
>
> I wanted the material to stay in Los Angeles and I contacted only the Getty Research Institute. . . . Claire Lyons was the first person I spoke with about the archive. I liked her immediately and felt that she would try to her greatest capacity to ferry the collection into the Getty [McCloskey, personal communication 2007].

The Le Plongeon collection is now archived at the Getty Research Institute. The Institute holds approximately 1,200 Le Plongeon negatives, prints, stereo cards, and lantern slides. The nonphotographic part of the collection comprises an extensive number of Alice and Augustus's letters, notes, diary, and manuscripts, plus Maude Blackwell's photographs and papers.

Prior to the acquisition of the collection, archival materials related to Alice were scarce; therefore, any writings about her that did exist were limited to a superficial level. Further, any memory of her accomplishments was soon overshadowed by the "mysterious, preposterous, opinionated, haphazardly informed, reckless," and "remarkable" Augustus (Brunhouse 1973:132, 159). Historian Robert Brunhouse's writings on the Le Plongeons broke new ground. He did his best to include something about Alice in a chapter devoted to Augustus in his 1973 book, *In Search of the Maya*. But, after a few scattered comments, he was at a loss to know what had become of her after Augustus died. "What happened to Alice is unknown. After she published an obituary of her husband and an article in a London magazine in 1910, she disappeared from public view. . . . Even the place and date of her death are unknown" [Brunhouse 1973:157].

His first reaction to the Le Plongeons was surprisingly on target, describing two strong personalities collaborating closely. But he quickly gave up that line of approach and simply credited Alice with being more "practical" than Augustus. In the end, he saw her as no more than a facilitator of Augustus's "fantastic speculations."

> At first glance it appears that we have here two archaeologists, but actually she did no more than absorb his ideas and tone down the fantastic speculations in order to gain a favorable audience. If she was more practical, he was undoubtedly the source of every idea advanced by either Le Plongeon [Brunhouse 1973:133].

He then attempted to put Alice in a better light by distancing her from Augustus: "[She] showed good judgment playing down Augustus's fanciful theories or avoiding them altogether" (Brunhouse 1973:153).

Twelve years earlier, archaeologist Robert Wauchope published *Lost Tribes and Sunken Continents* for a popular audience. The small but lively volume pointed out the archaeological fallacies proposed by a number of writers he labeled "crackpots," including the Le Plongeons. Wauchope was a graduate of Harvard University, taught at Tulane University, and as director of the Middle American Research Institute at Tulane had carried out important archaeological projects in Mesoamerica. He also had an impressive command of the literature on Atlantis, Mu, theosophists, Rosicrucians, the Lost Tribes of Israel, Egyptian civilization, and the Phoenicians.

His critique of Alice and Augustus was scattered over several chapters with humorous headings such as "Elephants and Ethnologists," "Egypt in America," "Lost Continents," "Atlantis and Mu," and "Dr. Phuddy Duddy and the Crackpots" (Wauchope 1962:7, 28, 69). Wauchope seemed, somehow, particularly offended by Augustus and began by characterizing him as "a French adventurer . . . whose bitter denunciations of his foes and whose arrogant flaunting of his own ego produced a lurid epoch in the history of American archaeology" (Wauchope 1962:7–8).

Unlike Channing Arnold and Frederick Frost or Albert Shaw, once he had unleashed his diatribe against Augustus, Wauchope welcomed the chance to argue against cultural diffusion, Atlantis, and the Le Plongeons' conclusions about the origin of Egyptian civilization. He had mastered a considerable literature by people he considered uncritical and uninformed and was determined to present archaeology to the public as a scientific endeavor. Of course by the 1960s, Augustus and Alice were remembered by only a few people, but Wauchope thought their archaeological errors were important enough to bring them out of almost fifty years of obscurity.

Wauchope, like Brunhouse, had little knowledge of Alice, and he gave her only a few sentences. She was probably lucky to get off with Wauchope's fictitious characterization as "the former Miss. Dixon of Brooklyn, . . . apparently a gentle soul, interested in music and poetry, and fiercely loyal to her much older and cantankerous husband" (Wauchope 1962:78). Then Wauchope added an anonymous bit of gossip about Alice from someone he called "one of Le Plongeon's most enthusiastic admirers" (Wauchope 1962:20). Like a reporter who had received an anonymous tip, he withheld the identity of his informant and passed on what he thought to be juicy news: "This friend described Le Plongeon's 'loyal little wife' as only seventeen [19] when she married the doctor, thirty years [25] older than she" (Wauchope 1962:20). One wonders if Wauchope saw Augustus as not only "flaunting his own ego" in archaeology, but also flaunting the young and talented Alice.

Brunhouse and Wauchope did what they could with the little material they had about Alice, and, of course, missed the mark. When they wrote about her, about one hundred years had passed since she "arrived in Yucatan . . . seeing the world for the first time" (Desmond and Messenger 1988:130). There was no one living who knew that as a young, strong-willed woman, *she* had chosen to spend her life with Augustus. Or that she had manned the barricades against a Chan Santa Cruz Maya assault, ran excavation crews, photographed people and archaeological sites, received honors from the diplomatic corps in Mexico City, and lectured for more than twenty-five years about the ancient Maya and the people of Yucatán.

As a young, middle-class, Victorian woman, Alice realized that without aristocratic ties she had little chance of fulfilling her dream of becoming a

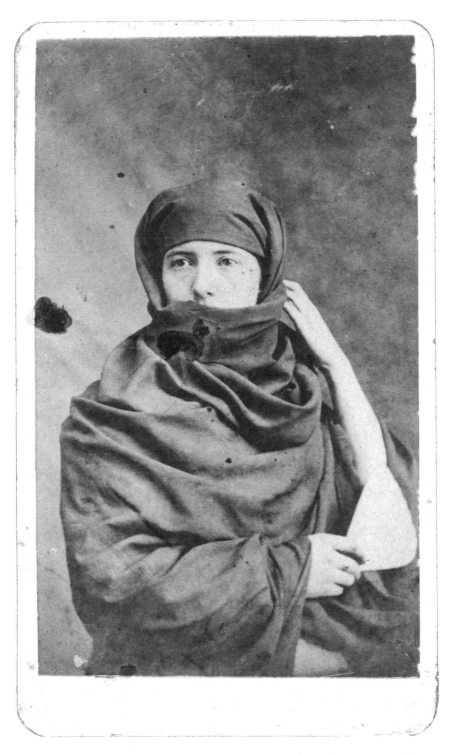

Alice Dixon Le Plongeon in a burka. Circa 1870. Photographer unknown. Research Library, The Getty Research Institute, Los Angeles, California (2004.M.18).

writer. But a solution presented itself in the form of Augustus who had come to London to read pre-Columbian manuscripts at the British Museum and intended to carry out archaeological explorations in Yucatán. They met and fell in love, and Alice decided to leave for Yucatán with Augustus and write about their explorations.

Alice's journeys throughout Yucatán and work at archaeological sites provided the raw material for her many articles and books. She wrote for newspapers and popular magazines, but her talent was also recognized by professional journals such as the *Magazine of American History, Engineering Magazine*, and the *Proceedings of the American Antiquarian Society.*

Alice's 1879 article, "Notes on Yucatan," for the *Proceedings*, was the American Antiquarian Society's first by a woman. Further, "Notes on Yucatan" gave Alice the confidence she lacked when she wrote her uncle Jacob at age twenty-four that, at best, she would be "a third rate writer" (ADLP 1875a). Her diary is not only a unique record of her own life but also of the lives of the rich and poor, Maya and Mestizo, and priest and soldier of 1870s Yucatán. It seems certain that she sensed that someday her observations would be historically important.

Alice's acceptance of Spiritualism and psychic phenomena contributed to the development of her conclusions about the Maya. But her beliefs made it nearly impossible for her to adapt her thinking about the Maya to the new evidence unearthed by archeologists because her mix of science and Spiritualism weighed in too heavily on the side of metaphysics. The new archaeological findings of the late nineteenth century and early twentieth were the direct result of important changes that were beginning to unfold in the field of archaeology. Alice and Augustus were never part of those changes; nevertheless, Alice's writings and lectures on the ancient Maya inspired the public and challenged archeologists.

Alice had the temperament of an artist, but she also had the persistence and perfection required to master the technically complicated world of nineteenth-century photographic processes. She often manned the camera, but she was also exceedingly talented in the darkroom with all its chemicals and special solutions. In Yucatán and Belize, she took responsibility for preparing and developing the wet collodion glass-plate negatives, printed the negatives, and even made "magic lantern" slides that were used to illustrate her lectures. Today more than 2,400 of her prints, lantern slides, and negatives remain in public and private collections.

While she succeeded as a writer and lecturer, Alice considered her work on behalf of social justice to be one of her most important commitments. Her lectures, writing, and years in Yucatán, and her twenty-five years of work for Sorosis and other women's organizations that advocated woman's rights and on behalf of the poor, must have been an inspiration to young women.

She was dedicated to making a difference in the world. Her decision to leave Yucatán and live permanently in New York City may have been motivated by the hope that her lectures would enhance the ideas and ideals she expressed in her writings. It turned out Alice was right, but it must have been difficult for her to leave her close friends and the quiet calm she experienced in the remote forests. She preserved throughout her life a letter written from Yucatán to her parents the day after Christmas in 1875. It expressed her need and love of a "life in the wilds."

If you were here . . . you would know the pleasure of life in the wilds. No one to please except yourself and companion, . . . complete silence for miles around, save the noise of the insects, the singing of the birds, and the wind rustling among the trees, an almost cloudless sky, for the rainy season is drawing to a close. Brilliant birds, butterflies, and wildflowers in any direction you please to stroll [ADLP 1875b].

Augustus Le Plongeon's Exploration of the Interior of the Pyramid of Kinich Kak Moo, Izamal, Yucatán, Mexico

Background

Slightly different versions of Augustus's explorations under the pyramid at Iza-mal are also found in the following publications by Alice Dixon Le Plongeon: "Notes on Yucatan" published in Proceedings of the American Antiquarian Society (ADLP 1897b) and "Yucatan: Its Ancient Palaces and Modern Cities. Life and Customs of the Aborigines" (ADLP 1884b).

The following description of Augustus's explorations is part of a lecture Alice gave to raise money for a Catholic school in Belize City in what was then British Honduras (ADLP 1876:39–44). While it was written as part of the 1873–76 Yucatán diary of Alice Dixon Le Plongeon, it precedes the first entry of the diary.

> As we have said that the people of Yucatan believe in witchcraft, we will tell you how Dr Le Plongeon acquired the reputation of a wizard.
>
> It was said that several persons had wished to enter the great artificial mound raised to Kinich Kakmo. The late Abbé Brasseur de Bourbourg among others, but as yet none had succeeded. Everybody considered the feat very dangerous as there might be many snakes and other venomous insects which abound throughout the country.

Dr Le Plongeon decided to enter if possible as his examination of the mound had persuaded him that it must contain interior chambers. He was happy enough to find a small opening on the eastern side. After penetrating ten yards, he found a dry stone wall blocking the way. To the right he perceived by the light of his candle, a small aperture. He made his way through that. Crawling on for about fifteen yards among immense blocks of hewn stone that form the foundation of the mound, he found no entrance in that direction. Returning, he felt a strong current of air, that seemed to come through the stone wall. He came to the conclusion that there was the road he sought. He had an order from the governor of the state to ask the Magistrate of Izamal for help if he needed it. This he did requesting him to find four prisoners from the penitentiary, as no free working men could be persuaded to enter, much less to work under the mound. The men were given and under direction of Dr Le P an opening was made through the wall. This took nearly a day, as there was little space for working. The next day the magistrate offered all kinds of causes for not lending the men again. The Doctor, however, went to the mound in company with Dr D. Baulio Mendez, and D. Joaquin Reyes. These gentlemen entered as far as the wall, but left Dr Le Plongeon to continue his explorations through the opening made by the prisoners. The passage was exceedingly small being half filled up with loose earth. He took a string between his teeth, to signal if anything should befall him, and penetrated by the light of a candle, about twenty-five yards in a westerly direction, crawling on the ground with his head scraping the roof. Reaching the end of the passage he found a place where he could sit upright. On the left hand side was an opening, almost blocked up with earth which had sifted between the stones. It left an aperture of about a foot and a half. Here his shoulders would not pass; but looking through he saw a kind of chamber, and on the south side the doorway of a subterranean passage leading south toward the mound upon which the church stands. A strong current of air blew through the passage.

There is no doubt that from time immemorial communication has existed between the two mounds. There ended the exploration in that direction, for the time being.

Among the indians and mestizos, a strange tradition is current, and firmly believed. It is, that under the mound is a large pool of crystalline water, and standing in the middle a beautiful image of a woman; so resplendent and shining that it illumines the whole place. But as in our modern times no one has made his way into the interior, we must accept the insistence of an image there as a possibility;

for the Indians like the Egyptians, were in the habit of bringing the effigies of their honored rulers under these pyramids.

The visit of the Doctor to the mound gave rise to the following ludicrous incident. A mischievous cat, poking his nose where he had no business, threw down a bottle containing a solution of nitrate of silver [a chemical used by the Le Plongeons to sensitize their glass plates to make a photograph]. To repair the damage, the Doctor set to work to make some, and for that purpose dissolved Spanish coin in nitric acid. Having precipitated the pure silver into chloride, in order to separate it from the alloy, he converted the chloride into black oxide, which resembles loam. In order to get rid of the zinc it might yet contain he sent it, well washed and dried, to the silver smith to have it melted. Our servant was a Mexican soldier of the pioneer regiment, accustomed to a street discipline, and to comply therefore with the orders he received he took the oxide of silver to the best silver smith, and requested him to melt it. The smith, having examined the stuff got angry at the idea that anyone should take him for a fool, and wish to play with him a practical joke—asked the soldier what he meant by requesting him to waste time trying to melt earth under pretense that it was silver. The soldier merely replied that such were his orders, he knew nothing else so begged him to do it. After much pour parler the smith at last took a small quantity of the stuff that he took for earth, placed it upon a piece of live coal, and with his blowpipe directed a flame upon it. When lo! to his astonishment and dismay a globule of bright silver appeared in lieu of the supposed earth. Then a lucid idea cross his brain. "Oh!," said he "I know now why that foreigner, your master, went under the mound. He knew that the earth there was pure silver, and went for it." The worthy man refused to melt the rest lest it might be bewitched. This took place on Saturday morning. On Monday morning we heard that very early on Sunday, the smith with some of his companions, had proceeded to the mound, entered it, not without fear and trembling, and filled some large bags with loam. This they carried to the forge and passed the day trying to obtain silver by blowing upon it. Alas! without success.

When this story was told to us, the Doctor thought it would be good to push the joke a little further. So he took a small quantity of solution of nitrate of silver, and poured into it a solution of common salt. You are aware that the result of this mixture is a white precipitate of chloride of silver that when dry resembles lime. Having obtained that salt, he sent to the smith to have it melted. After much hesitation the smith submitted it to the magic action of the blowpipe

AUGUSTUS
LE PLONGEON'S
EXPLORATION OF
THE PYRAMID
OF KINICH
KAK MOO

349

and flame. The globule of silver appeared. "Ah!" said he, angrily, "now I understand the whole thing, and why we worked all yesterday and burned so much coal for nothing. He knew that we were going to the mound, and by his power of witchcraft, changed the loam into Ɔac-cab!" (white earth).

From that time Dr Le Plongeon passed for a great wizard and enchanter among the lower classes of Izamal.

Such is the result of ignorance and superstition.

"The Hunter"

By WALTER JAMES TURNER (1889–1946), British Poet

With comments by LAWRENCE G. DESMOND

In 1991 Alison B. Eades, a great-grandniece of Alice Dixon, introduced me to Roberta Kathleen (Bobbie) Stacey (nee Igglesden; 1919–2004). Bobbie was the granddaughter of Mary Elizabeth Dixon, a sister of Alice Dixon. At the time we met, she was living in Kent, England, with her husband, William Stacey, and we spent a delightful afternoon telling stories about Yucatán and old aunt Alice. Bobbie's daughter Pat Young said, "She was very proud of her link with Alice, both of them were strong women!!!"

When she was a child, Bobbie often visited her great-uncle Thomas James Dixon, "TJ" (1857–1943). When he came of age, TJ had gone into partnership with his father Henry in the photographic business in London. Alice's adventures must have inspired TJ's interest in Yucatán, and on her visits to his home in Ware during the 1930s, Bobbie told us he insisted that she recite "The Hunter."

During the afternoon of our visit to Bobbie and Bill, and while we were all sitting in the living room talking about old times, Bobbie suddenly stood and began reciting "The Hunter" from memory. It was like a voice from the past—Alison and I sat listening in stunned silence. It was a moment neither of us will forget. After that, we all trooped off to their favorite pub for lunch!

THE HUNTER (circa 1917)
Walter James Turner
"But there was one land he dared not enter."

Beyond the blue, the purple seas,
Beyond the thin horizon's line,
Beyond Antilla, Hebrides,
Jamaica, Cuba, Caribbees,
There lies the land of Yucatan.

The land, the land of Yucatan,
The low coast breaking into foam,
The dim hills where my thoughts shall roam,
The forests of my boyhood's home,
The splendid dream of Yucatan!

I met thee first long, long ago
Turning a printed page, and I
Stared at a world I did not know
And felt my blood like fire flow
At that strange name of Yucatan.

O those sweet, far-off Austral days
When life had a diviner glow,
When hot Suns whipped my blood to know
Things all unseen, when I could go
Into thy heart, O Yucatan!

I have forgotten what I saw,
I have forgotten what I knew,
And many lands I've set sail for
To find that marvelous spell of yore,
Never to set foot in thy shore
O haunting land of Yucatan!

But sailing I have passed thee by,
And leaning on the white ship's rail
Watched thy dim hills till mystery
Wrapped thy far stillness close to me
And I have breathed "'Tis Yucatan!

"'Tis Yucatan, 'tis Yucatan!"
The ship is sailing far away,
The coast recedes, the dim hills fade,
A bubble-winding track we've made,
And thou'rt a Dream, O Yucatan!

"The Passing of an Enlightened Soul"

Probably coauthored by ALICE DIXON LE PLONGEON and MAUDE BLACKWELL (see Anonymous 1908–9).

Yes, it was two o'clock in the morning; and he said, with a pathetic sigh, "This fatal hour, probably the hour at which I shall die before long. How I which [sic] it were morning!"

He was seated in an arm-chair, for he had been unable to lie down for at least four months. His wife had been snatching a little sleep on a couch a few steps from him; now she sprang to her feet, and was at once by his side trying to cheer and console him. Suddenly his face grew very statuesque, and after a few minutes he said, "I am in a dreadfully negative magnetic condition! Take me out of it, if you please!"

He showed her how to do it, and she imitated him, but her efforts were quite uneffective. She asked him, "Can I take you out of this condition?" And he answered, "Yes, If you try long enough." She continued her efforts.

He remained in what seemed to be a cataleptic state, she renewing her efforts from time to time. Suddenly, several things occurred at once—he opened his eyes very wide, a fierce, quick breath came from his mouth and nostrils, he seemed thrilled with overwhelming life, and his tongue enunciated in a thunderous tone the name, "SARDOU!" She, the wife and nurse of the patient, exclaimed in her turn, "You!" But the patient instantly resumed his former passive condition. Soon he spoke again,—not in English, but in Italian:—

"Madam, I, like him, gave my thought and energies to medicine and to archaeology, and I tell you. . ." Here followed a long argument upon the subject of archaeology, to which the tired woman listened patiently until she involuntarily fell asleep. From this she was aroused again by the patient saying, "Try to free me from this condition."

With renewed efforts, the wife at last brought the sufferer to a normal state, when he immediately exclaimed, "O, how could you be so cruel! Why did you not leave me to die in that condition? Do you realize what it means for a man of my active temperament to be unable to help myself? O, promise me not to do this again!"
She was greatly distressed and troubled, and replied, "But you yourself begged me to awaken you from that strange condition; I was only complying with your request."

"Ah! well," he returned, "you will promise me not to detain me next time. You must let me go."

She clung to him, "If you assure me that this is your most earnest wish; if you are certain that your freed soul will also approve, then I am strong enough to promise, and to act as you desire."

He answered, "Yes, I want your solemn promise." And then he added, without a pause, "I shall pass away soon; it may be a few hours or days. In that state from which you aroused me, I have spoken with my Mother, with your Father and with your sister Jessie."

With eager tenderness she said, "O, I entreat them to make your going very sweet, peaceful and painless! Can they do this?"

After a moment's pause he replied, "Not always; there are cases when they cannot, but they tell me they will do their best. I think it may be very sudden at last, because I am seeing now that one valve of my heart is in a most peculiar condition."

The patient seemed to take a turn for the better a few days later, and asked for a little meat, something he had not tasted for more than a year. The improvement continued for a week, and, with the exception of one, the physicians who attended him, thought he might recover sufficiently to complete a work, of importance to history, upon which he was engaged.

On the night of December twelfth, the patient suffered so much from the weariness of being unable to lie down, that the morning of the thirteenth found him exceedingly feeble, and he did not like to take spirituous stimulants, disliking the taste of those the doctors had ordered, and in fact of all such things. At nine he took a very little breakfast, and at one o'clock he again took a small amount of food; after which he dozed for awhile. A few minutes before three, a friend, a woman of noble character, called, and he shook hands

with her;—The visitor stood by his side, his wife just in front of him. Before two minutes had elapsed, his countenance suddenly assumed a most noble expression of dignity and repose; he put is head back a few inches until it came in contact with the pillow; closed his eyes— nor did these open again—and with one soft breath was liberated, without the faintest expression or movement of agitation or distress. It was as if the spirit of his Mother had kissed his eyelids down, and he had felt too well pleased to open them again. His face and dome-like head became as set and as marble-white as a beautiful piece of statuary.

Within four minutes the favorite physician of the learned man was on the spot. To the widow he said, "Madam, do you recall the promise exacted from me by <u>him</u> in your presence, to have these remains removed at once and reduced to ashes at the earliest possible moment?"—"I do," the lady answered.

The physician then turned to three other persons who were present, and explained—"The dear friend we have just lost, exacted from me a promise to apply no artificial means to restore breathing, and with this I have also complied, because the widow was willing that I should keep my word to him, the same having been exacted of her also by him. Nevertheless, he was of such an unusual temperament, that I will make the tests." With this he left the house to see other patients. He returned at the time mentioned and did what was necessary and legal in the matter. On the following day the cremation took place.

She, who had been his constant attendant, had one thought night and morning "I wonder if he is happy—I wonder what he looked at so earnestly beside me just before closing his eyes"—On the morning of the eighteenth when her emotions were somewhat under control, she was awakened by a mental consciousness of his addressing her—"My child, (he had always called her thus, she being much his junior) I perceived that you were standing by a very lofty portal through which a marvelous light was streaming. I was going to tell you about it, but fell asleep suddenly"—and then, "Happy? O it is unspeakable! Unspeakable! The joy of this state. If only you were here! But though I take you to me at night, I must still lend you to the earth by day. Your happiness is still my ardent wish—Rejoice! Rejoice!"

Philosophy is apt to fail the best of us at the crucial moment. This woman had been the center and the circumference of his universe; it was not strange that her health was affected by the withdrawal of that constant love-force. A sea-voyage became necessary.

By the merest coincidence she came in contact, the night before she sailed, with a German lady, of good society who had, a short time back, commenced to see and hear strange things. In the presence of a third party this lady now said to the widow, whom she did not know even by name, "Madam, you must have suffered a bereavement very lately; the presence is that of an elderly man, and it imparts to me such a feeling of elation, that I would to heaven I might always feel as I do at this minute. A bright host seems to come with him and to invade this room. It is his wish that I say to you "Rejoice! Rejoice!"

On January thirteenth, at mid-day his ashes were cast upon the winds of the Atlantic ocean.

Alice Dixon Le Plongeon's Letter to Her Parents, Henry and Sophia Dixon

December 1875 and January 1876

The following letters were written to Henry and Sophia Dixon by Alice while she stayed in three villages in Yucatán: Pisté, Valladolid, and Motul (ADLP 1875b).

<div align="right">

Sunday Dec 26th 1875
Piste, Yucatan, Mexico.

</div>

My very dear father & mother

Yesterday was Christmas day, and perhaps before I am able to send this we shall have entered the year—76. I am sure that today you are shivering with cold; while we bask in the sun. Every place and every people with their joys and sorrow. How intensely I should now enjoy a visit to a theater, a little music; apiece of roast mutton; a cup of tea, etc., etc. Don't laugh—I am very much in earnest. If you were here you would feel the same thing, but you would know the pleasure of life in the wilds. No one to please except yourself and companion, nothing to do except your work. Nothing to bother you except your workmen; complete silence for miles around, save the noise of the insects, the singing of the birds, and the wind rustling among the trees, an almost cloudless sky, for the rainy season is drawing to a close. Brilliant birds, butterflies, and wildflowers in any direction you please to stroll. Large trees here are not common. The forest is close low brush and it is unwise to penetrate far. Tigers and snakes are plentiful and unless you mark your path it is very easy to

be lost. Even within the space of a few yards you may find yourself in a complete maze as that of Bosher ville Gardens. A native of the country has told me that during three days that he was lost he came three times upon the same spot. For our part, the time here flies so fast, that when we are Saturday, we believe it Wednesday, and we are anxious to return to Valladolid. We do not even know what goes on in that small place; so isolated are we.

It had been my intention to send you a long letter I cannot do it at present. I have no paper here, and it would take me a week to put notes in reading order. On our return to Valladolid which may be even a month later I shall write a long article and try to have it published in NY. If it is accepted I shall be well paid and with that see you receive a copy. If it is rejected I will send you the manuscript January 4th 1876.

I had written thus far when a man came to bring corn from the farm house of a friend, Colonel Traconis. Dr. proposed that we should return with him and come back to Piste on the following day. So we mounted and went 15 miles to pay a visit. I do not give you an account now. We were received with open arms. We found the colonel directing sugar making, and studied the operation from beginning to end. We invited Mrs. Traconis to return with us to Piste and visit the ruins of Chichen which she had never seen. As the horses were all employed on working the sugar, the lady said that until Saturday she would be unable to accompany us. We waited for her until that day, good manners would permit nothing else, though it was a loss of time for us. The day before yesterday, Sunday, we visited Chichen with Mr. and Mrs. Traconis, their son, and their servants. Yesterday they returned to their farm.

In as few words as possible I must tell you of a discovery we have made here. Dr. discovered in the bush a small artificial hill. By the ornamentation surrounding it he judged it to be a burial place. The men were set to dig from the top; and we found it to consist of loose stones. A hole was made, under Dr's direction 7 meters deep: the loose stones, of course, had to be propped up on every side, with sticks cut from the bush, we had no planks. The work was very tiresome, for the workmen did not understand our language nor we theirs. A little below the level of the earth we found a large statue, I send you a picture of it with the Dr. Amid a thousand difficulties this natus had been taken out by the Dr, and 8 men. I leave you to imagine how brain and body have been put to the stretch. With sticks and stones various machines have been made and used to lift this enormous weight, and Dr came out with his statue victorious.

There was no road through which to take it, and we wanted to carry it away, and send it to the exhibition of Philadelphia. So Dr put himself to open a road 5 miles long and 6 yards wide.

January 11, 1876.
[Vallodid, Yucatán]

In the midst of our work, the workmen were called away from us. We have left the statue hidden in the bush; and we pass on to Merida tomorrow; perhaps to return here very shortly.

As soon as possible I shall have the satisfaction of sending you 80 very pretty views: for the present I send a few that you may see the statue, and the hole from where it was taken.

We have a great deal to do now; drawings, plans, and photos which we wish to send to the exhibition of Philadelphia. We shall return to fetch the statue as soon as we can; meanwhile it remains hidden in the bush; we hope, in safety.

I cannot write now, because my mind is full of all sorts of things; but I promise you a long letter within a month.

January 27, 1876.
[Motul, Yucatán]

And here we are in the house of a very good friend, where we have been just 14 days, I very much occupied in printing the views: We had an order for a copy of the entire collection of 80 plates—they are finished—delivered—and paid for—stereoscopic views at 4 each. We shall send you alike collection as soon as possible. There exists in Mexico an absurd law which forbids the removal of any of the ruins or part of the ruins; and we are baulked in our plan of sending the statue to Philadelphia. Dr had been working hard, writing a petition to the supreme government of Mexico for permission to take from Chichen Itza whatever we please. The governor of the state, Yucatan, put at our disposal men to continue opening the road which we had begun from Piste to Dzitas from where the statue can be carried.

Notes

Preface

1. The diary that Alice kept of her first three years in Yucatán is untitled. But Maude Blackwell wrote in the margin of the first page, "This is the Diary of Alice Dixon Le Plongeon the wife of Dr. Augustus Le Plongeon. 1873. This book is in the handwriting of Madame Le Plongeon."

Chapter 1

1. Lynne MacNab has made the following additional observations about Alice's work as an "assistant" to her father in photography.

> It is quite likely that Alice was involved in more than "messenger work" for Henry. Women were quite commonly employed as photographic retouchers at this time, and I believe were also considered adept at portraiture, especially of children and animals as it was believed they were better at keeping them calm, and therefore still! It seems quite possible to me that Alice could have been involved in taking studio portraits and perhaps also the fine art and museum photography. It was common to "keep work in the family" at this time and would have made economic sense for Henry in the early years of his studio [MacNab, personal communication 2008].

2. Ten of the Le Plongeons' 3-D photos included in this book were printed with the right negative on the left side and the left negative on the right side and, therefore, viewing these prints through a stereoscope will not generate a 3-D stereo image. They can, however, be viewed in 3-D stereo by crossing the eyes. A little practice is needed, but once the cross-eyed method is mastered it works

very well. Instructions and practice materials for this method can be found on the World Wide Web. To identify these ten images in the book, look for a square format for both the left and right images and images that cover virtually all of the paper they were printed on.

In addition to the ten images, five images in the book were printed by the Le Plongeons so that they could be viewed in 3-D stereo with the traditional nineteenth-century Holmes Stereoscope. These five images were mounted on cardboard with a border, and the top of each image is half-rounded.

To view the images prepared for viewing through a stereoscope, purchase a tabletop viewer from a map or surveying equipment supplier or on the World Wide Web. Place the stereo viewer over the book page. You might also want to try to view these five images without an instrument using what is called the divergent or walleye viewing technique. You need to view the left image with the left eye and the right image with the right eye. Like the "cross-eyed technique," the divergent viewing technique takes a little time to learn, but is very convenient once mastered.

3. Lynne MacNab brought to my attention that there is an "invaluable" collection of Henry Dixon's Holborn Viaduct photographic project letters archived at the Guildhall Library Print Room in London.

Chapter 2

1. For additional background on stereo 3-D photography and the stereoscope see Bernard E. Jones, ed., *Encyclopedia of Photography* (New York: Arno Press, 1974), 520–22.
2. For a more detailed description of the process of making a wet collodion glass plate negative and its history see Beaumont Newhall, *The History of Photography: From 1839 to the Present* (New York: Museum of Modern Art, 1964), 47; and Bernard E. Jones, ed., *Encyclopedia of Photography* (New York: Arno Press, 1974), 120–22.

Chapter 3

1. The prints made by Alice were mailed to her father, Henry Dixon, in London. He proudly pasted them into an album that is now cared for by Donald Dixon of London, the great-grandson of Alice's brother, the artist Harry Dixon.
2. Alice's revised manuscript for this article is archived at the American Antiquarian Society. It is an edited version of the lecture she wrote in her diary on pages 1–45.

Chapter 4

1. Susan Milbrath, curator of Latin American art and archaeology at the Florida Museum of Natural History, identified the much-collapsed mound as the Castillo, the largest pyramid at Mayapan. She reported that it was initially restored in the mid-twentieth century by the archaeologists of Carnegie

Institution of Washington, D.C., who conducted excavations on the north side. Subsequently, Mexico's National Institute of Anthropology and History partially excavated a substructure on the southwest side (Q162a) and consolidated and restored the pyramid overlying this structure. See Susan Milbrath and Carlos Peraza Lope (2003:46).

Chapter 6

1. Saville was then assistant curator in the department of ethnology, but later became the first curator of Mexican and Central American archaeology and would go on to direct a number of important archaeological projects in Mexico.

Chapter 7

1. Alice's objection has not been borne out, and subsequent research has concluded that the Chacmool is one of many representations of the rain deity (called *Chac* by the Maya and *Tlaloc* in highland Mexico) in Mesoamerica.

2. In a tragic footnote to history, Hubbard and his wife boarded the doomed passenger ship *Lusitania* in New York City on May 1, 1915. The ship was torpedoed by the German submarine *Unterseeboot 2* on May 7, 1915, and as the ship was sinking they were last seen returning to their cabin after giving their places in a lifeboat to other passengers.

Epilogue

1. A copy of each Le Plongeon photographic item at the American Museum of Natural History, New York, is archived in the Lawrence G. Desmond Collection of Le Plongeon Photographs and Other Research Materials at the Wilson Library of the University of North Carolina at Chapel Hill, North Carolina.

 The Lawrence G. Desmond Collection is comprised of copies of Le Plongeon photographic materials from the American Museum of Natural History, Donald Dixon Album, Getty Research Institute, Peabody Museum at Harvard University, and Philosophical Research Society. The copies of 1,054 photographs were made in 1989 and cataloged with funding by a grant from the National Endowment for the Humanities. The catalog of the photographic items in five collections was published by the author in 2005 on compact disc and is available at a number of university libraries and other research institutions. See Lawrence G. Desmond 2005 in the References section of this book for a bibliographic citation.

References

Adams, Herbert B.
> 1891a Life and Works of Brasseur de Bourbourg. *Proceedings of the American Antiquarian Society.* April 29, 1891. Press of Charles Hamilton, Worcester, Massachusetts.

Adams, Herbert B.
> 1891b Abbe Brasseur de Bourbourg. *Proceedings of the American Antiquarian Society,* New Series 7:274–90. Worcester, Massachusetts.

Albany Institute of History and Art
> 1896 Minutes of the Albany Institute. Vol. 13, December 22, 1896. Albany Institute of History and Art, Albany, New York.

Anonymous
> 1880 *Pictorial Diagrams of New York Theatres.* Lansing, New York.

Anonymous
> 1908–9 The Passing of an Enlightened Soul. Description of the death of Augustus Le Plongeon. 3 pages, typewritten, double spaced. Probably coauthored by Alice Dixon Le Plongeon and Maude Blackwell. Manuscript on file, 2004.M.18, Research Library, Getty Research Institute, Los Angeles.

Arnold, Channing, and Frederick J. Tabor Frost
> 1909 *The American Egypt, A Record of Travel in Yucatan.* Hutchinson, London.

Athenaeum, The
> 1896 Review of *Queen Móo and the Egyptian Sphinx.* 29 August:296.

Aymé, Louis
> 1882 Letter to Stephen Salisbury, July 18, 1882. American Antiquarian Society, Worcester, Massachusetts.

Baqueiro, Serapio
> 1879 *Ensayo histórico sobre las revoluciones de Yucatán desde el año de 1840 hasta 1864.* 2 vols. Heredia Argüelles, Mérida.

Bancroft, Hubert H.

 1882 *The Works of Hubert Howe Bancroft*, Vol. 5. A. L. Bancroft, San Francisco.

Beaumont, William Comyns

 1909 Letter to Alice Dixon Le Plongeon from London. December 7, 1909. 2004.M.18. Research Library, Getty Research Institute, Los Angeles.

Benezit Dictionary of Artists

 2006 Harry Dixon. British 19th–20th century. In *Benezit Dictionary of Artists*, p. 971. Gründ, Paris.

Benton, Joel

 1902 Poets New and Old: The Latest Volumes of Verse Reviewed by Joel Benton. *The New York Times*, 2 August:519. New York.

Blackwell, Maude A.

 1910 Draft obituary of Alice Dixon Le Plongeon with handwritten note about the arrival of very ill Alice Dixon in New York aboard the *Celtic*. 2004.M.18. Research Library, Getty Research Institute, Los Angeles.

Blackwell, Maude A.

 1913 Xochicalco. A Study of the Name and Its Possible Meanings. *The Word* 18:165–80. Theosophical Publishing, New York.

Blackwell, Maude A.

 1931a Letter to Frans Blom. 3 July. Latin American Library, Tulane University, New Orleans.

Blackwell, Maude A.

 1931b Letter to Frans Blom. 16 November. Latin American Library, Tulane University, New Orleans.

Blackwell, Maude A.

 1935a. Application to the California Association for Adult Education. 2004.M.18. Research Library, Getty Research Institute, Los Angeles.

Blackwell, Maude A.

 1935b. The Veiled Lady. One page typed. 2004.M.18. Research Library, Getty Research Institute, Los Angeles.

Blavatsky, Helena P.

 1888 *The Secret Doctrine*. 2 vols. Theosophical Publishing, London.

Blom, Frans

 1931 Letter to Maude Blackwell. 18 August. 2004.M.18. Research Library, Getty Research Institute, Los Angeles.

Brasseur de Bourbourg, Charles E.

 1864 *S'il Existe de sources de L'Histoire du Mexique dan les monuments Egyptiens et de L'Histoire primitive de L'Ancien Monde dans ales monuments Amêricains? Extrait du volume intitulé Relation des choses de Yucatan [de Diego de Landa]*. Maisonneuve et cie, Paris.

Brasseur de Bourbourg, Charles E.

 1865 Rapport sur les ruines de Mayapan et d'Uxmal au Yucatan (Mexique). *Archives de la Commission Scientifique du Méxique* 1:234–88. Paris: Imprimerie Impériale.

Brasseur de Bourbourg, Charles E.

 1868 *Quatre Lettres sur Le Mexique*. Maisonnueve et cie, Paris.

Breton, Adela
 1906 Some Notes on Xochicalco. *Transactions of the Department of Archaeology, Free Museum of Science and Art* 51–73. Department of Archaeology, University of Pennsylvania, Philadelphia.
Brewster, David
 1856 *The Stereoscope: Its History, Theory, and Construction.* John Murray, London.
Brinton, Daniel G.
 1887a Letter to Alice Dixon Le Plongeon. 3 or 13 August. Philosophical Research Society, Los Angeles.
Brinton, Daniel G.
 1887b Letter to Alice Dixon Le Plongeon. November. Philosophical Research Society, Los Angeles.
Brooklyn Daily Eagle (BDE)
 1881 Yucatan, Its Ruins and the Ancient and Modern Customs of the Mayas. 28 December:2. New York.
Brooklyn Daily Eagle (BDE)
 1885 Yucatan: A Description of the Country and Its Inhabitants. 29 April:1. New York.
Brooklyn Daily Eagle (BDE)
 1888a Central America. 11 March:1. New York.
Brooklyn Daily Eagle (BDE)
 1888b Sunday Evening Lectures. 6 December:1. New York.
Brooklyn Daily Eagle (BDE)
 1889 A Boom for Anton Seidl. 16 June:2. New York.
Brooklyn Daily Eagle (BDE)
 1890 Explorer Le Plongeon's Request. 1 April:1. New York.
Brooklyn Daily Eagle (BDE)
 1893 The Voyages of Columbus. 2 March:2. New York.
Brooklyn Daily Eagle (BDE)
 1894 Coming Events. 14 November:7. New York.
Brooklyn Daily Eagle (BDE)
 1899 The Lily in Decoration. 2 April:21. New York.
Brooklyn Daily Eagle (BDE)
 1900 Mme. Le Plongeon's Lecture. 31 January:9. New York.
Brooklyn Daily Eagle (BDE)
 1901a Many Art Lectures Planned. 30 September:6. New York.
Brooklyn Daily Eagle (BDE)
 1901b. Ancient Yucatan Monuments. 24 December:13. New York.
Brooklyn Daily Eagle (BDE)
 1902a Coming Events. 7 March:5. New York.
Brooklyn Daily Eagle (BDE)
 1902b Queen Moo's Talisman: Mrs. Alice D. Le Plongeon's Narrative Poem Embodying Legends and Beliefs of the Maya Race. 5 July:8. New York.
Brooklyn Daily Eagle (BDE)
 1902c Club Woman's Plans for the Coming Week. 29 November:10. New York.
Brooklyn Daily Eagle (BDE)
 1908a Dr. Le Plongeon Dead; A Noted Archaeologist. 14 December:16. New York.

Brooklyn Daily Eagle (BDE)
 1908b Dr. Le Plongeon's Will. 30 December:2. New York.
Brunhouse, Robert L.
 1973 *In Search of the Maya.* University of New Mexico Press, Albuquerque.
California Academy of Sciences
 1873 Notes on Lectures by Augustus Le Plongeon. *Proceedings of the California Academy of Sciences, 1868–1872*, Vol. 4. California Academy of Sciences, San Francisco.
Carrillo y Ancona, Crescencio
 1883 *Historia Antigua de Yucatán.* Gamboa Guzman y hermano, Impresores-Editores, Mérida.
Charnay, Claude-Joseph Désiré
 1881 Letter to Stephen Salisbury, 5 December. Translated by Bart Anderson. American Antiquarian Society, Worcester, Massachusetts.
Churchward, James
 1926 *The Lost Continent of Mu.* William E. Rudge, New York.
Dailey, Abram H.
 1894 *Mollie Fancher, the Brooklyn Enigma: An Authentic Statement of Facts in the Life of Mary J. Fancher.* Eagle Book, Brooklyn.
Desmond, Lawrence G.
 1983 Augustus Le Plongeon: Early Maya Archaeologist. Unpublished PhD dissertation, Department of Anthropology, University of Colorado, Boulder.
Desmond, Lawrence G., and Phyllis M. Messenger
 1988 *A Dream of Maya: Augustus and Alice Le Plongeon in 19th-Century Yucatan.* University of New Mexico Press, Albuquerque.
Desmond, Lawrence G.
 2001 Augustus Le Plongeon (1826–1908): Early Mayanist, Archaeologist, and Photographer. In *The Oxford Encyclopedia of Mesoamerican Cultures*, edited by David Carrasco, 3 vols, 2:117–18. The Oxford University Press, New York.
Desmond, Lawrence G., and Paul G. Bryan
 2003 Recording Architecture at the Archaeological Site of Uxmal, Mexico: A Historical and Contemporary View. *Photogrammetric Record* 18(102):105–30.
Desmond, Lawrence G.
 2005 *Catalog of Collections of the Nineteenth Century Photographs of Alice Dixon Le Plongeon and Augustus Le Plongeon.* Le Plongeon photographs from the American Museum of Natural History, the Donald Dixon Album, the Getty Research Institute, the Peabody Museum at Harvard University, and the Philosophical Research Society. 1,054 entries. 416 pp. Published by the author as a PDF on compact disc.
Desmond, Lawrence G.
 2008 Excavation of the Platform of Venus, Chichén Itzá, Yucatán, México: The pioneering fieldwork of Alice Dixon Le Plongeon and Augustus Le Plongeon. In *Tributo a Jaime Litvak King*, edited by Paul Schmidt Schoenberg, Edith Ortiz Díaz, and Joel Santos Ramírez, 155–56. Mexico: UNAM. Instituto de Investigaciones Antropológicas.
Dixon, Lucy
 1910 Letter to Maude Blackwell. 21 June. 2004.M.18. Research Library, Getty Research Institute, Los Angeles.

Foote, Kenneth E.
 1987 Relics of Old London: Photographs of a Changing Victorian City. *History of Photography* 11(2):133–53.

Giles, Sue, and Jennifer Stewart (editors)
 1989 *The Art of the Ruins: Adela Breton and the Temples of Mexico*. City of Bristol Museum and Art Gallery, Bristol, England.

Goddard, Pliny E.
 1910a Letter to Dr. Townsend. 8 October. American Museum of Natural History, New York.

Goddard, Pliny E.
 1910b Letter to Dr. Townsend. 17 October. American Museum of Natural History, New York.

Graham, Ian
 2002 *Alfred Maudslay and the Maya*. University of Oklahoma Press, Norman.

Haven, Samuel F.
 1877 Report to the Librarian. *Proceedings of the American Antiquarian Society* 70:89–100.

Hearst, Phoebe A.
 1895 Letter to Alice Dixon Le Plongeon. 22 November. 2004.M.18. Research Library, Getty Research Institute, Los Angeles.

Hearst, Phoebe A.
 1896 Letter to Alice Dixon Le Plongeon. 7 May. 2004.M.18. Research Library, Getty Research Institute, Los Angeles.

Holmes, William H.
 1895 *Archaeological Studies among the Ancient Cities of Mexico. Part 1, Monuments of Yucatan*. Field Columbian Museum, Chicago.

Hubbard, Elbert
 1897 Review of *Queen Moo and the Egyptian Sphinx*. *The Arena* 17:342–45.

Huchim Herrera, José G.
 1991 Introducción al Estudio del Sistema de Aguadas de Uxmal, Yucatán. Professional thesis, Universidad Autónoma de Yucatán, Mérida.

Landa, Diego de
 1864 *Relación de las cosas de Yucatán*. French & Spanish. *Relation des choses de Yucatan de Diego de Landa; texte espagnol et traduction française en regard, comprenant les signes du calendrier et de l'alphabet hiéroglyphique de la langue maya, accompagné de documents divers historiques et chronologiques, avec une grammaire et un vocabulaire abrégés français-maya; précédés d'un essai sur les sources de l'histoire primitive du Mexique et de l'Amèrique Centrale, etc., d'après les monuments égyptiens, et de l'histoire primitive de l'Egypte d'après les monuments américains, par l'abbé Brasseur de Bourbourg*. A. Durand, Paris.

Le Plongeon, Alice Dixon (ADLP)
 1873–76 Travel diary. 28 July 1873–22 August 1876. Manuscript on file, 2004.M.18. Research Library, Getty Research Institute, Los Angeles.

Le Plongeon, Alice Dixon (ADLP)
 1875a Letter to Jacob Dixon. 15 August. 2004.M.18. Research Library, Getty Research Institute, Los Angeles.

Le Plongeon, Alice Dixon (ADLP)
 1875b Letters to Henry and Sophia Dixon. 26 December 1875, and 11 and 27 January 1876. 2004.M.18. Research Library, Getty Research Institute, Los Angeles.

Le Plongeon, Alice Dixon (ADLP)
 1875c Letter her family. Names not written. Pisté. 25 December 1875. 2004.M.18. Research Library, Getty Research Institute, Los Angeles.

Le Plongeon, Alice Dixon (ADLP)
 1876 Lecture given to raise funds for the Catholic school in Belize City, Belize. In the travel diary of Alice Dixon Le Plongeon, Yucatán, 28 July 1873–22 August 1876, pp. 1–44. Manuscript on file, 2004.M.18. Research Library, Getty Research Institute, Los Angeles.

Le Plongeon, Alice Dixon (ADLP)
 1877 Letter to Mrs. Gaylord in New York. 3 April. American Antiquarian Society, Worchester, Massachusetts.

Le Plongeon, Alice Dixon (ADLP)
 1879a Notes on Yucatan Manuscript. Manuscript on file, Salisbury Family Papers. Box 53, Folder 6. American Antiquarian Society, Worcester, Massachusetts.

Le Plongeon, Alice Dixon (ADLP)
 1879b Notes on Yucatan. *Proceedings of the American Antiquarian Society* 72:77–106. Worcester, Massachusetts.

Le Plongeon, Alice Dixon (ADLP)
 ca. 1880s a. Advertisement for Yucatan, Its Ancient Places and Modern Cities. Philosophical Research Society, Los Angeles.

Le Plongeon, Alice Dixon (ADLP)
 ca. 1880s b Poem. To A. J. H. LeP. Typed, 1 page. 2004.M.18. Research Library, Getty Research Institute, Los Angeles.

Le Plongeon, Alice Dixon (ADLP)
 ca. 1880s c Poem. To an Antiquary. Handwritten, 1 page. 2004.M.18. Research Library, Getty Research Institute, Los Angeles.

Le Plongeon, Alice Dixon (ADLP)
 1881a A Carnival at Yucatan. *New York World,* 27 March:3–4. New York

Le Plongeon, Alice Dixon (ADLP)
 1881b Ruined Uxmal. *New York World,* 27 June:1–2. New York.

Le Plongeon, Alice Dixon (ADLP)
 1881c Ruined Uxmal. *New York World*, 18 July:2. New York.

Le Plongeon, Alice Dixon (ADLP)
 1881d Yucatan's Buried Cities. *New York World*, 27 November:10. New York.

Le Plongeon, Alice Dixon (ADLP)
 1882 A Few Hints on Printing. *The Photographic Times and American Photographer* 12(143):427–28.

Le Plongeon, Alice Dixon (ADLP)
 1884a An Example of Patience for Photographers. *The Photographic Times and American Photographer* 14(162) (New Series no. 42):302–4.

Le Plongeon, Alice Dixon (ADLP)
 1884b Yucatan: Its Ancient Palaces and Modern Cities. Life and Customs of the Aborigines. Appendix added ca. 1897: Epitome of the War of Races in Yucatan. The Maya Indians. 535 pages typed double

spaced. Manuscript on file, 2004.M.18, Research Library, Getty
Research Institute, Los Angeles.

Le Plongeon, Alice Dixon (ADLP)

 1884c Dr. Le Plongeon's Latest and Most Important Discoveries Among
the Ruined Cities of Yucatan. *Scientific American Supplement*
18(448):7143–47.

Le Plongeon, Alice Dixon (ADLP)

 1884d Plague of Locusts in Yucatan. *Scientific American Supplement*
18(449):7174.

Le Plongeon, Alice Dixon (ADLP)

 1885a The New and Old in Yucatan. *Harper's Magazine* 70:372–86.

Le Plongeon, Alice Dixon (ADLP)

 1885b Baptism in America Before the Spanish Conquest. *Harper's Bazaar*
18(35):553–54.

Le Plongeon, Alice Dixon (ADLP)

 1885c New Year's Day Among Some Ancient Americans. *Harper's Bazaar*
18(37):594–95.

Le Plongeon, Alice Dixon (ADLP)

 1885d Remarkable Wells and Caverns. *Scientific American Supplement*
20(508):8105.

Le Plongeon, Alice Dixon (ADLP)

 1885e Dialogues of the Dead. *The Home Journal*. [No month][No page
numbers] 2004.M.18. Research Library, Getty Research Institute,
Los Angeles.

Le Plongeon, Alice Dixon (ADLP)

 1885f Yucatan. A Description of the Country and Its Inhabitants.
Brooklyn Daily Eagle 29 April:1. New York.

Le Plongeon, Alice Dixon (ADLP)

 1886a *Here and There in Yucatan*. J. W. Bouton, New York.

Le Plongeon, Alice Dixon (ADLP)

 1886b Yucatan, Its Ancient Temples and Palaces (extract). *New York
Academy of Sciences Transactions* V:169–78.

Le Plongeon, Alice Dixon (ADLP)

 1886c Illustrated lectures on Yucatan. Flyer. Archives of Spencer Baird.
Smithsonian Institution, Washington D.C.

Le Plongeon, Alice Dixon (ADLP)

 1887a Babies of the Maya Indians. [No publisher] 20(12) 18 March:[No
pages] 2004.M.18. Research Library, Getty Research Institute,
Los Angeles.

Le Plongeon, Alice Dixon (ADLP)

 1887b The Mayas: Their Customs, Laws, and Religion. *Magazine of
American History* 17:233–38.

Le Plongeon, Alice Dixon (ADLP)

 1887c Eastern Yucatan, Its Scenery, People, and Ancient Cities and
Monuments (abstract). *New York Academy of Sciences Transactions* 7
7 November:44–48.

Le Plongeon, Alice Dixon (ADLP)

 1888a The Discovery of Yucatan. *Magazine of American History*
19(1):50–57.

Le Plongeon, Alice Dixon (ADLP)
 1888b The Conquest of the Mayas, Part I: Montejo on the Coast.
 Magazine of American History 19(4):324–30.
Le Plongeon, Alice Dixon (ADLP)
 1888c The Conquest of the Mayas, Part II: Montejo in the Interior, and
 Foundation of Merida. *Magazine of American History* 19(6):449–61.
Le Plongeon, Alice Dixon (ADLP)
 1888d The Conquest of the Mayas, Part III: Montejo in the Interior, and
 Foundation of Merida. *Magazine of American History* 20(2):115–20.
Le Plongeon, Alice Dixon (ADLP)
 1888e Collodion vs. Gelatine. *Photographic Times and American
 Photographer* 18(377):581–82.
Le Plongeon, Alice Dixon (ADLP)
 1889a The Maidens of Yucatan. [No publisher] [No number][No pages].
 2004.M.18. Research Library, Getty Research Institute, Los Angeles.
Le Plongeon, Alice Dixon (ADLP)
 1889b Pizarro's Death and Burial. *Home Journal* 22 March:[No pages].
 2004.M.18. Research Library, Getty Research Institute, Los Angeles.
Le Plongeon, Alice Dixon (ADLP)
 ca. 1890s a Lectures by Alice Le Plongeon, traveler and author. 2004.M.18.
 Research Library, Getty Research Institute, Los Angeles.
Le Plongeon, Alice Dixon (ADLP)
 ca. 1890s b An American Prince. Handwritten, 9 pages. 2004.M.18. Research
 Library, Getty Research Institute, Los Angeles.
Le Plongeon, Alice Dixon (ADLP)
 ca. 1890s c Carnival Days. Typed, 6 pages. 2004.M.18. Research Library, Getty
 Research Institute, Los Angeles.
Le Plongeon, Alice Dixon (ADLP)
 ca. 1890s d A Hammock Story. Typed, 3 pages. 2004.M.18. Research Library,
 Getty Research Institute, Los Angeles.
Le Plongeon, Alice Dixon (ADLP)
 ca. 1890s e Spanish Discovery of Yucatan. Typed, 1 page. 2004.M.18. Research
 Library, Getty Research Institute, Los Angeles.
Le Plongeon, Alice Dixon (ADLP)
 1890a The Mayas. A Lecture Delivered at the Blavatsky Lodge,
 Theosophical Society. *Theosophical Siftings* 3(14):1–20.
Le Plongeon, Alice Dixon (ADLP)
 1890b Ancient Races. *Lucifer* 7 November:235–36.
Le Plongeon, Alice Dixon (ADLP)
 1890c. Art Photography in London. *The Photographic Times*
 20(484):647–48.
Le Plongeon, Alice Dixon (ADLP)
 1892. Incinerating the Dead. *Commercial Advertiser* 25 December:[No
 pages] New York. 2004.M.18. Research Library, Getty Research
 Institute, Los Angeles.
Le Plongeon, Alice Dixon (ADLP)
 1893a Letter to Mary Newbury Adams. 18 February. American Museum
 of Natural History, New York.
Le Plongeon, Alice Dixon (ADLP)
 1893b Yucatan since the Conquest: The War of Races. *Magazine of
 American History* 30: 158–80.

Le Plongeon, Alice Dixon (ADLP)
 1894a Early Architecture and Engineering in Peru. *Engineering Magazine*
 7(1):46–60.
Le Plongeon, Alice Dixon (ADLP)
 1894b Customs and Superstitions of the Mayas. *Popular Science Monthly*
 44(5):661–70.
Le Plongeon, Alice Dixon (ADLP)
 1894c Golden Flower: A Dark Page in American History. *Home Journal*
 19 September:1–2.
Le Plongeon, Alice Dixon (ADLP)
 1895a The Yucatan Indians: Their Struggle for Independence—Their
 Manner of Living and Method of Warfare, and Occultism among
 the Mayas. *New York Evening Post* 2 July:7. New York.
Le Plongeon, Alice Dixon (ADLP)
 1895b Occultism Among the Mayas. *Metaphysical Magazine* 1:66–72.
Le Plongeon, Alice Dixon (ADLP)
 1896a Paris. Handwritten, 36 pages. Manuscript on file, 2004.M.18.
 Research Library, Getty Research Institute, Los Angeles.
Le Plongeon, Alice Dixon (ADLP)
 1896b The Potter's Art among Native Americans. *Appleton's Popular
 Science Monthly* 49 (May–October):646–55.
Le Plongeon, Alice Dixon (ADLP)
 1896c Occultism Among the Tahitians. *Metaphysical Magazine* 4:275–81.
Le Plongeon, Alice Dixon (ADLP)
 1896d The Monuments of Mayach and Their Historical Teachings. Paper
 read by Alice Dixon Le Plongeon before the Albany Institute, New
 York. Printed by Alice Dixon Le Plongeon. On file, Department
 of Anthropology archives, American Museum of Natural History,
 New York.
Le Plongeon, Alice Dixon (ADLP)
 1896e Our Feathered Foundling. *Forest and Stream* 46 (19) 9 May:372–73.
Le Plongeon, Alice Dixon (ADLP)
 ca. 1896 London. Typed, 55 pages. Pages 1 through 36 missing. Manuscript
 on file, 2004.M.18. Research Library, Getty Research Institute,
 Los Angeles.
Le Plongeon, Alice Dixon (ADLP)
 1897 Christmas Eve in Yucatan. *New York Evening Post* 24 December:11.
 New York.
Le Plongeon, Alice Dixon (ADLP)
 1898a Muffins and Ragamuffuns. *Forest and Stream* 22 January:68.
Le Plongeon, Alice Dixon (ADLP)
 1898b Creatures of the Tropics. *New York Evening Post* 24 September:[No
 pages] New York. 2004.M.18. Research Library, Getty Research
 Institute, Los Angeles.
Le Plongeon, Alice Dixon (ADLP)
 ca. 1899 Hawaii Long Ago. Typed, 5 pages. 2004.M.18. Research Library,
 Getty Research Institute, Los Angeles.
Le Plongeon, Alice Dixon (ADLP)
 1899 A Thought on Government. *Woman's Tribune* 14 January:4.

Le Plongeon, Alice Dixon (ADLP)
 ca. 1900–1910 Poem. Immortality. Typed, 1 page. 2004.M.18. Research Library,
 Getty Research Institute, Los Angeles.

Le Plongeon, Alice Dixon (ADLP)
 1900a Letter to Phoebe A. Hearst. 17 March. Bancroft Library, University
 of California, Berkeley.

Le Plongeon, Alice Dixon (ADLP)
 1900b Letter to Phoebe A. Hearst. 18 March. Bancroft Library, University
 of California, Berkeley.

Le Plongeon, Alice Dixon (ADLP)
 1900c That Famous Foundling. *Forest and Stream* 7 July:5.

Le Plongeon, Alice Dixon (ADLP)
 1900d Letter to Morris K. Jesup. 28 May. American Museum of Natural
 History, New York.

Le Plongeon, Alice Dixon (ADLP)
 1900e Splendors of Kinsay: A Chinese Metropolis of the Middle Ages.
 Commercial Advertiser 8 September sec. 2:1. New York.

Le Plongeon, Alice Dixon (ADLP)
 1900f A Battle Prayer. Unpublished poem. 7 February. 2004.M.18.
 Research Library, Getty Research Institute, Los Angeles.

Le Plongeon, Alice Dixon (ADLP)
 ca. 1900 A Maiden of Yucatan. [No publisher. Probably the *Commercial
 Advertiser*, New York] [No pages] 2004.M.18. Research Library,
 Getty Research Institute, Los Angeles.

Le Plongeon, Alice Dixon (ADLP)
 1901a Chan Santa Cruz's Fall. *Commercial Advertiser* 8 June:1. New York.

Le Plongeon, Alice Dixon (ADLP)
 1901b Mexico's Mayan War. *Commercial Advertiser* 20 July sec. 2:1.
 New York.

Le Plongeon, Alice Dixon (ADLP)
 1901c A Yucatecan Girl. *Commercial Advertiser* 27 July:14. New York.

Le Plongeon, Alice Dixon (ADLP)
 1902a Letter to Frederick W. Putnam. 24 March. American Museum of
 Natural History, New York.

Le Plongeon, Alice Dixon (ADLP)
 1902b Letter to Frederick W. Putnam. 25 March. American Museum of
 Natural History, New York.

Le Plongeon, Alice Dixon (ADLP)
 1902c *Queen Móo's Talisman.* Peter Eckler, New York.

Le Plongeon, Alice Dixon (ADLP)
 1903 Maya Melodies of Yucatan, Taken from the Indian airs by Alice
 Dixon le Plongeon. With Musical Settings by Susanne Vaughn Reed
 Lawton. Brooklyn (New York). Sheet music with lyrics. 2004.M.18.
 Research Library, Getty Research Institute, Los Angeles.

Lc Plongeon, Alice Dixon (ADLP)
 1905 Letter to Phoebe A. Hearst. 4 March. Bancroft Library, University
 of California, Berkeley.

Le Plongeon, Alice Dixon (ADLP)
 1908 Psychic Experiences of Alice Dixon Le Plongeon. Unpublished.
 Manuscript on file, 2004.M.18. Research Library, Getty Research
 Institute, Los Angeles.

Le Plongeon, Alice Dixon (ADLP)
>1909 Augustus Le Plongeon. (Nécrologie) *Journal de la Société des Américanistes de Paris* 6(2):276–79.

Le Plongeon, Alice Dixon (ADLP)
>1909–11 A Dream of Atlantis—The Land of Mu. *The Word* 1909–11, 9:14–20, 136–44, 226–33, 284–90, 364–71; 10:46–57, 103–15, 179–86, 243–49, 305–12, 367–75; 11:49–59; 116–22, 178–86, 236–46, 288–301, 353–67; 12:47–55. Theosophical Publishing, New York.

Le Plongeon, Alice Dixon (ADLP)
>1910a The Mystery of Egypt: Whence Came Her Ancestors? *London Magazine* 24(140):121–32.

Le Plongeon, Alice Dixon (ADLP)
>1910b Letter to Dr. Hermon C. Bumpus. 21 April. American Museum of Natural History, New York.

Le Plongeon, Alice Dixon (ADLP)
>1910c Last will and testament. Written in London. 21 April. Somerset House, London.

Le Plongeon, Augustus (ALP)
>1873a *Manual de Fotografía*. Scovill Manufacturing Co. New York.

Le Plongeon, Augustus (ALP)
>1873b The Morrison Lens. *The Photographic Times* 3(33):133–34.

Le Plongeon, Augustus (ALP)
>1876 Letter to Chas. F. Meudue. 12 December. American Antiquarian Society, Worcester, Massachusetts.

Le Plongeon, Augustus (ALP)
>1877a Letter to Augustus Gaylord. 14 July. American Antiquarian Society, Worcester, Massachusetts.

Le Plongeon, Augustus (ALP)
>1877b Letter to Porfirio Diaz. 14 September. American Antiquarian Society, Worcester, Massachusetts.

Le Plongeon, Augustus (ALP)
>1878a Matters of the Month. Treatment of Albumen Paper. *The Photographic Times* 9(94):232.

Le Plongeon, Augustus (ALP)
>1878b Letter to Henry Dixon. 7–10 February. American Antiquarian Society, Worcester, Massachusetts.

Le Plongeon, Augustus (ALP)
>1878c Letter to Stephen Salisbury. 7–19 February. American Antiquarian Society, Worcester, Massachusetts.

Le Plongeon, Augustus (ALP)
>1878d Letter to Stephen Salisbury. 24 December. American Antiquarian Society, Worcester, Massachusetts.

Le Plongeon, Augustus (ALP)
>1879a Archaeological Communication on Yucatan. *Proceedings of the American Antiquarian Society* 72:65–75. Worcester, Massachusetts.

Le Plongeon, Augustus (ALP)
>1879b Letter from Dr. Le Plongeon. *The Photographic Times* 9(100):77–79.

Le Plongeon, Augustus (ALP)
>1880a An Open Letter from Professor Le Plongeon of Belize, British Honduras. *The Present Century* 2:337–39.

Le Plongeon, Augustus (ALP)

 1880b Letter to Stephen Salisbury. 22 May. American Antiquarian Society, Worcester, Massachusetts.

Le Plongeon, Augustus (ALP)

 1880c Letter to Stephen Salisbury. 14 June. American Antiquarian Society, Worcester, Massachusetts.

Le Plongeon, Augustus (ALP)

 1880d Letter to Stephen Salisbury. 29 September. American Antiquarian Society, Worcester, Massachusetts.

Le Plongeon, Augustus (ALP)

 1880e Letter to Stephen Salisbury. 2 November. American Antiquarian Society, Worcester, Massachusetts.

Le Plongeon, Augustus (ALP)

 1881a Letter to Stephen Salisbury. 14 August. American Antiquarian Society, Worcester, Massachusetts.

Le Plongeon, Augustus (ALP)

 1881b Mayapan and Maya Inscriptions. *Proceedings of the American Antiquarian Society* (New Series)1:246–82. Worcester, Massachusetts.

Le Plongeon, Augustus (ALP)

 1881c *Vestiges of the Mayas, or, Facts tending to prove that communications and intimate relations must have existed, in very remote times, between the inhabitants of Mayab and those of Asia and Africa.* J. Polhemus, New York.

Le Plongeon, Augustus (ALP)

 1881d An Interesting Discovery. A Temple with Masonic Symbols in the Ruined City of Uxmal. *Harper's Weekly* 17 December: 851–52.

Le Plongeon, Augustus (ALP)

 1882a The Ancient Palaces of Uxmal, Mexico. *Scientific American Supplement* (316):5042.

Le Plongeon, Augustus (ALP)

 1882b Letter of resignation from the American Antiquarian Society. 24 July. Peabody Museum, Harvard University, Cambridge.

Le Plongeon, Augustus (ALP)

 1883 Are the Ruined Monuments of Yucatan Ancient or Modern. *Scientific American Supplement* (405):6468.

Le Plongeon, Augustus (ALP)

 1885a A Chapter from Dr. Le Plongeon's New Book, "Monuments of Mayax." *Scientific American Supplement* (509):8130–32.

Le Plongeon, Augustus (ALP)

 1885c The Maya Alphabet. *Scientific American Supplement* (474):7572–73.

Le Plongeon, Augustus (ALP)

 1888 The Egyptian Sphinx. *The American Antiquarian and Oriental Journal* 10(6):358–63.

Le Plongeon, Augustus (ALP)

 1894a Letter to Marshall H. Saville. 2 July. American Museum of Natural History, New York.

Le Plongeon, Augustus (ALP)

 1894b Dr. Le Plongeon to Dr. Brinton. *Brooklyn Daily Eagle* 19 August: 4. New York.

Le Plongeon, Augustus (ALP)
>1896a *Queen Móo and the Egyptian Sphinx*. Published by the author, New York.

Le Plongeon, Augustus (ALP)
>1896b Letter the Charles P. Bowditch. 23 April. Peabody Museum, Harvard University, Cambridge.

Le Plongeon, Augustus (ALP)
>1900 *Queen Móo and the Egyptian Sphinx*. 2nd ed. Published by the author, New York.

Le Plongeon, Augustus (ALP)
>1902a Letter to William J. McGee. 12 August. Smithsonian Institution, Washington, D.C.

Le Plongeon, Augustus (ALP)
>1902b Letter to William J. McGee. 22 August. Smithsonian Institution, Washington, D.C.

Le Plongeon, Augustus (ALP)
>1902c Letter to Charles P. Bowditch. 13 December. Peabody Museum, Harvard University, Cambridge.

Le Plongeon, Augustus (ALP)
>1906 Letter to Charles P. Bowditch. 2 December. Peabody Museum, Harvard University, Cambridge.

Le Plongeon, Augustus (ALP)
>1907 Letter to Charles P. Bowditch. 28 May. Peabody Museum, Harvard University, Cambridge.

Le Plongeon, Augustus (ALP)
>ca. 1907–8 Experiences of Augustus Le Plongeon. Manuscript on file, 2004.M.18. Research Library, Getty Research Institute, Los Angeles.

Le Plongeon, Augustus (ALP)
>1913 Pyramid of Xochicalco. *The Word* 18(1–3):9–29, 100–113, 154–62. Theosophical Publishing, New York.

Le Plongeon, Augustus (ALP)
>1913–14 The Origin of the Egyptians. *The Word* 17:9–20, 70–83, 161–76, 196–209, 273–81, 345–60; 18:47–60, 67–84, 181–90, 224–28. Theosophical Publishing, New York.

London Public Records Office
>1871 Census, City of London. ED12, p. 52, F824591. Public Records Office, London.

London Public Records Office
>1881 Census, City of London. P. 38, 1341038. Public Records Office, London.

Los Angeles Social Service
>1938 Letter to Maude Blackwell. 7 September. 2004.M.18. Research Library, Getty Research Institute, Los Angeles.

Lucifer
>1890–91 Untitled review of the lecture: The Mayas. Presented by Alice Dixon Le Plongeon to the Blavatsky Lodge of the Theosophical Society, London, September 6, 1890. *Lucifer* September 1890–February 1891 7:165–66. Theosophical Publishing, London.

MacNab, Lynne
>1997 Henry Dixon & Son chronology. Research notes on file at the Guildhall Library, London.

MacNab, Lynne
 1998 Henry Dixon & Son 1860 ca. 1944. Manuscript on file at the Guildhall Library, London.

McVicker, Mary F.
 2005 *Adela Breton. A Victorian Artist amid Mexico's Ruins.* University of New Mexico Press, Albuquerque.

Mayer, Brantz
 1857 *Observations on Mexican History and Archaeology, with Special Notice of Zapotec Remains. Smithsonian Contributions to Knowledge* 9.

Milbrath, Susan, and Carlos Peraza Lope
 2003 Revisiting Mayapan: Mexico's Last Maya Capital. *Ancient Mesoamerica* 14:1–46.

Morley, Sylvanus G.
 1931 Letter to J. C. Merriam. 10 October. Carnegie Institution of Washington, Washington, D.C.

New York City Archives
 1871 Certificate of marriage. Alice Dixon and Augustus Le Plongeon. Certificate No. 1883. Date of marriage: October 16, 1871. New York City Department of Records and Information Services Municipal Archives.

New York City Archives
 1910 Certificate and record of death of Alice Dixon Le Plongeon. Certificate No. 18150. Date of death: June 8, 1910. Certificate dated: June 9, 1910. New York City Department of Records and Information Services Municipal Archives.

New York Evening Post
 1910 Obituary of Alice Dixon Le Plongeon. 9 June:9. New York.

New York Times (NYT)
 1883 Personal. 22 October:18. New York.

New York Times (NYT)
 1885 Some of the Wonders of Yucatan. 25 April:8. New York.

New York Times (NYT)
 1888 Lecture on Yucatan. 25 November:6. New York.

New York Times (NYT)
 1890 Lectures. Cooper Union Free Saturday night lectures. 28 March:7. New York.

New York Times (NYT)
 1893a Lectures. Cooper Union free Saturday night lectures . . . January 7, the lecture will be delivered by Mrs. Alice Le Plongeon on "Columbus," with lantern slides. 6 January:7. New York.

New York Times (NYT)
 1893b A Lecture about Yucatan. 28 March:5. New York.

New York Times (NYT)
 1893c Lectures. Cooper Union free Saturday night lectures . . . November 25th. Lecture will be delivered by "Mme. Alice D. Le Plongeon" on "Peru," with lantern illustrations. 25 November:7. New York.

New York Times (NYT)
 1893d The Woman's Club. 5 March:4. New York.

New York Times (NYT)
 1894a Not Yet Enough for the Poor. 28 February:9. New York.

New York Times (NYT)

1894b Firm Believer in Cremation. 16 September:18. New York.

New York Times (NYT)
1895 Sorosis at Breakfast. 19 March:8. New York.

New York Times (NYT)
1908 Dr. Augustus Le Plongeon. Obituary. 14 December:9. New York.

New York Times (NYT)
1909 This Week's Free Lectures. Alice Le Plongeon scheduled to give the lecture "Famous ruins of Yucatan," on January 14, at Public School 82 in New York City. 10 January:C8. New York.

New York Times (NYT)
1910a Mrs. Le Plongeon Here, Ill. 17 May:18. New York.

New York Times (NYT)
1910b Obituary of Alice Dixon Le Plongeon. 10 June:9. New York.

New York Tribune
1900 Women in Science. Only Woman's Page. 30 June:5. New York.

Palmquist, Peter E., and Thomas R. Kailbourn
2000 *Pioneer Photographers of the Far West. A Biographical Dictionary 1840–1865.* Stanford University Press, Stanford, California.

Philadelphia Record
1909 Ashes of Archaeologist Scattered in Mid-Ocean. 17 January, Sunday, magazine sec., 3rd pt:2. Philadelphia.

Photographic Times and American Photographer
1886 General Notes. Announcement of a lecture by "Mrs. Augustus Le Plongeon" at the Cooper Union Institute. *Photographic Times and American Photographer* 16(269):589.

Putnam, Frederick W.
1902 Letter to Morris K. Jesup. 25 March. American Museum of Natural History, New York.

Putnam, Frederick W.
1911 Letter to Maude Blackwell. 26 January. Peabody Museum, Harvard University, Cambridge.

Ramey, Earl
1966 Augustus Le Plongeon. An address given April 12 at a meeting of the Mary Aaron Museum Society, John Packard Library, Marysville, California.

Reed, Nelson
1964 *The Caste War of Yucatán.* Stanford University Press, Stanford.

Review of Reviews
1895 A Fairy Tale of Central American Travel. How Cain and Abel Were Found in the Lost Atlantis. Attributed to Albert Shaw. *Review of Reviews* 12:271–81.

Salisbury, Stephen, Jr.
1877 Dr. Le Plongeon in Yucatan. *Proceedings of the American Antiquarian Society* 69:70–119. Worcester, Massachusetts.

Salisbury, Stephen, Jr.
1878 Terra Cotta Figure from Isla Mujeres. *Proceedings of the American Antiquarian Society* 71:71–89. Worcester, Massachusetts.

Schele, Linda, and Mary E. Miller
1986 *The Blood of Kings. Dynasty and Ritual in Maya Art.* Kimball Art Museum, Fort Worth, Texas.

Scientific American (SA)
 1895 A Woman Archaeologist. 10 August. *Scientific American Supplement*
 1023, 73(6):83.
Sharer, Robert J., and Loa P. Traxler
 2006 *The Ancient Maya*. Stanford University Press, Stanford.
Sheldon, May French
 1894 An African Expedition. In *Eagle*, edited by Mary Kavanaugh
 Oldham, pp. 131–34. The Congress of Women: Held in the
 Woman's Building, World's Columbian Exposition, Chicago, 1893.
 Monarch Book Company, Chicago.
Spinden, Herbert J.
 1947 Letter to W. H. Linklater, Sceptre, Saskatchewan, Canada.
 25 March. Brooklyn Museum, New York.
Stephens, John L.
 1843 *Incidents of Travel in Yucatan*. 2 vols. Harper and Brothers,
 New York.
Turner, Walter J.
 1920 The Hunter. In *Modern British Poetry*, edited by Louis Undermeyer.
 Harcourt, Brace and Howe, New York.
Wake, Charles Staniland
 1904 The Mayas of Central America. *American Antiquarian and Oriental
 Journal* 26:361–63.
Wauchope, Robert
 1962 *Lost Tribes and Sunken Continents*. University of Chicago Press,
 Chicago.
Zárate, Agustin de
 1577 *Historia del descubrimiento y conquista de las provincias del Peru,
 y de los successos que en ella ha auido, desde que se conquistò, hasta
 que el licenciado de la Gasca obispo de Siguença boluiò a estos reynos:
 y de las cosas naturales que en la dicha prouincia se hallan dignas de
 memoria. La qual escreuia Augustin de C,arate, contador de mercedes
 de Su Magestad, siendo contador general de cuentas en aquella
 prouincia, y en la de Tierrafirme*. Alonso Escriuano, Sevilla.

Index

Lawrence G. Desmond received his PhD in anthropology and archaeology from the University of Colorado, Boulder, his MA in anthropology from the Universidad de las Americas in Puebla, Mexico, and has carried out research in Mesoamerica for more than thirty-five years. He has taught at the University of Minnesota and San Francisco State University, published on his archaeological projects, and about the Le Plongeons in a previous book called *A Dream of Maya*. Currently he is a senior research fellow in archaeology with the Moses Mesoamerican Archive and Research Project at Harvard University and a research associate with the Department of Anthropology at the California Academy of Sciences in San Francisco.

—Photo by Andreas Zuercher, Rhine Fall, Schaffhausen, Switzerland, 2007.